Sport, Beer, and Gender

Toby Miller
General Editor

Vol. 17

PETER LANG
New York • Washington, D.C./Baltimore • Bern
Frankfurt am Main • Berlin • Brussels • Vienna • Oxford

Sport, Beer, and Gender

*Promotional Culture
and Contemporary Social Life*

Lawrence A. Wenner and Steven J. Jackson

EDITORS

PETER LANG
New York • Washington, D.C./Baltimore • Bern
Frankfurt am Main • Berlin • Brussels • Vienna • Oxford

Library of Congress Cataloging-in-Publication Data

Sport, beer, and gender: promotional culture and contemporary social life /
edited by Lawrence A. Wenner, Steven J. Jackson.
p. cm. — (Popular culture and everyday life; 17)
Includes bibliographical references and index.
1. Sports–Marketing. 2. Beer–Marketing.
3. Sports spectators–Alcohol use. 4. Gender identity.
5. Masculinity. I. Wenner, Lawrence A. II. Jackson, Steven J.
GV716.S585 381'.4566342—dc22 2008036472
ISBN 978-1-4331-0488-6 (hardcover)
ISBN 978-1-4331-0076-5 (paperback)
ISSN 1529-2428

Bibliographic information published by **Die Deutsche Bibliothek**.
Die Deutsche Bibliothek lists this publication in the "Deutsche
Nationalbibliografie"; detailed bibliographic data is available
on the Internet at http://dnb.ddb.de/.

Cover design by Joni Holst

The paper in this book meets the guidelines for permanence and durability
of the Committee on Production Guidelines for Book Longevity
of the Council of Library Resources.

© 2009 Peter Lang Publishing, Inc., New York
29 Broadway, 18th floor, New York, NY 10006
www.peterlang.com

Printed in the United States of America

Table OF Contents

Part II: Texts and Representation

Part III: Consumption and Reception

Preface

LAWRENCE A. WENNER

STEVEN J. JACKSON

The concept for this book emerged out of our shared interest and perhaps even fascination with the intersections of sport, beer, and gender within contemporary social life. We came across the occasional publication and conference paper but there were few focused collections. This is certainly not the first book written about sport, beer, and gender (cf. Collins & Vamplew, 2002; Sperber, 2000), nor is it likely to be the last. Nevertheless it is striking that this "holy trinity" of contemporary popular life has received so little attention. While it might be a stretch to claim that the holy trinity is a global phenomenon, it is increasingly becoming so. Even within Islamic countries where each of the cultural phenomena is often taboo, they exist in private realms.

Sport, Beer, and Gender: Promotional Culture and Contemporary Social Life brings together a unique group of esteemed international scholars to focus on the important, complex, and mutually reinforcing relationships between sport, beer, and gender in fashioning promotional strategies and shaping cultures of consumption. The book features leading scholars with different vantage points on this important naturalized dynamic in the global marketplace.

Together, we examine a well-known social constellation that has received little specific scholarly attention although it sits at the axis of many lines of expanding inquiry in sport studies, media studies, gender studies, cultural studies,

consumer studies, and the study of alcohol and substance abuse. We know, for example, that sport is a major driver of the beer marketplace and that beer engages in primary advocacy in the sports marketplace. In the United States alone, of the approximately $1 billion spent on alcohol advertising, 60% of it supports sports programming. The social effects of this nexus, manifest not only in advertising but also in multivalent promotional strategies that sit at the core of the questions of cultural harm, from the costs of alcohol abuse to those associated with domestic violence. Part of the conundrum is that both beer and sport are masculine-centered social products that have far-reaching consequences for gender relations and identities across the globe. It is a puzzling but potent social phenomenon. As Wenner asked in the early 1990s: "How is it that alcohol consumption in the face of athleticism is not portrayed as a cultural irony? How has this come about? How is it that the sports fan feels at ease in judging athletic prowess with a beer can in hand?" (1991, pp. 391–392).

Towards answering these and related questions, this book seeks to understand and denaturalize the dynamics of a systematically naturalized holy trinity, that of sport, beer, and masculinity as they interact with the marketplace and a broader drawing of gender in contemporary culture. The goal of this book is to explore the underpinnings, workings, and effects of the promotional culture that brings beer to the market through sport settings. This is important not only because the relationship between the marketing of beer and sport is both mutually beneficial and mutually parasitic, but because the marketplace for both are globalized and driven by normative understandings of gender. Beer and what might be called the "vestigial hypermasculinity" of much mainstream sport have been naturalized through iterative practices in promotional culture. This is done through institutional and marketing strategies, the careful construction of key texts that influence the beer and sport connection and how it is interpreted and, finally, the process of establishing and legitimizing particular contexts for consumption. Thus, the key purpose of this book is to interrogate the cultural bonding of sport and beer in promotional culture and to better understand this connection through its characterization and strategic positioning of gender.

Though any attempt at organization is arguably somewhat arbitrary, our intention is to enable our contributors work to collectively offer a perspective on how a particular commodity circulates through various parts of social life and in turn how it articulates and shapes a range of social relations and identities. Towards this end, this book is organized into three main sections that broadly correspond to Richard Johnson's (1986/1987) analysis of the "circuit of culture" (later adapted by du Gay (1997). Viewing a particular commodity as it circumnavigates the circuit of: (1) institutions and production, (2) texts and representation, and (3) consumption and reception enables us to trace its life as it moves from concept

to reality, from the private to the public realm, and ultimately its effects on identity. It is important to keep in mind that while we may conceptualize various parts of the circuit as distinct segments, they are, in fact, highly interrelated and mutually reinforcing. This is also true of the chapters within each of the sections outlined in this book.

Part One, "Institutions and Production," includes four chapters beginning with Walker, Hathcock, and Bellamy's analysis of how the changing context of post-World War II America influenced changes in the marketing of beer. They note, for example, how the suburbanization of American life, with the lengthy commutes to work, larger family responsibilities, and more activities centered in suburban communities, meant beer marketing through sport media needed to reflect the reality of drinking, including where and with whom one consumed. In the second chapter Horne and Whannel discuss the relationship between the holy trinity (sport, beer, and male bonding) alongside a fourth important element— social class—for making sense of the contemporary state of play between sponsorship, sport, and alcohol in the UK and most specifically in England. They suggest that in the UK, social class acts as a means of identifying differential relationships to sport and to types/codes of sport as well as differential relationships to alcohol and types of alcohol. Shifting analysis to Latin America, Jette et al. outline how major global breweries such as InBev, Anheuser-Busch, and SABMiller have been moving aggressively to exploit opportunities for growth in developing countries where alcohol marketing is less regulated and where large populations of youth offer enormous sales potential. In particular, they focus on how the beer industry is able to circumvent limited national regulations and promote beer drinking as a normative practice through lifestyle and sport event sponsorships that appeal to national culture and identity along with valorized notions of masculinity and femininity. In the final chapter of Part One, Amis, Mower, and Silk take us to Africa in order to illustrate how one of the world's most famous beer brands, Guinness, works to locate within a specific context. Specifically, they examine how advertising agency Saatchi and Saatchi use a fictional character named Michael Power to embody the values of the Guinness brand while simultaneously functioning as a representative subjectivity of African culture for the African marketplace.

Part Two, "Texts and Representation," consists of five chapters beginning with Lawrence Wenner's exploration of how beer commercials that build on sport characterize men and their bonding. A key focus is on how sites of sport and beer consumption provide a temporary refuge from both work and women but often at the cost of alienating those to whom one is closest. Next, Meân follows the construction of masculinity and the mobilization of intertextual relations to sport and beer within Miller Lite's "Men of the Square Table" and "Man Laws" advertising campaigns. These popular multidimensional campaigns drew upon highly stereotyped

and humorous constructions of masculinity and male-female relationships that ultimately served to "mobilize predominant gendered and heterosexualized discourses by framing women, sport and beer as objects of masculine possession and interest and alternative masculinities as gay, effectively policing the male category and entitlements within traditional hegemonic, heterosexual boundaries". Moving to the Australian context, McKay, Emmison, and Mikosza use Connell and Messerschmidt's (2005) reformulated concept of hegemonic masculinity to analyze changes in representations of masculinities over the last three decades in advertisements for one of Australia's most popular beers, Victoria Bitter (VB). They argue that "there has been a significant shift in the VB advertisements from traditionally monolithic representations of hegemonic masculinity toward more complex constructions via the entwined and contradictory concepts of laddishness, larrikinsm, mateship, irony, nationalism, sport, celebrityhood, and the carnivalesque." Across the Tasman, Jackson, Gee, and Scherer identify related but unique patterns of representations of masculinity in beer advertising. They draw upon Speights, one of New Zealand's top brands, and trace the development of one of the most enduring advertising campaigns of the nation: "The Speight's Southern Man." Specifically, Jackson et al. examine the contradictions associated with the political economy of the brand as well as with localized forms of resistance to the potential exclusionary, sexist, and misogynist nature of a celebrated campaign that has triumphed within the context of an increasingly flexible masculinity. Returning to Australia, Rowe and Gilmour demonstrate how the promotion of alcohol has consistently deployed stereotypical representations of the performance of Australia's both lifestyle and national identity. In turn, they describe "a recurring narrative of exclusion within many Australian television beer commercials released over the past three decades with regard to gendered, multicultural and indigenous representational power relations."

Finally, the four chapters in Part Three, "Consumption and Reception," help to articulate the relationship between the institutional organization of the production of beer, how it is publicly represented through the media and advertising, and its potential influence and effects upon contemporary patterns of consumption and identity formation. Catherine Palmer offers an ethnography of a group of Australian Rules Football (AFL) fans known as the "Grog Squad" as a way of understanding the role of alcohol consumption in cultural expressions of particular values, social structures, and identity. Within an American context, Margaret Carlisle Duncan and Alan Aycock explore one of the world's most watched single annual sporting events, the Super Bowl. As they note, the event has also become infamous for its annual onslaught of advertising campaigns from a range of companies, including breweries. While many of the Super Bowl campaigns are

known for their use of innovation, humor, and sex, these authors note the recent trend towards negative advertising including the "infliction of pain or suffering, anger, threatened or implied violence, betrayal, scenes of chaos or extreme disorder, substantial embarrassment, or some combination of these." Overall, they highlight the potential negative consequences of the use of violence in advertising (cf. Jackson, 1999; Jackson & Andrews, 2004). In a second American-based analysis focusing on the potential negative impact of the beer-sport connection, Atkin and Gantz examine the intersection of alcohol, college sports, and media campaigns. In particular, they focus on the tension and contradiction between the media's role in reinforcing the link between sporting events and drinking culture while at the same time producing advertising campaigns that promote responsible consumption. They assert that public relations initiatives that serve to demonstrate corporate responsibility on the part of breweries may be less effective than targeted "social norm" campaigns. Our final Part concludes with Garry Crawford's analysis of the relationship between sport and beer consumption in everyday life. Drawing on Brian Longhurst's (2007) recent attempt to theorize contemporary forms of "elective belonging" through the utilization of the concept of "scene," Crawford explores the sites (scenes) where sport and alcohol consumption assume greater significance. In turn, he discusses how these particular scenes serve as places where masculinity and even deviance can be performed.

We have deliberately incorporated contributors whose perspectives are variant, yet complementary. These scholars draw upon various combinations of media and cultural studies, sociology, and gender studies to examine the gendered dynamics associated with promotional cultures that surround the beer/sport relationship. The contributors form an internationally diverse group, bringing perspectives from the United States, UK, Canada, South America, Australia, and New Zealand.

Ultimately, we offer this book as a starting point and encourage other scholars to critique and extend. Indeed, we see further inquiry that might explore a range of more culturally and contextually specific manifestations of sport, beer, and gender. For example, how has the rise of women's participation in sport—in particular, contact sports such as ice hockey, rugby, boxing—impacted both on the culture of alcohol consumption and on gender relations? What impact, if any, is the pink dollar having on the holy trinity particularly in relation to targeted sporting events such as the Gay Games? How are beer producers, sponsors, and cultural intermediaries reacting to these new markets? What are the likely implications for the holy trinity in a post–Beijing Olympics scenario? How and why are both national and transnational brewing companies undertaking corporate responsibility programs in relation to the production, marketing, and promotion of

responsible consumption of alcohol? How could and should governments regulate and set policy on the relationships between sport and the promotion of alcohol? These lines of inquiry will help us gain a better understanding of the holy trinity within the world's many global locals.

REFERENCES

Collins, T. & Vamplew, W. (2002). *Mud, sweat, and beers: A cultural history of sport and alcohol.* New York: Berg.

Du Gay, P. (1997). *Production of Culture/Cultures of Production.* London: Sage.

Jackson, S.J. (1999). *Sport, violence and advertising in the global economy.* Working papers in sport and leisure commerce, 4, 1–20.

Jackson, S.J., & Andrews, D.L. (2004). Aggressive marketing: Interrogating the use of violence in sport related advertising. In L. Kahle & C Riley (Eds.). *Sports marketing and the psychology of marketing communications* (pp. 307–325). Fairfax, VA: Lawrence Erlbaum Associates Publishers.

Johnson, R. (1986/1987). What is cultural studies anyway? *Social Text*, 16, 38–80.

Longhurst, B. (2007). *Cultural change and ordinary life.* Maidenhead: McGraw Hill.

Sperber, M. (2000). *Beer and circus: How big-time college sports is crippling undergraduate education.* New York: Henry Holt.

Wenner, L.A. (1991). One part alcohol, one part sport, one part dirt, stir gently: Beer commercials and television sports. In L.R. Vande Berg & L.A. Wenner (Eds.), *Television criticism: Approaches and applications* (pp. 388–407). New York: Longman.

Sport, Beer, AND Gender IN Promotional Culture: ON THE Dynamics OF A Holy Trinity

LAWRENCE A. WENNER

STEVEN J. JACKSON

How is it that alcohol consumption in the face of athleticism is not perceived as cultural irony? How has this come about? How is it that the sports fan feels at ease in judging athletic prowess with beer can in hand?

(WENNER, 1991, PP. 391–392)

Asked almost 20 years ago in framing a naïve inquiry into the workings of beer commercials shown in televised sports broadcasts, questions growing from those above continue to resonate today. Yet, in considering the evolution of sport, beer, and men as a cultural space, we recognize that many things have changed. Over the last 20 years, sport, in its increasing commodification, has become more extreme and spectacularized. At the same time, the place for women in sport has evolved. Here, equity in and democratization of sport have come in the form of "sport for all" programs across the globe and Title IX in the United States. These mirror broader changes in social relations, from the malleability of postmodern response to hypercommodification to a new pastiche of gender roles. Still, and perhaps because of this situation, the sport and beer mixture continues to serve as a sign of a vestigial but potent hegemonic masculinity.

In exploring this lingering phenomenon, we find ourselves sitting on a fence looking at the workings of sport, beer, and gender in contemporary promotional culture. On one side, in the casting of dominant masculinity into this mixture, we see a holy trinity, or certainly a holy grail that is a marketer's dream. On the other

side, there is the realization that much about gender has or needs to be changed. We see this in recognizing that the bounds of gendered identity are great and also that much harm, to heterosexual relations amongst others, continues to come from narrow understandings that influence the performance of gender roles. In acknowledging this, we gaze through a necessarily different lens of gender as a site of struggle to view sport, beer, and gender in a commodity culture dominated by media representations. Here we see something far more profane, a constructed entity, as was Mary Shelley's Frankenstein, that we call Sportenstein. In this instance, the construction results from a set of myths fashioned about sport, beer, and masculinity. Seemingly reinforced at every turn by mad marketing scientists, the construction has naturalized cultural sensibilities behind a veil of carefully manicured assertions that hold the potential to wreak havoc in everyday gender relations.

Perched on the fence, we recognize that "truths" about sport, beer, and gender in promotional culture lay on either side, both sides at once, and in places in between. In short, the holy trinity occupies a strategic yet flexible and continually shifting position. We aim to understand this potent cultural brew, both how it came to be and how it may play out. To help frame these efforts, we focus in the next sections on a series of dynamics that set the stage to understand sport, beer, and gender in promotional culture.

SPORT AND MEN

A complex set of historical forces has built a naturalized relationship between sport and the cultural definition of masculinity. Necessarily considered here selectively and superficially, the cultural marriage of men to sport has been carefully charted and assessed by many (Burstyn, 1999; Connell, 1993; Dunning, 1986; Kidd, 1987, 1990; Messner, 1992, 2002; Messner & Sabo, 1990; Sabo, 1985; Sabo & Jansen, 1992; Wenner, 1998; Whitson, 1990). Messner (1992) has argued that the cumulative effects of the lessons of sport have resulted in a series of promises that sport makes in the transition from boyhood to manhood. As Whitson (1990) suggests, and Wenner (1998, p. 310) summarizes, these "may be reduced to the interlocking promises, that as a male: (a) you are strong, therefore dominant; and thus (b) you are special, therefore superior to women."

These promises have evolved from a set of responses to changing societal formations and power relations, many of them initially raised by the demands of industrialization. As it unfolded as a broad-based male rite of passage in early industrial and postfordist times, participation in sport was seen to address concerns over (1) problematic leisure in the working class, and (2) the "feminizing" of the middle- and upper-middle-class workforce (Burstyn, 1999). Both sought to

redress issues of gender formation. In the former, sport was seen to be a civilizing influence, building character and a gentlemanly disposition. The latter addressed fears "that males were becoming too 'soft'" (Messner, 1992, p. 14) in industrial society. Wound around emerging concerns for health and fitness, initiatives that addressed "true manliness" to prevent it from becoming a recessive trait came to dominate. Here the role of increasingly organized boy's sport came to fill a void. Rising in response to boys increasingly being raised, taught, and supervised by women, came the proliferation of youth and school sport leagues. These, as Burstyn (1999, pp. 50–54) has put it, filled the "father gap" and addressed what was called a "crisis of paternity." Here, lessons actually important enough to be taught by men to boys (beyond the watchful eyes of women) took on greater significance. Lessons of sport became lessons of life.

Central were lessons about how "real men" competed and how those who did not were not. Men's physicality was related to one's moral stock. Here boys learned that gains come from physicality and playing through pain. Failure to display such traits in competition called into question one's manhood and raised the specter of being "the other," feminine, a sissy, or homosexual. In short, sport brought "men together to celebrate their shared manliness and develop strength, competitiveness, efficiency: attributes and beliefs that were 'natural' to their differences with women and beneficial to the 'greater good' of the economy" (Wenner, 1998, p. 309).

In linking sport to the greater good and a righteous manhood—one that facilitates character, economy, and nation—Burstyn (1999, p. 18) has observed that it functions as a "secular sacrament." Thus, it is not surprising that the male attributes of sport have often been aligned with the interests and male performance of "nation-building, imperialism, and militarization" (Burstyn, 1999, pp. 66–74). In pairing sport with such endeavors, it is important to recognize the importance of men setting themselves apart from women not only culturally, but also physically. In this regard, there is a compelling "sexual geography" of sport (Reiter, 1975; van Ingen, 2003; Wenner, 1998) that has done much to facilitate its place as sacred. For years, the playing field was "off limits" to women. Its perpetuation as a male preserve was fueled by "scientific" arguments that girls would be harmed, using up precious reproductive energy and thereby harming society (Kidd, 1987).

Nowhere is sexual segregation more pronounced than the locker room where male bonding is privileged. Here, boys hear inspirational talks about overcoming adversity, including pain, to show they are "real men" in competition. Here, talk of opponents is commonly disparaging, sarcastic, and offensive, often characterizing them as weak and attributing weakness to the feminine (Pronger, 1990). In this setting of building oneself up, talk about women is often hostile and aggressive, objectifying them in a way consonant with promoting rape culture (Curry, 1991; Kane & Disch, 1993).

The importance of the sexual geography of sport is vividly seen in the cultural role of the elite sport stadium. Here, Kidd (1987, p. 256) sees a "secular cathedral" on the urban landscape serving the function—as likely the largest and most expensive building in town—of a publicly supported "men's cultural center." Indeed, much learning for the boy about being a man takes place at this sacred place. Often in the company of fathers or other elder males, boys learn how to act (including appropriating resources and consuming) in response to the "big game."

This "critical event" lesson is mirrored in the domestic setting where households are transformed to accommodate the male camaraderie that ritualistically celebrates male athleticism as dominant, helping to legitimize its right to push aside other matters of life (Wenner, 1998, p. 310). While women may indeed come to join in "die-hard" fanship and be engrossed in the nuance of the game, men often "help" women in interpretation by displaying superior knowledge and complex mastery (Duncan & Brummett, 1993). Thus, in the context of sport, such helpful gestures may push men and women apart even while they sit side by side. The persistence of the football widow myth and stories about the relational angst that has come from the overindulgent male fan are testimony that men and women do not often sit side by side when it comes to sport (Gantz et al., 1995a, 1995b).

Even in the face of women's increased interest, knowledge, and involvement in sport, the cumulative weight of the male-sport dynamic remains considerable. These gain force as layered linkages:

> [M]uch of the cultural power of sports is linked to its functioning as male rite of passage and the role sports spaces and places play as refuge from women. Sports explicitly naturalize "man's place" in the physical. Implicitly, it also appropriates "woman's place" as "other," inherently inferior on the yardstick of the physical, and thus life. These dynamic elements allow sports to play a fundamental role in the construction and maintenance of patriarchy. (Wenner, 1998, p. 308)

Even if one were to view such logics only as a historical point of reference in culture, its legacy has left women with much to overcome and ample room to brew resentment.

BEER AND MEN

Just as men have been enmeshed in and escaped through sport, men have raised many glasses of "cheer" in settings where women are seen as the other. Indeed, there are many parallels between the male-sport dynamic and the one that exists

between men and drinking. Foremost, both mark a masculine rite of passage. As Lemle and Mishkind (1989, p. 214) note, the first drinking experience is often "one of the fundamental activities by which a boy is initiated as a man, perhaps because more formal rituals have dwindled."

This mirrors the experience of the first "big game" or match in the company of elder males in key ways. Often occurring in the company of more experienced male peers, the first drink may be seen as "sacrament" that marks the gaining of privilege for the boy. Similar to the "big game" with more experienced males in the stadium, the first drink, as well as the first incident of heavy drinking and intoxication, often happens in public—in parks, parking lots, and cars (Fromme & Sampson, 1983; Harford, 1979; Snow & Cunningham, 1985; Waller & Lorch, 1977).

The rites of continued public place drinking for male adolescents ease the transition through a challenging "threshold" stage of the life cycle. Here, between boy and man, one is called upon to act like a "real man," even though the provider or family head roles are nowhere in sight. As Burns (1980, p. 280) notes, beer, because it is more readily accessible and cheaper than other forms of alcohol, has played a key role in the North American context:

> [U]ntil attaining that stage in the life cycle, as best he can he and his fellows must participate in whatever masculine activities are open to them to assert themselves as men. This is accomplished by "being rowdy." When young males are together, their conversations are filled with references to street fighting, acting "tough," and "being rowdy"—activities usually involving large amounts of beer.

In its lessons of consumption, beer, like sport, teaches masculinity. Paralleling the promises that sport makes to the boy, the lessons of beer promise masculinity. In making good on these, public displays of heavy consumption in young male adulthood showcase a triad of activities. Here, masculinity is "signed" by proofs of being able to "hold liquor," by having the means and generosity to buy a "round of drinks," and by letting the drinking permit generous displays of "toughness" (Wilsnack & Wilsnack, 1979).

Other lessons about masculinity come with drinking. Men drinking more are thought to be "manly," while teetotalers or those drinking in more measured amounts risk being castigated or even marked as "other." Heavier drinking, even to the point of drunkedness is viewed as "typical" and often "desirable" for men, but not for women (Bruun, 1959; Burns, 1980; Orlofsky et al., 1982). Rooted in this is the public ritual of "drinking each other under the table." Underlying such face-offs is concern for how one's masculinity is being taken by one's peers (Gough & Edwards, 1998). Lemle and Mishkind (1989, p. 214) provide evidence

that such "'drinking with the boys' has two mutually reinforcing effects: it furthers the male image of alcohol, and it makes the men engaged in the activities seem more manly." Linking drinking to the broader "doing of gender," Messner (2002, p. 127) argues that "[t]he consumption of beer confirms one's sense of masculinity, solidifies one's membership in a community of men, and positions men as consumers of sexy women."

SPORT, BEER, AND MEN

Given the many parallels in how both sport and beer play roles in male rites of passage and in foundational socialization of what it means to be a "real man," it is not surprising that their paths cross frequently. Indeed, the beer, sport, and men nexus has had a long cultural history. Much of this is rooted in the evolution of the alehouse, tavern, and pub. As Collins and Vamplew (2002, p. 5) have carefully chronicled, "[e]ver since it acquired its distinct identity, the public house has always been closely connected to sport." They note that by no later than the sixteenth century, "the ale house was the main arena for staging sports events" with fields, greens, courts, rings, and the like arranged in close proximity on the grounds. Here came much cockfighting, boxing, bowling, rugby, foot-races, and more. Riding on the tendency of retired sport players to become pub owners, proprietors became sports promoters and programmed contests that would draw the largest crowds for the sale of brew (Collins & Vamplew, 2002).

FROM PLACE TO SPACE

What became a long linkage of grog to sport in the sexually segregated geography of the pub has done much to naturalize its connection to masculinity. As a result, the pub came to represent the archetype for what Oldenburg (1989) has called "the third place." Seen throughout history in the form of beer gardens, pubs, cafes, taverns, markets, bakeries, barber and beauty shops, these are "great good places," neither home nor work. For Oldenburg, the best of these "are the haunts of men or women, but not both" and the "joys of the third place are largely those of same-sex association, and their effect has been to maintain separate men's and women's worlds more than to promote a unisex one" (1989, p. 230). Not surprisingly, he notes that "third places seem to be mainly a male phenomenon" (p. 232) with women recognizing they often "don't even have a second place" (p. 230). Providing contrast to the notion that "women's work is never done," the third place character of the pub magnified its role as a sacred refuge, "a 'man's place—where nothing

much got done when much remained to be done at home." In this sanctum came a "territorial imperative" where "boys could be boys" (Wenner, 1998, pp. 306–307).

The stability of the British pub as a third place that brought together beer, sport, and men was enhanced by the formal courting of club by pub. In developing their roles beyond those of promoters, pub owners increasingly became shareholders in rugby and football clubs. This more firmly established the local pub's functioning for players and their supporters. In its course, the structure of the pub affected the structure of sport. Here the rules of "amateurism" were routinely skirted, with arrangements made for players to be gainfully employed by breweries, the pub, and its patrons in jobs that often did not demand much. The cementing of the pub to sport so blurred the lines that Collins and Vamplew (2002, p. 13) wryly note: "Rather than football being an adjunct of the pub, the pub almost become an adjunct of football." Over time, this inexorable blurring of the line separating beer from sport has left a broader imprint on more than the pub. A good case may be made that the mixture itself, symbolized by and materialized in the pub, has transcended the bounds of physical place and evolved into a sacred "third space" for men.

In the contemporary world, much is destabilized. Certainly, the geography of the urban landscape is ever changing. Going back to the old neighborhood to find the landmarks of one's youth is virtually impossible. In all likelihood, the pub will have been leveled to make room for something new. Thus, in today's world, cultural space often trumps place in terms of stability. There is no denying that spaces such as the one defined by sport, beer, and masculinity are ever changing as well. Yet, it is the ability to port space to place that has made this holy trinity ubiquitous. On today's landscape, the space of sport, beer, and men can be seen in many places. These range from the public to private, from stadium to living room, from liquor store to the sports bar, to our positions in front of and the images on the screens of televisions, computers, and mobile phones.

SPACE CASES

In the spaces of an increasingly hypercommodified world, many lineal descendants of the club and pub marriage may be seen. The role of beer drinking in male team cultures remains strong and a closer look at its workings are sobering. In examining how male collegiate athletes act and bond through frequenting local campus bars, Curry (2000, p. 169) has concluded that "athletes would try to 'own' every bar they frequented." Special dispensation was often given for their rowdiness. Barroom behaviors characterized by "drinking, picking up women, and getting into fights" (p. 168) were more likely rewarded than

sanctioned. Often victims of their group violence were the ones tossed out by the bouncer. For this, it was not atypical for the bartender to reward the athletes with a round of free drinks. Curry (p. 170) notes that group celebrations associated with this anomaly were "a way of building team character and expressing masculine courage." This subcultural tableau was characterized by heavy competitive drinking, the point of which one athlete told Curry (p. 169) was "to prove you're not a pussy."

Such shadings of sport, beer, and masculinity extend in familiar ways to fan cultures spanning the globe as well. In the United States, we see the "beer and circus" (Sperber, 2000) of intercollegiate athletics, a culture where, as Messner (2002, p. 79) observes, "beer promotions keep college sports afloat." Sperber (2000) has argued that this is a dysfunctional culture, aided, abetted, and enabled by the mixture of beer, sport, and masculinity. Here, as he has put it, men lead the "party around the team" (pp. 182–200). Disproportionate binge drinking rooted in the male competitive tradition of "drinking each other under the table" is most notable at universities with large athletic programs and seen on the occasion of "big games." Sperber notes that, in expanding the considerable health dangers, this sport-driven phenomenon not only attracts binge drinkers but also serves a recruiting function by pressuring and encouraging nondrinkers to binge.

The naturalization of partying "around the team" may be seen in two other manifestations of fanship—tailgating and hooliganism. In the former, it sets the stage for a more domesticated weekend ritual. Anchored in the drinking of beer, tailgating is most pronounced in the United States with college football on Saturdays and professional football on Sundays. In getting sufficiently fortified for the "big game," men lead the way. Reports from one study at Virginia Tech (Clarke, 2006) are typical. Here, three-quarters of tailgaters were men and almost 90% of tailgaters consumed alcohol. Blood alcohol levels for men were almost twice those of women and men were significantly more likely to be intoxicated than women. The male-sport-beer nexus is further seen in "chicken or egg dilemma" findings of a strong correlation between alcohol consumption and intoxication levels and both affective and cognitive involvement in the college football program. Here we see dueling equations for our holy trinity: men and beer fueling interest in sport *versus* men and sport fueling interest in beer. In either instance the trinity is bred, although the equations may cancel themselves out.

Such equations factor into hooliganism and the broader specter of fan violence in the aftermath of games. As Collins and Vamplew (2002, p. 69) note, these sometimes related phenomena are anchored in alcohol being so integral to sport spectatorship that "it would be difficult to argue with the contention

that for many spectators, the activity on the field of play is often secondary to the opportunity to drink." Yet, the move from this to explaining alcohol's role in hooliganism and fan violence is complex. Dunning, Murphy, and Williams (1988, p. 13) argue that "[d]rinking cannot be said to be a 'deep' cause of football hooliganism for the simple reason that not every fan drinks."

Even if one recognizes that not all fans drink and further that not every fan who drinks is a hooligan, there is little denying that alcohol is almost always present in incidents of hooliganism and fan violence (Stainback, 1997). Almost always present as well are men. Thus, in explaining the causes of spectator aggression, both the psychological stimulants, such as the frustration-aggression link and the needs for self-esteem maintenance and excitement, and the salience of social predictors, such as class and national identity, point to men. Yet in summarizing these and other more nuanced psychological and sociological determinants, Wann et al. (2001) add alcohol as a third overarching determinant of spectator aggression. They conclude (p. 128):

> [I]f you were to stop someone on the street and ask what causes spectators to act violently while watching their favorite sporting events, the answer is almost certain to involve alcohol consumption. Certainly, not all acts of spectator violence are fueled by alcohol, but surely many are. The fact is, spectators who overindulge and become bellicose and belligerent are primed for anti-social behavior that runs the gamut from profanity to throwing a beer can on the field to picking a fight with another spectator.

The debates over the role of alcohol in hooliganism often hinge on whether the acts are "spontaneous" or "strategic." Indeed in recent times, there has been a rise of strategically planned hooliganism where alcohol was not a chief fuel (Collins & Vamplew, 2002). Yet, the link between the spontaneous eruptions of hooliganism and fan violence that breaks out in celebration of victory or in response to disappointment with defeat is clear. This is rooted in beer, circus, men, and sport.

ON RECOGNIZING CULTURAL EFFECTS

Such beer and circus often seem like a fact of life that we have to accept. After all, "boys will be boys." Perhaps our tolerance grows from the perception that, most of the time, its effects are benign. Yet, the artifacts of beer and circus in the context of sport certainly have not been neutral. Heavy drinking, in any circumstance, compounds problems. Alcohol, more than any other drug, is linked to violent behavior (Fagan, 1990, 1993). Up to 85% of intimate assaults have been attributed to alcohol, fueling much spousal abuse and rape (Jasinski, 2001). For many

men, the recipe is simple: confidence goes up, inhibition goes down, and bravado overcomes judgment. When sport enters the picture, there is much evidence that men are further fortified and too often this brings violence and harms women (Benedict, 1998; Boswell & Spade, 1996; Leichliter et al., 1998; Messner, 2002; Miller et al., 2006; Robinson, 1998).

Thus it might be expected that alcohol-infused fans, whether fortifying themselves in preparation for spectatorship or reacting to winning or losing, can wreak much havoc. Often this is done in full public view. Yet, there is a private side to alcohol use that is fostered by naturalizing the beer to sport—a connection that is no less ugly. The evidence here, because it is so often underreported, tends to mask the severity of the problems. Still there is no denying that alcohol use, in the course of games as well as in their aftermath, can have real impacts on domestic life (Gantz et al., 1995a, 1995b; Wann et al., 2001; Wenner & Gantz, 1998). This is true not only in the case of the sore, drunken loser taking out his frustrations on his spouse. Milder dysfunctions such as getting "a little buzz on" while watching the game can have lingering effects. When promises to do chores around the home are routinely broken week after week from lethargy resulting from the ritual, this becomes a constant drip that can have ill effects on the relational dynamics in the household.

Examples like this provide a reminder that in looking for the effects of the brew of sport, beer, and masculinity, one does not have to look for the "big bang." This is particularly true as the contours of the sport, beer, and masculinity mixture increasingly come to be defined by the forces of promotional culture. Here, constancy of drip is a key feature.

SPORT, BEER, AND MEN IN PROMOTIONAL CULTURE

With masculinity as the common ingredient, the linking of beer to sport cements dual historical alliances, between sport and men on one hand, and beer and men on the other. The amalgam has become so naturalized in the United States that, as Scott (2001, p. 60) has observed: "Mention beer to Americans and predictable images come to mind. Some will think of the baseball game last weekend. Some will picture couches, coolers, and *Monday Night Football*." Evident in permutations across the globe, such "predictability" has been made possible by the forces of promotional culture. In the specter of sport, this has often been referred to as the "sports/media complex" (Jhally, 1989), or more to the point, as the "sport-media-commercial" complex (Messner, 2002). Certainly, such characterizations highlight that media has driven the commercial engine of contemporary sport. Yet, in doing so, it masks something widely recognized—that breweries

have been the "dominant sponsors" (Howard & Crompton, 1995, p. 283) of this complex and have played a key role in its development (Burstyn 1999; Messner, 2002; Scott, 2001).

Conceived of in this way, beer is the essential fuel for this complex, filling much of the tank that allows the commercial engine to run. So much so, we think it may be more transparent to characterize this as a unique and powerful ecosystem—*the sport-media-beer commercial complex.* The cultural melding has been so considerable that it is no longer a case of beer fueling the commercial engine of sport. Rather, sport, media, and beer have inexorably bonded in a synergistic system of mutual sustenance. Ever running, this cultural engine leaves its constant drip as naturalized residue for sense making, and thus for performance, in lived experience.

For a "synergistic system of mutual sustenance" to remain salient and vibrant, it has to work successfully and simultaneously along overlapping fronts. This is duly recognized in contemporary marketing strategy, where the watchword has become IMC, which stands for integrated marketing communication. The management concept can be summarily defined as a strategy "to make all aspects of marketing communication such as advertising, sales promotion, public relations, and direct marketing work together as a unified force, rather than permitting each to work in isolation" ("Integrated marketing...," 2007). This is clearly evident in the promotion, sponsorship, advertising, distribution, event development, and other elements that characterize the quickly growing and professionalized area of strategic sports marketing (Shank, 1999). Here, a key focus is in bringing "partners" together to create a "win-win" situation.

Over time, these "partnered" fronts work to blend the sensibilities about the products being sold, so that they may be likened to "blurred genres" (Geertz, 1973). In this way, the selling of sport and the selling of beer have been blended. Blurred genres depend on the notion of "cultural borrowing" (Leach, 1976). Here the borrowing goes both ways. Foremost, beer seeks a ride on the logic of sport. This is clearly seen in much beer advertising and sponsorships for events, venues, and participants. However the converse is also true. Sport rides on beer. For many, spectatorship is not quite the same without it. And the sports bar is foremost a bar that promotes sports.

Johnson (1988, p. 74) has commented on what has allowed this blurring: "Beer drinkers and sports fans are one and the same—indivisible, inseparable, identical! No one drinks more beer than a sports fan, and no one likes sports better than a beer drinker." Yet, we know that such unity has resulted not from a naturally occurring ecosystem. Rather, its manufacture has relied on the "dirtiness" of strategic cultural borrowing. The notion of "dirt" helps illuminate the transference of meaning, back and forth, between sport and beer

in the commodity context. Conceptualized as "matter out of place" (Douglas, 1966, p. 35), cultural dirt transcends boundaries, moving from places where it "belongs" to others where it may not. Leach (1976, p. 62) has observed that "power is located in dirt," because as it crosses boundaries, dirt brings meaning and merges sensibilities.

Still, the workings of dirt in commodity culture can be complex (cf. Wenner, 2007). For example, that which moves, the dirt itself, may be benign, but "the contagion that results from its strategic use may be ethically problematic" (Wenner, 2008b). Inevitably such things get noticed and the received view of dirt must be tempered. Hartley (1984, pp. 122–123, 127) sees communicative dirt as "parasitic" and "tainting" but notes that because readers intervene, it may not be fully "semiotically stolen" in the new setting. Yet, in contexts such as sport, as marketers well know, partial theft may be enough:

> [T]he movement of dirt has special resonance in understanding the cultural reach of hypercommodified media sport....As it does in other settings, dirt facilitates the transfer of power and logic from one context to another. Thus when we speak of "sport's appeal" or build a case that "sport provides a special setting for marketing products," this recognizes the power of sport dirt. Through manufactured connections, dirt helps make the sell. (Wenner, 2008b)

Accordingly, dirt helps make the blurring of cultural space possible. In the realm of the sport to beer to consumer transference, we see three key spaces where cultural dirt about sport, beer, and men is manufactured and spread. These draw on existing relationships—between sport and men, beer and men, and amongst sport, beer, and men—considered earlier. In conceptualizing them as programmed space, sponsored space, and performance space, we recognize their necessary overlap and intertwining. Although perhaps not exhaustive, the categorical scheme focuses on key roles in the manufacture and performance of commodity culture. In the next sections, we briefly characterize each space in terms of textual and economic roles by considering some limited but dominant examples.

PROGRAMMED SPACE, MASTER TEXTS, AND THE NARRATIVE ECONOMY

In selling beer through sport, it helps to have coherent social constructions of sport. The relative stability of sport myths assists with beer's ability to attach itself. In a way, this is a simple equation. For there to be sponsored space, there needs to be something to be sponsored. Herein lies what may be thought of as

programmed space. While we may think of a sports broadcast as archetypal of programmed space, the variants are many. Certainly, stories of sport fashioned in newspapers, magazines, movies, video games, and across the Internet all qualify. Game events, often lavishly produced, in stadiums or arenas may also qualify. Narrators and the narrative frame change with time, technology, and venue. Regardless, here are narratives about sport that tell its story and extol its virtues. While there may be variances in emphasis among texts, and certainly texts may be tailored in distinct ways for audiences, the program narrative must keep its distance from its commercial companion. This is true, even as it is increasingly the case today, when the commercial companion may be embedded in the programmatic text. For the commercial to build on the logic of programmatic, this is an essential dance. Ironically, to aid the success of dirt from the programmatic realm in being ported to the commercial setting, it must have some purity. In a sense, this is what advertisers or sponsors are paying for when they "buy sport." As seen many times in the marketplace, if the programmatic product throws off some moral surprises, sponsors revolt (Wenner, 2008c).

Over the last half-century television has been the primary programmatic engine of sport. Through game and contest broadcasts and sports reports, television "delivers" men as consumers (Burstyn, 1999). Because 18–49-year-old men are both an elusive and desirable demographic with their high levels of disposable income, there is strategic pandering to men in both sports-related programming and its advertising. In broadcasting both the big events and "daily drip" of sports, television has relied on a cohesive set of overarching themes. Even as television's dominance has begun to give way to the web and other platforms to tell sport's story, it remains as the chief driver of sport's master text. Because of its ubiquity, the assertions of this text form the core dirt that may be ported to sponsored spaces, whether those be on television or elsewhere, such as in print, on the web, or in the stadium or bar.

In an extensive examination of varied forms of sports programming on television, Messner, Dunbar, and Hunt (2004) have characterized this master text through its reliance on what they call "The Televised Sports Manhood Formula." Codified along a set of interlocking dimensions, the formula is anchored in sport as man's place. Here not only is it natural for boys and men to be violent, but also aggression is rewarded and those who play nice lose. Sport is seen as war, a place where one must show his mettle and be willing to endure pain and injury in sacrifice for the team. In an important link to commodity culture, the myth shows that it is "real men" who reap rewards:

He must avoid being soft; he must be the aggressor, both on the "battle fields" of sports and in his consumption choices. Whether he is playing sports or making

choices about which snack food or auto products to purchase, his aggressiveness will net him the ultimate prize: the adoring attention of conventionally beautiful women. (Messner et al., 2004, p. 241)

In featuring the commodity value of a sport-centered outlook, Messner et al. argue that the hegemonic masculinity being promoted by the sport/media/commercial complex in turn supports and stabilizes it. In having it both ways, sport dirt wins. A circular conflict of interest allows for reification to be produced through the flattering promise of self-fulfilling prophecy:

> The Televised Sports Manhood Formula is a master discourse that is produced at the nexus of the institutions of sport, mass media, and corporations who produce and hope to sell products and services to boys and men...within an ideological field that is conducive to the reproduction of the entrenched interests that profit from the sports/media/commercial complex. The perpetuation of the entrenched commercial interests of the sports/media/commercial complex appears to be predicated on boys accepting—indeed glorifying and celebrating—a set of bodily and relational practices that resist and oppose a view of women as fully human...(Messner et al., 2004, p. 242)

That breweries have historically spent the bulk of their advertising dollars in sports programming where desirable 18–49-year-old men congregate ("Alcohol advertising...," 2004; Carter, 1996) speaks to their allegiance to the manhood formula and the effectiveness of its dirt being ported to commercial space. Indeed, as we will see in the next section, the "beer commercial formula" is built on this logic.

Although the television sports logic has dominated programmed space for sports, commodity culture plays out along many fronts. Some of these are traditional, such as newspapers and magazines, and others take new forms such as sport-programmed websites, blogs, video games and extends to a new pastiche of "user-generated content," such as that seen on YouTube. In this move toward a more decentralized model for media and its commodification, sponsors have, in more forward ways, invaded programmed space, including that produced by individuals in social networking on MySpace, Facebook, and the like.

Notable among such invasion efforts in the United States has been the mounting of Bud.TV as part of the brewing behemoth Anheuser-Busch's shift of its marketing dollars away from television advertising. In what is deemed an exploratory online marketing effort, tens of millions of dollars are being spent by the brewer to build an entertainment network for its Budweiser beer brand. The foremost purpose is to produce and program its own entertainment. In creating its own "programmed space" full of short "series" of short

"shows," Bud.TV has hired writers and performers from *Saturday Night Live* and other iconic successes that have appealed to the young male audience. As Manly (2007, p. 52) explains:

> Bud.TV may be a marketing venture at heart, but it is marketing sotto voce. The show's plots won't revolve around the quest for the perfect beer and a beautiful woman to share it with. Characters won't declaim the virtues of Budweiser's freshness. The site won't be cluttered with banner ads. Instead, Anheuser-Busch executives are banking on a more subtle connection.

Still, when one looks at the content of Bud.TV, there is an evident reliance on the Televised Sports Manhood Formula. Many of the comedies rely on jokes about women, the reality shows drift towards lingerie contests, and the sport to man connection is featured prominently in both newly produced sports shows and in the prominent display of beer commercials that have run in television sports programming. While the Bud.TV strategy is still evolving, its merger of programmed space with sponsored space reminds us of the importance of fashioning affinities in programmatic settings so they may adhere more potently in the commercial sphere.

SPONSORED SPACE, SUBTEXTS, AND THE COMMERCIAL ECONOMY

In the sport to beer to men pathway, sponsored space is the connector. It links programmed space with performance space. In drawing on the master text of programmed space (and thus its dirt), sponsored space necessarily relies on subtext. In classic manner, subtext underlies the master text and serves to characterize a relationship, in this instance between the mostly male sports fan and the consumption of beer ("What is subtext?" 2007). The connector function is essential to characterizing that relationship. So too, are implications about fanship.

Fanship—and more broadly, identity with sport such as that which comes with participation—allows for the pleasures and dirt associated with sport to be encouraged in performance. Increasingly in the sporting context, as Crawford (2004, p. 4) explains, so much relates "directly or indirectly to acts of consumption" that "being a fan is primarily a consumer act and hence fans can be seen first and foremost as consumers." As a result, the programmed space to performance space link is necessarily predisposed to consumption. The fact that this transitional space is sponsored naturalizes and focuses this disposition. In

this instance, for men in the sporting realm, this means drinking beer as part of a larger performance to signify identity with sport and its peculiar brand of dominant masculinity.

For the sponsored space of beer to play a lynchpin role between programmed and performance space, the meaning of beer needs definition. As Scott (2001, pp. 60–61) has noted:

> We respond to beer in distinct ways because of its presentation in culture. From the moment of first visual exposure and physical experimentation through years of consumption, the way we think about beer is determined by where and how we see, buy, and use it....Undoubtedly, cultural conditions and accepted conventions determine where and how we drink. But who sets these conditions and conventions, and how? For most of us, they just seem natural....Beer comes packaged with commodified cultural activities and social consciousness. Beer has been systematically invested through sophisticated advertising with images that associate it with events, emotions, and personalities. Beer has been given identity.

Arguably, a substantial part of that identity comes from sport. While estimates vary, it is clear that major brewers focus the bulk of their marketing dollars on the sport marketplace, with estimates typically falling in the 60–70% range ("Alcohol advertising...," 2004; Carter, 1996). One need only look at the annual U.S. domestic marketing budget of over US$600 million for brewing industry behemoth Anheuser-Busch (Manly, 2007) to see how large the push is to connect sports with beer. So great is this symbiosis that industry observers see sports networks "staying afloat on beer" (Consoli, 2004, p. 20). Echoing the claim that "This ESPN's for you" (Brunelli, 2001, p. SR3), one Anheuser-Busch executive candidly explained that "[w]e went after the young, male, heavy beer drinkers with our advertising, and they were watching ESPN" (Consoli, 2004, p. 20).

Just as was the case with our choice of terms and the characterization of programmed space, we recognize that sponsored space is a broad category. In fact, in choosing this term, we admit being unsure of its ever-shifting promotional grounds. We know, for example, that the face of sponsored space may be seen in the many variants of advertising. So too, we know it may be seen in the myriad sponsorships that beer has taken on in sport. These range from naming rights at stadiums, to signs in the stands and on scoreboards, to logos emblazoned on fields, to branding that glows on NASCAR vehicles. Strategies move from such big-time settings to more local endeavors, such as sponsoring the local 6K road race and throwing a branded t-shirt on each competitor's back in sponsoring the local youth sports team. The reach of sponsored space through

sponsorships and promotions is endless. One cannot go to a bar or restaurant where there is a television set and not see the sponsored space of beer and sport in action.

While strategies of brewers will surely continue to change as the contours of sponsored space move into the new terrains of the web, such as blogs and social networking, the ubiquity of the sport to beer to men connection in sponsored space seems unlikely to fade. What these efforts share in common is that all tell a story about the relationship of beer to sport. Because the vast bulk of these settings are disproportionately populated by men or celebrate the athletic achievements of men, it is unavoidable as well to tell a story—sometimes implicitly, but often explicitly—about the relationship of men to sport. Some of these, such as a beer sign prominently displayed at a stadium, may tell less fully formed narratives. Still, when a ball or puck goes in the goal or when a baseball clears the outfield fence, the connection is made between male athletic prowess and beer.

More fully formed narratives may, of course, be seen in the television beer commercials that are never far from a game broadcast. Similar to the "manhood formula" that dominates the programmed space of sport, we see the sponsored space of the beer commercial as archetypal. Indeed, the genre has been characterized by Strate (1992, p. 78) as a "manual on masculinity." Speaking to this larger phenomenon as it is articulated in the American context, Scott (2001, p. 75) makes the case that this manual relies on a "beer commercial formula" with four steps:

Step 1: Advertisers note that Americans like sports.
Step 2: Beer is advertised with sports, as sports, and during sporting events.
Step 3: Through time and repetition, beer is perceived with the positive feeling of sports.
Step 4: Americans grow to associate the two, combining the appeal of both.

With such a strategy, he argues that the "cultural hypocrisy" expressed in the question of how "a beverage that impairs motor skills, causes health problems, and warps judgment [could] be equated with the pinnacle of physical conditioning" as seen in elite athletics can be overcome. The key to this comes from the further fashioning of existing "myths about manhood, sexuality, self-determination, and hard work that are all reflected, reinforced, and recombined through calculated advertisements to include beer" (Scott, 2001, p. 74).

More extensive work on beer commercials in the context of sport confirms these broad assessments. Key here, in the dynamic to link sport with beer, are drawings of gender. Often just a step away from the programmed space of a

game broadcast are campaigns meant to cast the eyes of the male sports spectator on Old Milwaukee's shapely blonde "The Swedish Bikini Team," the amorous "Coors Light Twins," and the overtly violent and sexual Miller Lite portrayals of "Catfights" between increasingly naked women (Chambers, 2005). While such blatantly sexist renderings have understandably provoked sufficient criticism that beer companies have backed off a bit, such tactics are more typical than not (Farhi, 2005; Ives, 2003, Poulton, 2004; Teinowitz, 1993). To Chambers' (2005, p. 174) claim that "in the world of advertising, sex and beer are inseparable" may be added "and never more than a step away from sport."

Meshing with this, the "beer commercial formula" tends to lean on the virility of "real men." In a study of almost 200 beer commercials shown in sports programming, Wenner (1991, p. 395) concludes "most beer commercials are intentionally contaminated with sport." Here "real men" were painted in the company of others (1) actively engaged in sporting activities, (2) demonstrating empathy for sports, often through fanship, and (3) constructing narratives that idealize professional sports dreams and success. In virtually every instance, whether in the great outdoors, at a pool table, working out at the gym, spectating in the stadium or living room, or retelling sports stories at the bar, real men capped their sport-centered camaraderie with beer. In this study and in a more recent one (Wenner, 2008a) looking at gender relations in beer commercials linked to the sporting context, women remain the "other." They are alternatively sexy and desirable but beyond reach, a challenging problem, or too confusing to be understood. Regardless, the formula pushes men back into the safety of their pack, a place where beer and sports can be enjoyed without distraction or accommodation. In such a setting, beer drinking is painted as a command performance.

PERFORMANCE SPACE, CONTEXTS, AND THE LIVED ECONOMY

As Crawford (2004) notes, performance lies at the heart of sport fanship. Why be a sports fan if one cannot show it? Increasingly at the heart of the sport fan's performance is consumption. In a time of disorganized capitalism, consumption aids and abets not only performance, but identity as well. For the fan and participant of sport alike, this is unavoidable because, as Giulianotti (2002) argues, the everyday state of contemporary sport is characterized by "hypercommodification." This has resulted in a norm for sport that is anchored in "spectacle that sells the values of products, celebrities, and institutions of the media and consumer society" (Kellner, 2001, p. 38). An artifact of this is that "the commodified sports fan is a ubiquitous feature of contemporary life" (Wenner, 2008b).

Every time we watch a game or other constructions in the public eye about sports, we also learn how to enact the role. In the course of everyday lived experiences come opportunities to demonstrate contextual understandings through performance. In providing context it is difficult not to draw on the master texts of programmed space and the subtexts of sponsored space. This is nurtured by having our surrogates regularly cast into fanship roles in commercial narratives. With this comes exposure to idealized ways of consuming fanship on the path to performing it. Such a dynamic underlies what Abercrombie and Longhurst (1998) have called the spectacle/performance paradigm of the audience. Following Crawford (2004), we believe not only that contemporary sport must "be consumed with all of its 'spectacularized' entailments" (Wenner, 2008b), but also that it is unavoidable not to reference these in one's own performance of sporting identity. This is true even in the cases of resisting the dominant logic of the sporting the "carnivalesque" (Bakhtin, 1984). As a result, not even resistant inventiveness in sporting identity can proceed completely free of the influences of promotional culture.

There is much room to study the performance space of sporting identity. Much of this, as we have suggested earlier, happens in relatively private places, such as the locker room, in the fraternity or club house ramping up for "bread and circus," or even in the suburban living room. Regularly, these identities are performed in more public settings, from the playing field or court itself, to the sidelines, to cheering our children in nascent performance in competition. Our participant roles, if there are or remain any, merge with our fanship (or lack thereof) as we play the role of spectator. Whether our roles are within the confines of an athletic subculture performing on the field, imbibing at the team tavern, or displaying one's stripes of fanship, performances draw both on mediated tellings of these roles as well as on the performances of others that are also reliant on those tellings. The logic of this is self-evident. Certainly, in the United States, one is likely to have seen more Super Bowl parties than to have actually attended them. It becomes unavoidable that we have seen more of these—courtesy of beer commercials—in our own living rooms. Their carnival influences the performance we give of ours.

This tendency is compounded as more and more of the performance space for the "lived experience" of sporting identity comes to us courtesy of "the experience economy" (Pine & Gilmore, 1999; Wolf, 1999). As Crawford (2004) has noted, this is particularly true in the rising spectacularization of the sporting venue as "theme park." In what Giulianotti (1999, p. 83) has called the "mallification" of the stadium, there comes a host of ancillary activities to be experienced, and hence performed, in relation to watching the contest. Virtually all of these involve consumption in the performance of sporting identity. This

is true whether the game is exciting or dull. In fact, a dull game can be made more exciting by participating in drawings that bestow prizes (inevitably linked to sport and "given" by sponsors), by shopping for branded merchandise and memorabilia, buying sporting "fanzine" publications and posters, consuming food both fine and fast, and, of course, drinking the beer that is "official" for the venue and its sporting inhabitants. Today's sport fans are, as Gruneau and Whitson (1993, p. 243) have put it, "free-floating consumers" who participate in "consumption at play" (Holt, 1995).

While the performance of beer is often central to the fan performance at the increasingly hypercommodified stadium, it plays broadly in the performance of sporting identity across a host of settings. However, nowhere is its casting more archetypal than its starring role at the ever evolving and increasingly global sports bar. Here, seen more clearly than on any other stage, is the simultaneous performance of sport, beer, and masculinity all enmeshed in unified commodification. In digesting the fact that sports bar chains, such as *Champions*, have reported the largest grosses per square foot of any liquor bars in the United States (Ballard, 2005), one may deduce that beer is a key part of the performance at sports bars But it is a performance linked to many others. In their extensive study of gendered behavior in the "male preserve" of *ESPN Zone Chicago*, one of the network's chain of sports theme park bars, Sherry et al. (2004, p. 152) call attention to the opportunity for layered performances of gender.

> There are performances within performances in the *Zone*. Expected performances, promised performances, actual performances, remembered performances, and fantasized performances, and these multiple performances take place on a stage that, like the field and courts of professional sports themselves, structures gender roles within highly conventional and tightly defined boundaries.

Places such as the *ESPN Zone*, with its servicescape of participatory arenas, games, and screens, may be thought of as the "postmodern" sports bar. These have evolved as the corner pub that offered the chance to view an important boxing bout or football contest in the early days of television gave way to the local tavern being sprinkled with so many sets to watch contests that over time the local, and seemingly authentic, "modern sports bar" emerged (Wenner, 1998). In recent years, many of these "home town" sports bars have given way to hypercommodified, corporatized, "anytown" incarnations. Ballard (2005, p. 67) notes that the *ESPN Zone* franchise relies on a formula with "more than 150 monitors, all managed from a control station that looks like the flight deck of the Death Star. Unquestionably, the place is a marvel of technology and a testament to the twin American ideals of branding and bigness." Yet in this

articulation of theme park in the experiential economy, technology is not the only thing experienced, so too are beer and the living of carefully constructed masculinity. For ESPN, the *Zone* makes sense in mirroring the triad of structural dependencies—on technology, beer, and men—that underlie the success of the many manifestations of their sports network.

Indeed, in the postmodern sports bar one may be drawn to the swirling changes seemingly implicit in what Ellul (1964) has called "la technique" and miss that much has stayed the same. In fact, male tools, in this instance technological ones, help structure the ability to reach back and recreate familiar myths of masculinity. Extending Kidd's (1987) observation that the urban sports stadium is a "secular cathedral" for men, the postmodern sports bar may be seen as a "corporate physical culture museum" (Wenner, 1998, p. 324) that is a shrine to vestigial hegemonic masculinity. Towards this end, major operators, such as the *Champions* chain, take pride in having cornered the market for original sports memorabilia that fill warehouses and keep curators and support staffs busy (Keegan, 1990). In such "set decoration" to make their venues "authentic," sports bars have relied on a circumspect set of myths about men and sport, to the virtual exclusion of women's achievement. Thus, affinities cultivated in the postmodern sports bar museum inherently rely on "imperialist nostalgia" (Rosaldo, 1989). As Slowikowki (1993, pp. 27–28) has put it: "Imperialist nostalgia is a yearning for the past that no longer exists or never existed."

To many men, the past that postmodern sport builds on is one that acts as a precious reminder of the glory days. It is a sanctuary where men can go to relive and dramatize that which may be eroding. It provides a safe haven where men can bask in their collective reflected glory in sport. In sport, beer, and male camaraderie, all is well. As a young man at *ESPN Zone Chicago* (Sherry et al., 2004, p. 151) put it:

> [W]e all get together at *ESPN Zone*, with that competitive spirit to sit and watch the games and talk about each other's picks, (you know) that fellowship type of thing. You get together with guys you grow up with and guys you meet over time, as a just a natural male thing. The male thing at *ESPN Zone* is a place where you can just watch all the games and that's one thing that really (ah) drives the testosterone…it's definitely a male dominated atmosphere, testosterone flying in the air. Women there don't change the dynamics….If anything that female presence has to really kind of adapt to our environment or else, it's kind of like a "tough luck" situation….Guys sometimes use it as their escape (you know). Guys need an escape.

Prescient in this observation is the shadow of time running out—that in the need for sanctuary, there are fewer places for it. For the time being, in the sports bar,

one may comfortably down cocktails of beer, sport, and masculinity. Outside, there are emergent signs of discomfort.

SPACE WARS AND GRAIN DRAIN

For many, the space of beer and sports has never been sacred. There is mounting concern and evidence about sport's role in helping to fuel earlier and more positive associations with drinking, underage and earlier drinking, and alcohol abuse (Ellickson et al., 2005; Grube & Wallack, 1994; Slater et al., 1997, Zwarun & Farrar, 2005). Because of this, there have been calls for the NCAA and FIFA to "just say no," or at least "not so much," when it comes to alcohol marketing and advertising dollars ("Coaches, CSPI...," 2005; "Give Bud...," 2006). Some of this pressure will likely result in more cautious courting of brewers for sport sponsorships, especially in youth, amateur, and collegiate sectors. In particular, the ongoing Campaign for Alcohol-Free Sports TV being mounted by the Center for Science in the Public Interest seems to have some teeth. For example, their report on "How the NCAA Recruits Kids for the Beer Market" (Gotwals, Hedlund, & Hacker, 2005) has the potential to disconnect programmed sport with sponsored space by prohibiting beer advertising in future contracts to broadcast collegiate sports.

At the same time, the beer market is changing. While it remains true that men consume 80% of beer (Goldhammer, 2000; Staseson, 2000), the marketplace is becoming more responsive to smaller segments for specialty beer (Kaplan, 2004) that requires a more delicate palette and fatter wallet than may be evident in the more massive "beer and circus" crowd. In recognizing both that 20% of the market is nothing to sneeze at and that women disproportionately service the premium beer market and its higher prices and margins, brewers have begun to see women as assets to profitability (Staseson, 2000).

As a result, according to a major brewer's senior marketing executive, "'inclusion' seems to be the buzz word frequently used among beer brand managers to describe their targeting strategies" for women (Farhi, 2005). Thus, while they don't go after women exactly, they don't want to alienate them either. The same tendency is seen in certain quarters of the restaurant and drinking establishment development business. This has real implications for sports bars. As one observer (Goodman, 1999, p. 2) put it: "The sports bar thing is never really going to work. The fundamental problem with them is that you tend not to get women in them." Perhaps in recognition of this, there has been some turning away from reliance on myths of "old reliable," the myth of dominant hegemonic masculinity, in beer commercials that run alongside sports programming. Here, a countertype of the

male beer consumer as a "loser" is increasingly seen, even in clear association with sports (Messner & Montez de Oca, 2005; Wenner, 2008a). The loser is both foolish and inept, often with little physical prowess or sporting talent. Seemingly a poster child for masculinity lost, the loser is continually foiled and flummoxed by beautiful and smarter women. Thus, his advances both risk public humiliation and illuminate his stupidity.

Still, the emergent loser countertype leaves much room to express displeasure with the current state of heterosexual gender relations. Here, as Messner and Montez de Oca (2005, p. 1906) recognize that there are both limits and risks.

> [T]he fact that male viewers today are being hailed as losers and are being asked to identify with—even revel in—their loser status has its limits. The beer and liquor industry dangles images of sexy women in front of men's noses. Indeed, the ads imply that men will go out of their way to put themselves in position to be voyeurs....But ultimately, men know (and are increasingly being told in the advertisements themselves) that these sexy women are not available to them. Worse, if men get too close to these women, these women will most likely humiliate them...So, in the end, men have only the safe haven of their male friends and the bottle.

There are two ways to take this allegory. One, is that "[w]hen sport and beer are involved, men gladly take the opiate, becoming boys and losing" (Wenner, 2008a). The other is that this is a latent sign of brewing anger on the part of men. Evidence of this comes from the parallel telling of this story alongside that of the loser. Seen in a series of beer commercials with sports themes, emasculated men bite back, voicing resentment—often, just privately to other men—with a vehemence that does not portend well for heterosexual gender relations (Wenner, 2008a).

In the end, it is not clear whether the loser will have staying power. Certainly, there is little evidence of brewers moving to this as an archetypal strategy. While "inclusiveness" for women may garner more attention, it seems unlikely to drive brewers' marketing efforts. As one beer industry advertising analyst put it:

> Most of the major breweries will target young men as their major target area, because those are their long-term beer drinkers....If you can find a campaign that is successful and appealing to young males, you will gain significantly more market share than if you find a campaign that is successful and appealing to young females—just because there aren't enough young females who will become regular, heavy-duty beer drinkers. It just ain't going to happen. (Staseson, 2000, p. 15)

Thus, the tendency of the women's market not to guzzle works to counterbalance the "added-value" they bring in attending to the premium beer market. One more intriguing piece of evidence mediates the direction that beer marketers may go in reaching women, especially in their tendency to feature "gorgeous babes" in the context of sport. This is the finding that among women who considered themselves feminists, the blatant use of sexism in beer advertisements—even though it was recognized—did not negatively affect purchase intentions (Polonsky et al., 2001). Apparently, the naturalized logic of sexist beer advertising is so ingrained that even feminist women are not predisposed to voting with their pocketbooks.

THE SACRED MEETS THE PROFANE: COMPETING VIEWS OF SPORT, BEER, AND GENDER IN PROMOTIONAL CULTURE

In considering the forces that bear on the mixing of sport, beer, and gender in promotional culture, it is clear that there are many competing pushes and tugs. Working strategically in shifting sands of not only gender identity and roles, but in response to changing cultural sensibilities over the body and fitness, beer marketers are confronted with the necessity and pragmatics of getting messages across to men, while building their market, if they can, with women. Here, on the field of sport, marketing sensibilities meet and compete with sensibilities of gender identity and relations. In this, relationships amongst sport, beer, and gender may be seen to coexist and commingle in at least two contrasting, but not mutually exclusive, conceptions of cultural space and struggle.

Each may be thought of as multidimensional, and drawn as they are in postmodern times, may be viewed in terms of what Jameson (1991) has called "hyperspace." Anchored in the struggle for individuals to locate themselves in hypercommodified times, Jameson (p. 49) sees such spaces characterized by "the incapacity of our minds, at least at present, to map the great global multinational and decentered communicational network in which we find ourselves caught as individual subjects." In the instance of the struggle over sport, beer, and promotional culture, two sites coexist in space. One, marketing hyperspace, is centered in the sensibility that the phenomenon is sacred. The other, gendered hyperspace, anchors its sense making of the phenomenon in the perception that it may be profane. Perhaps not surprisingly, such distinction and resulting tensions between the sacred and profane (Belk, Wallendorf, & Sherry, 1989) may be seen to underlie contemporary theorizing about themed retail spectacle (Sherry et al., 2004).

THE SACRED IN MARKETING HYPERSPACE: SPORT, BEER, AND MASCULINITY AS HOLY TRINITY

For the sport marketer, the mix of sport, beer, and men has represented an ever-reliable perfect storm. If they can work to include women without disrupting the holy trinity that has worked so well for so long, then women will be accommodated. Still, the word "accommodate" connotes a mixed blessing. The accommodation here is in many ways a begrudging one. The sporting turf, for men, and for those using both to market their brew, has long been sacred. The cultural logics, seated as they are in deep cultural understandings of sport and men on one hand, and beer and men on the other, are long. Certainly, such associations both precede and enable a web of promotional forces that have seized this holy ground. Over time, continuing to bless this ground with reliable sacraments has enabled the mutually beneficial growth of both the sporting and brewing industries. What has changed, of course, is that now such blessing takes place in the public sphere. Media connects the two, as we have suggested in our characterization of the *sport-media-beer commercial complex*. With this, the magnitude and hence significance of these rituals is far greater. In their mediation, major sports events such as the Super Bowl and World Cup have come to define "cultural high holy days." In such manifestations, beer has not only become essential sacrament but is also embedded in the rituals. As a result, in both marketing and cultural terms, this is something that is delicate to tamper with.

Still, "hypercommodification," if nothing else, is malleable. It will become and be applied to anything that will fuel its own growth. Viewed this way, there can be no sacred in the sacred place of sport, beer, and hegemonic masculinity. As women come to have more money, both sport and beer will have to adapt or find their relevance marginalized on the landscape of commodity culture. Certainly, there is increasing realization that reliance on sophomoric ogling of women may have a limited time clock as a marketing strategy. Certainly, it doesn't build affinities with women, who statistically make up more than half the population. It also weakens your product category and individual brand appeal to gay men whose disposable income is ever-alluring. The relevance of such strategies to the more sophisticated palettes and fatter wallets of the baby-boomers also remains suspect.

In the short run, marketers seem less than sure-footed in whether or how to abandon its reliance on the holy trinity of sport, beer, and dominant masculinity. It is less than clear whether "more guzzling" on the part of women will nuzzle at their sensibilities. If any one portion of the holy trinity gives way, their formula will undoubtedly change. In the drifting away from television to the Internet may come one of the bolder clues of what is to come. As brewery dollars make this move, the underwriting and consequently the viability

of big-time hypercommodified sport will likely fade. Indeed, there are already some signs of fatigue for big-time sport. Clearly, with steroid use, routine moral offenses, and the cavalier "follow the money" attitudes of contemporary athletes, signs of "authenticity" are scarce. Sport, and consequently beer with it, has come to a far more profane place.

THE PROFANE IN GENDERED HYPERSPACE: SPORT, BEER, AND GENDER AS SPORTENSTEIN

In contrast to the marketing hyperspace view of sport, beer, and dominant masculinity as a dependable holy trinity comes the view that there is little to be celebrated in this manufactured self-fulfilling prophecy. Here, with a feminist eye, comes an assessment that commodified constructions of sport, beer, and men that have caricatured and problematized gender identities and relations. There is little denying the frequently damaging role that alcohol has played in men's violence against women. It is difficult too to deny the twin influences of sport. Too much sport has glorified the "aggressive" real man to the exclusion of other more representative and meaningful alternatives. With beer disproportionately underwriting the sport marketplace, it has encouraged both those stories and its product's connection to them. As a result, in the multidimensional hyperspace of gender relations, much of the residue of this mix may be viewed as profane, an all too familiar social construction that might be succinctly characterized as Sportenstein. We find this term particularly fitting. Foremost, it recognizes, like Mary Shelley's Frankenstein, that the marriage of sport to beer for men has been arranged from a bin of cultural parts. Thus, as was true of Frankenstein, Sportenstein is a constructed entity. Yet, in his singularity, Frankenstein was more easily dispensed of. Sportenstein may cast a much broader and lasting cultural shadow as it is continually reinvented and refined. Although many of its more recent articulations undergird a construction of male identity that, to many, have had horrific implications for gender relations, the future may be played on more contested terrain.

Here, just as was the case with Frankenstein's making, a closer look at the forces of production portends lurking evils. In Sportenstein, the manufacture has been driven by a set of interlocking forces—commodification, globalization, and glocalization among them—that have remarkable resourcefulness and the malleability to create and reappropriate local cultures and sell them back as authentic and, thus, worthy. In this ability to spectacularize particular localized versions of hegemonic masculinity, these forces may, in their pragmatic quests for market penetration, continue to naturalize and perpetuate a retrograde culture of gender

relations that is anchored in the past rather than one that is emancipatory and sensitive to changed cultural conditions.

Yet, as is the case in the formulation of response to any behemoth construction in commodified space, the resiliency and inventiveness of the postmodern pastiche need to be considered. Indeed, in the realm of the postmodern, Sportenstein may largely function as a parody of itself. Indicants of this may be seen in countervailing trends, such as the male as loser (cf. Messner & Montez de Oca, 2005; Weimer, 2008a) archetype, that may signal a self-reflexive death of Sportenstein. Still, it is hard to see, even with the inventiveness of postmodern sensibility and its ability to see the ironic, that deep-seated cultural logics about sport and men, beer and men, and the intertwining of sport, beer, and men will disappear overnight. When taken in light of evidence that even feminists are undeterred in beer purchase intentions by sexist strategies, we should be tempered in our expectations. Thus, we expect an all-too-slow fade with much resistance. Letting go of one of the last bastions of vestigial hegemonic masculinity is, after all, a scary proposition just as was the case in confronting Frankenstein.

LAST CALL

To many, theorizing and otherwise attempting to understand the dynamic of sport, beer, and gender in promotional culture may seem an odd preoccupation. Often with good reason, the claim may be made that matters not receiving much scholarly attention have avoided scrutiny because ultimately they are trivial and unimportant. Certainly, in this instance, we disagree with this assessment. Much of our case relies on recognizing that beer has been the chief fuel of the "mediasport" commercial engine. With this, two complementary and interlocking systems of gender identity—of sport and beer—come together on the turf of commercial culture. We find the potency of this brew difficult to ignore.

Both alcohol and sport are sharp double-edged swords. One must recognize that alcohol, including beer, has played a strong role in human bonding and celebration. Yet, at the same time, they have taken a considerable toll on and taken many lives. Sport too has provided much nourishment to human existence. It has both accentuated health and fitness and fostered inclusiveness through its building of local and national identities. In celebrating this, we must also recognize that a price has been paid in damaged bodies, fractured psyches, and misplaced priorities. As well, it cannot be denied that sport has often been fickle in its inclusiveness. A notable example has been in its tendencies to exclude women and to place their achievements on a

lesser plane. The sport we celebrate is not the one that makes accommodations to bodies less able or older. In focusing on the power of sport to bring us together, we often miss how it works to both devalue those amongst us who are less smitten and to characterize those who stand on the other side as enemies.

Similarly, the sport, beer, and gender concoction in promotional culture must be approached as double-edged. Here we may find Sportenstein playing an increasingly large role in shaping our holy trinity, one that is culturally traceable and endlessly reproduced in commodification. As commodity culture evolves to seek and more graciously appeal to market segments, variances in gender identity may be more easily responded to in programmed, sponsored, and performance spaces. In doing so, the profane view of sport, beer, and masculinity may push back at the sacred one that has enabled this holy trinity.

REFERENCES

Abercrombie, N., & Longhurst, B. (1998). *Audiences*. London: Sage.

Alcohol advertising on sports television: 2001–2003 (2004). Washington, DC: Center on Alcohol Marketing and Youth (Georgetown University). Retrieved June 29, 2007 at http://camy.org/factsheets/index.php?FactsheetID=20

Bakhtin. M. (1984). *Rabelais and his world*. Bloomington, IN: Indiana University Press.

Ballard, C. (2005, February 7). Finding the perfect sports bar. *Sports Illustrated*, pp. 67–77.

Belk, R., Wallendorf, M., & Sherry, J. F. (1989). The sacred and the profane: Theodicy on the odyssey. *Journal of Consumer Research, 16,* 1–38.

Benedict, J. R. (1998). *Athletes and acquaintance rape*. Thousand Oaks, CA: Sage.

Boswell, A. A., & Spade, J. Z. (1996). Fraternities and collegiate gang rape: Why some fraternities are more dangerous places for women. *Gender and Society, 10,* 133–147.

Brunelli, R. (2001, June 11). This ESPN's for you. *Mediaweek*, p. SR3.

Bruun, K. (1959). *Drinking behavior in small groups*. Helsinki: Finnish Foundation for Alcohol Studies.

Burns, T. F. (1980). Getting rowdy with the boys. *Journal of Drug Issues, 10,* 273–286.

Burstyn, V. (1999). *The rites of men: Manhood, politics, and the culture of sport*. Toronto: University of Toronto Press.

Carter, D. M. (1996). *Keeping score: An inside look at sports marketing*. Grants Pass, OR: Oasis.

Chambers, J. (2005). Taste matters: Bikinis, twins, and catfights in sexually oriented beer advertising. In T. Reichert & J. Lambiase (Eds.), *Sex in consumer culture: The erotic content of media and marketing* (pp. 159–177). Mahwah, NJ: Lawrence Erlbaum Associates.

Clarke, S. W. (2006, November). Football tailgating at Virginia Tech (typescript report). Blacksburg, VA: Virginia Tech University College Alcohol Abuse Prevention Center. Retrieved November 10, 2007 at www.ncsu.edu/police/Tailgating_Virginia_Tech.pdf

Coaches, CSPI urge NCAA to end beer ads on college sports (2005, April 1). Center for the Science in the Public Interest (Campaign for Alcohol-Free Sports): Washington, DC. Retrieved June 27, 2007 at http://www.cspinet.org/new/200504011.html

Collins, T. & Vamplew, W. (2002). *Mud, sweat, and beers: A cultural history of sport and alcohol*. New York: Berg.

Connell, R. W. (1993). *Which way is up? Essays on class, sex, and culture*. Sydney: Allen & Unwin.

Consoli, J. (2004, July 26). Staying afloat on beer. *Mediaweek*, p. 20.

Crawford, G. (2004). *Consuming sport: Fans, sport, and culture*. London: Routledge.

Curry, T. (1991). Fraternal bonding in the locker room: Pro-feminist analysis of talk about competition and women. *Sociology of Sport Journal, 8,* 119–135.

Curry, T. (2000). Booze and bar fights: A journey to the dark side of college athletics. In J. McKay, M. A. Messner, & D. F. Sabo (Eds.), *Masculinities, gender relations, and sport* (pp. 162–175). Thousand Oaks, CA: Sage.

Douglas, M. (1966). *Purity and danger: An analysis of the concepts of pollution and taboo*. London: Routledge & Kegan Paul.

Duncan, M. C., & Brummett, B. (1993). Liberal and radical sources of female empowerment in sport media. *Sociology of Sport Journal, 10,* 57–72.

Dunning, E. (1986). Sport as a male preserve: Notes on the social sources of masculine identity and its transformation. *Theory, Culture, and Society, 3* (1), 79–80.

Dunning, E., Murphy, P., & Williams, J. (1988). *The roots of football hooliganism: An historical and sociological study*. London: Routledge.

Ellickson, P. L., Collins, R. L., Hambarsoomians, K., & McCaffrey, D. F. (2005). Does alcohol advertising promote adolescent drinking? Results from a longitudinal assessment. *Addiction, 100* (2), 235–246.

Ellul, J. (1964). *The technological society*. New York: Knopf.

Fagan, J. (1990). Intoxication and aggression. In M. Tonry & J. Q. Wilson (Eds.), *Drugs and crime* (pp. 241–320). Chicago: University of Chicago Press.

Fagan, J. (1993). *Set and setting revisited: Influences of alcohol and illicit drugs on the social context of violent events*. Rockville, MD: National Institute on Alcohol Abuse and Alcoholism Research.

Farhi, P. (2005, December 31). The frat house is now closed; TV commercials clean up and dumb down. *Washington Post*, p. C1.

Fromme, K., & Sampson, H. H. (1983). A survey analysis of first intoxication experiences. *Journal of Studies on Alcohol, 44,* 905–910.

Gantz, W., Wenner, L. A., Carrico, C., & Knorr, M. (1995a). Assessing the football widow hypothesis: A coorientation study of the role of televised sports in long-standing relationships. *Journal of Sport and Social Issues, 19,* 352–376.

Gantz, W., Wenner, L. A., Carrico, C., & Knorr, M. (1995b). Television sports and marital relations. *Sociology of Sport Journal, 12,* 306–323.

Geertz, C. (1973). Thick description: Toward an interpretive theory of culture. In *The interpretation of cultures* (pp. 3–30). New York: Basic Books.

Give Bud the boot from World Cup, groups say (2006, June 22). Center on Alcohol Marketing and Youth (Georgetown University): Washington, DC. http://www.cspinet.org/new/200606221.html

Giulianotti, R. (1999). *Football: A sociology of the global game*. Cambridge: Polity Press.

Giulianotti, R. (2002). Supporters, followers, fans, and flaneurs: A taxonomy of spectator identities in football. *Journal of Sport and Social Issues, 26,* 25–46.

Goldammer, T. (2000). *The brewer's handbook*. Clifton, VA: Apex.

Goodman, M. (1999, November 14). Sports bars bid to kick men-only image. *Sunday Business*, p. 2.

Gotwals, A. E., Hedlund, J., & Hacker, G. A. (2005). Take a kid to a beer: How the NCAA recruits kids for the beer market. Washington, DC: Center for Science in the Public Interest.

Gough, B., & Edwards, G. (1998). The beer talking: Four lads, a carry-out and the reproduction of masculinities. *The Sociological Review, 46* (3), 409–435.

Grube, J. W., & Wallack. L. (1994). Television beer advertising and drinking knowledge, beliefs, and intentions among school children. *American Journal of Public Health, 94,* 254–259.

Gruneau, R., & Whitson, D. (1993). *Hockey night in Canada.* Toronto: Garamond.

Harford, T. C. (1978). Contextual drinking patterns among men and women. In F. A. Seixas (Ed.), *Currents in alcoholism: Volume IV* (pp. 287–296). San Francisco: Grune & Stratton.

Hartley, J. (1984). Encouraging signs: TV and the power of dirt, speech, and scandalous categories. In W. Rowland & B. Watkins (Eds.), *Interpreting television: Current research perspectives* (pp. 119–141). Beverly Hills CA: Sage.

Holt, D. B. (1995). How consumers consume: A typology of consumption practices. *Journal of Consumer Research, 22,* 1–16.

Howard, D. R., & Crompton, J. L. (1995). *Financing sport.* Morgantown, WV: Fitness Information Technology.

Integrated marketing communication (IMC) (2007). In About.com: Marketing. Retrieved November 11, 2007 at http://marketing.about.com/cs/glossaryofterms/l/bldef_imc.htm

Ives, N. (2003, July 31). After a wild period, beer ads sober up and put some clothes on. *New York Times,* p. C2.

Jameson, F. (1991). *Postmodernism, or, the cultural logic of late capitalism.* Durham, NC: Duke University Press.

Jasinski, J. L. (2001). Theoretical explanations for violence against women. In C. M. Renzetti, J. L. Edleson, & R. K. Bergen (Eds.), *Sourcebook on violence against women* (pp. 5–21). Thousand Oaks, CA: Sage.

Jhally, S. (1989). Cultural studies and the sports/media complex. In L. A. Wenner (Ed.), *Media, sports, and society* (pp. 70–91). Newbury Park, CA: Sage.

Johnson, W. O. (1988, August 8). Sports and suds. *Sports Illustrated,* 68–82.

Kane, M. J., & Disch, L. (1993). Sexual violence and reproduction of male power in the locker room: The Lisa Olsen incident. *Sociology of Sport Journal, 10,* 331–352.

Kaplan, A. (2004, August). Future of specialty beer. *Beverage World,* pp. 6–7.

Keegan, P. O. (1990, June 18). Sports bars. *Nation's Restaurant News,* pp. 33–36, 40.

Kellner, D. (2001). The sports spectacle, Michael Jordan, and Nike: Unholy alliance? In D. L. Andrews (Ed.), *Michael Jordan, inc.: Corporate sport, media culture and late modern America.* New York: SUNY.

Kidd, B. (1987). Sports and masculinity. In M. Kaufman (Ed.), *Beyond patriarchy: Essays by men on pleasure, power, and change* (pp. 250–265). Toronto: Oxford University Press.

Kidd, B. (1990). The men's cultural centre: Sports and the dynamic of women's oppression//men's repression. In M. A. Messner & D. F. Sabo (Eds.), *Sport, men, and the gender order: Critical feminist perspectives* (pp. 31–44). Champaign, IL: Human Kinetics.

Leach, E. (1976). *Culture and communication.* Cambridge: Cambridge University Press.

Leichliter, J. S., Meilman, P. W., Presley, C. P., & Cashin, J. R. (1998). Alcohol use and related consequences among student with varying levels of involvement in College Athletics. *Journal of American College Health, 46,* 257–262.

Lemle, R., & Mishkind, M. E. (1989). Alcohol and masculinity. *Journal of Substance Abuse Treatment, 6,* 213–222.

Manly, L. (2007, February 4). Brew tube. *New York Times Magazine,* pp. 50–55.

Messner, M. A. (1992). *Power at play: Sports and the problem of masculinity.* Boston: Beacon.

Messner, M. A. (2002). *Taking the field: Women, men, and sports.* Minneapolis: University of Minnesota Press.

Messner, M. A., & Montez de Oca, J. (2005). The male consumer as loser: Beer and liquor ads in mega sports media events. *Signs, 30,* 1879–1909.

Messner, M. A., & Sabo, D. F. (Eds.) (1990). *Sport, men, and the gender order: Critical feminist perspectives.* Champaign, IL: Human Kinetics.

Messner, M. A., Dunbar, M., & Hunt, D. (2004). The televised sports manhood formula. In D. Rowe (Ed.), *Sport, culture, and the media: Critical readings* (pp. 229–245). Berkshire: Open University Press.

Miller, K. E., Melnick, M. J., Farrell, M. P., Sabo, D. F., & Barnes, G. M. (2006). Jocks, gender, and adolescent violence. *Journal of Interpersonal Violence, 21,* 105–120.

Oldenburg, R. (1989). *The great good place.* New York: Paragon.

Orlofsky, J. L., Ramsden, M. W., & Cohen, R. S. (1982). Development of the revised sex-role behavior scale. *Journal of Personality Assessment, 46,* 632–638.

Pine, B. J., & Gilmore, J. H. (1999). *The experience economy: Work is theatre and every business a stage.* Boston: Harvard Business School Press.

Polonsky, M. J., Ford, J., Evans, K., Harman, A., Hogan, S., Shelley, L., & Tarjan, L. (2001). Are feminists more critical of the portrayal of women in Australian beer advertisements than non-feminists? *Journal of Marketing Communications, 7,* 245–256.

Poulton, T. (2004, May 17). The issue in question: Are the days of T&A over for beer? *Strategy,* p. 2.

Pronger, B. (1990). The arena of masculinity: Sports, homosexuality, and the meaning of sex. New York: St. Martin's Press.

Reiter, R. R. (1975). Men and women in the south of France: Public and private domains. In R. R. Reiter (Ed.), *Toward an anthropology of women* (pp. 252–282). New York: Monthly Review Press.

Robinson, L. (1998). How the CHL fails young women. In L. Robinson (Ed.), *Crossing the line: Violence and sexual assault in Canada's national sport* (pp. 123–152). Toronto: McClelland & Stewart.

Rosaldo, R. (1989). *Culture and truth.* Boston: Beacon.

Sabo, D., F. (1985). Sport, patriarchy, and male identity: New questions about men and sport. *Arena Review, 9* (2), 1–30.

Sabo, D. & Jansen, S. C. (1992). Images of men in sport media: The social reproduction of gender order. In S. Craig (Ed.), *Men, masculinity, and the media* (pp. 169–184). Newbury Park, CA: Sage.

Scott, B. (2001). Beer. In R. Maxwell (Ed.), *Culture works* (pp. 60–82). Minneapolis: University of Minnesota Press.

Shank, M. D. (1999). *Sports marketing: A strategic perspective.* Upper Saddle River, NJ: Prentice-Hall.

Sherry, J. F., Kozinets, R. V., Duhachek, A., DeBerry-Spence, B., Nuttavuthisit, K., & Storm, D. (2004). Gendered behavior in a male preserve: Role playing at *ESPN Zone Chicago. Journal of Consumer Psychology, 14,* 151–158.

Slater, M. D., Rouner, D., Domenech-Rodriguez, M., Beauvais, R., Murphy, K., & Van Leuven, J. K. (1997). Adolescent responses to TV beer ads and sports content/context: Gender and ethnic differences. *Journalism and Mass Communication Quarterly, 74,* 108–122.

Slowikowski, S. S. (1993). Cultural performance and sports mascots. *Journal of Sport and Social Issues, 17,* 23–33.

Snow, R. W., & Cunningham, O. R. (1985). Age, machismo, and the drinking locations of drunken drivers: A research note. *Deviant Behavior, 6,* 57–66.

Sperber, M. (2000). *Beer and circus: How big-time college sports is crippling undergraduate education.* New York: Henry Holt.

Stainback, R. (1997). *Alcohol and sport.* Champaign, IL: Human Kinetics.

Staseson, H. (2000, October 16). Beer is still for boys: Women may enjoy a nice cold one, but don't expect breweries to market to the female sex; They simply don't quaff the required volume. *Marketing Magazine,* p. 15.

Strate, L. (1992). Beer commercials: A manual on masculinity. In S. Craig (Ed.), *Men, masculinity, and the media* (pp. 78–92). Newbury Park, CA: Sage.

Teinowitz, I. (1993, October 4). Days of "beer and babes" running out. *Advertising Age,* p. S8.

Van Ingen, C. (2003). Geographies of gender, sexuality and race: Reframing the focus on space in sport sociology. *International Review for the Sociology of Sport, 38* (2), 201–216.

Waller, S., & Lorch, B. D. (1977). First drinking experiences and present drinking patterns: A male-female comparison. *American Journal of Drug and Alcohol Abuse, 4,* 109–121.

Wann, D. L., Melnick, M. M., Russell, G. W., & Pease, D. G. (2001). *Sport fans: The psychology and social impact of spectators.* New York: Routledge.

Wenner, L. A. (1991). One part alcohol, one part sport, one part dirt, stir gently: Beer commercials and television sports. In L. R. Vande Berg & L. A. Wenner (Eds.), *Television criticism: Approaches and applications* (pp. 388–407). New York: Longman.

Wenner, L. A. (1998). In search of the sports bar: Masculinity, alcohol, sports, and the mediation of public space. In G. Rail (Ed.), *Sport and postmodern times: Culture, gender, sexuality, the body and sport* (pp. 301–332). Albany, NY: SUNY Press.

Wenner, L. A. (2007). Towards a dirty theory of narrative ethics. Prolegomenon on media, sport and commodity value. *International Journal of Media and Cultural Politics, 3,* 111–129.

Wenner, L. A. (2008a). Gendered sports dirt: Interrogating sex and the single beer commercial. In H. Hundley & A. Billings (Eds.), *Examining identity in sports media.* Thousand Oaks, CA: Sage.

Wenner, L. A. (2008b). Playing dirty: On reading media texts and the sports fan in commercialized settings. In L. W. Hugenberg, A. Earnheardt, & P. Haridakis (Eds.), *Sports mania: Essays on fandom and the media in the 21st century.* Jefferson, NC: McFarland & Company.

Wenner, L. A. (2008c). Super-cooled sports dirt: Moral contagion and Super Bowl commercials in the shadows of Janet Jackson. *Television and New Media, 9,* 131–154.

Wenner, L. A., & Gantz, W. (1998). Watching sports on television: Audience experience, gender, fanship, and marriage. In L. A. Wenner (Ed.), *MediaSport* (pp. 233–251). London: Routledge.

What is subtext? (2007). At *Wisegeek.* Retrieved November 10, 2007 at http://www.wisegeek.com/what-is-subtext.htm

Whitson, D. (1990). Sport in the construction of masculinity. In M. A. Messner & D. F. Sabo (Eds.), *Sport, men, and the gender order: Critical feminist perspectives* (pp. 19–30). Champaign, IL: Human Kinetics.

Wilsanck, S. C., & Wilsnack, R. W. (1979). Sex roles and adolescent drinking. In H. T. Blane & M. E. Chafetz (Eds.), *Youth, alcohol, and social policy* (pp. 183–224). New York: Plenum Press.

Wolf, M. (1999). *The entertainment economy: How mega-media forces are transforming our lives.* New York: Random House.

Zwarun, L. & Farrar, K. M. (2005). Doing what they say, saying what they mean: Self-regulatory compliance and depictions of drinking in alcohol commercials in televised sports. *Mass Communication & Society, 8,* 347–371.

I. INSTITUTIONS AND PRODUCTION

Domesticating THE Brew: Gender AND Sport IN Postwar Magazine Advertising FOR Beer

JAMES R. WALKER

NELSON HATHCOCK

ROBERT V. BELLAMY, JR.

INTRODUCTION

Historians have long noted the demarcation in American lifestyle brought about by the Second World War. The postwar era was categorized by hyperdelineated gender roles reflected in a suburban lifestyle built around the nuclear family. With the emergence of television as the new family hearth, the marketing of beer in the United States began to shift in focus.

No longer was beer drinking seen as an almost exclusively male activity separate from family or domestic life and located in the clubby environments of the corner bar, country club, or the ballpark. The suburbanization of American life—with the lengthy commutes to work, larger family responsibilities, and more activities centered in suburban communities—meant beer marketing through sport media needed to reflect the new "drinkers" reality. Similarly, the marketing of baseball and other major sports could no longer focus on an audience mainly composed of middle-aged white men wearing jackets and ties and arriving at the ballpark in a streetcar.

In this chapter, we will examine how these changes were reflected in the magazine and scorecard advertising used by brewers. A primary focus is how the well-established baseball and beer marketing relationship shifted to reflect

the new domestic realities. We will examine this change through a content analysis of beer advertising placed in mass-circulation magazines, sports magazines, and Major League Baseball scorecards and programs. But first, we will examine the social context that produced that beer advertising.

THE POSTWAR CONTEXT: RECONVERTING AMERICA

In post–World War II, America the transition from wartime to a peacetime economy meant "reconversion," a neologism the redundancy of which only seemed to give it added reach. Veterans returning from the far-flung theaters of conflict would need to be reconverted to students, laborers, and white-collar professionals in the rapidly expanding corporate environment. Women who had left school and home to take up positions in the burgeoning heavy industry that fed the war effort would now need to be reconverted to Rosie-the-ex-Riveters, taking their "appropriate" places in the home. Industry that for the previous three years had been concentrated exclusively on the production of armaments and the machinery of war would need to be reconverted to the manufacture of consumer goods of all description.

Accordingly an entire population raised on a decade and a half of a sacrifice-and-saving ideology must be reconverted to acquisitive purchasers motivated by a sense of both entitlement and responsibility. Debt would have to be reconverted from a moral failing to a means of access, from puritanical echo to vibrant, civic faith. As economist Robert Nathan asserted in *Mobilizing for Abundance* (1944), "Only if we have large demands can we expect large production. Therefore...ever-increasing consumption on the part of our people [is] one of the prime requisites for prosperity. Mass consumption is essential to the success of a system of mass production" (p. 98). Within a short time, in the wake of the baby boom, children would need to be reconverted from dependents to market participants, contributing their purchasing power to the economic health of the system. And, almost immediately, all of this peacetime buying and selling would itself need to be reconverted into a weapon in the struggle of capitalism against the predations of the "world-wide communist conspiracy." Needless to say, some reconversions were easier than others.

In his popular history of the 1950s, David Halberstam argues that "[t]here was in all this new and seemingly instant affluence the making of a crisis of the American spirit," and he points to yet another reconversion—"capitalism that was driven by a ferocious consumerism, where the impulse was not so much about what people needed in their lives but what they needed to consume in order to keep up with their neighbors and, of course, to drive the GNP endlessly upward" (1983, p. 506).

Halberstam's appraisal touches by implication on several interlinked phenomena of the period: the explosive growth of suburban development that establishes the bourgeois home as the veritable center of consumer desire; the corresponding emphasis on families and the gendered roles of the consumers within them; and the ways in which experts would answer the call of that "crisis of the American spirit" as an opportunity to reconfigure the markets irrevocably.

Even before the war ended, America's birth rate had begun its dizzying climb, and government and industry both, through subsidies and publicity, began promoting the suburban home to the families of yet-absent servicemen. Between 1941 and 1946, the *Ladies Home Journal* published a series of architects' "dream houses" (Jackson, 1985, p. 232), setting before a whole generation of young wives still living under their parents' roofs a vision of freedom, privacy, and space. The Servicemen's Readjustment Act of 1944 (the G.I. Bill) created a Veteran's Administration mortgage program, and the stage was set—housing starts went from $114,000 in 1944 to $1,692,000 in 1950, according to Elaine Tyler May, then "an all-time high" (1988, p. 151). May goes on to point out that cold war anxiety also contributed to suburban sprawl when Congress passed the Interstate Highway Act in 1956, covering 90% of the cost for 41,000 miles of national highways (p. 151). A corresponding, historic upsurge in automotive production put the vehicles for access to the subdivisions within the budgets of those prospective inhabitants. The resulting suburban home became the standard domestic image of the nation, a home "planned as a self-contained universe" and "designed for enjoyment, fun, and togetherness" (May, 1988, p. 153).

Just how much fun and togetherness depended largely on how well the members of the suburban family took to their assigned functions in the "unit." May describes the dynamic succinctly:

> There can be no doubt that the gender roles associated with domestic consumerism—homemaker and breadwinner—were central to the identity of many women and men at the time. It is also evident, however, that along with the ideology of sexual containment, postwar domestic consumerism required conformity to strict gender assumptions that were fraught with potential tensions and frustrations. (p. 162)

These conventional roles were pressurized in part by the very same affluence that seemed to define them. In *The Hearts of Men* (1983), Barbara Ehrenreich has charted the gender conflict of white suburbia in the 1950s, discerning in popular culture and mass media a male surrounded by a fenced-in frontier and beleaguered by the insistent knock of his wife on the door of his den or utility room. For this generation of young professionals, work was represented as relief from home. Hungry young entrepreneurs such as Hugh Hefner (following the lead of Smart, Weintraub, and Gingrich with *Esquire* in the 1930s) saw the potential of a

market segment that had only in the most conventional scenarios been treated as a consumer, and they set out to make buyers of men and to disguise the impulse as a kind of rebellion. In this effort, they were riding the crest of a more general trend—the paradigm shift from the mass market to one segmented by increasingly slender valences. Had the young husband been left to fulfill a singular function as one of William Whyte's "organization men" or C. Wright Mills' "white collars," his role as consumer would have remained insignificant and incidental, but the postwar period also ushered in the era of the experts, among them the psychoanalysts, and marketers quickly began to apply the techniques of that science to the study of buyers' decisions (Cohen, 2003, p. 298). The "minisociology," for example, that had "conflate[d] femininity and consumption as denominators of progressive modern life" (Breazeale, 1994, p. 4) in the 1920s would be developed in the 1950s in ways that were more "gender-equitable."

When design critic Thomas Hine coined the term "Populuxe" to describe the objects of the decade-long shopping spree between 1954 and 1964, he noted the phenomenon in language that stressed the emotional commitment of the buyer: "The essence of Populuxe is not merely having things. It is having things in a way that they'd never been had before, and it is an expression of outright, thoroughly vulgar joy in being able to live so well" (Hine, 1986, p. 4). The "vulgar joy" of abundance drew the attention of anthropologists, social psychologists, economists, and historians who interrogated how this characteristic of the American experience could be shaping a drastically altered political and social landscape. One answer was offered by Stanford professor of history David M. Potter who, by 1954, had already published a series of lectures—*People of Plenty: Economic Abundance and the American Character*—in which he argued for acknowledging the institution of advertising as having been changed by such an economy into one of the foremost instruments of social control. Potter's claim was that advertising in the postwar period had "joined the charmed circle of institutions which fix the values and standards of society," a development he observed with trepidation (Potter, 1954, p. 177). But the interest in consumer motivation provided marketing and advertising a new pantheon of researchers—among them George Katona, Ernest Dichter, Herta Herzog—who pointed to new ways of diversifying consumers' reasons for acting (Cohen, 2003, p. 298).

To suggest how these sweeping social and market changes might manifest themselves in a particular product, one need only consider the response of brewers in the U.S. market. In 1946, the seven leading beers controlled but 20% of the market, a market dominated by local and regional brands mostly distributed through neighborhood outlets (Cohen, 2003, p. 297). While brewers still conceived of a mass market for their product, the rapidly evolving circumstances in the early 1950s—suburbanization, the idealization of the home, the car culture,

the targeting of male *and* female consumers, the political climate—implied that even the mass had changed shape and direction. If the bourgeois ranch house were to be the center of consumer desire, then must it not become a site for male and female sociability and relaxation? With the urban neighborhoods giving way to suburban backyards and screened porches, the representation of beer drinking would need to change. As we will examine in more detail later in this chapter, the United States Brewers' Foundation sponsored a series of ads in the 1950s that resituated beer consumption, by men and women, in the home. Now a nice set of pilsner glasses would be a standard accessory for the neighborly bridge game, and the middle-class "breadwinner" need not hide from his wife. He was "freed" from the tavern and could spend quality time with family and friends. Gender segmentation of the beer market would reemerge in the 1960s, after postwar reconversion was itself reconverted.

Stephanie Coontz has pointed out how a confluence of forces actually contributed to the movement away from the family values-centered, 1950s consumerism; the counterculture, the student movement, and feminism all influenced the shift, but advertising remained the "reconverting" generator since it both anticipated and took advantage of the pressure exerted by these oppositional critiques (Coontz, 1992, p. 173). This analysis complicates assumptions about the American family of the 1950s, with both men and women straining at the confines of that constructed ideal. Market segmentation by advertisers gathers momentum not just from the realization that the family contained a plurality of consumers, but from the slowing market for the big-ticket items that had fueled the postwar boom. While radio and television led the way in segmentation, mass market publications were bound to reflect the altered image of the family from a unit to a collective of individualistic buyers, each with his or her own priorities to be tapped (Coontz, 1992, p. 175). That individualization was also enabled by women's presence in the workforce, which, for all the problems encountered there, still resulted in buyers with disposable income of varying amounts.

By 1965, with the economy having responded vigorously to the Kennedy-Johnson administration's incentives, speech-writer Richard Goodwin would reveal the effects of those critiques on his own conception of "the Great Society" as "concerned not with how much but how good—not with the quantity of our goods but the quality of our lives" (Collins, 1994, p. 27). So, when, by the end of the decade, a major brewer can admonish its consumers to "grab for all the gusto you can," not only is the pitch gender-specific (male) and individualistic, but also its vision of the "good life" as one with *more* life coincides surreptitiously with some of the values of a media-enhanced counterculture. Women would have to wait another decade before the beer advertisers once again considered them a target market, rather than as just one more means of illustrating that good life.

GENDER IN POSTWAR MAGAZINE ADVERTISING

This reconversion of American life after the Second World War, and the market segmentation that would follow in the counterculture era, was reflected in the nation's mass-circulation magazines. Several scholars have used content analysis to show how gender was represented in these publications during these changing eras. In examining women's roles in national magazine advertising, previous content analyses found stereotypically feminine representations in ads through the early 1970s, with a substantial shift in tone in later decades. Courtney and Lockeretz (1971) reviewed 312 ads with one or more adults in seven magazines (*Life, Look, Newsweek, The New Yorker, Saturday Review, Time,* and *U.S. News and World Report*) published the week of April 18, 1970. They found men substantially outnumbered women (397 to 278), and representations of women failed "to show the true range of women's roles within our society" (p. 94). From their analysis of the ads, Courtney and Lockeretz identified four major female stereotypes: "A women's place is in the home," "women do not make important decisions or do important things," "women are dependent and need men's protection," and "men regard women primarily as sex objects; they are not interested in women as people" (pp. 94–95).

Examining national magazine ads over a longer time frame, Belkaoui and Belkaoui (1976) compared advertisements from eight publications (*Life, Look, Newsweek, The New Yorker, Saturday Review, Time, U.S. News and World Report,* and *Readers' Digest*), for issues published in the second week of January 1958, to results obtained from Courtney and Lockeretz's (1971) 1970 and Wagner and Banos's (1973) 1972 samples. Women had a similar presence in the family activities in both 1958 and 1970 (about 24%) but showed a dramatic drop to 8% of ads in 1972. Women were more likely to be shown in secretarial/clerical positions in 1958 (74.4% of working women) than in 1972 (46% of working women). Women were absent from high-level business positions in all three years and from professional positions in 1958 and 1970. But by 1972, women were appearing as professionals, but these workforce pioneers represented only 4% of working women.

In a content analysis that closely parallels the time period of our study, Sexton and Haberman's (1974) comparison of magazine ads from 1950–51, 1960–61, and 1970–71 found significant changes in the representation of women between 1950–51 and 1960–61, but little change thereafter. Coders reviewed 1827 ads from five publications (*Good Housekeeping, Look, Newsweek, Sports Illustrated,* and *TV Guide*), examining ads from seven product categories: cigarettes, cigars and pipe tobacco, nonalcoholic beverages, automobiles, home appliances, office equipment, and airline travel. In the cigarette ads in *Look,* the percentage of ads

with more men than women increase between 1950–51 (26%) and 1960–61 (32%) and 1970–71 (37%), while the percentage of ads with more women than men showed a dramatic decline (23% in 1950–51, 5% 1960–61, and 3% in 1970–71). In the 1950–51 cigarette ads, nearly two-thirds of the women were models, public personalities, or in unassigned roles, while 81% of the women in 1960–61 and 67% in 1970–71 cigarette ads were shown as social companions. The 1950–51 nonalcoholic beverage ads were more likely to show women as housewives or mothers than ads in the later decades. Ads for home appliances showed "a large decrease over each successive time period in the percentages of ads showing women as housewives and mothers" (p. 45). The home as the location for the ad showed a similar decline over time. The authors concluded that only about 16% of ads show women in nontraditional roles, but over the three decades, there was a "substantial decrease in ads portraying (women) as housewife or mother" (p. 46). In this three-decade study, the domestication of magazine advertising in the early 1950s, represented by the inclusion of home settings and women in domestic roles, seems to give way to market segmentation in the later decades.

By the 1980s, representations of men and women in magazine advertising were changing. In a study of 364 magazines ads from the November 1983 issues of six magazines (*Life, Newsweek, The New Yorker, Reader's Digest, Time,* and *U.S. News and World Report*), Sullivan and O'Connor (1988) found some enrichment in the representation of women compared to Courtney and Lockertz's (1971) and Belkaoui and Belkaoui's (1976) earlier studies. Women were more likely to be employed in the 1983 ads (23%, versus 9% in 1970 ads and 13% in 1958 ads). No women were represented as business executives or professionals in the 1958 and 1970 ads, while 4% were business executives and 15% were professionals in the 1983 ads. The 1958 ads showed 24% and the 1970 ads 23% of women in nonworking activities in family settings, compared to only 9% of the 1983 ads. Sullivan and O'Connor (1988) concluded that, by 1983, a women's place was no longer just in the home, as only about 7% of women were shown in a family environment. Women were also more likely to be shown in working roles and less dependent on males. The days of domesticity reflected in the reconversion era of the 1950s were waning. However, women were more likely to be shown in "decorative roles" than in earlier studies, although most of this imagery appeared in advertising for products used by women (cosmetics, health, and beauty ads), rather than in ads that depicted women as "eye candy" for male consumers. Sexual content in magazine ads has continued to increase in more recent decades. For example, Reichert and Carpenter (2004) found an increase in sexual dress and intimate contact when they compared ads from 1983 and 2003.

HYPOTHESES

Our review of gender roles in print advertising in the decades after the Second World War led us to examine beer advertising in two contrasting eras: (1) the postwar era (1946–1956), when American culture was suburbanized and focused on home and family, and (2) an emerging counterculture era (1961–1971), when, with a focus on market segmentation, advertisers increasingly targeted youthful baby boomers reacting against suburbanized, domestic normalcy of their childhood. We argue that in the postwar era beer advertisers attempted to reposition their product as one that both men and women could enjoy, alone or with friends, at home or in public locations: what we have called "domesticating the brew." As advertising focus shifted from the family to the individual in the counterculture era, the focus was more on men, the core consumers of beer. Thus, the role of women would likely be reduced.

Based on this analysis, we propose to test three hypotheses:

H1: The number of women appearing in beer print advertising will be greater in the postwar era than in the counterculture era.

H2: Women will be more likely to handle beer in the print advertising in the postwar era than in the counterculture era.

H3: The frequency of women serving beer to men will be greater and the frequency of men serving beer to women will be less in the postwar era than in the counterculture era.

In addition to our chronological analysis, we will examine the differences in beer advertisements in different types of publications. The mass-circulation magazines *Life* and *Look* were targeted to families by offering features appealing to males, females, and young people. Sports publications (*Sport* and *Sports Illustrated*) were more clearly targeted to males, with all but a few articles focused on men's sports. Scorecards or programs were distributed at Major League Baseball games with predominately male audiences, and their beer advertising especially targeted men. Thus, we expect women's roles will be reduced in the more sports-oriented publications (sports magazines and MLB scorecards/programs) when compared to mass-circulations magazines.

Based on this analysis, we propose to test three additional hypotheses:

H4: The number of women appearing in beer print advertising will be greater in mass-circulation magazines than in sports publications.

H5: Women will be more likely to handle beer in the print advertising in mass-circulation magazines than in sports publications.

H6: The frequency of men serving beer to women will be greater and the frequency of

women serving beer to men will be less in mass-circulation magazines when compared to sports publications.

Given the symbiotic relationship between masculinity, beer, and sports extensively documented in the opening chapter of this volume, we will also analyze the prevalence of sport in print beer advertising by examining how often sports locations and sports activities are featured in beer advertising of different eras and types of publications. We believe that beer advertising will reflect gender differences in the locations and activities portrayed in the ads, leading to four more hypotheses:

H7: Men will be more likely to be portrayed in the traditional male havens of the sports facility or great outdoors than women.

H8: Women will be more likely to be portrayed in ads set in the home.

H9: Men will be more likely to be shown engaging in sports or outdoor activities than women.

H10: Women will be more likely to be shown in ads that feature socializing or relaxing activities.

Finally, we will also examine how common the actual drinking of beer (beer touching the mouth of the drinker) is in our sample of beer advertising, as well as gender differences in beer drinking. Although we expect that ads showing the actual consumption of beer to be rare, it is the most direct visual expression of the link between consumer and product. Given the strong connection between masculinity and beer, two-thirds of the "holy trinity" discussed in the first chapter of this volume, we predict that when the liquid touches the lips, those lips will be of men. Thus, we offer a final hypothesis:

H11: Men will be more likely than women to be shown drinking beer.

METHOD

Sample

The sample consisted of 329 advertisements for beer[1] from mass-circulation magazines (N = 140), sports magazines (N = 67), and Major League Baseball scorecards and programs (N = 122) published every five years starting in 1946 and ending in 1971. To facilitate comparability, the 12 issues per year were used for each magazine in the sample. Mass-circulation magazines included *Life* and *Look*, while sports magazines included *Sport*, and *Sports Illustrated*.[2] For the weekly magazines *Life* and *Sports Illustrated* the first member of the sample was

drawn randomly, and every fourth issue thereafter was included in the sample. The same issue numbers were used in each year. For the bimonthly magazine *Look*, the issue number of the first member of the sample was drawn randomly, and every second issue thereafter was included in the sample. The same issue numbers were used in each year. For the monthly magazine *Sport*, all issues appearing in the sample years were used.[3] In every magazine, all beer advertisements were included in the sample.

The scorecard sample consisted of one scorecard or program per year from each of eight Major League franchises: Boston Red Sox, Brooklyn/Los Angeles Dodgers, Chicago Cubs, Chicago White Sox, Cincinnati Reds, New York Yankees, Philadelphia Phillies, and Pittsburgh Pirates. Scorecards and programs were obtained from the Joyce Sports Research Collection at the University of Notre Dame. Every beer advertising in each scorecard or program was included in the sample.[4]

Content Categories

Each beer advertisement was coded for eight types of content. Gender was analyzed in four ways: (1) gender of those appearing in the ad (appearance), (2) gender of those holding a beer can or bottle (hold bottle/can), (3) gender of those holding a glass/mug of beer (hold glass), and (4) the gender for those serving beer (serving beer). For the first three gender variables, coders selected from three categories: (1) males(s) only, (2) female(s) included (ads with only females and ads with male(s) and female(s) together), and (3) neither. The fourth gender variable (gender of those serving beer) was coded into four categories: (1) male(s) serves female(s), (2) female(s) serves male(s), (3) any other combination of serving including self-serve, and (4) no serving shown.

In addition, to the four gender categories, both the location and primary activity portrayed in the advertisement were coded. The initial location categories were (1) party (including four or more people), (2) at home (indoor or outdoor), (3) bar/tavern/restaurant, (4) sports facility, (5) the great outdoors (forest, lake/river, ranch), (6) public space (park, picnic, beach), (7) other location, and (8) location cannot be determined. Because only a few ads featured a party, this category was combined subsequently with the at home category. The "other location" and "location not determined" category were also combined into a single "other" category.

Initially, the primary activity portrayed in the advertisement was one of the following: (1) pouring beer (no other activity shown), (2) partying (at least four people shown), (3) watching TV/listening to the radio, (4) cooking/eating/drinking, (5) relaxing/resting/working on hobby alone, (6) relaxing/resting/

working on hobby with spouse/children/family/friends, (7) working at a job, (8) attending a sports event, (9) outdoor recreation (hunting/fishing/camping/hiking/rock climbing), (10) participating in an organized team sport, (11) participating in a individual sport, (12) other recreation, (13) other activity, and (14) cannot be determined. The use of so many categories produced several with only a few ads. Thus, these 14 categories were reduced subsequently to five conceptually related and more robust ones: (1) pouring beer; (2) socializing/relaxing (including partying, watching TV/radio, cooking/eating/drinking, relaxing alone or working on a hobby with family and/or friends); (3) job-related activity; (4) sports/outdoor recreation (including attending sports events, participating in individual or team sports, and outdoor recreation); and (5) other (including all other activities or cannot be determined).

In addition, each ad was coded for beer drinking (beer touching the drinker's lips) and the gender of the drinker.

Coding

Digital photographs were made of each beer advertisement in the sample. Two different trained coders independently coded each advertisement for each content category. When coders reached different judgments, one of the researchers reviewed the disputed item and made the final coding, selecting between the choices made by the two original coders.

RESULTS

Gender Differences

Comparisons of the gender variables for the two eras, postwar, and counterculture show substantial support for hypotheses 1 and 2, and weak support for hypothesis 3, as reflected in Table 2.1.

While females were included in 22.8% of postwar era ads, they appeared in only 7% of counterculture era ads. The percentage of appearance by males also decreased, but not nearly so dramatically, from 20.7 to 16.4%, $X^2(2, N = 329) = 42.97, p < .01$. The percentage of ads featuring women holding a glass of beer showed a similar proportional decline from 9.7 to 2.4% and ads featuring only males holding a glass of beer declined less severely from 10.9 to 7.6%, $X^2(2, N = 329) = 15.01, p < .01$. The respective percentages of women and men holding beer in a bottle or can showed a similar pattern also producing a significant chi-square, $X^2(2, N = 329) = 9.14, p < .01$. However, since one cell (counterculture era, females included) in this chi-square

Table 2.1 Gender Differences in Appearance and Holding Beer (Bottle/Can and Glass) (percentage of total ad sample)

	Males Only	Females Included	Neither
Era Comparisons			
*Appearance**			
Postwar Era	20.7	22.8	10.3
Counterculture Era	16.4	7.0	22.8
*Holding Beer in Bottle/Can**			
Postwar Era	9.1	3.6	41.0
Counterculture Era	6.4	0.3	39.5
*Holding Beer in Glass**			
Postwar Era	10.9	9.7	33.1
Counterculture Era	7.6	2.4	36.2
Publication Comparisons			
*Appearance**			
Mass Circulation	12.2	22.8	7.6
Sports Publications	24.9	7.0	25.5
*Holding Beer in Bottle/Can**			
Mass Circulation	7.3	2.1	33.1
Sports Publications	8.2	1.8	47.4
*Holding Beer in Glass**			
Mass Circulation	9.7	9.1	23.7
Sports Publications	8.8	3.0	45.6

* Chi-square significant ($p < .01$).

had only one ad, this significant finding should be questioned. Comparisons of the two eras on male(s) serving female(s) or female(s) serving male(s) found only small percentage of the sample ads included either (see Table 2.2).

We found that 3.6% of postwar era ads did feature female(s) serving male(s) versus none of the ad from the counterculture era, producing a significant chi-square, $X^2(3, N = 329) = 13.05$, $p < .01$, and this trend did support hypothesis 3. However, the cross-tabulation contained one cell (female serves male, counterculture era) with no ads at all.

Analyses of the ads appearing in mass-circulation and sports publications provided support for hypotheses 4 and 5, but not for hypothesis 6 (see Table 2.1). Ads in sports publications were more than twice as likely to feature males only (24.9 to 12.2%) than ads in mass-circulation magazines, while females were more than three times as likely (22.8 to 7.0%) to be included in mass-circulation magazines than in sports publications, $X^2(2, N = 329) = 68.20$, $p < .01$. Females were also significantly less likely to be shown holding a glass of beer (3.0 to 9.1%) in ads in sports publications, $X^2(2, N = 329) = 26.17$, $p < .01$. However, there was

Table 2.2 Gender Differences in Serving Beer (percentage of total ad sample)

	Male Serves Female	Female Serves Male	Self Serve	None
*Era Comparisons**				
Postwar Era	3.0	3.6	6.1	41.0
Counterculture Era	1.2	0.0	5.2	39.8
Publication Comparisons				
Mass Circulation	1.8	2.4	5.2	33.1
Sports	2.4	1.2	6.1	47.7

* Chi-square significant ($p < .01$).

Table 2.3 Locations Portrayed in Beer Ads (percentage of total ad sample)

	Era Comparison*			Publication Comparison*	
	All Ads	Postwar	Counter-culture	Mass	Sports
Home/Party	16.7	13.4	3.3	14.6	2.1
Bar/tavern/ restaurant	5.8	1.8	4.0	2.7	3.0
Sports facility	13.7	8.5	5.2	2.4	11.2
Great outdoors	10.6	6.4	4.3	3.3	7.3
Public space	4.3	2.7	1.5	3.0	1.2
Other/no location	48.9	21.0	28.0	16.4	32.5

* Chi-square significant ($p < .01$).

no significant gender difference in holding beer in a bottle or can between the sports publications and mass-circulation magazines, $X^2(2, N = 329) = 1.32, p = .52$. Although few ads featured male(s) serving female(s) or female(s) serving male(s), the findings were not significant, $X^2(3, N = 329) = 3.30, p = .35$, and the trend was the reverse of that predicted in hypothesis 6. Males were less likely to serve females and females were more likely to serve males in mass-circulation magazines, while the opposite was true for sports publications (see Table 2.2).

Location of Ads

The locations shown in beer ads seem to shift from more domestic setting in the postwar era to more bars, taverns, and restaurants in the counterculture era (see Table 2.3).

More than four times as many ads of postwar ads were located at home or a party compared to counterculture era ads (13.4 to 3.3%), while ads were more

than twice as likely to be set in bars, taverns, or restaurants (4.0 to 1.8%) in the counterculture era. Other location differences between the two eras were not as pronounced, although ads were less likely to be set in sports facilities, the great outdoors, or public space in the counterculture era. This cross-tabulation produced a significant chi-square, $X^2(5, N = 329) = 29.17, p < .01$.

Differences in the locations shown in mass-circulation magazines and sports publications were even more pronounced (see Table 2.3). Ads in mass-circulation magazines were nearly seven times more likely to be located at home or a party (14.6 to 2.1%) and more than twice as likely in public spaces (3.0 to 1.2%). Ads in sports publications were much more likely to feature a sports facility (11.2 to 2.4%) and the great outdoors locations (7.3 to 3.3%), $X^2(5, N = 329) = 68.37, p < .01$. Bars, taverns, and restaurants were almost equally represented in both publications.

Activities Portrayed in Ads

As shown in Table 2.4, postwar ads were more likely to show people engaged in socializing/relaxing, job activities, or sports and outdoor activities than counterculture era ads, $X^2(4, N = 329) = 16.58, p < .01$.

Favored activities were clearly split for mass-circulation and sports publications. Mass-circulation magazines were almost three times as likely to feature socializing/relaxing (18.8 to 6.4%), while sports magazines were nearly four times as likely to feature sports or outdoor activity (17.6 to 4.6%) and nearly twice as likely to feature simply pouring the beer (9.4 to 4.9%). Job-related activity was slightly more common in mass-circulation magazines, $X^2(4, N = 329) = 56.82, p < .01$. Ads featuring other activities or no activities were more common in the counterculture era and in sports publications.

Gender Differences in Locations and Activities Portrayed

Table 2.5 reveals clear differences in location and portrayed activity for ads with only male(s) and ads that included female(s).

The cross-tabulation between gender and location produced a significant chi-square, $X^2(5, N = 220) = 37.41, p < .01$. Male-only ads were nearly five times as likely to be located at a sports facility, and much more likely to be set in the great outdoors. Ads set at home or at a party were 2.8 times as likely to include women when compared to male-only ads. Likewise, the relationship between gender and portrayed activities was significant, $X^2(4, N = 220) = 51.96, p < .01$. Ads portraying sports or outdoor activities were 3.5 times more likely to feature only males, while those featuring socializing or relaxing were 3.2 times more likely to include some females. Male-only ads were also more than twice as likely to show beer pouring

Table 2.4 Activities Portrayed in Beer Ads (percentage of total ad sample)

	Era Comparison*			Publication Comparison*	
	All Ads	Postwar	Counter-culture	Mass	Sports
Pouring Beer	14.3	6.7	7.6	4.9	9.4
Socializing/Relaxing	25.2	16.7	8.5	18.8	6.4
Job Related Activity	7.6	4.9	2.7	4.3	3.3
Sports/Outdoor Activity	22.1	13.4	8.8	4.6	17.6
Other/Can Not Determine	30.7	12.2	18.5	10.0	20.7

* Chi-square significant ($p < .01$).

Table 2.5 Locations and Activities Portrayed in Beer Ads by Gender (percentage of sample with males and/or females, $N = 220$)*

	Males Only	Females Included
*Location***		
Home/Party	5.9	16.4
Bar/tavern/restaurant	2.7	5.9
Sports facility	15.0	3.2
Great outdoors	7.3	2.7
Public space	2.7	3.2
Other/no location	21.8	13.2
*Activities Portrayed***		
Pouring Beer	10.9	4.5
Socializing/Relaxing	8.6	27.7
Job Related Activity	7.7	3.2
Sports/Outdoor Activity	20.9	5.9
Other/Can Not Determine	7.3	3.2

* To avoid empty cells in the cross-tabulations, the ads without a human presence were not used in these analyses.
** Chi-square significant ($p < .01$).

as the only activity. These results provided clear support for hypotheses 7, 8, 9, and 10.

Actual Beer Drinking

Actual drinking (beer touching the mouth) also was rare with only 14 ads (4.3% of the sample) showing this behavior. In only one instance was a female shown drinking beer. This result directly supports hypothesis 11.

DISCUSSION

The results of our content analysis illustrate a generational shift in beer advertising between the period after the Second World War and the 1960s, confirming the reconversion followed by segmentation advertising pattern we proposed earlier in this chapter. Women became less common in beer ads and are less likely to touch the product when served in glasses. Although the trend was not statistically significant, women did serve beer to men in a small percentage of the postwar era ads but did not in the counterculture ads. The setting for the ads is much less likely to be in the home at a social gathering and more likely to be at public bar, tavern, or restaurant. The postwar era ads were more likely to feature a specific activity (socializing/relaxing, job activities, or sports and outdoor activities) than in counterculture era. The postwar American push toward the normalization of domestic life with its focus on home life and family activities appears to be reflected in our findings.

The results also found most of the expected gender differences between mass-circulation magazines (*Life* and *Look*) and sports publications (*Sports Illustrated*, *Sport*, MLB scorecards/programs). Women were much less likely to even appear in sports publications than in a mass-circulation magazine and were three times more likely to hold a glass of beer in mass-circulation publications than in a sports publication. Contrary to expectation, women were more likely to serve beer to men in mass-circulation magazines, while the opposite was true for sports publications. The women in mass-circulation magazines seem to be reflecting a more traditional, servile role for women, while in the more male-oriented sports publications, men may have been offering beer to attract women into their brew culture.

Looking at the entire sample, gender differences were clearly evident in the locations presented and the activities portrayed in our sample of magazine and scorecard ads. Male-only ads were much more commonly located in a sports facility or the great outdoors and featured sports/outdoor activities, job-related activities, or simply pouring beer. Ads that included women were more likely to be set in the home, a bar, or a restaurant and feature socializing/relaxing activities. The only surprising finding, that females are frequently shown in bars, a traditional male "third place" (Oldenburg, 1989), is perhaps a product of including both bars/taverns and restaurants in the same category to increase the number of ads in that category.

Regardless of era or publication the actual consumption of beer was rare (less than 5% of ads) and almost nonexistent for women. The golden brew passed through female lips only once. Thus, the most direct observable and direct connection between the product (beer) and the customer (the beer drinker), although rare, was almost entirely a masculine experience. In our sample of beer

advertising, beer was more than a man's drink, but when beer was drunk, it was men who drank it.

Not surprisingly, ads from sports publications featured sports locations; they were four times more likely than mass-circulation magazine ads to be set in sports facilities. They were also more than twice as likely to be set in the great outdoors. The domestic scene including the home or parties appeared in mass-circulation magazine ads almost seven times more frequently than sports publications. For sports publication ads, beer belonged to traditional man's space (fields of sport and the great outdoors), while for the family-based mass-circulation magazines beer was sold as a normal part of domestic life. This pattern was reinforced by the activities portrayed in the ads: with mass-circulation ads featuring socializing/relaxing activities, and those in sports publications featuring sports/outdoor activities.

Although sports and beer have long been strongly connected in popular culture, as discussed in detail in the introductory chapter of this volume, sports played a more minor role in the 1946–71 ads examined here. Even for the ads in sports publications, nearly two-thirds of which were scorecards/programs sold at baseball stadiums, only about 11% were located in sports facilities, while only 2.4% of mass-circulation magazines feature these locations. The link between sports and beer, though clearly present, is not overwhelmingly dominant in our sample of magazine ads.

A CLOSER LOOK

Although the content analysis revealed clear gender differences, we also want to examine more closely ads that illustrated these differences. The domestication of the brew was especially evident in a series of 13 ads sponsored by the United States Brewers Foundation, an industry trade association, published in the 1951 and 1956 issues of *Look* (12 ads) and *Life* (one ad). There was only one ad of this type in the counterculture era sample (a 1961 ad in *Life*). The 13 postwar era ads featured men and women in equal numbers (usually four or more adults) and six ads included older adults in what appeared to be family gatherings. Consistent with our argument that advertising the counterculture era reflected a segmentation of the beer market, the only United States Brewers Foundation ad in our sample from this era did not feature an intergenerational family. Instead it showed two women, relaxing after a round of golf and posed the question "who says beer is a man's beverage?"

Most postwar era ads showed food either in the main illustration or in a smaller separate image, including one Thanksgiving dinner and one scene

showing "Men's Night in the Kitchen." The activities varied (serving/preparing food, boating, camping, watching TV, playing a musical instrument), but casual conversation and, of course, beer were constants. All the postwar era ads included the copy "beer belongs, enjoy it" and "America's Beverage of Moderation." Nine of the ads directly link beer to American values of independence and sociability with the phrase "in this friendly, freedom loving land of ours" before "beer belongs, enjoy it." Two ads directly associated beer with relaxation, encouraging consumers to "just sit awhile" and "let's just sit and talk" while they sipped a cold brew. Overall, the United States Brewers Foundation ads position beer as a normal part of domestic life, part of the social lubricant that helps make time with friends and family special. Compared to hard liquor, beer is "America's Beverage of Moderation" and not a source of male isolation from family or any larger social problems. In a veiled reference to the restrictions of prohibition, Americans are also exercising their "freedom" by choosing to drink a socially acceptable and legal alcoholic beverage.

The placement of all but one of these ads in *Look* was no accident. *Look* was published by Des Moines, Iowa-based Cowles Publications and more focused on mainstream American interests and less on the international events featured in the New York-based *Life*. In its earlier years, *Look* appeared to shun alcoholic beverage advertising altogether. Our review of 24 sample *Look* issues from 1941 and 1946 found no ads for alcoholic beverages, compared to 200 ads for beer, wine, or hard liquor in 24 *Life* issues from the same years. Through its 12 ads in *Look*, the United States Brewers Foundation was trying to persuade "middle class," predominantly Protestant Americans that beer could be a compatible component of family life. In the UBF's *Look* ads, the reconversion of postwar American was well represented.

CONCLUSIONS

The major findings from our content analyses of magazine advertising is consistent with our review of postwar America's reconversion from a land of austerity, brought on by economic depression and war, to a nation of affluence centered on home and family. Beer advertising in all publications in the postwar years showed a greater role for women and stronger emphasis on domestic settings and activities. As the 1950s turned into the 1960s and early 1970s, the beer advertising in our sample became more focused on men, bringing together the "holy trinity" (sport, beer, and men) discussed in chapter 1. Mass-circulation magazines and sports publications clearly reflected a different world. Sports publications were much more likely to link beer to traditional male activities and locations, including the

sports arena or field: the "secular cathedral" or "men's cultural center" described by Kidd (1987, p. 256). Finally, for our sample of magazine advertisements for beer, a women's place was much more likely to be in the home involved in social or relaxing activities. Men were more likely to "get out of the house" and go to a sports facility or the great outdoors and engage in sports or outdoor activities. Although magazine advertising domesticated the brew in the first decade after the Second World War, ultimately, the ancient link between men, sport, and beer would prove too strong for one lasting reconversion.

NOTES

1. In addition to advertisements for various brands of beer, the sample also included 8 ads for beer containers and 14 ads sponsored by an industry trade group promoting beer without reference to any particular brand.
2. Since *Sports Illustrated* did not start publication until 1953, our sample started with 1956.
3. Since *Sport* started publication in mid-1946, the missing 1946 issues were replaced with the same issues from 1947.
4. When a scorecard/program for a team in a targeted year (1946, 1951, 1956, 1961, 1966, and 1971) was not in the collection, a substitute from the nearest available year was used. The advertising appeared to be the same in all scorecards/programs for a given team in a given year.

REFERENCES

Belkaoui, A. & Belkaoui, J. M. (1976). A comparative analysis of the roles portrayed by women in print advertisements: 1958, 1970, 1972. *Journal of Marketing Research, 13*, 168–172.

Breazeale. K. (1994). In spite of women: "esquire" magazine and the construction of the male consumer. *Signs, 20* (1), 1–22.

Cohen, L. (2003). *A consumers' republic: The politics of mass consumption in postwar America.* New York: Knopf.

Collins, R. (1994). Growth liberalism in the sixties: Great societies at home and grand designs abroad. In D. Farber (Ed.), *The sixties: From memory to history* (pp. 11–44). Chapel Hill & London: University of North Carolina Press.

Coontz, S. (1992). *The way we never were: American families and the nostalgia trap.* New York: Basic Books.

Courtney, A. E. & Lockeretz, S. W. (1971). A women's place: An analysis of the roles portrayed by women in magazine advertisements. *Journal of Marketing Research, 8*, 92–95.

Ehrenreich, B. (1983). *The hearts of men: American dreams and the flight from commitment.* New York: Anchor Books.

Halberstam, D. (1993). *The fifties.* New York: Villard Books.

Hine, T. (1986). *Populuxe.* New York: Knopf.

Jackson, K. (1985). *Crabgrass frontier: The suburbanization of the United States.* New York: Oxford University Press.

Kidd, B. (1987). Sports and masculinity. In M. Kaufman (Ed.), *Beyond patriarchy: Essays by men on pleasure, power, and change* (pp. 250–265). Toronto: Oxford University Press.

May, E. T. (1988). *Homeward bound: American families in the cold war era.* New York: Basic Books.

Nathan, R. R. (1944). *Mobilizing for abundance.* New York: McGraw-Hill.

Oldenburg, R. (1989). *The great good place.* New York: Paragon.

Potter, D. (1954). *People of plenty: Economic abundance and the American character.* London & Chicago: University of Chicago Press.

Reichert, T., & Carpenter, C., (2004). An update on sex in magazine advertising: 1983–2003. *Journalism and Mass Communication Quarterly, 81,* 823–837.

Sexton, D. E., & Haberman, P. (1974). Women in magazine advertisements. *Journal of Advertising Research, 14,* 41–46.

Sullivan, G. L., & O'Connor, P. J. (1988). Women's role portrayals in magazine advertising: 1958–1983. *Sex Roles, 18,* 181–188.

Wagner, L. C., & Banos, J. B. (1973). A women's place: A follow-up analysis of the roles portrayed by women in magazine advertisements. *Journal of Marketing Research, 10,* 213–214.

Beer Sponsors Football: What Could Go Wrong?

JOHN HORNE

GARRY WHANNEL

Before Middlesbrough was a hundred years old, it had more than a hundred thousand inhabitants, whose chief passions, we were always told, were beer and football. It is a dismal town even with beer and football. J.B. Priestley (1934).

<div align="right">

ENGLISH JOURNEY, P. 340.

</div>

INTRODUCTION

Beer, football, working class men—in England these three elements appear locked together, at least in the popular imagination. So it seems highly logical that beer companies have chosen to sponsor football over the years. Working class men as a marketing sector consume a limited range of media forms, so choosing to advertise in televised football or to sponsor football clubs or competitions is a rational choice. Few other advertisers have working class men as a target, as they have less spending power and spend on a narrow range of commodities and services, so, now that tobacco advertising and sponsorship is barred, the providers of football and television football inevitably have looked to the brewers as a prime target. Football and beer seem made for each other. Beer sponsors football—what could go wrong? Beer, football, and working class masculinity appear as elements in a

well-established cultural configuration, inscribed in cultural rituals, practices, and organizational forms for more than 100 years.

Yet, if working class men who follow football are a prime market segment for beer, they also became, from the mid 1960s, a high-risk target. The emergence of the folk devil of "football hooligan," the development of a moral panic around violence at football, and the slow decay that characterized most English football grounds between the 1960s and 1980s did not constitute a particularly favorable brand image. The transformation and rebranding of football during the 1990s constituted an apparently highly successful exercise in which Sky and the Premier League alliance has brought unprecedented riches into the game.

Glance into thousands of public houses in England on a Sunday, and you will see Sky TV's Premier League football coverage. You may also notice a small icon in the shape of a beer glass in a corner of the screen. It is not always on and is not always in the same location on the screen, but this is an electronic device (or "bug") that guarantees that the venue is a legitimate Sky commercial subscriber allowed to show the live games publicly (See http://business.sky.com/czone_fighting_fraud. qa.asp). Legitimacy comes at a price, and the satellite broadcaster attempts to satisfy the demands of the commercial subscribers that their financial outlay is worthwhile by employing "field forces" whose job it is to detect unauthorized displays, aided by the beer glass surveillance device. As a broader symbol though, the beer glass also serves to connote the relation between beer, football, and, at least implicitly, men. Indeed, this has been described as "the male holy trinity of alcohol, football and male bonding" (Weed, 2007, p. 400). Men, beer, and football—a complex cluster of social practices, structures, and representations seem to hold these three elements together. Men, beer, and football have all changed in dramatic ways during the twentieth century and yet, still this trinity retains symbolic force. In this chapter we discuss these changes alongside a fourth important element—social class—for making sense of the contemporary state of play between sponsorship, sport and alcohol in the UK and most specifically in England. In the UK, social class acts as a means of identifying differential relationships to sport and to types/codes of sport as well as differential relationships to alcohol and types of alcohol. We approach this topic, therefore, by considering a series of contrasts/dualities within alcohol, sport, class, and not least gender and ask, what could go wrong for beer sponsors, for football, and for gendered social class relations?

The collaboration from which this chapter stems was forged through discussion in the Mortimer Arms, Tottenham Court Road, and the Skinners Arms, Judd Street, in Central London, and is informed methodologically by a degree of reflexive auto-ethnography. Individually, the authors have watched football while drinking beer in many different contexts, indeed GW recently saw highlights of the Arsenal versus Wigan game on three consecutive days in different

countries—only the beer remained the same, thus underlining the globalized character of the beer-football relationship. We have also searched newspaper and advertising archives and other documentary sources.

HISTORY ON TAP

Whilst there is variability in the relationship between sport and alcohol, especially between sport and alcohol advertising within the countries of Europe, Tony Collins and Wray Vamplew (2002) have charted a long-standing relationship between alcohol, sport, and social class in the United Kingdom. Traditionally breweries targeted working class, spectator sports, especially association football (soccer) and rugby league, whilst distilleries have had a closer relationship with middle class and—until relatively recently—more amateur sports such as rugby union and cricket. If we were to outline the elements of the "ideal types" of association football ("soccer") and rugby union football ("rugger") and their relationships to alcohol for most of their nearly 150-year-long history in the UK, they would look something like the following:

Association Football	Rugby Union Football
Working class	Middle class
State school education	Private school education
Professional	Amateur
Breweries	Distilleries/Breweries
Beer ("bitter")	Spirits/Beer

Football or "soccer" is still widely enjoyed in most state sector schools. It is the national team sport, and in the devolved United Kingdom, it remains a major focus for national, regional, and city identification. Football professionalized in the 1880s and until the 1950s, professional football was largely played by working class people and watched by them, even if most of the professional teams were funded by relatively small local businesses. Beer—ale, stout, or bitter—was the tipple of choice for the working class and hence attracted breweries to sponsor and even establish football clubs. Rugby Football (so named after the private school in the East Midlands where this code of football—predominantly involving handling, rather than kicking—was originally developed) has long been associated (outside of Wales) with the private (or independent) school sector. The sport has retained a middle class image—for example, in Scotland, the Scottish national team is sometimes disparagingly referred to as "15 solicitors from Edinburgh." Rugby Union professionalized only in 1995, as opposed to the similar code of Rugby League, professionalized in 1895, which has largely been played in the

north of England since the late 1890s. Rather than attract breweries alone, the tipple of choice of rugby followers and hence of sponsors have been the distillers of spirits such as whisky and gin.

But these relationships are not immutable and can change. Chas Critcher (1979) outlined several changes in professional football in the 25 years after the end of the Second World War in England, including styles of play, its televising and organization, and the experience of both followers and players, as an "index of tradition and change in working-class culture" (Critcher, 1979, p 161). He described this as a form of "spectacularization" (Critcher, 1979, p. 183). In the next 25 to 30 years, the changes he noted have developed further so that the relationships between the elements in the lists above have been transformed some more. The cultural transformation of professional football/soccer has been most profound as it has become the "world game"—an increasingly televised spectacle—and as a result more acceptable to middle class audiences whilst the cultural meaning of "rugger," at least in most parts of the UK, has retained its exclusive middle class connotations. Yet between the two football codes and associated social class relations, another contrast exists along the lines of alcohol consumption and drinking cultures.

Association Football	Rugby Union Football
"lager lout"	"real ale"

The emergence of the "lager lout" epithet in the 1980s, whilst not exclusively related to sport or football, echoes the fact that consumption of alcohol has traditionally been seen as irresponsible within the working class. It was associated with the nineteenth-century distinction between "respectable" (i.e., unproblematic cultural practices) and the "rough" working class. In the middle class, such distinctions were never so evident. Contemporary concern about the transmission of "drinking cultures" through such domains as geographical location, peer group, work, and/or the media tends to mask class differences through focusing attention on generational differences and the youth-adult contrast (e.g., see Joseph Rowntree Foundation 2007). Whilst it is undeniable that the relationship between young people and drink has risen up the public health policy agenda, it is less often considered as a product of the associations between alcoholic drink, sport, and the independence imagined to be part of adult status (Curtis, 2007). Yet small-scale research into the attractiveness of drink in the consumer preferences of youth has indicated that sport and alcohol are closely aligned in the gendered acquisition of personal and consumer identities. (Davies, 2006). Arguably, therefore, greater media literacy

and economic literacy are required to offset the experience of socialization as consumerization—or the induction into lifelong affiliation with consumer culture as a way of life (Miles, 1998). To pursue the discussion, it is now necessary to examine our terms more closely.

MEN

The cultural image of working class masculinity features the pub as a core site at the heart of an imaginary community. In the postwar era the community within which this mythic image of male solidarity was situated was undergoing recomposition, a process described with precision by Phil Cohen in his much-cited essay "Sub-Cultural Conflict and Working Class Community" (Cohen, 1972). Greater earning power for young workers, changing social conventions, and the emergence of rock and roll were combining to foster the emergence of a teenage youth culture, and a widening generational gap in which the authority of the parent generation was weakened. These factors in turn, it has been argued, contributed to the growing visibility of forms of gang-based crowd violence at football. "Men" are clearly not a simple stable and homogenous category, and young working class men were not all "football thugs"; however, in representation at least, the skin-headed football fan became firmly established in the popular imagination in the 1970s. Stylistic and behavioral patterns amongst working class men tend to oscillate between upward (mod, casual, new romantic) and downward (rocker, skinhead, punk), and football in the 1970s was firmly tied to the downward cultural trajectory. The reconfiguration of football between 1985 and 1995, with all-seated stadia, surveillance, executive boxes, and the promotion of a "family" atmosphere (still more mythic than actual), took place in the context of the growth in spectacular consumption and postmodern culture. However, recompositions within terrace subcultures also played a role, the fanzine generation developing a greater sense of cross-club solidarity, and a tendency to redraw the "rules of disorder" to marginalize violence.

Nostalgia for the old football was expressed in ironic terms by "new lads" in profoundly self-conscious ways. This was signaled by the masthead for the most successful new lad magazine, *Loaded*, "for men who should know better." The point here is that masculinity is not a natural given but is heavily culturally constructed; is not unitary but rather constituted as multiple competing masculinities; and is not fixed but is changed and shaped by social, economic, and discursive factors. Two discursive elements, one hedonistic and irresponsible, one self-reflexive and ironic, existed together and interacted, often within the same social actors.

BEER

Embedded as a cheap source of refreshment, relaxation, and inebriation for poorer men and women for many centuries, beer has a long cultural history in the United Kingdom, but by the late nineteenth century the structure of breweries, pubs, and working class male customers was well established. With the emergence of branded goods, advertising, and wider distribution networks, came a growing consolidation and concentration in the brewing and pub trade. This trajectory became more rapid in the 1950s, resulting in the dominance of a few major breweries. Rationalization of the production process meant the decline of old fashioned hand-drawn ales in favor of the new more gassy keg beers, which were easier to produce, distribute, and store, meaning less wastage and greater profits.

This process of producing keg beers in the UK was attempted by Watney's during the 1930s, but the first brewers to brew keg on a commercial basis were J. W. Green of Luton, Bedfordshire, in 1946. Ironically, one factor underlying the introduction of these new lighter beers was the intervention of an American general famous for being a formidable cold war warrior. According to Hornsey (2003, p. 671), locally stationed American airmen "became disenchanted with drinking murky draught beer (bottled beer being in short supply). The area Commander General Curtis LeMay, beseeched the Luton firm to produce something free of sediment and, after some considerable expenditure, they succeeded in putting bright, carbonated beer into metal casks, and secured a considerable by trade doing so."

Keg beers were then developed at Flowers Brewery in Luton, with major brewers Charrington and Ind Coope following the innovative trend. A consortium involving Guinness, Courage, and Scottish and Newcastle launched Harp lager in 1962 (Young, 1980, pp. 60–61). Consumer resistance developed during the 1960s, with Watney's Red Barrel becoming a despised symbol of the new weak and gassy product. This resistance, which led to the establishment of the Campaign for Real Ale (CAMRA) in 1971, though was somewhat middle class in character. By the 1970s, the new lagers were winning over the working class lads who were at the core of the football terrace subcultures, and lager has remained the principle drink of choice at football ever since. In the spectacular consumption of the 1990s, though, new options—Breezers, Vodka-based pre-bottled cocktails, alco-pops, and shorts—began to win the more upwardly oriented youth market and football began to look like the last bastion of "beer." Meanwhile the brewing industry was being reshaped by the needs of globalization, and the brands that did well were those that managed to establish an international presence—Budweiser, Carlsberg, Guinness, and also Tiger, the new Asian tiger that began burning brightly in the bars of the world. So like masculinity, beer, too is not a fixed given. It has been kegged, canned, fizzed, chilled, globalized, and generally rebranded.

FOOTBALL

As is well known, association football in the UK, like many other popular public communal leisure activities, had its peak crowds in the late 1940s, with the end of the Second World War and the return of the troops. The peak was short-lived. The growth of television and car ownership, rising affluence, and the enhancement of home life through consumer electronics such as stereo sound systems, meant that football, like the pub, the cinema and the dance hall, suffered dramatic decline in audiences that continued from the early 1950s to the mid-1980s. Since the mid-1980s, English football crowds have steadily risen. Interestingly though, cinema and to a degree pub attendances have all followed the same pattern. Rising affluence has been a factor, but it may be that the first generation to grow up with television in its developed form has found it a less gripping cultural form than those for whom it was a novel innovation.

Football underwent rapid changes from the early 1960s. The maximum wage was abolished, regular television highlights began, and action replay, slow motion, color, and satellites all added to the aesthetic appeal of televised football. In the 1970s, advertising and sponsorship revenue began to grow, and in the 1980s, English football agreed to the broadcasting of live football in exchange for television accepting shirt advertisements. But crowd violence remained a persistent problem into the 1980s, until the culminating impact of a series of stadium disasters. In 1985, a fire in Bradford City's old-fashioned wooden stand killed 56 people, and later the same month, at the European Cup Final at Heysel Stadium in Brussels, 39 people, mostly Italians, were killed when a crowd battle caused a wall to collapse. Football faced intense public pressure for reform, with calls for identity cards for fans, and the banning of away supporters from grounds. Three years later, in 1989, 96 people died at the FA Cup semifinal at Hillsborough Stadium in Sheffield as a result of severe overcrowding in one section of the ground (for discussion of this and other football-related spectator issues before the 1990s, see Murphy, Williams, & Dunning, 1990). The resultant report, by Lord Justice Taylor, recommended the introduction of all-seated stadia. This was subsequently imposed for the top two divisions of football as a legal obligation by the Football Licensing Authority, established in the 1989 Football Spectators Act. Adjustments were made to the tax on Football Pools (a betting system) to provide funding support for stadium redevelopment, although by 1995, it was clear that the establishment of a Premier League supported by greatly increased television revenue from the satellite operator BSkyB was providing a massive growth in revenue for the top clubs.

Meanwhile, the terrace subculture began transforming its own internal norms; this coupled with greater surveillance led to a marginalization of much violent behavior, which began to migrate to prearranged sites away from the grounds,

away from the eyes of the media and limited to hardcore fighters. Like "men" and "beer," then, "football" is not a stable social or cultural category. The establishment of the Premier League fuelled by the ever-growing television revenues, the increasing of admission prices far more rapidly than inflation, and the growing ubiquity of live football in pubs has perversely meant that the pub experience is now more like the traditional mode of watching football than the modern highly regulated stadium experience. Indeed it is in the pub, more than in the de-classed environs of the stadium, that the old alliance of beer, men, and football has been re-forged.

THE CURRENT STATE OF PLAY

So, eight years into the new millennium, what shape are our four elements—alcohol, sport, class, and gender—in? The state of alcohol and beer in particular is complex. Beer is losing its market share as young drinkers favor alcopops, shorts, and other options, whilst the English middle classes switch to wine in greater numbers. According to figures released by the British Beer and Pub Association (BBPA) in November 2007, there has been a 49% slump in sales of pints of beer in pubs since the postwar peak year of 1979 (Jones, 2007). This is offset somewhat by the fact that more beer consumption now takes place at home, rather than the pub, but overall beer sales have still fallen by 22% since 1979. From the 1950s onwards, mergers and acquisitions restructured the drinks industry in Britain along textbook monopoly capitalist lines (Hutt, 1973). In 1952, for example, the largest five breweries in the UK accounted for just over 21% of total sales. By 1967, this had risen to 63%. This in part helped to stimulate the development of interest groups involved in the politics of beer—especially in Britain, the Campaign for Real Ale (CAMRA). Hutt became the first chairman of that organization. Partly as a result of the activities of this campaign group, but mainly as a result of the de-/re-regulatory zeal of the Thatcher governments, legislation in the 1980s lead to the offsetting of some of the market power of the biggest brewing conglomerates—at least in the domestic UK market.

In 1986, the Monopolies and Mergers Commission (MMC) investigated possible monopoly in the sale of beer on licensed premises in the UK. At that time, the industry was dominated by six breweries, which owned three-quarters of all tied public houses. According to a debate in the House of Lords in 2002, the MMC report in the 1980s "concluded that consumer choice was severely limited, independent producers and wholesalers were denied access to thousands of retail outlets, and both wholesale and retail prices were higher than they needed to be." As a result, breweries were forced by the government to reduce the extent of their pub ownership. There were two legislative orders: the

Supply of Beer (Tied Estates) Order 1989 and the Supply of Beer (Loan Ties, Licensed Premises, and Wholesale Prices) Order 1989. Brewers owning more than 2,000 pubs had to dispose of half the surplus over 2,000, thus creating some 11,000 more free houses, which were not linked to any particular brewery chain. National brewers had to allow their publicans complete freedom "to buy non-beer drinks from any source and to sell at least one draught cask-conditioned guest beer." As a result microbrewers have become more numerous in the UK, although their collective market share has only ever been small—producing around 2% of beer for the UK market. (Source of all quotes in the above paragraph: http://www.parliament.the-stationeryoffice.com/pa/ld200203/ldhansrd/vo021219/text/21219–20.htm, accessed November 22, 2007).

Despite the growth of opportunities since the 1980s to purchase "real ale" made by the 500 or so microbreweries in the UK, it is the case that behind the numerous brand names that occupy the market there still lies large brewing concerns (Protz, 2007). Britain's largest brewing company—Scottish and Newcastle (S&N)—for example, owns brands such as Newcastle Brown Ale, John Smith's Bitter, Kronenbourg's and Foster's Lagers, and Strongbow Cider. The global market for beer, estimated to be worth US$450 billion (GBP225 billion), remains large and buoyant as breweries look to offset the fall in sales in traditional markets (Kollewe, 2007). Business in the emerging market economies—Russia, China, and India—is especially brisk, and it is clear that the old stereotypical images of the UK and Germany as the core of the beer trade are now redundant. Market analysts predict that a third of global beer consumption will shift to Russia and China.

According to Euromonitor data (see Table 3.1), China is now the world's largest beer market by volume, having overtaken the United States in 2002.

Table 3.1 Top ten beer markets in 2005 and 2006 (in million hectoliters)

	2005	2006
China	294.2	311.8
United States	238.0	242.1
Brazil	94.8	103.6
Russia	87.7	96.8
Germany	91.6	90.8
Japan	65.4	63.3
Mexico	57.6	61.0
United Kingdom	57.8	58.4
Spain	33.5	34.5
Poland	28.6	29.5

Source: http://www.euromonitor.com/Movers_and_shakers_in_top_10_beer_markets_in_2006

Perhaps it comes as no surprise then that the 2008 Summer Olympic Games held in Beijing was referred to as the "beer Olympics" by some Chinese. Below the top tiers of the worldwide Olympic TOP partners and national partner levels of sponsorship for the 2008 games, three of the ten sponsors at the national sponsors level were beer companies—Anheuser-Busch (Budweiser), Qingdao-based Tsingdao beer, and the Beijing-based Yanjing beer. In Russia, the brand leader beer, "Baltika," is produced by Baltic Beverages Holding (BBH), a joint venture owned by Britain's biggest remaining brewer, Scottish & Newcastle, and the Danish firm Carlsberg. BBH accounts for almost 30% of the former's profits and 40% of the latter's. In China, "Snow," the South African/United States conglomerate SABMiller's beer, now outsells Miller Lite in the United States and the local brew Tsingtao (in which Anheuser-Busch, the makers of Budweiser, has a large stake). Branding has become a key element in product promotion, and in the competitive beer market, in which German, American, British, Czech, and now Asian brands are fighting for supremacy, association of your brand name with a globally marketed sport competition has distinct merits (see Lewis & Vickerstaff, 2001, pp. 341–350). Often, such branding draws on image constructions emphasizing a national belongingness, whilst masking the transnational ownership of the brand—note the strenuous attempts to promote the Spanish beer (American owned) Estrella by the use of advertising emphasizing its "Spanish-ness."

One continued threat to beer in the UK (and in Western Europe and North America) is the growing pressure for limitations on alcohol advertising, for higher taxation of alcohol, and other restrictions on its promotion and consumption. Now that England has introduced a ban on smoking in public places, these pressures are likely to only grow, and the brewers are worried that, in the wake of the smoking ban coming into force in Ireland, beer sales dropped 6% (*The Sunday Times*, October 31, 2004). In 2007, Professor Ian Gilmore, the president of the Royal College of Physicians in the UK, called for higher taxes on alcohol, an end to "irresponsible" cheap drink promotions in supermarkets, and a complete ban on alcohol advertising (*Evening Standard*, February 23, 2007). The Labour Government, led by Tony Blair, introduced 24-hour licensing to England in 2006, only for the new incoming prime minister, Gordon Brown, to hint that he planned to reverse this innovation. A government review that reported in February 2008, however, confirmed, rather than propose a complete reversal, the principle of 24-hour licensing. So traditional beer is facing some market challenges, at a moment when its core audience would appear to be that very market sector—football fans—most likely to damage the image of the producers of the product and sponsors of the sport.

Despite fluctuations in national team performance, professional club football in the UK, especially in England, appears to be undergoing an unprecedented

boom in which television revenues, crowds, admission prices, merchandising, earnings, wages, and transfer fees all keep growing, whilst top clubs race to expand stadia or build new ones to accommodate more spectators. Although there have been warnings that this level of growth might not be sustainable, the successful exporting of the English Premier League around the world via satellite and cable TV seems likely to provide expanding revenues for some time to come. In that watershed moment in 1992 when the (English) FA Premier League and broadcaster BSkyB (now simply Sky TV) laid down the basis for the economic revolution in football, there was no title sponsor, but within a year the union between football, (satellite) TV, and beer was consolidated anew, with the competition renamed the FA Carling Premier League. Carling's beer sales soared and the renewal of the deal in 1997 was to cost them £9m per season for the next three years. As top flight English football has expanded financially one of the most significant developments to have occurred is the introduction of leading foreign players and managers with different attitudes toward training, dietary regimes, and other forms of bodily discipline and of care for the self (a la Foucault). As a marker of this development, the cultural connotation of the term "six-pack" has undergone a transformation from being a reference to the number of beer cans or bottles in a plastic or cardboard container, to being more likely understood today as a reference to the desirable muscular definition of the male abdomen.

Of course, we are certainly not suggesting that football players no longer take part in behavior that is deemed socially unacceptable. It seems clear, though, that social class context still allows different interpretations to be placed on the activities of athletes in different sports. So in cricket, the English team's vice-captain, Andrew ("Freddie") Flintoff was demoted and severely criticized for engaging in drunken behavior involving the use of a pedalo boat during the Cricket World Cup held in the Caribbean in 2007, whilst the trousers of prop Matt Stevens were pulled down as he was photographed disembarking from the team's airplane after the Rugby World Cup Final held in France in 2007, yet neither of these incidents attracted the same level of public debate or social reprobation as might be forthcoming if a professional football player had been involved.

The supposed magical restorative and aphrodisiacal properties of beer have for much of the last 100 years been a feature of beer advertising. Sexual innuendo has always endeavored to hint at the priapic effect of beer, attempting to counteract the well-known (understood experientially by both men and women, albeit in radically different form) phenomenon of "brewers droop." Slogans have included, "Guinness is Good for You," "Tankard Helps You Excel (After one you'll do anything well)," "Only Heineken can do this because it refreshes the parts other beers cannot reach"; "I bet he drinks Carling Black

Label." However, the association between beer and a strutting masculinity fell foul of the regulators in the 1980s when the Hofmeister beer advertisement— featuring a bear with a flash yellow satin jacket, a strutting walk, the voice of a cockney lad, and the slogan "If you want great lager, follow the bear"—was banned for encouraging laddish and loutish behavior. It was the first sign of a re-emergent attempt to impose a greater moral regulation on beer and its image, which has become a more significant theme in the last few years, in the context of a moral panic over young people binge drinking, with the advocacy of the slogan "drink sensibly."

More recently, beer has been linked with images of perfection and luxury. An advertisement in Carlsberg's series based around the slogan "Carlsberg do not....but if they did..." featured a rather incompetent Sunday League Player who nonetheless appears to have a top of the range Ferrari, a £100,000-a-week salary, a stunning mansion with acres of land and a Sunseeker yacht. The final scene shows his muddy football boots, being cleaned by ex-footballer and BBC pundit Alan Hansen, as the voice-over proclaims, "Carlsberg aren't football agents. But if we were, we'd probably be the best football agents in the world" (details from PR Newswire for Carlsberg, May 17, 2002. The advertisement first aired on May 29, 2002).

Just as beer and football are symbolic ties linking men (in representation at least), so they constitute the barrier between men and women. The unease and repressions that exist around the relation between men, women, sexuality, beer, and sport keep resurfacing in symbolic form in advertising. In one advertisement, the subsequent subject of ASA complaints, the theme was that only beer could lure men into sexual interaction. As the ASA ruling described it:

> The commercial showed a woman returning home to find her male partner, sitting, drinking beer surrounded by a mess. In attempting to clear away the empty beer cans, she inadvertently spills the remnants on the table, which the man then licks away. The woman then pours beer all over the flat with the man following her on his hands and knees, licking up the spilt beer. The flat is then seen sparkling clean. The pen-ultimate shot shows the man licking the bathroom clean, including the toilet bowl. The last scene shows the woman in the bedroom wearing only underwear. She pours beer onto herself and the man can be seen crouching with his tongue sticking up. The word "REWARDING" then appeared on the screen. (Advertising Standards Authority ruling, 2002, http://www.asa.org.uk/asa/focus/background_briefings/ Taste+and+Decency+-+the+depiction+of+men, accessed February 22, 2008)

Clearly, this advertisement is open to readings that might emphasize its potential for offensiveness or humor, or both. Those who complained to the ASA found the advertisement to be "lewd, offensive and demeaning to men in its inference of

oral sex," and it is interesting both that oral sex should be regarded as "demeaning" and that this should be regarded by complainants as "offensive" to men. The ASA, though, considered that most viewers would "find the woman's method of getting the man to clean the flat humorous" and concluded that the advertisement was not demeaning or offensive (Advertising Standards Authority ruling, 2002 http://www.asa.org.uk/asa/focus/background_briefings/Taste+and+Decency+-+the+depiction+of+men, accessed February 22, 2008). Regardless of offense or comic effect, however, what the advertisement does do is link beer, masculinity, and sexuality in a way that could well be construed as offensive to women, who, it is suggested here, are only desirable when soaked in beer.

If the man in this advertisement is portrayed as vulgar, hedonistic, and at the mercy of base desires, by contrast, a Birra Moretti advertisement portrays a male character who manipulates expectation in a far more instrumental manner. The man in "Home Sweet Home"—a viral advertisement for the low/nonalcoholic beer made by Birra Moretti, Birra Moretti Zero, a brand/company owned by Heineken—offers a good example of the way that the brewing industry tries to manage the contradictions of having to promote responsible drinking to a generation who wanted to grow up to be "men behaving badly." The male character enters a room, tie askew, apparently the worse for wear for drink. The blonde female, who is intently watching television, with a romantic music soundtrack and dim lighting, acknowledges his arrival but focuses on her TV program. The male approaches the sofa and sits down with a pronounced bounce. He belches and the woman scowls. The male starts to sidle toward her and eventually falls into her lap. The woman stands up quickly, turns, and throws the TV remote control at the man and storms out of the room. The male immediately sobers up, seizes the remote control, and changes the channel to one with football commentary and settles down to enjoy the moment. Titles emerge reading "Birra Moretti Zero, 100% taste, 0% alcohol" (http://www.birramoretti.it). This advertisement thus portrays two universes—the male and the female. The latter is romantic, blonde, and emotional; the former is scheming, brunette, and instrumental. Men are more keen on beer than sex and more interested in football than a romantic evening to the extent that they are prepared to manipulate the situation to their advantage whilst women are unwitting.

Beer is not innocent but has to bear the weight of symbolic productivity that links social class, national identity, and male homosociality. Even the well-established dominance of lager is read by some as unpatriotic—one blog entry complained, "I've just seen an advert for Carlsberg Beer featuring old England Football legends. 'The Beer of England.' And it's a Lager!... why is the Football team associated with Lager? It annoys me!" (http://blogs.warwick.ac.uk/mcooper/entry/british_beer 4/3/07, accessed February 22, 2008). This angry voice reminds

us that when we were young, there would have been a common contrast made between good old warm flat English bitter and nasty cold fizzy continental lager. But images are not fixed, "traditions" are not immutable, social patterns shift and transform, and even carefully constructed brand image is not stable. In Aarhus, Denmark, one of the authors met some Danes who were absolutely contemptuous of Carlsberg and its claims to be the finest lager in the world and indeed much preferred imported lager from the UK, brewed in Burton-on-Trent, suggesting if nothing else that the other man's beer is forever amber.

Brands can be "hijacked" by consumers who are not the original target market of the companies who produce them. One case of brand hijacking featured the clothing company Burberry, whose distinctive checked-pattern baseball-style cap became the status emblem of choice for low-status, council housing estate dwelling, "chavs" in the UK in the 2000s. Stella Artois has a similar problem—despite being advertised as "Reassuringly Expensive," it is one of the cheapest and strongest lager beers available and became known in some areas of the UK as "wife beater" after the assumed relationship between its consumers and their inclination toward domestic violence. Stella's owners, InBev, have sought to overcome this lowering of the perception of the brand by diversifying—there are currently three different types of Stella product available in bars and clubs in certain regions—and also by requiring the beer to be served in a glass the shape of an "ornate chalice" (Boorman, 2007, p. 115).

This association between beer and national identity and the suggestion of resistance to foreign products, whilst not noticeable affecting adversely the success of Carlsberg, Heineken, and Stella in the UK market, may constitute a problem for beers with an American (i.e., non-football) image. Budweiser, owned by St Louis-based brewer Anheuser-Busch, "has always struggled to earn the respect of football fans because of its US heritage." To combat this, the promotional strategy took to parodying the supposed US lack of comprehension of *association* football, adopting the slogan "You do the football, we'll do the beer" (*Precision Marketing*, June 2006). In the European context, by contrast, the awareness of a shared regard for beer can constitute a basis for international male homosociality, as this 2006 World Cup Guide shows:

> For those who'll be visiting Germany for the football this Summer, there's a handy guide to the various beer styles and some good places to try them on the German Agricultural Society website. Don't forget to pack the new CAMRA Good Beer Guide Germany: a guide to Germany's breweries, the beers they brew, and the best places to enjoy them. Order quickly to be sure of getting it in time. Take it easy and don't go embarrassing us over there, now! (From: An Independent Guide to German Beer: Football World Cup: finding good beer in Germany. (http://www.germanbeerguide.co.uk/May2006, accessed May 2006))

Indeed football fans cannot be allowed to go without their beer. In 2007, it was reported that rather than leave a train full of football fans without booze after a beer pump failed on a buffet car, a German train firm called a taxi to bring spare parts. The train was held at a station for 25 minutes for repairs "in order not to endanger the good mood of the fans" (*The Press Association, 2007*).

The young male target market for beer is, however, a difficult one to reach. This market sector, never comprising heavy television viewers, has in recent years been abandoning television for the Internet, prompting a considerable caution about television advertising amongst beer companies (See *Internet Advertising Bureau*, May 10, 2006). For a brief while, Heineken withdrew £6.5m from UK television advertising because of this tendency and the attempt to use viral marketing techniques such as those used for the low/zero alcohol product Birra Moretti Zero, via the Internet and such websites as You Tube (*Food Marketing and Retailing*, October 24, 2005). However in 2007, almost 35 years after Heineken launched its classic TV campaign with the slogan "Heineken refreshes the parts other beers cannot reach," a new television advertisement sold the beer in an advertisement featuring a woman apparently using a lobster "inappropriately" in a bath (see http://www.metacafe.com/watch/717086/heineken_lobster/).

Heineken, which has a £70m global advertising account, intended instead to focus its attentions on point-of-sale advertising and sports sponsorship. Foster's too decided to abandon television in favor of online advertising in 2006 (*The Independent*, August 4, 2006). Direct sponsorships can be problematic, however, especially where they may conflict with wider public concerns about the influence of advertising on the consumption of alcohol by children. Hence *The Sunday Times* (June 3, 2007) (and also see Winnett & Templeton, 2007) reported that the Portman Group, a drinks industry organization, had agreed to restrict advertising on replica football shirts for those under the legal drinking age—in Britain, those who are 18 or over, who form the bulk of the market for replica shirts.

However, the televising of major football events does, in itself, provide the beer market with regular massive boosts, triggering price-cutting wars between British supermarkets, which feature displays that appear intended to remind women that their menfolk will need copious quantities of drink, snack food, and nibbles. According to *Food Marketing and Retailing*, an extra £1.25bn could be attributable to "World Cup Fever" in 2006. Asda launched a range of World Cup salted potato snacks featuring national theme flavors such as French Garlic, Frogs Legs, German Sausage, British Vindaloo, and Brazilian Salsa. The supermarket claimed a 65% rise of beer sales in the days before the England-Paraguay match. Tesco cut barbecue prices and all major supermarkets offered heavily discounted prices on multipacks of beer (*Food Marketing and Retailing*, June 9, 2006). Pubs too benefit. According to the British Beer & Pub Association, every England

match generated an additional £30m in beer sales (*Precision Marketing,* June 2006).

In 2002, 9.1 million people watched live sport on television in a pub or bar in comparison to 8.7 million who paid to watch live sport at an event (Weed, 2007). By the same token, the failure of any of the British football teams to qualify for the UEFA European Championships, co-hosted by Switzerland and Austria in June 2008, meant that the spike in consumption traditionally associated with such sports mega-events (and in terms of television audiences and revenues, "the Euro" has a claim to being the third largest sports mega-event) was not felt to the same extent in the UK in the summer of 2008.

Major event sponsorship, too, offers distinct advantages. According to the report *Sponsorship in the Drinks Industry*, sponsorship as a marketing tool has changed dramatically in recent years as companies have realized that associations with prominent events could lend visibility and credibility to their respective brands (*Alcohol Policy UK: News and Analysis for the Alcohol Harm Reduction Field,* November 15, 2006). Beer has utilized football in the growing intensity of the battle to become a dominant global brand. Greater competition has threatened profits—in 2004, Heineken's profits dropped 33% to £371m and, despite its Euro 2004 sponsorship, Carlsberg's profits dropped by 3% to £312m. Amsterdam-based Heineken, the world's third-biggest brewing company, which counts Amstel, Tiger, and Murphy's stout among its 90 brands and operates in 170 countries, planned to spend £69 million more on its marketing and promotional costs in the following year (*Edinburgh Evening News,* February 23, 2005). Increasingly, this is a battle in which Asian beer brands are active participants. The well-established giants, Tiger, Singha, and Cobra have been joined by smaller competitors such as Thailand's Chang beer, promoted through its sponsorship of Everton F.C. As we have noted already, many analysts feel that mainland China's brands will become leading players in the next few years—hence the interest of Western brewing conglomerates (such as SABMiller and Anheuser-Busch) in forming alliances (also see *International Market News,* July 5, 2005). Anheuser-Busch (or Budweiser) has been the official beer supplier at most of the FIFA World Cup finals ever since the "tripartite model" of exclusive sponsorship began in 1990. The company has allied itself firmly to the future of the tournament and is already the official beer in both South Africa in 2010 (thus outflanking the local giant SABMiller) and Brazil in 2014.

The "tripartite" model of sponsorship stems from the formation of a sport-media-business alliance that has transformed professional sport generally in the late twentieth century. Through the idea of packaging, via the tripartite model of sponsorship rights, exclusive broadcasting rights and merchandising, sponsors of mega-events, the Summer Olympics and the football World Cup, and other

large-scale sports competitions and events, have been attracted by the association with the sports and the vast global audience exposure that the events achieve. The idea of selling exclusivity of marketing rights to a limited number of sponsoring partners began in Britain in the 1970s with Patrick Nally and his associate Peter West as the media agency West-Nally. In the early 1980s, the idea was taken up by Horst Dassler, son of the founder of Adidas, and at the time chief executive of the company. With the blessing of the then FIFA president Joao Havelange, Dassler established the agency ISL Marketing in 1982. ISL linked up with the International Olympic Committee (IOC), presided over by Juan Antonio Samaranch, and established TOP, or "The Olympic Program," in which a few select corporations were able to claim official Olympic worldwide partner status. As Sugden and Tomlinson (1998, p. 93) note in relation to the football World Cup: "Fast foods and snacks, soft and alcoholic drinks, cars, batteries, photographic equipment and electronic media, credit sources—these are the items around which the global sponsorship of football has been based, with their classic evocation of a predominantly masculinist realm of consumption: drinking, snacking, shaving, driving."

Fans have been exploited in the struggle between the official sponsors and their competitors who seek to compete through "ambush marketing." During the 2006 World Cup, Dutch fans wearing orange lederhosen with the name of a Dutch beer company Bavaria were forced to remove them in order to be allowed entry to the stadia (*The Guardian*, June 19, 2006). Major events provide less obvious opportunities too, for example, for data gathering. During the 2006 World Cup, Scottish & Newcastle UK (S&N UK) captured consumer data by linking with Ladbrokes.com. Consumers buying promotional multipacks of brands such as Foster's, Kronenbourg 1664, John Smith's Extra Smooth, or Strongbow could claim a free £5 bet by using a code number to open an account (*Precision Marketing*, June 2006).

It is both questionable and hard to determine the extent to which the various much-discussed labels of supposed transformations in male style since the 1980s—new men, new lads, metrosexuals, and now "real men"—have corresponded to actual social types. Certainly, despite stylistic changes, the behavioral forms of working class masculinity do not seem to have shifted much. The exception, though, maybe in that rather rarefied strata of working class youth—professional footballers. It may well be true that the influence of foreign coaches such as Arsene Wenger (Arsenal FC) and foreign players not committed to a boozy lifestyle has begun to erode the hegemonic hedonism of alcohol-fuelled boys nights out that appeared to be at the core of English professional football. Footballer Jason McAteer believes modern-day footballers have cleaned up their act, that the past decade has seen an end to the drink culture within the

English game and that the influence of foreign coaches has been a major factor in the change (Liverpool.com quoted in: *Alcohol Policy UK: News and Analysis for the Alcohol Harm Reduction Field*, November 7, 2006). Set against this rather utopian image, however, is the continuing tabloid exposure of the alcohol-fuelled misbehavior of some top footballers. Advertisers, sponsors, and image consultants cannot sleep easily, because, where beer, football, and blokes are concerned, something can always go wrong.

CONCLUSIONS

Six industries dominate European sport sponsorship—telecommunications, automobiles, finance, soft drinks, sports goods, and beer (Clarke, 2003, p. 52). Beer has been dominant in football sponsorship in Britain since the 1990s. Carling, Worthington, Tennents, and Carlsberg are the names that have been most closely associated with knock-out competitions and championships during this period. Of course, the regulatory frameworks governing advertising and alcohol especially in relationship to sport differ in different European countries. For example, the Heineken Cup in Rugby Union is called the "H Cup" in France because of the prohibition there on linking alcohol with sport (for the same reason, electronic goods company Casio replaced Budweiser as sponsor during the 1998 FIFA World Cup Finals played in France). As Anheuser-Busch is a multinational conglomerate with nonalcoholic interests, it replaces beer/alcohol logos on cars it sponsors in Formula 1 racing with other properties when the competition takes place in France.

Brand narratives establish relationships between people, products, and ways of living in consumer culture (Dewhirst & Sparks, 2003). The beer advertisers and sponsors associated with football have thrived in the last two decades as the economic scale of football has expanded dramatically. As one marketing document put it, "When football succeeds so does the brand" (Bass Breweries, 1998, p. 4). The failure to qualify for major tournaments/mega-events, then, is a problem for advertisers as well as for English football and will inevitably impact on the market.

Consumer skepticism about consumerism can, however, be used as a tool for promoting it—especially where associations are established with "authentic" products or experiential commodities such as football (Frank, 1997). So despite the entrance of the "new breed" of football club owners, profit maximizers rather than utility maximizers, especially in English football, football retains an aura of authenticity as a point of identification for supporters/fans/consumers/customers that few other contemporary cultural practices can command.

Beer sponsors football: what could go wrong? Over the course of the past 50 years several things already have, but there are several reasons why these contradictions have been surmountable. Firstly the globalizing dynamics of capitalist production enable companies to respond to declining markets in traditional areas by expanding to emerging markets, of which the Beijing "Beer Olympics" is one vivid example. Secondly, the continuing association between consumption of alcohol and the rite of passage into adulthood or at least relative independence means that any link between sport and physical development will also potentially be coupled with the allure of drink. Thirdly, in the UK at least, social class and gender continue to shape culturally transmitted conceptions of both appropriate types of alcohol consumption and drinking cultural practices and sports participation and involvement. Sport and beer are highly attractive, seductive, and enjoyable but socially conservative forces.

REFERENCES

Bass Breweries (1998). *Sponsorship*. Burton on Trent: Bass Breweries.

Boorman, N. (2007). *Bonfire of the brands*. Edinburgh: Canongate.

Clarke, R. (2003). *The business of sports marketing*. London: Sport Business Group Ltd.

Cohen, P. (1972). Sub-cultural conflict and working class community. *Working Papers in Cultural Studies*, No. 2. University of Birmingham: Centre for Contemporary Cultural Studies.

Collins, T. & Vamplew, W. (2002). *Mud, sweat and beers: a cultural history of sport and alcohol*. Oxford: Berg.

Critcher, C. (1979). Football since the war. In J. Clarke, C. Critcher, & R. Johnson (Eds.), *Working class culture*, (pp. 161–184). London: Hutchinson.

Curtis, P. (2007). Balls calls for new policies to help "tweenagers" cope with temptation. *The Guardian*, November 20, p. 14.

Davies, F. (2006). Sportsman, sports fan, drinker: Investigating teen socialisation into a sponsorship-reinforced identity. *Cardiff Marketing and Strategy Working Papers*, M2006/5, July. Cardiff: Cardiff Business School, Cardiff University.

Dewhirst, T. & Sparks, R. (2003). Intertextuality, tobacco sponsorship of sports, and adolescent male smoking culture. *Journal of Sport and Social Issues*, 27, 373–398.

Frank, T. (1997). *The conquest of cool*. Chicago: University of Chicago Press.

Hornsey, I. (2003). *A history of beer and brewing*. Cambridge: Royal Society of Chemistry.

Hutt, C. (1973). *The death of the English pub*. London: Hutchinson.

Jones, S. (2007). Do we think we've had enough? Beer sales plunge as Britons stay at home. *The Guardian*, November 20, p. 3.

Joseph Rowntree Foundation (2007). Call for proposals: research on the transmission of drinking cultures, http://www.alcoholpolicy.net/2007/10/jrf-call-for-pr.html accessed November 22, 2007.

Kollewe, J. (2007). Britain's smoking ban sends brewers east as western markets go flat. *The Guardian* June 27, p. 31.

Lewis, C. & Vickerstaff, A. (2001). Beer branding in British and Czech companies: a comparative analysis. *Marketing Intelligence & Planning*, 19 (5), 341–350.

Miles, S. (1998). *Consumerism as a way of life*. London: Sage.

Murphy, P., Williams, J. & Dunning, E. (1990). *Football on trial. Spectator violence and development in the football world*. London: Routledge.

Priestley, J.B. (1934). *English journey*. London: Heinemann.

Protz, R. (2007). Bright news for good beer. *The Guardian*, November 21, p. 35.

Sugden, J. & Tomlinson, A. (1998). *FIFA and the contest for world football*. Cambridge: Polity.

Weed, M. (2007). The pub as a virtual football fandom venue: an alternative to "being there'? *Soccer and Society*, *8*, 399–414,

Winnett, R. & Templeton, S-K. (2007). Ban on child football shirt with drink ads. *The Sunday Times* June 3, http://www.timesonline.co.uk/tol/news/uk/health/article1875555.ece accessed November 22, 2007.

Young, J. (1980). *A short history of ale*. Newton Abbott: David and Charles.

Youth, Sports, AND THE Culture OF Beer Drinking: Global Alcohol Sponsorship OF Sports AND Cultural Events IN Latin America[1,2]

SHANNON JETTE, ROBERT E. C. SPARKS

ILANA PINSKY, LILIANA CASTANEDA

REBECCA J. HAINES

INTRODUCTION

This chapter investigates the political, economic, and ideological framework of the beer industry sponsorship of sports and cultural events in Latin America as a case study in the globalization of beer, sports, and the gender order. In the face of rising industry consolidation and leveling or declining sales in developed markets in North America, the UK and parts of Europe, major global breweries such as InBev, Anheuser-Busch, and SABMiller have been moving aggressively to exploit opportunities for growth in developing countries that have relatively open or underenforced alcohol-marketing regulations and large populations of youth that show potential for increased consumption and sales. Part of their strategy entails targeting women as a growing "segment" of the market in national contexts where changing gender roles have reduced the influence of traditional social and religious proscriptions against female drinking. These changing conditions invite us to think critically about

the social impacts of beer sponsorships and related marketing and about the efficacy of national efforts to regulate domestic beer marketing where parent companies increasingly are transnational corporations that operate in a global context. We focus on the impact of these developments in three countries—Brazil, Colombia, and Argentina—and examine how the beer industry is able to circumvent limited national regulations and promote beer drinking as a normative practice by using lifestyle and cultural appeal methods and sport and event sponsorships that draw on national identity and culture, and valorized notions of masculinity and femininity. We have selected Brazil, Colombia, and Argentina to be representative of the broader context in Latin America and also as leading many of the trends. Brazil has an estimated population of 190.1 million people, which makes it the sixth most populated country in the world and largest in Latin America. Colombia and Argentina with 46.7 and 38.9 million people, respectively, rank second and third in population in South America and third and fourth in Latin America (behind Mexico, which is second with 107.5 million people) (UN, 2007). All three countries have well-developed economies and large metropolitan centers including Sao Paulo (19.2 million) and Rio de Janeiro (11.6 million) in Brazil (IBGE, 2007), Bogota (7.0 million) in Colombia (NDS, 2007), and Buenos Aires (13.8 million) in Argentina (INDEC, 2007), with well-established beer marketing and production industries.

Our objective is to take seriously the processes and products of beer marketing as an instance of cultural production and map out its impacts. This entails looking at the lifestyles of consumption and the cultural field of beer and sport that are produced and the effects of these constructions on the gendered practices and conceptions of sports, identity, drinking, and health among youth. This approach has both supply-side and demand-side implications in a Bourdieusian sense (Bourdieu, 1978, 1988; Harvey & Sparks, 1991), however, the chapter focuses mainly on the supply-side of beer marketing to the extent that it engages the production of messages about beer and drinking and the provision of cultural events as opportunities to drink, rather than examining peoples' interpretations of these messages and their participation in the events. To theorize consumer demand for alcohol products and drinking occasions, it is necessary to take account of the role of promotional culture itself in shaping peoples' understandings and interest in their use. Among youth in particular, first- and second-hand exposure to alcohol-related messages in promotional media share influence with family and community values and peer influences in shaping patterns of alcohol use, as seen in a growing body of research that connects exposure to alcohol advertising with adolescent alcohol consumption (see, for instance, Connolly et al., 1994; Ellickson et al., 2005; Snyder et al., 2006). The rise of global marketing and an oligopoly of transnational

breweries has exacerbated this condition and served to undermine many of the checks and balances on drinking that were once endemic to local communities. Jernigan (2001) observes that while, historically, the cultural meanings and roles of alcohol were defined by the communities that produced and served the alcohol, "global alcohol plays a cultural role primarily defined by its global brand owners.... [and] as global businesses, these brand owners have a single paramount goal (and responsibility to their shareholders): to maximize sales—and thus presumably consumption—of their products" (p. 11). Profit maximization is tied closely to sales maximization as well as production efficiencies, and both support exploitation of the demand-side of consumer interest through supply-side stimulus.

YOUTH MARKET

In this context, the youth market is essential, as youth tend to be the group that sets cultural trends and that is most amenable to trying new ideas. In Latin American countries, youth also constitute a major part of the population and have relatively low levels of alcohol use—which in beer industry terms is an opportunity for growth. Over 30% of the population in Latin America is under the age of 18; during the past several years, domestic and global breweries alike have allocated significant resources to youth-oriented advertising and event sponsorships in an effort to capture the interests and loyalty of youth and increase overall sales. In addition to sponsoring established events such as World Cup soccer and cultural festivals such as Carnival in Brazil, breweries are providing new drinking occasions through the creation of youth-oriented events such as music festivals and beach parties. A range of new media technologies that cater to youth, including the Internet, email, and text messaging, are being used to promote these events, in addition to traditional electronic, print, and outdoor media that are the current focus of most industry regulations (Casswell & Maxwell, 2005). A central feature in these strategies is the gender messaging that is embedded in beer marketing and that plays to prevalent features of the gender order, including the gendered nature of drinking.

Despite the near universality of gender differences in drinking behavior globally (compared with women throughout the world, men are more likely to drink heavily and excessively and to cause problems by doing so), the level of difference has varied across societies and over time, suggesting that gender differences in drinking are not strictly physiological but are also related to social, political, and cultural factors (Wilsnack, Wilsnack, & Obot, 2005). Societies have long used alcohol consumption and its effects to differentiate and regulate gender roles.

As Wilsnack et al. (2005) note, "differences in normative drinking patterns help reveal to what extent societies differentiate gender roles, for example by making drinking behavior a demonstration of masculinity or by forbidding women to drink as a symbol of subservience or to prevent sexual autonomy" (p. 2). While beer marketers often draw on sexualized imagery and exploit women's bodies to attract male interest, the apparent convergence of male and female drinking patterns that is occurring among youth in Latin America adds complexity to this issue. In several Latin American countries, the gender gap in drinking is decreasing or reversing —a trend thought to be associated with increased opportunities for women to engage in traditional "male" roles. For example, in the 2002 GENACIS survey conducted in the province and city of Buenos Aires, Argentina, lifetime prevalence of alcohol use ("have drunk alcohol at least once") by 12–15-year-olds was 40% for females and 38% for males (Munné, 2005). Heavy drinking was also higher among females, although the results should be interpreted cautiously since the survey was not nationally representative. Among the 18–29-year-olds, 69.2% of female participants were found to be heavy drinkers (5+ drinks on one occasion), as compared to 52.4% of males (Munné, 2005, p. 35). Drinking patterns among Brazilian males and females (aged 18–34) also appear to be converging, with the exception that relatively more males are frequent heavy drinkers, while more females are infrequent heavy drinkers (Kerr-Correa et al., 2005, p. 57). According to Euromonitor International (EI), global breweries have recognized these patterns and are endeavoring to promote beer to females without alienating their core male consumers (EI, Beer: Brazil, 2006). One such strategy is to position premium brands as a sophisticated alternative to wine and an acceptable drink for women and men because of its refined taste and social status. The irony in this turn of events is that women stand to share more equally in alcohol-related problems as their consumption rates approach or exceed those of men.

DETRIMENTAL EFFECTS OF ALCOHOL ABUSE

An important, if sometimes overlooked, factor in alcohol marketing is the broad range of detrimental effects of alcohol as a socially condoned and widely available, psychoactive drug. Even though there is some evidence that consumption of limited quantities of alcohol with food may have health benefits, established drinking patterns do not correspond to these guidelines, particularly among youth who tend to engage in occasional but concentrated bouts of drinking. These are important considerations. As McCreanor et al. (2005) warn, research on the effects of promotional culture must situate marketing "as a historically contingent

and contextually bound social practice that creates meaning and significance only in the context of wider social practices" (p. 253). Youth drinking as a social practice embodies the consumption patterns most highly correlated with negative health impacts. World Health Organization (WHO, 2002) data rank alcohol as the fifth most significant risk factor for premature death and disability in the world among 26 risk factors they assess (behind malnutrition and water, sanitation and hygiene, but on a par with unsafe sex). While long-term health consequences of alcohol abuse include esophageal and liver cancers and cirrhosis of the liver, more immediate effects include motor vehicle accidents, violence and domestic abuse, intentional/unintentional injuries, sport and leisure injuries, and sexually transmitted diseases (STDs). The Americas surpass global statistics for alcohol-related deaths, alcohol consumption rates (40% greater than the global average), negative drinking patterns, and alcohol-use disorders (Monteiro, 2007). Alcohol is the *leading* risk factor for the burden of disease in the region, particularly in Latin America where research shows that young people engage in risky patterns of drinking (Monteiro, 2007), including binge drinking that is closely associated with violence, accidents, unplanned pregnancy, unprotected sex and STDs (Ellickson et al., 2005). The seriousness of the issue is underscored by the fact that in 2002, alcohol accounted for 34.8 % of the total deaths of Latin American males aged 15–29 years and 7.9% of total deaths for females in the same age group—significantly higher than the global average of 13.9% (male) and 2.2% (female) in the same age category. These figures raise important questions about the use of sport and event sponsorships to promote beer brands and beer drinking and help to explain why in many countries, alcohol marketing is regulated through health legislation as well as through industrial and trade legislation.

According to Sparks et al. (2005), 41 countries currently restrict beer sponsorship (32 via legislation, 8 via industry self-regulation, and 1 via a combination of voluntary industry code and legislation) and 52 countries restrict wine and spirit sponsorship (the 41 just noted plus an additional 11). Despite inherent limitations in these figures, including that they were derived from national-level summaries and may underreport subnational restrictions (regional, provincial, municipal) and countries with religious prohibitions against alcohol consumption (this would add 20 nations), it is still clear that a large number of countries globally have few or no restrictions on alcohol sponsorship—the WHO has 193 member states, and only 72 are accounted for here. Two additional observations are that most of the restrictions reported by Sparks et al. are not actual prohibitions but allow alcohol sponsorship promotions on some basis (Casswell, 2004; Sparks et al., 2005), and that national sponsorship restrictions have limited force internationally and are difficult to keep up-to-date in the face of ongoing innovation in global marketing

practices. A particular problem is the "spillover" effect that occurs when event coverage from a country with limited restrictions reaches audiences in a country with greater restrictions, or when adult-oriented content reaches youth. In both of these case, new communications technologies such as the Internet and World Wide Web have made these problems more complex.

This chapter provides a brief overview of the recent consolidation in the global beer industry and then examines the specific market and regulatory contexts in Brazil, Colombia, and Argentina, and the industry's use of lifestyle and event marketing in these countries. It concludes with a preliminary set of recommendations from the Brasilia Declaration on Alcohol Public Policies that would help Latin American countries to more effectively regulate beer sponsorships.

THE GLOBAL ENVIRONMENT —
AN EMERGING BEER OLIGOPOLY

Evidence suggests there is a shift underway towards a global oligopoly in the beer industry as a result of a continuing worldwide consolidation. Whereas the top 10 breweries in 1999 accounted for only a third of the world's beer production by volume (Haddock, 1999), by 2004 they accounted for just under half (or 48.3%), with the top *four* breweries producing fully a third of the world's beer (EI, Beer: World, 2006). Sales wise, the top 10 global breweries produced less than a quarter of international sales volume in 1980, while this figure increased to just under 61% by 2005, with the top *five* (InBev, SABMiller, Anheuser-Busch, Heineken, and Carlsberg) holding 48% of the market in 2005 (Standard & Poors, 2006). Industry analysts predict that the consolidation will continue over the next several years (EI, Beer: World, 2006; Standard & Poors, 2006); at this writing, the recent (October 2007) merger of SABMiller and Molson Coors has raised speculation about an impending partnership between InBev and A-B, a deal that would give them control of one quarter of the world beer market (Credeur & Bhatia, 2007).

The consolidation has resulted in the diffusion of sophisticated marketing techniques from developed markets into developing countries as the major breweries compete for sales. A typical pattern is to preserve the value of local brands while also promoting global and premium brands. Global brands are coveted by the industry because they sell at higher prices and have better profit margins than local beers (Tomlinson, 2004), and the top breweries now have global or near global distribution channels (Smith, 2005). Heineken, for example, has been marketed as a global brand for many years. SABMiller is now promoting the Italian beer Peroni Nastro Azzurro along with its Latin American brands Aguila, Cristal, and Cusqueña, and InBev has launched Brahma, Stella Artois, and Becks

on a global scale. "Premiumization" is a complementary strategy in markets where rising incomes, an increased standard of living, and concerns with health and social status have made consumers willing to "trade up" from less expensive labels to more expensive ones that are perceived to be healthier and/or image enhancing (EI, Beer: World, 2006, p. 3). The rise of "global" brands and the trend towards "premiumization" have led to increased emphasis on advertising and sponsorship to differentiate products, build brand equity, and increase sales. While industry representatives claim they are only trying to differentiate brands, the health community has noted that alcohol advertising has *product category* effects as well as *brand* effects in that it promotes product consumption at the same time that it constructs brand identities. Comments by A-B CEO Patrick Stokes reinforce the understanding that the industry is endeavoring to enhance profit by increasing overall consumption and sales. A-B was the global leader in sales at the time, and Stokes identified four priorities to continue to stimulate growth: (1) improve the image and desirability of beer; (2) keep beer fun and social; (3) grow [increase] beer occasions; and (4) improve retail sales (Pas, 2005, p. 44). Sponsorship of sports and cultural events fits well with all four of these strategies and has become a medium of choice in most markets, including Latin America.

LATIN AMERICAN BEER INDUSTRY— BRAZIL, COLOMBIA, AND ARGENTINA

The perceived growth potential in Latin America makes it attractive to global breweries, and analysts predict the region will remain a strategic focus for the major multinationals in the future (EI, Beer: World, 2007). Per capita consumption of beer remains low and the large youth population translates into increased opportunity for sales and profit. In Brazil, it is estimated that 3 million young people will reach legal drinking age each year over the next several years. The total volume of beer sales is forecast to increase by 24% between 2005 and 2010 (EI, Beer: Brazil, 2006), and to reach nearly 12 billion liters by 2011 (or a per capita consumption level of 60L per year—as opposed to the current 53L) (EI, Beer: Brazil, 2007). In Colombia, approximately 29% of the population is between the ages of 10 and 24 years (2005 data) and this age category is predicted to remain high (28% in 2010 and 27% in 2015) (EI, Consumer Lifestyles: Colombia, 2005). Sales of beer are expected to grow by 37% in volume and 29% in constant value terms from 2006 to 2011 (EI, Beer: Colombia, 2007). SABMiller, a major company in the region, anticipates a rise in per capita consumption from 45L a year to 60L per year (Mawson, 2007). Argentina is already witnessing a rapid increase in beer consumption.

Traditionally a wine-drinking culture (consuming in moderation during family meals), drinking habits in Argentina have shifted towards beer over the past decade. Wine consumption dropped from 80L to 32L between 1996 and 2003 and beer consumption grew from 10L in 1996 to 36L in 2003 (EI, Consumer Lifestyles: Argentina, 2006). The past year saw significant increases in beer sales due to increases in youth consumption; as the drinking initiation age continues to drop among Argentinean youth, it is predicted beer sales will continue to grow (24% in constant value terms) (EI, Beer: Argentina, 2007).

Transnational corporations such as InBev and SABMiller have become firmly established in Latin America over the last several years and are significantly influencing marketing practices. InBev (created in 2004 when Belgium brewer Interbrew merged with top Brazilian brewer AmBev) is the top brewer in the region, and AmBev has remained as the local headquarters and operating unit for InBev in Latin America. In 2005, AmBev (InBev) controlled approximately 67% of the market in Brazil and 71.4% in Argentina (due to its strategic alliance with Quilmes)[3]; it also has monopoly positions in Venezuela, Uruguay, and Paraguay (EI, Beer: Argentina, 2007; EI, Beer: Brazil, 2007). SABMiller currently holds the number two position in Latin America and controls the majority of the Colombian and Peruvian markets as a consequence of purchasing Grupo Empresarial Bavaria (GEB or "Bavaria") in 2005 (Chauvin, 2005; McKenna, 2007).

The Latin America beer market was competitive in its own right before the arrival of the multinationals, and there was a relatively high degree of within-region consolidation and takeover activity during the 1990s as brewers competed for entrance into new markets and an increased share in their domestic markets. However, the arrival of the multinationals brought a new level of sophistication and aggressiveness to the region. Upon purchasing Bavaria in 2005, SABMiller launched a new campaign that aimed to increase sales through better brand differentiation and by repositioning beer as an "aspirational" purchase for consumers (EI, Alcoholic drinks: Colombia, 2006). Poker, its domestic standard lager, was re-launched with sleeker packaging meant to appeal to youth, and Club Colombia, its domestic premium lager, was supported by a national mass media campaign. SABMiller believes there is room for improvement. In a 2007 corporate strategy presentation, Barry Smith, president of the Latin American division, stated that in Latin America the "beer category lacks appeal, is unaspirational, restricted to a few occasions," has "historically undifferentiated portfolios with largely regional identities," and that the beer franchise is weak amongst key target groups (young adults, upscales, and females) (SABMiller, 2007, slide 63). The brewery recently announced plans to introduce three or four new brands into the Colombian market in 2008 (EI, Beer: Colombia, 2006) and

is working on "brightening the image of existing Colombian beers, giving them more attractive packaging and a wider range of prices in an effort to increase sales of premium brands" (Pfanner, 2007).

BEER MARKETING REGULATIONS AND INDUSTRY RESPONSES—BRAZIL, COLOMBIA, AND ARGENTINA

To assess the political context and social impacts of these developments, we examined the regulatory framework and marketing strategies of the major breweries in the three focal countries, emphasizing their use of sports sponsorship and their appeals to youth. We briefly examine advertising regulations and then turn to sponsorship.

ADVERTISING REGULATIONS

Of the three countries, Argentina has the most comprehensive regulations on alcohol advertising. Article No. 6 of the National Anti-Alcoholism Law (Law 24788, March 1997) prohibits any kind of advertising that targets minors, portrays minors drinking, suggests that alcohol enhances physical, sexual, or intellectual performance, or encourages violence (Castaneda-Rojas, 2006; EI, Alcoholic Drinks: Argentina, 2006). The law also requires that every alcoholic drink ad campaign (on TV or in print) must contain a warning to "drink with moderation" and "not to be sold to people younger than 18 years old" (EI, Alcoholic Drinks: Argentina, 2006). However, according to EI, alcohol companies are rarely fined for transgressing the legislation due to the vagueness of the advertising restrictions and the difficulty of defining advertiser intentions (EI, Alcoholic Drinks: Argentina, 2006).

Brazil also has legislated restrictions on alcohol advertising (under Law 9,294 of 1996), but the time limits for media exposure apply only to beverages above 13GL (% volume in alcohol), mostly spirits (EI, Alcoholic Drinks: Brazil, 2006). In fact, alcohol advertising in Brazil relies mostly on self-regulation through the Brazilian Council for Self-Regulation in Advertising (CONAR). In response to concerns about the increase in youth drinking as well as the prevalence of alcohol-related motor vehicle accidents (MVAs) (Brazil has one of worst drink driving accidents rates in the world with about 30,000 victims per year), in 2003 the Brazilian government began to experiment with new restrictions to reduce alcohol-related problems. A few cities implemented local regulations restricting the hours for selling alcohol and the minister of health

proposed that the advertising restriction on time exposure in the media of alco-holic beverages should apply to beer and wine (not just spirits) (EI, Alcoholic Drinks: Brazil, 2006; Pinsky & Laranjeira, 2003). In an attempt to avert the implementation of further legislation, however, CONAR, several media orga-nizations, and the beer companies launched a series of countermoves, including a campaign to pose legal obstacles for the Brazilian Health Agency to legislate against advertising (http://www.conar.org.br/).

Until recently, alcohol advertising was completely self-regulated in Colombia, the exceptions being Law 30 of 1906 and Law 124 of 1994 that require that all ad campaigns featuring alcoholic drinks include the warning "excessive drinking is hazardous to your health" and "the sale of alcoholic drinks to minors is prohibited" (EI, Alcoholic Drinks: Colombia, 2006). However, faced with pressure to tighten regulations around alcohol advertising, in 2006 the TV National Commission (an autonomous entity with government input) issued regulations that prohibit messages that target youth, show people drink-ing alcohol, or include minors in TV ads. This legal instrument also specifies that advertising messages cannot suggest that alcohol consumption improves personal, sexual, economic, or social performance, or that alcoholic beverages help to solve problems.

SPONSORSHIP REGULATIONS

All three countries have restrictions on event sponsorship, although these measures are generally less restrictive than the advertising regulations. Attempts to make beer sponsorship regulations stricter (like advertising) so far have largely failed. In Argentina, for example, a legislative initiative in the National Congress (file #64, 2994-D–2006) that attempted to prohibit all advertising and sponsorship of beer products was unsuccessful and failed to strengthen controls on alcohol spon-sorship or advertising. In Colombia, the current self-regulatory framework (No. 001, 2006) was preceded by legal resolution No. 004, 2005 (also issued by the TV National Commission) that actually prohibited *any kind* of advertising on televi-sion (promotional, direct, and indirect). Mention of beer sponsors was permitted only at the beginning or at the end of an event. Potential financial losses due to a withdrawal of brewery advertising were calculated at US$ 12 million, however, and lobby campaigns from soccer teams and national leagues led the TV National Commission to modify the resolution and issue the current one (No.001, 2006) that forbids any kind of direct advertising but allows *indirect* advertising between 9 p.m. and 5 a.m., and promotional advertising between 9:30 p.m. and 5 a.m. one month before and during the event broadcast.

Argentina	Brazil	Colombia
Partial restrictions on sponsorship of youth and sport events: • Prohibits events where drinking is required (tasting, consumption– Law 24788, art 7)	Voluntary restrictions for sport events (does not apply to beer, only to spirits): • The self-regulation code forbids the use of sports uniforms as brand promotion tools (Annex P of CONAR code). However, it is allowed to mention sponsor's brands and show marketing material during the event broadcast.	Partial restrictions on sponsorship of youth and sport events. • May mention sponsored brand only if directly connected to the event.
• No brand logos on sport uniforms.		• Promotional material on TV allowed as part of the stage or decoration (stadium banners).

At this writing, both Argentina and Colombia have partial restrictions on sponsorship of youth events and sports events. Brazil has voluntary restrictions on the promotion of sport events—although these do not apply to beer, only to spirits and wine (beverages with over 13% alcohol). All three countries have restrictions on the use of sports uniforms as brand promotion tools.

INDUSTRY RESPONSES AND THE PROMOTIONAL FIELD OF BEER

To obtain a representative view of how the industry is responding to the conditions noted above and how this affects the promotional culture of beer drinking, we collected industry data in the three countries and conducted a review of the breweries' websites. Industry data in Argentina was collected between June 2006 and October 2006 by an associate living in Argentina (C. Rojas). The Colombia data was gathered by one of the authors (Castaneda) between October and December 2006, and the Brazil information was gathered by a second author (Pinsky) from January 2005 to August 2007. Data collection included news reports, industry and company reports, and marketing legislation. Marketing campaigns and strategies were followed over these time periods, with a focus on sponsored events, advertising in traditional media (including broadcast and print), as well as websites and other new media technologies. The website reviews covered AmBev, Schincariol and Kaiser (Brazil), Bavaria (Colombia), and Quilmes (Argentina) and were piloted in November 2005 and conducted intensively during July–November, 2007. We have summarized major findings under three headings: beer, football, and nationalism; connecting with youth; and valorizing masculinity and femininity.

Beer, Football, and Nationalism. To profit from the saliency and social attraction of soccer ("football"), the major breweries in each country have invested heavily in national team sponsorships. In each case, sponsorship regulations prohibit use of alcohol brand names and logos on uniforms, yet by matching national colors and brand colors the breweries have been able to effectively circumvent the restrictions and establish a strong link to sporting nationalism and national identity. In Colombia, for example, SABMiller's Bavaria recently renewed a sponsorship contract with the Colombian national team up to the 2010 World Cup ("The Colombian Football Federation," June 26, 2007) with its Aguila brand, a leading domestic lager. The national team uniforms, which are yellow, blue, and red, match both the national flag and the colors of the Aguila logo so that the association between Aguila and the national sport is made clear without having to include Aguila's logo. Any doubt about Bavaria attempting to associate its flagship brand with Colombian nationalism is dispelled by a June 2007 press release that proclaims: "Aguila is more than a beer. Aguila is Colombia…The new image of Aguila is as vibrant and colourful as Colombia's flag" (www.bavaria.com.co/, 2007). Quilmes of Argentina (owned by InBev) has also aligned itself with soccer, sponsoring teams at all levels including the Argentine national team for the 2006 World Cup. The company's annual report shows the marketing and sponsorship budget for soccer as US$2.5 million, more than rugby and equestrian. Here again, Quilmes' brand colors of light blue and white match both the jersey colors and the national flag, making Quilmes synonymous with Argentine nationalism and soccer (www.clarin.com/diario/, 2006) The Quilmes bottle cap has the outline of a soccer ball to reinforce this association.

AmBev's sponsorship of the Brazilian national team is an interesting case, because it links the company's leading soft drink as well as beer with the team. The sponsorship, announced May 24, 2001, consists of an 18-year contract (for 5 World Cup Championships) that provides US$10 million annually to the Confederacao Nacional de Futebol (CBF) (www.ambev.com.br/, 2005). AmBev selected its juice soft drink Guaraná Antarctica to sponsor CBF in an effort to make gains on Coca-Cola's 36.1% share of the soft drink market (versus Ambev's 8%) (Ambev releases marketing campaign, 2002). Even though the Guaraná Antarctica logo is printed visibly on the training uniforms of the Brazilian soccer team, the jerseys use the distinctive blue color of Antarctica, one of AmBev's popular beers, in what amounts to a textbook example of a "brand extension" strategy. Game jerseys use variations of the green, yellow, and blue that are the three colors of the national flag, two (blue and yellow) of which figure in the Antarctica label. The relationship between AmBev and the national soccer team has not been free of controversy, for although Guraraná Antarctica is the official sponsor, the soccer club is expected to promote other AmBev brands, including

Brahma. When Brazil won the 1994 World Cup, players such as Romario, Bebeto, and Zinho raised their index finger emulating the Brahma TV commercials at the time. More recently, Ronaldinho has appeared in Brahma beer commercials (EI, Beer: Brazil, 2007). Other controversies have included an ad with the slogan "The Brazilian Team Is Brahma" that led the CBF to insist they are identified only with Guaraná Antarctica. Despite this conflict, AmBev continues promoting a link between the national team and its brands. In each of these three cases, the juxtaposition of the national flags, national team uniforms, and brand logos is quite striking and constructs a concrete association and cross-referencing of beer, sport, and national identity within the social field of sports, while also valorizing and affirming traditional gender roles and (apparently) reaching youth. Not only does this association create brand awareness (build brand equity), but it also helps to position beer drinking as part of a national pastime and passion—soccer.

Connecting with Youth. InBev CEO John Brock, in a speech to the World Beer and Drinks Forum held in Germany in September 2005, stated that "Today's young adults are different…They have more money. They have very different life styles. They want sophistication. They want variety. They understand the internet…They are skeptical…In my view, we are doing a fairly miserable job in making the connection with these consumers…we really better figure it out" (Speeches by InBev's Brock, 2005). Our results suggest the industry has figured it out, at least in the sense that they have embraced the Internet and new media technologies as a key strategy to appeal to youth. Many of the leading brands in the three countries now have sophisticated, interactive websites, with music downloads for MP3s, iPods, and cell phones, interactive games, contests, and e-cards. InBev's Skol beer, for instance, offers downloads from various music concerts and instant videos of these shows, as well as cell phone ringtones with brand jingles (see www.skol.com.br/ and http://baixeredondo.skol.com.br/main.asp, 2007). Interactive games are also popular. InBev's Brahma site features a game where the player must flip a beer coaster off the edge of the table and then try to catch it (using the space bar and mouse). Scores are totaled and can be stored in the system so that players can compete against their own score or the scores of others (www.brahma.com.br/, 2007). The use of e-cards is a common feature on many sites and allows individuals to enter a friend's email address to send brand logos, event information, and photos to their friends. To promote its e-card feature, the Brahma site uses the tagline "Vira-bolacha," which means the user can "defy a friend" by sending an email to them. SABMiller's Aguila site uses a different angle. Online users can send a friend an e-card featuring a photo of the Aguila poster girls (Chicas Aguila), clad only in bikinis and frolicking on the beach (www.cervezaaguila.com.co, 2007).

Podcasts are also used to promote events and brand releases and on some sites, such as Brazilian brand Kaiser, users can create their own podcasts and listen to others' (www.kaiser.com.br, 2007)—although they are branded with the Kaiser "k" and called podkasts. The Kaiser site also shares the details of a promotional alliance with the popular television show "Panico na TV" (Panic on TV) through which users can get free beer in exchange for bottle covers or can rings. This alliance speaks to the deliberateness of their youth strategy because the television program won the Q Media Award ("Premio MediaQ 2005") as the best show for the 12 17-year-old audience members (www.kaiser.com.br, 2007). The site also has instructions on how to conduct a blind beer tasting test with friends.

A common interface for the various sites is a fully interactive, virtual bar (see, for instance, Quilmes, Antartica, and Cristal). Perhaps the most sophisticated is the night club recreated by Quilmes of Argentina (www.quilmes.com.ar, 2007), where patrons socialize, watch the live band, play pool—and drink Quilmes beer. There is a definite sexual energy in the animated scene, created by the body positioning and clothing worn by the female drinkers as well as by the dim lighting. By clicking on the big screen television, the user is linked to the latest sporting events promoted by the brand. A click on the stage featuring the live band takes the user to another animated page listing the various music concerts sponsored by the brewery. Not all of the links are obvious, such as the light over the pool table, which takes the user to a page that allows them to download music, watch the latest television commercial, and play video games (the options are football, rugby, or crowd surfing in a mosh pit). InBev's Antartica also features a bar on its animated website, with popular actress Juliana Paes accompanying the user throughout the bar and explaining the various links (www.antarctica.com.br, 2007). These sites emulate strategies observed in other countries such as New Zealand and exemplify the transnational character of the industry (see Casswell, 2004). While such sites are obviously high in youth appeal, the only controls on youth access is the home page that asks "Are you 18 years old?" and sometimes provides a place to enter a birth date, although there is no means for verifying the information. Such new media technologies circumvent all advertising and sponsorship regulations with the exception of Brazil, which requires Internet sites to display a warning message about alcohol consumption and follow the self-regulatory code.

Another common marketing strategy is the creation of new events as opportunities to drink (these events are heavily promoted on the brand websites). AmBev was an industry leader in this category even before merging with Interbrew and marketed its leading youth brand Skol—"a beverage favored by youthful people who know how to enjoy life.... perfect for the evenings, whether

in gatherings, concerts or parties" (www.inbev.com/brands/2__3__58__skol.
cfm, 2007)—through a series of events called "Skol Beats" that started in 2000
and have become the largest electronic music festival in Latin America with
national and international DJs. Skol Beats has its own website with a schedule
of events, downloads of the music played at the Skol beats festivals, videos and
lists of techno music stars, and interviews with celebrities (www.skolbeats.com.
br, 2007). In addition to Skol Beats, there are now additional concerts includ-
ing Skol Stage, Giro Skol, and Roda de Samba Skol. Building on the success
of the Skol Beats concert series, in 2003 Ambev launched a Skol Beats brand of
beer. According to the company website, the beer has "unique" characteristics and
innovative packaging (a curvy bottle), with "all the characteristics the consumer
desires when he/she is enjoying a party.... Skol Beats has such a good combi-
nation that it is like a party, when you notice, it is over!" (http://www.ambev.
com.br/eng/pro_21_en.htm, 2007). The party associations and simile suggest the
marketers are aware of the symbolic capital associated with partying and drinking
among youth (Järvinen & Gundelach, 2007). Skol also sponsors university events.
During Easter 2005, for example, Skol joined Namosca, a specialized university
marketing agency, to sponsor the University Games (IV Universíadas). This sport
event attracts more than 1,000 athletes and 6,000 attendees. Soccer tournaments
are another event used to draw youth together in an environment where the spon-
soring brand (and drinking) can be promoted. AmBev created the Brahma 2007
Soccer Cup, for instance, and Kaiser organized the 2007 Kaiser Cup where the
minimum age requirement for male soccer contestants was 16 years (as opposed
to 18) (http://www.simmm.com.br/copa2007/, 2007).

In combination, new technologies and events provide sponsors with opportu-
nities to reach youth in relevant media and contexts that provide access (virtually
and actually) to alcohol and associated symbolic capital. Research on youth life-
styles shows that drinking and partying have high appeal for youth (Jackson et al.,
2000). As Järvinen and Gundelach (2007) note: "alcohol experience goes together
with prestige...the more parties you have gone to and the bigger your partying
network...the stronger your position within the peer group.—[The most active
drinkers]...receive more SMS [text messaging]" (p. 64).

Valorizing Masculinity and Femininity. Latin American breweries cur-
rently sponsor a wide range of events to promote their brands and provide oppor-
tunities to drink, including traditional celebrations such as carnivals and rodeos
as well as sports, concerts, and beach parties. In each case, it is readily seen that
the representations of men and women in the event promotional materials (with
few exceptions) follow traditional hegemonic masculine and feminine lines
and are deeply invested in the cultural and symbolic capital of beauty and suc-
cess. Some of the events have straightforward links to youth culture—including

extreme sports, concerts, and parties. Amidst this ensemble of events, beauty pageants signify most graphically the process of valorization through which these cultural codes of masculinity and femininity are rendered concrete and invested with economic value (capital) through circulation in the marketplace. Three major breweries in the region sponsor beauty pageants and have traditionally used the pageants and the women to help build brand equity in a manner similar to the use of cheerleaders in sports—notably Bavaria (SABMiller) with Aguila in Colombia, Quilmes (SABMiller) with Cristal in Argentina, and AmBev (InBev) with Brahma in Brazil. In some respects, beauty pageants may seem trivial compared to the obvious impacts of sponsored beach parties and sports events on actual drinking behavior. Nevertheless, the lessons of promotional culture are not insular and the association of female beauty and accessibility to beer contributes to an ongoing sexualization of drinking that is already manifest in popular media. At the very least, the connections with beauty pageants remind young women and men that drinking, like beauty, has to do with social distinction, sexuality, and personal identity. The role of pageants in social distinction was nicely summarized by Tice (2006) in her review of Liz Conor's (2004) *The Spectacular Modern Woman*: "Beauty contests, according to Conor, reminded women that the modern scene was competitive and that inclusion depended on one's ability to measure up" (p. 153).

The recognition of women as an "untapped" market for beer has somewhat complicated this picture and appears to be leading to promotional appeals that are more transparently class-based (more "up-market") and urbane. The Colombian brewer Bavaria (now owned by SABMiller), which traditionally promoted Aguila with pageants and the Chicas Aguilas, purports to no longer support this strategy, and the new president has stated in the trade press that the company will use new images in its advertising (EI, Beer: Colombia, 2007). The parent company, SABMiller, has been leading the way in repositioning beer as a sophisticated, image-enhancing product—a beverage that may replace wine and is likely to appeal to females. It has chosen its Italian brand Peroni Nastro Azzuro to be its leading "aspirational" product in Colombia. This campaign is not limited to Latin America but is part of a larger, global marketing strategy that attempts to associate the brand with "effortless Italian style." The brand targets "key trendsetters, opinion leaders, [and] modern sophisticates" and has been launched at fashion shows and theater events in various metropolitan centers. A 2007 corporate report indicates the brand's global equity position and volume are growing rapidly (SABMiller, 2007, slide 11). In Colombia, Peroni Nastro Azzuro was the first international brand to be launched following the SABMiller and Bavaria merger and was backed by a strong marketing campaign that included a fashion show featuring Italian designers (Tabion, 2006). It was also promoted at 200 upscale

nightclubs in Colombia and in 2007, sales and appeal were reported to be well ahead of corporate expectations.

SABMiller also introduced a new, female-oriented beer in October 2007. The new brand Redd's is described as "not quite a beer" but rather "an apple infused malt beverage with a citrus flavour" (Pfanner, 2007). In a further effort to appeal to women, the Redd's bottles hold less volume than standard-sized bottles and are sold in packages of 5 or 10 (versus the heavier 6-, 12- or 24-packs). The 5- and 10- packs are also shaped like a woman's handbag in what one industry executive calls an attempt to market to women "as intelligent consumers, not as bimbos" (Pfanner, 2007). InBev launched its global premium brand Stella Artois in Brazil and Argentina in 2005 and similarly is endeavoring to position the brand as more sophisticated and up-market to attract a broader demographic (Tabion, 2006). According to the 2006 InBev annual report, sales of Stella Artois in Argentina have surpassed expectations.

The results of our analyses show that these strategies are not replacing the sexist representations of women in traditional beer ads so much as broadening the scope of appeals with a complementary set of messages for an upper-middle class, social demographic. A key point to make is that no matter which way the industry categorizes women, as "bimbos" or "sophisticates," marketing to them continues to embrace a narrow set of reified and valorized representations of women and men that promote beer as part of a gendered (and sexualized) culture of drinking. These depictions and the carefree social order they embrace appear fun, natural, and quite harmless, until one recalls the broader social realities of the gendered order of alcohol consumption they support and help to create. Bourdieu (2001) described the mass commercialization of women's bodies as a form of gendered *symbolic violence* in that it serves iconically to reproduce the social and political conditions in male-dominated societies that undermine women's authority and reinforce the feminine as a subaltern social position. These conditions, he felt, are internalized by women to the point that they become complicit in their own sub-jugation (Haines, 2008). There can be little doubt that the promotional frame-work of beer sponsorships and sports in the three countries we studied aids in the reproduction of the gender order, and that the ads' implicit promises of social mobility and success from having good looks and drinking beer are not only empty but actually also serve to reproduce a quiet tyranny of masculine hegemony under the guise of liberalizing women's roles and identities. The rise in young women's drinking in Latin America, to the point that it matches or surpasses that of young men, is not good news and speaks to the critical importance of coming to terms with the supply-side of consumer culture with regard to the beer industry.

This, in turn, raises the question of what can be done to help address these issues. One clear step is to take better account of how beer promotional culture

(in the expanded sense of the totality of beer messaging in popular media and events) becomes interpreted and incorporated into popular culture, particularly among youth. As McCreanor et al. (2005) have warned, "public health policy and practice must respond to the interweaving of marketing and the self-making practices of young people to counter this complex threat to the health and well-being of young people" (p. 251). Health promotional strategies must come to terms with these translational and adaptive practices and the role of drinking and partying in youth culture. A second step is to undertake transnational agreements and strategies to cope with the transnational character of the industry. This is necessary not only to address the "spillover" effect but also to cope with the current globalization of youth culture and beer marketing. These steps are in keeping with recommendations contained in the Brasilia Declaration (PAHO, 2005), mainly that:

Preventing and reducing alcohol consumption–related harms be considered a public health priority for action in all countries of the Americas.

Regional and national strategies be developed, incorporating culturally-appropriate evidence-based approaches to reduce alcohol consumption–related harm.

Presently there is little coordination of alcohol policy in Latin America, however, this does not mean that such a development will not be forthcoming in the future.

NOTES

1. This research has been supported by FAPESP 03/06250–7 and 04/13564–0.
2. We would like to thank Orlando E. Castaneda Rojas, Daniela Pantani, and Raquel Zanelatto Alves for their assistance in the collection of data for this project.
3. AmBev formed a partnership with Quilmes Industrial (Quinsa) in May 2002 and at the writing of this chapter owns over 90% of Quilmes and recently announced its intent to purchase all outstanding shares (InBev announces AmBev intent to make a voluntary offer, December 24, 2007).

REFERENCES

Ambev releases marketing campaign (Guaraná Antarctica veste a camisa do Brasil para a Copa do Mundo), Gazeta Mercantil, January 17, 2002. Retrieved from RDS Business & Industry ® Gale Group, April 11, 2005.

Bourdieu, P. (1978). Sport and social class. *Social Science Information*, *17*, 819–840.

Bourdieu, P. (1988). Program for a sociology of sport. *Sociology of Sport*, *5*, 153–161.

Bourdieu, P. (2001). *Masculine domination*. Oxford: Polity Press.

Casswell, S. (2004). Alcohol brands in young peoples' everyday lives: New developments in marketing. *Alcohol & Alcoholism*, 39, 471–476.

Casswell, S., & Maxwell, A. (2005). Regulation of alcohol marketing: A global view. *Journal of Public Health Policy*, 26, 343–358.

Castaneda-Rojas, O. E. (2006). Technical report on the beer industry in Argentina (June–October).

Chauvin, L. (August 2005). South America: The beer battleground. *Beverage World*, 124, 8–11.

The Colombian Football Federation (June 26, 2007). Sportsmedia. Retrieved July 16, 2007 from http://www.pa-sport.com/en/newsletters/sports-media.html

Connolly, G., Casswell, S., Zhang, J., & Silva, P. (1994). Alcohol in the mass media and drinking by adolescents: A longitudinal study. *Addiction*, 89, 1255–1263.

Conor, L. (2004). *The spectacular modern woman: Feminine visibility in the 1920s*. Bloomington: Indiana University Press.

Credeur, M., & Bhatia, M. (October 11, 2007). Deal may drag Bud to alter. *The Toronto Star, Business*, B6.

Ellickson, P., Collins, R., Hambarsoomians, K., & McCaffrey, D. (2005). Does alcohol advertising promote adolescent drinking? Results from a longitudinal assessment. *Addiction, 100*, 235–246.

Euromonitor International (EI). Global market information database for the University of British Colombia: http://www.gmid.euromonitor.com/ReportSearch.aspx.

Alcoholic drinks: Argentina (April 4, 2006). Retrieved May 6, 2007.

Alcoholic drinks: Brazil (April 7, 2006). Retrieved May 6, 2007.

Alcoholic drinks: Colombia (May 8, 2006). Retrieved May 6, 2007.

Beer: Argentina (June, 2007). Retrieved November 16, 2007.

Beer: Brazil (April 7, 2006). Retrieved May 6, 2007.

Beer: Brazil (August, 2007). Retrieved November 16, 2007.

Beer: Colombia (May 8, 2006). Retrieved May 6, 2007.

Beer: Colombia (June, 2007). Retrieved November 16, 2007.

Beer: World (December 19, 2006). Retrieved May 6, 2007.

Beer: World (November 6, 2007). Retrieved November 16, 2007.

Consumer lifestyles: Argentina (October 25, 2006). Retrieved May 6, 2007.

Consumer lifestyles: Colombia (May 13, 2005). Retrieved May 6, 2007.

Haddock, F. (1999). The globalization of beer. *Global Finance, 13* (7/8), 53–57.

Haines, R. (2008). Smoke in my eyes: A Bourdieusian account of young women's tobacco use, Dissertation, University of Toronto.

Harvey, J., & Sparks, R. (1991). The politics of the body in the context of modernity. *Quest, 43*, 164–189.

http://baixeredondo.skol.com.br/main.asp. Retrieved November 9, 2007.

http://www.conar.org.br/. Retrieved January 12, 2008.

InBev Annual Report 2006: Delivering commitments, Resolved to be the best. Retrieved from www.inbev.com/annualreport2006/pdf/UK_Full_AnnualReport_2006.pdf, July 25, 2007.

InBev announces AmBev intent to make a voluntary offer to purchase any and all outstanding shares of Quilmes Industrial S.A. (December 24, 2007). Retrieved January 25, 2008 from http://www.inbev.com/go/media/global_press_releases/press_release.cfm?theID=289&theLang=EN.

InBev becomes biggest brewer after sales surge (March 2, 2007). *The Toronto Star*, p. F02.

Instituto Brasileiro de Geografia e Estatística (IBGE, 2007). Retrieved January 24, 2008 from http://www.ibge.gov.br/home/.

Instituto Nacional de Estadisticas y Censos (INDEC, 2007). Population per province—Argentina. Retrieved December 30, 2007 from http://www.indec.gov.ar/.

Jackson, M., Hastings, G., Wheeler, C., Eadie, D., & MacKintosh, A. (2000). Marketing alcohol to young people: Implications for industry regulation and research policy. *Addiction, 95* (Supplement 4), S597–S608.

Järvinen, M., & Gundelach, P. (2007). Teenage drinking, symbolic capital and distinction. *Journal of Youth Studies, 10*, February, 55–71.

Jernigan, D. (2001). *Global status report: Alcohol and young people.* Geneva: World Health Organization.

Kerr-Correa, F., Hegedus, A., Trinca, L., Tucci, A., Kerr-Pontes, L., Sanches, A., & Floripes, T. (2005). Differences in drinking patterns between men and women in Brazil. In I. Obot & R. Room (Eds.), *Alcohol, gender and drinking problems: Perspectives from low and middle income countries* (pp. 49–68). Geneva: World Health Organization.

Mawson, N. (October 13, 2007). Latin America pays off for SABMiller. *Business Day, Economy, Business and Finance*, p. 10.

McCreanor, T., Greenaway, A., Moewaka Barnes, H., Borell, S., & Gregory, A. (2005). Youth identity formation and contemporary alcohol marketing. *Critical Public Health, 15*, 251–262.

McKenna, B. (October 10, 2007). Now, more than ever, it's SABMiller time. *The Globe and Mail, Report on Business*, B 16.

Monteiro, M. (2007). *Alcohol and public health in the Americas: A case for action.* Washington, DC: Pan American Health Organization Report.

Munné, M. (2005). Social consequences of alcohol consumption in Argentina. In I. Obot & R. Room (Eds.), *Alcohol, gender and drinking problems: Perspectives from low and middle income countries* (pp. 25–47). Geneva: World Health Organization.

National Department of Statistics (NDS, 2007). *Municipal population projection per area. Colombia 2005–2008.* Retrieved January 24, 2008 from http://www.dane.gov.co/files/investigaciones/poblacion/proyepobla06_20/ProyeccionMunicipios2005_2008.xls

Pan American Health Organization (PAHO) (2005). *The Brasilia Declaration: Alcohol public policies.* Approved at the first Pan American Conference on Alcohol Public Policies, Brasilia, Brazil, November 28–30.

Pas, R. (2005). The top 100 beverage companies. *Beverage Industry*, June, 96, 38–50.

Pfanner, E. (October 15, 2007). Five-packs for Latinas. *The International Herald Tribune, Finance section*, p. 12. Accessed through LexisNexis database on October 16, 2007.

Pinsky, I., & Laranjeira, R. (2003). Alcohol consumption in Brazil: Recent public health aspects. *The Globe*, Issue 3. Retrieved April 25, 2007 from the Global Alcohol Policy Alliance website: http://www.ias.org.uk/resources/publications/theglobe/globe200303/gl200303_p17.html.

SABMiller corporate presentation. Presented at the Consumer Analyst Group of New York Conference. Scottsdale, Arizona, February 2007. Retrieved December 26, 2007 from http://www.sabmiller.com/corporatepresentation/cagny%20slide%20presentation%202007.pdf

Smith, S. (January 2005). Global ambitions aren't small beer. *Marketing Week, 28*, 5.

Snyder, L., Milici, F., Slater, M., Sun, H., & Strizhakova, Y. (2006). Effects of alcohol advertising exposure of drinking among youth. *Archives of Pediatrics & Adolescent Medicine, 160*, 18–24.

Sparks, R., Dewhirst, T., Jette, S., & Schweinbenz, A. (2005). Historical hangovers or burning possibilities: Regulation, adaptation, and brand equity in tobacco and alcohol sponsorship. In J. Amis & T. B. Cornwell (Eds.), *Global sport sponsorship*. Oxford, UK: Berg.

Speeches by InBev's Brock and SAB's Mackay at World Beer & Drinks Forum (November 21, 2005). *Modern Brewery Age, 56* (47), 4.

Standard & Poor's (November 2006). Industry surveys: Alcoholic beverages and tobacco. *Standard & Poor's, 174*, 1–44.

Tabion, M. (November 20, 2006). Latin beverage courts younger clients. *Latin Business Chronicle.* Retrieved April 27, 2007 from Latin Business Chronicle website: http://latinbusinesschronicle. com/app/article.aspx?id=545.

Tice, K. (2006). For appearance's sake: Beauty, bodies, spectacle and consumption. *Journal of Women's History, 18,* 147–156.

Tomlinson, R. (October 2004). The new king of beers. *Fortune, 150,* 63–67.

United Nations. (2007). *Statistical yearbook for Latin America and the Caribbean, 2006,* Economic Commission for Latin American and the Caribbean.

Wilsnack, R., Wilsnack, S., & Obot, I. (2005). Why study gender, alcohol and culture? In I. Obot & R. Room (Eds.), *Alcohol, gender and drinking problems: Perspectives from low and middle income countries* (pp. 1–23). Geneva: World Health Organization.

World Health Organization (WHO) (2002). *The world health report 2002: Reducing risks, promoting healthy life.* Geneva, Switzerland: WHO.

www.ambev.com.br/english/imprensa/press_releases/ano2001/0021. Retrieved November 25, 2005

www.ambev.com.br/eng/pro_21_en.htm. Retrieved November 8, 2007.

www.antarctica.com.br. Retrieved November 9, 2007.

www.bavaria.com.co/pdfs/ing/aguila_120607_en.pdf. Retrieved July 18, 2007.

www.brahma.com.br/sitebrahma/bolacha/score, Retrieved November 9, 2007.

www.cervezaaguila.com.co/Secciones/chicasAguila.aspx. Retrieved November 9, 2007.

www.clarin.com/diario/2006/04/14/elpais/p-01601.htm. Retrieved December 25, 2007.

www.inbev.com/brands/2__3__58__skol.cfm. Retrieved April 27, 2007.

www.kaiser.com.br/. Retrieved November 9, 2007.

www.quilmes.com.ar/. Retrieved November 8, 2007.

www.simmm.com.br/copa2007/. Retrieved November 9, 2007.

www.skolbeats.com.br/. Retrieved April 27, 2007.

www.skol.com.br/. Retrieved November 9, 2007.

(Michael) Power, Gendered Subjectivities, AND Filmic Representation: Brand Strategy AND Guinness' *Critical Assignment* IN Africa[1]

JOHN AMIS, RONALD L. MOWER

MICHAEL L. SILK

In recent years, discussion of multinational corporations (MNCs) as key functionaries in the promulgation of "corporocentric globalizing forces" (Amis & Silk, 2007) has brought to light the need to uncover the influences on, and actions of, individual managers of global corporations (Athanassiou & Nigh, 2000; Leung et al., 2005; Parker, 1999). Increasingly, the importance of global actors' negotiation with and embracement of local cultural sensibilities has necessitated new management processes, which simultaneously, and ironically, require a type of global convergence while creating unique and locally resonant marketing campaigns within targeted geographic territories (see Hitt et al., 2006; Holt et al., 2004; Leung et al., 2005; Quelch, 2003). However, little empirical evidence exists that highlights the manner in which competing global and local cultural pressures intersect (Leung et al., 2005). As such, the investigation of global/local strategizing, processes of cultural ingratiation and commodification, and the tangible embodiments of management's strategic commercial creations within a MNC are required.

As a truly global brand with a proven history of managerial excellence, market responsiveness, and product innovation, Guinness has evolved concomitantly with changes reflective of a global age, marked by increased interconnectivity, interpenetration, and a heightened global infrastructure. Some of our recent research has provided an examination of global management strategies as executives at Guinness seek to regain the global prominence of a once dominant global brand (see Amis, 2003, 2005; Amis & Silk, 2007). This has highlighted the management processes leading toward an increased global convergence while simultaneously engaging with local cultural sensibilities to ingratiate the Guinness brand within unique particularities of target markets. Specifically, Amis and Silk (2007, p. 1) exhumed the processes and mechanisms of top Guinness managers in "negotiating the complexities of a transnational marketplace through the creation and active management of polysemic, multi-vocal [advertising] texts" within their three largest markets: Ireland, Great Britain, and Africa. One strategy deployed to negotiate the local saw the Saatchi and Saatchi advertising agency create a fictional character named Michael Power to embody the values of the Guinness brand while simultaneously functioning as a representative subjectivity *of* African culture *for* the African marketplace.

Essentially, Michael Power was crafted as the physical personification of the key brand values of the company—namely, power, goodness, and communion. Created for the African market, Power offers a living, a *real,* albeit faux, manifestation of Guinness characterized by the ostensible flair and confidence of a "black James Bond who performs a series of death-defying acts in defense of all that's good and honorable" (Koenderman, 2002). Following the success of several "mini adventures" broadcast via local radio and television, Guinness bankrolled a full-length feature film, *Critical Assignment,* to further ingrain the Michael Power character within their defined marketplace. Specifically, Power's identity was carefully contoured to both personify select attributes of the Guinness brand and to shape audience interpretations through an overt bodily display of popular cultural understandings about African masculinity and self-identity.

Stemming from an interest in Guinness' (g)local corporate infusion of fictional characters and brand values, our particular purpose in this chapter lies in the exhibition of gendered subjectivities in Michael Power's filmic exploits. *Our* critical assignment then speaks not only to Guinness' infiltration of a local market by rapaciously seeking unique cultural particularities to which the brand identity can be associated through appropriation and (re)presentation (see, for example, Amis, 2005; Amis & Silk, 2007; Dirlik, 1996; Silk & Andrews, 2001), but also to the—often highly selective, superficial, if not utopian and inspirational—representation of culture, gender, ethnicity, and, class within

the commercial production process. It is against this backdrop that we consider the ways in which the film acts to deliver particular messages within a specific context. In so doing, we assess the manifestations of selected gendered sexual representations and body politics as they relate to the strategic positioning of the brand within the African market. In this sense, we offer a critical reading of *Critical Assignment* in an effort to delineate the *fictionalized* presentation of gendered subjectivities and embodied Guinness values.

Influenced by a critical feminist perspective that has been utilized with an understanding of the complex articulations between sport, media, and gender politics (see for example, Hall, 1996; Messner, 2002; Messner et al., 2000), we deconstruct the representation of characters as critical pedagogical tools embodying the salient messages of the Guinness brand appurtenant to traditional notions of masculine ideology.[2] Through this analysis we deconstruct inflected notions of an ideal hegemonic masculinity and depict the processes of Guinness' advertising within a framework of discursive gender narratives that function to articulate the intertextual (Kristeva, 1984) and indeed dialectical nature of mediated gendered subjectivities on corporate brand identity, African cultural understandings, and global/local brand positioning. Not surprisingly then, our analysis considers the corporately created actor Michael Power as the embodiment of a particular African masculinity, the role of alcohol and sport in masculine identity (re)construction, and the commercial exploitation of gendered stereotypes.

BREWING GENDER TROUBLE: SPORT, GUINNESS, AND CREATING MASCULINE POWER

With a history stretching back to 1755, the firm founded by Arthur Guinness has always had an intriguing global narrative. Indeed, centered on brewing a black porter beer, Guinness had by 1886 become the largest brewery in the world with an annual production of 1.2 million barrels and important markets in the West Indies, United States, Portugal, and Sierra Leone. Throughout the twentieth century, Guinness' position as a truly global brand was reified, such that by the turn of the twenty-first century, Guinness was brewed in 50 different countries, often under license or through joint ventures, and sold in over 150 countries. Despite this broad presence, the maturing of the industry in many of Guinness' major markets had led to stagnating sales along with heavily increased competition from other beer manufacturers. Consequently, Guinness management found a context in which, rather than being the largest beer manufacturer in the world, the brand had slipped in most markets to little more than niche status. It was perhaps not

surprising, therefore, when, in 1997, Guinness merged with the food and drink conglomerate Grand Metropolitan. The outcome of this was the creation of the firm Diageo, listed on the London Stock Exchange, with Guinness becoming one of an array of premium drink brands—including Smirnoff, Johnnie Walker, Bailey's, and Captain Morgan—owned by the firm. In 2000, Guinness appointed a Global Brand Director (GBD) who immediately set about developing a marketing strategy that would re-elevate the Guinness brand to global prominence. Central to this was the establishment of a global brand position that Guinness could occupy that would draw on the brand's long-established values and work to differentiate it from its major global competitors.

The "brand essence" of Guinness—*power*, goodness, and communion—has long underpinned the positioning of the beer in markets around the world. However, recognizing the need to negotiate the essence of the brand within relevant global markets, the GBD created what was termed a "Key Brand Benefit" (KBB): "Guinness brings out your inner strength." Crafted to fit with the brand essence and the self-described brand identity of Guinness as "masculine, strong, genuine, and independent," the KBB becomes coterminous with masculinity. Crucially, however, the KBB speaks to a particular form of masculinity, that which is synonymous with "inner strength." As stated in the internal publication "The Brand Map" (2001):

> The Guinness brand positioning...shows that Inner Strength is a highly relevant and motivating concept to men throughout the world who need to feel strong, assertive and independent. This need, described as "potency" or "independence," is the consumer need that Guinness currently meets across the world. This means that it is already a credible positioning from a consumer point of view on which we can build even further. Our global insight also highlights that in a world of increasing speed, disconnection and uncertainty there is a greater need for self-reliance. Inner Strength is a powerful and motivating position because it is seen as the foundation stone of self-reliance.

For Guinness, to deliver the message of "inner strength" required a centralization of the overall global advertising strategy. This involved paring down the number of advertising agencies used from seven to two: BBDO was given the brief to develop campaigns in the draught markets, most notably Great Britain, Ireland, North America, Australia, Japan, and Continental Europe while Saatchi and Saatchi was asked to develop the Extra Stout and Foreign Extra Stout markets, particularly Africa, Asia, and the Caribbean. Working with these agencies, the Global Brand Executive, supported by a Global Brand Team, created campaigns to translate the KBB into local markets. Sport has played a very prominent role in this process, given the perception among Guinness' decision makers that it

is a useful vehicle through which to affirm images of inner strength, often in the form of an individual athlete drawing upon his—the athletes are always male—self-belief to achieve a desired outcome (see Amis, 2003, 2005). Of course, in so doing, Guinness' advertisers have utilized the historically entrenched association between men, masculinity, and sport (e.g., Messner, 2002; Sabo & Jansen, 1998).

Reflecting the patriarchal dominance in society throughout the nineteenth and most of the twentieth centuries, heavily influenced by the inherent notion of men as "public" beings and women as "private" inferiors (Ferree, 1990; Rao, 1985), the Guinness brand is far from absent in the discursive articulation between alcohol and ideals about hegemonic masculinity. Such popular rhetoric is certainly bound up within the act of frequenting the public drinking house—the "great good place" or the vanishing convivial "third place"—as a distinctively male preserve akin to the sporting grounds, which functioned as spaces for masculine identity (re)construction and social bonding to the exclusion of women (Wenner, 1998, p. 301; see also Collins & Vamplew, 2002). Indeed, the masculine pedagogy of sport is inextricably linked to the supposed "masculinizing" effects of alcohol consumption and associated social behaviors—sport serving to "explicitly naturalize 'man's place' in the physical" (Messner, 2002; Wenner, 1998, p. 308). Further, and following Judith Butler's (1990) Foucauldian interpretation in *Gender Trouble*, it is the regulatory discourses of our present late capitalist conjuncture—advertising, marketing, mediation—that provide the subjective possibilities of gender and sexuality. In this sense, the seeming "natural" embededdness of sport, gender, and alcoholic consumption provides a disciplinary regime for the repetitious stylized acts of gendered performance that so constitute the core of the cultural construction of gendered norms. That is, the male rituals of sport participation and/or spectatorship as well as public drinking that have evolved concurrently with the escalating influence wielded by cultural intermediaries—whose cleverly constructed marketing campaigns occupy a ubiquitous presence in the domain of twenty-first-century sport (Jackson & Andrews, 2005; Jhally, 1998; Silk & Andrews, 2005)—serve to further constitute a "masculine republic" (Collins & Vamplew, 2002; Ripley & Wood, 1994), which further constitutes, if not brews, such "trouble."

The seemingly inexpungible articulations between the logics of sporting institutions, alcohol brand strategizing, and the politics of masculine physicality and power appear particularly important for Guinness' African brand team. In concert with the aforementioned global strategy to exploit moments of "self-belief," Guinness has sponsored, among other sports, golf, tennis, and rugby. Perhaps most notable has been the continual attempt to leverage an association with football (soccer), by far the most popular sport on the African continent, in

an effort to ingratiate the "inner strength" message within the particularities of the African market. The import of this was explained by the brand director for Africa in an interview with one of the authors:

> The need for self-belief, the need for inner strength is particularly relevant in Africa. The reason for this is that Africans see themselves as coming from a disadvantage. In every way of life, Africa is behind the world. Again Africans believe, because we are Africans we can overcome all of those obstacles and we can achieve things almost of world standard. It comes through in football and we've leveraged it, so one good example will be where we begin to say…if you believe in yourself and your ability you can overcome your obstacles and your disadvantages and perform at a first world class. We have leveraged that during the [2002 football] World Cup with the football ad, where we have shown Africans training on sub-standard pitches, without sports equipment and saying "Well, because we are what we are, because we believe in ourselves, we can overcome" and then we lead on from that showing national teams, African national teams, that have played in the World Cup and have performed well. So again, it is tying that need of Africans to believe that in spite of our disadvantages we can still be reckoned with at the global stage, and tying that to the brand benefit of inner strength, that it reflects your inner strength.

Enter Michael Power who, following several promotional appearances, was included in a number of Guinness' football advertising spots in order to further infuse the brand message with the peculiarities of the market, a process that inevitably involved negotiating with the cultural politics of the continent. Building on the "inner strength" mantra, advertising agency Saatchi and Saatchi developed the Michael Power character to personify what came to be known as "the Simple, Universal, Relevant Truth that would persuade a continent to adore Guinness" (Gibbons, 2004). Marketing director Eric Frank adds, "we expressed it this way: Inside me there's a powerful heroic assured person. I want to live my life as that person. When I drink Guinness I become more fully who I am" (Gibbons, 2004, p. 2).

Given the supposed crisis of masculinity (see, for example, Giroux, 2001; Messner, 1994), the feminization of the workplace, and a growing uncertainty about self-identity increasingly remedied through the realization and expression of brand associations and consumption choices (Elliott & Wattanasuwan, 1998), corporations such as Guinness have shifted toward processes of lifestyle marketing (Sparks et al., 2005). Realizing the opportunity to position their products in a manner that culturally translates particular brand attributes and eases the difficulty of making critical purchasing decisions that represent consumers' lifestyle preferences (Featherstone, 1991; Olins, 2000), Guinness' executives have embraced a logic that reaches its target market (legal, male drinkers up to the age of 35) by positioning its brand in such a way as to suggest a transfer of masculine qualities

onto the purchaser of the product (Craig, 1993). Further, given the inescapable oversaturation of commercial media messages in every nook and cranny of social life (see Klein, 1999), corporations are continually looking for new ways to stand out amongst the barrage of competitors. Herein lies the power of Power for he provides an extensively branded commercial synergy through film, advertisements, and special appearances as a living, breathing Guinness incarnate—one who also represents African culture and tradition through a clever dissemble of genuine authenticity. This strategy has contributed to a marked increase in consumption of Guinness products in Africa despite the lower level of disposable income compared to more affluent markets (Amis, 2003, 2005). The discursive constitution of Power and masculinity is perhaps most fully realized in the full-length feature film *Critical Assignment*. It is to an analysis of this film that we devote the remainder of the chapter, following a brief consideration of the concept of masculinity within an African context.

THE (DISCURSIVE) CONSTITUTION OF AFRICAN MASCULINITIES

Although our reading of the radical history of present (Grossberg, 2006) African masculinities is somewhat "partial" and, necessarily, partisan (see Frow & Morris, 2000), there are some striking similarities between African scholarship and the study of asymmetrical gender studies in the United States. Specifically, as with its U.S. counterpart, the emergence of gender research in Africa over the past 20 years has largely focused on the female, with males being positioned as the given, static backdrops for the study of women's experiences (Lindsay & Miescher, 2003). Reflective of this normative male dynamic in academic inquiry, the roles, authority, experiences, and power of African males retain vestiges of a patriarchal past. However, and unlike the colonial representation of a dangerous, savage, sexual, and threatening black physicality (Hobson, 2003), the notion of "men/husbands as owners, controllers, deciders, and providers" (Cornwall, 2003, p. 234) is also ironically juxtaposed with a postcolonial existence of multiplicitous and seemingly amorphous sexual and gendered identities that have been altered, contested, and adopted based upon the experiences of peoples in varying tribes or geographic locations (Lindsay & Miescher, 2003).

For instance, among the Igbo people, who are mainly located in western Africa, most notably Nigeria and, to a lesser extent, Cameroon—Guinness' two most important African markets—a "dual sex/flexible gender" system provided the opportunity for men and women to coexist as equals in all facets of social, economic, and political workings (Amadiume, 1987). Further, understanding

that gender is a dynamic social construct, in some cases women could attain the status of men through evidence of "female masculinity," change their gendered roles in particular social contexts, and become "honorary men," chiefs, or tribal leaders (Achebe, 2003; Epprecht, 1995). However, despite the existence of female authority in some regions and time periods of Africa's history, the majority of pre- and postcolonial African societies still privilege male hegemony and have contributed heavily to modern notions of masculinity. For example, leaders of the pastoral Maasai societies, most prevalent in Tanzania, have worked to reinforce and expand "the political and economic power of Maasai men over women as 'individuals', 'owners', 'citizens', 'taxpayers', 'workers', and 'household heads'" (Hodgson, 2003, p. 212). Further, traditional notions of Maasai masculinity have been influenced by contemporary processes of economic decline, globalization, and political crises (Hodgson, 2003). The notion of "ormeek" masculinity—a derogatory label coined in early colonial times to represent a weaker and somewhat effete form of masculinity—has come into prominence over the past few decades due to its progressive association with the Westernized world through education, religion, political structures, and new economic models that oppose the pastoral dominance of traditional hegemonic masculinity (Hodgson, 2003).

In essence, these shifts in masculine identity have largely emerged as a result of a clash between old world customs and new world realities. As new opportunities for education and occupational training are made available, traditional male roles in the agrarian-based economy are being replaced by male working professionals, creating new expectations, conflicts, and challenges for the construction of masculine identities and successful conjugal relationships (Cornwall, 2003). Further complicating the lived experiences of men in Africa, gendered discursive pressures from the onslaught of global media, economic change, and shifting roles for men and women in the home and society leave the navigation of masculine identity construction fraught with contradictions. However, despite these shifts, what remains somewhat constant is that masculinity and power—whether viewed by men or women—are resolutely associated with, and tentatively based upon, the ability of men to provide for themselves, their wives, and their children (Cornwall, 2003). What appears clear in African scholarship is that profuse variations of masculine and feminine identities are dynamically expressed and interchangeably altered based upon time, colonial influence, and geography (Lindsay & Miescher, 2003; Morrell, 1998).

Of course, our focal point is the discursive constitution of gender politics within the film *Critical Assignment*. As sources of critical pedagogy, films, deeply imbricated within material and symbolic relations of power, produce and incorporate ideologies, offer up subject positions, mobilize desires, influence us

unconsciously, and help construct the landscape of culture that represents the outcome of struggles marked by the historical realities of power and the deep anxieties of the time (Giroux, 2002). It is in this sense that movies are extremely *popular,* both in terms of broad-based appeal and with respect to how they function as a continuing tension (relationship, influence, and antagonism) to the dominant culture (Hall, 1981). Thus, filmic representations of popular culture (Hall, 1981) provide important spaces through which to interrogate how such texts operate within the material and institutional contexts that structure everyday life. This approach requires locating these texts as elements of the cultural terrain within a wider cultural politics. It understands film as a site through which various discourses are mobilized with regard to the organization and discipline of daily life in the service of particular agendas (Giroux, 2002). Further, contextualizing filmic discourse in relation to political economy and transnational capitalism will give us a better understanding of how such forces produce dominant social reading formations that often limit the range of meanings that can be taken up by readers in addressing films and other media texts (Giroux, 2002). This raises a number of pertinent and critical questions for our reading of *Critical Assignment.* Given the film was inspired by a corporate (non-African) advertising agency (Saatchi and Saatchi) with responsibility for boosting Guinness' African sales, will the film promulgate a "locally resonant yet superficially inspired" (Silk & Andrews, 2001) Guinness-infused rhetoric of African culture to increase consumption and, inevitably, shareholder wealth? Further, given that the main character—a living embodiment of the Guinness "brand DNA"—is himself an invention of the same advertising agency, what underlying, fermenting, gender identities will be inscribed?

CRITIQUING *CRITICAL ASSIGNMENT*

As is often the case in movies featuring Michael Power's English counterpart James Bond, the opening scenes of the film provide an opportunity for Power to exemplify stereotypically desirable male characteristics. Centered on an epic battle staged in Eastern Europe, African News Bureau reporter Michael Power must acquire the breaking news story at all costs. Inevitably, Power is the hero. Noticing that a bomb has been planted in an abandoned warehouse where a reporting crew has entered to seek refuge from the firefight, Power literally leaps into action, leaving behind his female photographer, Anita, and exiting the safety of his viewing position by jumping out of a war-ravaged building. As a terrified Anita looks on, with bullets and bombs raining down all around him, Power runs stealthily to get an injured reporter out of the warehouse just

seconds before its dramatic explosion. Such bravery in the face of danger is just the beginning of a series of events that portray Power as the embodiment of particular hegemonic masculine qualities: strong, muscular, athletic, confident, and fearless—clearly, a far from subtle embodiment of Guinness' KBB and brand values. As the film unfurls, we see other "desirable" Guinness "qualities" infused in Power: educated, friendly, popular, witty, modern, sophisticated, internationally renowned, wise, loyal, patriotic, hard working, and with immense integrity.

After receiving a "Special Journalist of Merit Award" at the "64th Annual International Journalist Awards" banquet in Chicago, Power returns to his home-land of Africa to acquire a story about a "Water for All" project that the president of his country has implemented to provide clean running water nationwide. Due to the cost of the project, the president cuts the defense budget, providing motive for the secretary of state, Charles Ojuka, to become involved in a conspiracy with international arms dealer Thomas Rhines to protect their lucrative deal making. The course of the film is played out with Power uncovering clues that lead him to solve the mystery and make the connection between the water project and the conspiracy. In so doing, in true James Bond style, he saves the "girl," captures the "bad guys," and earns the gratitude of his president. Of course, during his trip, Power and his associates manage to enjoy the seemingly omnipresent Guinness, usually in the bottled Foreign Extra Stout variant that is most popular in Africa: at the Awards banquet, at the bar with friends, with family at home, and at a "traditional" village party. Further, when we are not watching the main characters drinking the product, we would do well to miss the far from subtle advertising boards, delivery trucks, t-shirts, and, other assorted commercial accoutrements promoting the product.

Critical Assignment's narrative is centered on "clean water and dirty politics" and draws together several elements of commercial, cultural, and social promo-tion to create a film that, although functioning as a glorified beer advertisement, satisfies the indigenous public's yearning to see local places, people, and a laudable representative of *their* culture on the big screen (Foster, 2003). Indeed, British producer Bob Mahoney stated that a conscious effort was made to "get out there and show Africa" (Foster, 2003). Thus, the film is shot in Africa and offers an official endorsement by the United Nations Environmental Programme along with a poignant reminder that 1.1 billion people worldwide lack access to safe water—"a basic human right"—to further legitimize the production. However, the film is, of course, a commercially inspired, highly sanitized, inflection of Africa. We are treated throughout to a colorful panorama centered on sweep-ing vistas and safari landscapes, bustling marketplaces, stunning architecture, sophisticated cityscapes, high-rent apartments, and indigenous cultural artifacts,

dancing, and music. No doubt the various African tourist boards (the film was actually filmed in six different countries including Ghana, Kenya, Nigeria, and Cameroon, all, of course, key markets for Guinness) would have been pleased with a representation that steered clear of the Africa that often frequents our news broadcasts with its ethic violence, poverty, starvation, high crime rates, and shanty towns.

The film overtly avoids naming any particular African country, instead offering a Pan-African representation. Indeed, at the International Journalist Awards banquet, Power is introduced as "Africa's own Michael Power." This is an approach that can be read as a corporately inspired creative cartographic revisionism that avoids the particularities of specific African markets, offering instead a homogenous cultural, political, and economic climate. This is a strategy that mirrors other pan-African marketing activities in which attempts have been made to affiliate Guinness with local initiatives, but not in a way that might alienate other, possibly competing, national groups (see Amis, 2005; Amis & Silk, 2007). Further, the blended logics of Guinness' strategizing and gendered subjectivities are made abundantly apparent in the characterization and depiction of *particular* forms of African masculinity within *Critical Assignment*. These "logics" deny the possibilities of the masculinities alluded to above in Africa, offering instead a gendered system of meaning based on activities, positions of authority, and roles that are best suited for males; a system that by its very nature excludes females or assigns them to traditional stereotypical positions, such as student, girlfriend, wife, matriarch, and photographer. In this sense, the creators (predominantly white males) of films and commercials reinforce what is perceived to be *the* commercially viable patriarchal logic that becomes overtly manifest in the positions, roles, and depictions carried out by male and female actors (Messner et al., 2000).

GENDERED DIVISION OF LABOR AND
FEMALE INVISIBILITY/INFERIORITY

Attesting to the inexorable representation of power and influence in *Critical Assignment*, males—in addition, of course, to Power's lead—occupy the defining roles in the film: Secretary of State Ojuka, arms dealer Rhines, a U.S. military general, the U.S. vice consul, the president of Power's country, an African military general, the chief of Power's village in Africa, the chief of police, U.S. television reporter Ed Johnson, and Power's best friend, Jomo. Meanwhile, only four female characters are significantly acknowledged in the film and only in relation to Power; his editor and mentor (Madam Baka), his aunt (Aunt Comfort), his

photographer (Anita), and his girlfriend (Sabina, the adopted daughter of Ojuka). A fifth female, apparently the minister for health, is given only a passing reference and plays, both in position and deferential manner, heavily into perceived female stereotypes. The final female character is Laura, Ed Johnson's wife. On the verge of a divorce that Johnson is opposed to, Power not only counsels his friend on how to save his marriage but also directly intervenes by secretly bringing Laura to Africa to meet up with her husband at the very end of the film. Laura is thus the traditional prize for a man who has been integral to helping solve the mystery; this reinforces the subservient acquiescence that frequently accompanies such depictions. Interestingly, and somewhat against the "traditional" masculine values that the film works so hard to portray, Power's unsolicited advice and care for Johnson is made possible through the appearance of two bottles of Guinness—the magic porter again providing a safe space for what otherwise could be read as a somewhat feminized "goodness" and "communion."

The female roles in *Critical Assignment* situate women as caring supportive, submissive, and passive accessories in relation to the central narrative. This is far from surprising given that beer commercials generally tend to position women as silently excluded characterizations, background props for male entertainment, sexy rewards for male achievement or proper consumption choices, or as the nagging housewife or girlfriend (Messner, 2002; Messner et al., 2000; Messner et al., 1999). Such popular discursive manifestations also reinforce traditional gender biases by foregrounding men as dominant voices of authority, amidst the submissive characterization of female wives or girlfriends (Messner, 2002). However, the representation of female characters in *Critical Assignment* seems far removed from American beer companies' portrayal of ultra-feminized sexual objects for the male gaze (see Messner, 2002; Messner & Montez De Oca, 2005). Rather, the depiction of women followed the logic of silent exclusion and an exhibition of gender normative roles that are discursively propagated to define marital and social relationships in traditional African societies and in the conservative United States (Lindsay & Miescher, 2003; Messner, 2002).

In one emblematic scene, Power's Aunt Comfort is depicted as the epitome of domesticity and submissiveness to her husband and village chief. During the dinnertime conversation, Power's aunt notes that it is the women and children who are solely responsible for making the arduous trek to fetch water since their village lacks running water and modern conveniences, a point reinforced by a scene of children carrying water into the village early in the film. Such scenes subtly reinforce a traditional division of labor in the home, deduced from the duties performed by Power's aunt—namely, her actions in cooking, acquiescing to the requests of male figures, and acknowledging their authority. Likewise, Sabina (a college student), Anita (photographer), and Madam Baka (newspaper

editor) play limited roles in the central plot of the film and, while Baka does hold some authority, the female characters overwhelmingly occupy positions that hold little power and are subjected to the constraints of the systems under which they labor and to the control of male leaders. Such gendered inequalities are congruent with Lindsay and Miescher's (2003) scholarship on traditional African marital relationships: the male is both a provider and an owner of his wife and children, despite the fact that he has little to do with the nurturing and raising of the children.

MALE PHYSICALITY AND POWER:
BEER AS MASCULINE PEDAGOGY

Despite the strong link between the masculinized domains of sport and beer, exhibitions of male bravado are certainly not limited to the sporting realm. In *Critical Assignment*, Power, a journalist not an athlete, exudes characteristics of traditional masculinity through his heroic actions, fearlessness, body image, athleticism, reinforced heterosexuality, and resilience. However, attesting to the existence of multiple masculinities, what differentiates Power from the majority of characterizations in other beer companies' advertisements is that Power is also respectful of women and his elders, a friend who is loyal, honest, and thoughtful, and a man who exhibits a calm sense of temperance and resolve—attributes that, of course, play into the KBB of Guinness. In essence, Power commands adulation from men and women alike by representing a type of masculinity that, despite, if not because of, its context within a beer advertising campaign, is wholesome, even utopian, in contradistinction to the base representations of males' denigration of sexually objectified females in advertisements for many American beer brands (see Messner & Montez De Oca, 2005).

Clearly, Power is emblematic of Guinness logics entailing strength of character and self-belief, attributes deemed necessary for a man to be legitimized as truly masculine amidst the effeminizing effects of twenty-first-century social life (Guinness Strategy, 2001). As such, he reinforces the KBB with an "inner-strength" that is clearly meant to resonate among Africans. However, the broad appeal of the film and its production values that are in line with the expectations of audiences in other countries (see Silk & Amis, 2000) render the message transferable to other markets in a way consistent with the global "Believe!" campaign (see Amis, 2005; Amis & Silk, 2007). In fact, the KBB resonates throughout the film and is particularly emphasized in Power's acceptance speech at the International Journalist Awards banquet in Chicago, and in the film's closing scene in which the president, in a speech to open the "Water for All" project in Power's village, speaks

to the example that the local people have provided by drawing upon their "inner strength" as a means to "triumph over adversity."

Furthermore, as a barely disguised advertisement, the consumer-driven logics of the film reinforce yet another mode of manifesting one's masculinity: that the pursuit of symbolic meaning and self-identity can be successful through proper consumption choices that will supplant the desirable attributes of the brand onto the consumer (Elliott & Wattanasuwan, 1998). This obviously encompasses, most ostensibly, the consumption of Guinness as the means to develop or show-case particular masculine qualities through self-expression and identity realization. As such, Power's habitual consumption of Guinness, in celebrating achievements or enjoying an evening out with friends, is depicted repeatedly throughout the film as something "natural" and inherent to his masculine identity. As noted by Wenner, (1998), the male ritual of public drinking hinges on "men's concerns over how their masculinity is evaluated by other men" (p. 304). Guinness, as with other beer companies, plays on this fear.

Undeniably, Guinness has promoted its beverage variants with a more socially responsible ethic than many of its competitors, most explicitly manifest by parent company Diageo's message to "Drink Responsibly." Drinking responsibly has been echoed in governmental as well as commercial arenas and is reinforced in the film by Jomo's decision to turn down the offer of another beer at the bar "because I'm driving" and by Power making the same decision "because we're flying in the morning." Nevertheless, there remains a clear association with the strategically positioned brand identity as a strong, bitter beer that is challenging to drink and makes a man look and feel stronger and more masculine (Guinness Strategy, 2001). Denoting the strength of the drink, its seemingly inseparable tie to masculinity, and its historically established lore within cultural circles, Collins and Vamplew (2002) note the response that iconic comedian Spike Milligan supposedly received after deciding he had drunk enough beer: "I…said to the barman, 'look, I can't drink all this bloody Guinness—I'll have some wine.'" The bugger shouted down the bar, "A glass of wine for Mrs. Milligan" (p. 25). Such a popular discourse further polarizes and stereotypes certain behaviors and consumption choices as distinctively masculine or feminine and, along with Guinness' association of potency and strength with masculinity, heavily reinforces the product positioning in *Critical Assignment*.

Of the occasions in which Guinness variants are explicitly consumed, most of them focus directly on men's faces during the physical act of swallowing Guinness, thereby denoting the strength of the drink, the difficulty and the time it takes to drink, and its supposed ability to transfer strength to its possessor. Within those scenes, only one woman, Anita, is shown drinking Guinness, and she is most often seen holding a rounded glass, while the men almost always drink directly

from Foreign Extra Stout bottles. The exception is the awards banquet in Chicago at which the Guinness surrogate for wine is consumed from a glass, perhaps in deference to the formality of the occasion or to the United States being one of Guinness' largest draft markets. The juxtaposition of Anita's glass to the men's bottles places her simultaneously as the female "other," as a visitor or "irregular" (Wenner, 1998), and also as "one of the guys" due to her friendship with the men in the group and the fact that she too drinks Guinness. This depicts her as starkly different from the typical ultra-feminine stereotype embodied by Power's love interest Sabina. Interestingly though, there is a different take on the "sexual geography" (Wenner, 1998) of the sports bar given that Power, Anita, and Jomo all sit together at the "physical bar," a space traditionally reserved for male-only hardcore regulars.

SPORT, STRATEGY, AND INNER STRENGTH

Guinness' carefully crafted brand values and marketing campaigns suggest that consumption of the strong, dark porter will provide self-confidence, inner strength, and a feeling of vitality and vigor (Guinness Strategy, 2001) to "allow" men to define themselves as truly masculine without the laborious efforts requisite in developing athletic talent, strength, and a muscular physique. Further, by carving out a synergistic relationship with sport, Guinness has used physical contact sports in marketing campaigns to align male physicality with values inherent to their beer and brand identity. For example, in the "Free In" commercial centered on the Irish sport of hurling, one man's fearlessness and triumph in the face of seemingly insurmountable odds during the final shot of a match is juxtaposed with images of the man enjoying a pint of Guinness surrounded by beautiful women and the adulation of fans and friends (Amis, 2005). This narrative suggests two possibilities: that the man's dreamlike images of Guinness, women, and stardom functioned as motivating rewards that gave him the courage and will—the inner strength—to make the winning shot, and/or that through his masculine performance he is rightfully entitled to the celebratory spoils of beer, women, and fame.

Sport has also featured as a regular staple in Guinness advertising in Africa, not surprising given Guinness' global strategizing and the supposed "natural" affinity between sport and masculinity. As described above by the brand director for Africa, football has been a popular way of attempting to bring the KBB of "inner strength" to the target market in a locally resonant way. Within the film, while Power and football are not directly juxtaposed, there are continual underlying references to the sport, primarily through Jomo. From the moment that

Jomo first appears in the film—late in picking up Power from the airport because a football match had gone into extra-time—it is clear that the sport is an integral part of his life. His appearances in the film are often accompanied by a reference to football, and he is playfully teased by Anita about his love of the sport. Indeed, he even defends Ojuka because of his appropriation of funds to allow a football team from his country to compete in the "Junior World Cup." Another early shot in the film shows children playing football in Power's home village. Such references provide a useful link to Guinness' other brand positioning armatures, both in Africa and further afield. They also play to Power's previously crafted football affiliations, acting to reify his established persona among the African populace.

Somewhat based on the historically entrenched imperial role of football in the advancement of a Christian message and a moral education, and on the subsequent appropriation of the game by the indigenous population for their own sporting and social aspirations (Darby, 2002), football in Africa is a popularized sport of the masses, functioning as a symbol of liberation and source of national autonomy and self-expression within postcolonial Africa (Sugden & Tomlinson, 2003). Juxtaposed against Power and Jomo's affinity for the game and its popular appeal, the antihero of the film, Thomas Rhines, is shown at his own private golf facility at his mansion. Indeed, further reinforcing the classed masculine logics at work in the film, Rhines explains to Power that the golf course is the "place where all the big deals are done." Although Guinness does have a history of sponsoring golf, this scene further marks golf and indeed "business" as essentially masculine enterprises, but in a somewhat ironic twist, given the political economy of the film, "big-business" as represented by Rhines is seen to be corrupting what should be at the core of Africa—clean drinking water for the masses. Indeed, unlike the moral, dare we say sober, Michael Power, Rhines is coded as evil, selfish, and self-serving, attributes as far from the Guinness marketing table as possible. Indeed, and in a further ironic twist, Rhines whiteness stands in stark and crisp contrast to Power's blackness, which somewhat reverses the racial "logics" of the film industry in which blackness often stands for criminality, poverty, danger, physicality, and, sexuality (see, for example, Giroux, 2002).

CODA: RETHINKING POWER

The creation of Michael Power, his advertisements, and special appearances have apparently helped to catapult the Guinness brand into the forefront of the consumer imaginary as a distinguished "lovemark"—a Saatchi and Saatchi—defined term that denotes a brand that inspires "loyalty beyond reason" and

is habitually used by high-end consumers throughout their lifetime amidst more affordable alternatives (Gibbons, 2004). This is particularly significant given the fact that the film sidesteps a number of social problems in Africa: the poor state of educational institutions and questionable media literacy, the AIDS epidemic, ethnic rivalries, and contested and shifting gender roles that have traditionally privileged men as the dominant figures in social relationships at all levels of socioeconomic status (see Lindsay & Miescher, 2003). Power's family's village is seen to be lacking running water, technological capabilities, and basic amenities. However, somewhat paradoxically, the villagers are shown drinking Guinness that is sold at a 100% premium over other beer brands in Africa (Amis, 2003). Furthermore, Guinness strategically capitalizes upon the belief that "Africans see themselves as coming from a disadvantage...[from] behind the world" (African brand director), tacitly exploiting their knowledge of African experiences, self-identity, and disadvantage in the leveraging of the brand (see also Delios & Beamish, 2001; Lord & Ranft, 2000). Of course, this is further manipulated by conflating the notion of self-belief—the driving logic behind the attainment of confidence and inner strength, the realization and expression of a particular hegemonic masculinity, and the successful performances in sport, work, and life—with the suggested idea that the habitual consumption of Guinness provides the means to those ends.

Despite Power being a fictitious creation, the film's credits list Michael Power as playing Michael Power, thus creating a perceived authenticity to his character. Ironically, Power is played by a Jamaican-born British actor Cleveland Mitchell. However, his identity is completely obscured, as it has been for the several years during which he has filmed commercials and made special appearances to promote the Guinness brand across Africa. The logic behind Power's recondite identity and personality can be deduced from Saatchi and Saatchi CEO Kevin Roberts' statement about the three keys to their branding strategy: "*Mystery* involves great stories, taps into dreams, myths and icons and delivers inspiration; *sensuality* is about the five senses; and *intimacy* is about commitment, empathy and passion" (Gibbons, 2004, p. 1). Several popular press articles written about Power discuss this mysteriousness and alluring sensuality; he never reveals where in Africa he is from, choosing rather to explain that he "is a man of Africa" (Ogujiuba, 2004, p. 2) who proclaims Guinness' logics of self-belief and inner strength while subtly and ambiguously making references to African history, culture, and heritage. To this degree, Michael Power's power is a signifier of Guinness' commercial brand values and selected elements of Africana, and a representative subjectivity who has an affinity with perceived feelings of impoverishment and disadvantage. Indeed, drawing on Selznick (1957), Power and by association the Guinness brand have become infused with value beyond the immediate technical require-

ments of a brand representative: they have become institutionalized within the African cultural landscape (see, for example, Foster, 2003).

As the semiotic mantle for Guinness in Africa, Power's association is precisely what also conjoins his fictional identity to an archetype of African masculinity in a capricious and uncertain global age (Albrow, 1996). Power's strength, confidence, and heroism as a heterosexual male communicate powerful messages about gender, sex, and sexuality to twenty-first-century boys and men in a country that has struggled with the (re)construction of masculinity amidst morphing economic, political, and social structures (Lindsay & Miescher, 2003). In short, the discursive representation of Guinness' Michael Power has ubiquitously ingrained the character as a locally resonant symbolic aspiration of hopeful Africans, an archetype of prescribed hegemonic masculinity, and a polysemic signifier of Guinness values.[3] Yet, and by way of conclusion, we wonder and indeed worry about the trouble brewing when often depthless and superficial representations of the "local," the environment, and gendered, classed, raced, and sexualized identities are corporately created and then resold to the very people who served as the inspiration for such "creative" productions.

NOTES

1. The authors would like to thank the staff at Guinness for their generous help in providing information that has been used in the broader project on which this chapter is based. The authors are listed in alphabetical order.
2. Gender is far from a dichotomous variable; rather, stemming from Connell's (1987) framework of male hierarchies, our reading of the gendered performances should be understood as existing on a continuum in which multiple masculinities and femininities exist.
3. So successful was the campaign that Guinness led the African beer market by 50% in 2000, volume growth rose up to 50% in some markets, brand recognition reached a reported 95%, and by 2003, sales of Guinness variants doubled two years ahead of schedule (Gibbons, 2004). Furthermore, the influence of Power has led to the creation of his symbolic twin Adam King, to help develop the Guinness brand in Asia using a similar strategy to the one featuring Power in Africa.

REFERENCES

Achebe, N. (2003). "And she became a man": King Ahebi Ugbabe in the history of Enugu-Ezike, Northern Igboland, 1880–1948. In L. Lindsay & S. Miescher (Eds.), *Men and masculinities in modern Africa* (pp. 52–68). Portsmouth, NH: Heinemann.

Albrow, M. (1996). *The global age: State and society beyond modernity.* Stanford: Stanford University Press.

Amadiume, I. (1987). *Male daughters, female husbands: Gender and sex in an African society.* London: Zed Books.

Amis, J. (2003). "Good things come to those who wait": The strategic management of image and reputation at Guinness. *European Sport Management Quarterly,* 3, 189–214.

Amis, J. (2005). Beyond sport: Imaging and re-imaging a global brand. In M. Silk, D. Andrews & C. Cole (Eds.), *Corporate nationalisms: Sport, cultural identity & transnational marketing* (pp. 143–165). Oxford: Berg.

Amis, J., & Silk, M. (2007). Transnational organization and symbolic production: Creating and managing a global brand strategy. Working paper.

Athanassiou, N., & Nigh, D. (2000). Internationalization, tacit knowledge and the top management teams of MNCs. *Journal of International Business Studies,* 31, 471–487.

Butler, J. (1990). *Gender trouble: Feminism and the subversion of identity.* London: Routledge.

Collins, T., & Vamplew, W. (2002). *Mud, sweat, and beers: A cultural history of sport and alcohol.* Oxford, NY: Berg.

Connell, R.W. (1987). *Gender and power.* Stanford, CA: Stanford University Press.

Cornwall, A. (2003). To be a man is more than a day's work: Shifting ideals of masculinity in Ado-Odo, Southwestern Nigeria. In L. Lindsay & S. Miescher (Eds.), *Men and masculinities in modern Africa.* Portsmouth, NH: Heinemann.

Craig, S. (1993). Selling masculinities, selling femininities: Multiple genders and the economics of television. *Mid-Atlantic Almanack,* 2, 15–27.

Darby, P. (2002). *Africa, football and Fifa.* Southgate: Frank Cass.

Delios, A., & Beamish, P.W. (2001). Survival and profitability: The roles of experience and intangible assets in foreign subsidiary performance. *Academy of Management Journal,* 44, 1028–1038.

Dirlik, A. (1996). The global in the local. In Global/Local: Cultural production and the transnational imaginary. In R. Wilson & W. Dissanayake (Eds.), *Global/Local* (pp. 21–45). Durham/London: Duke University Press.

Elliott, R., & Wattanasuwan, K. (1998). Brands as symbolic resources for the construction of identity. *International Journal of Advertising,* 17(2), 131 (LN).

Epprecht, M. (1995). "Women's "conservatism" and the politics of gender in late colonial Lesotho." *Journal of African History,* 36, 29–56.

Featherstone, M. (1991). *Consumer culture & postmodernism.* London: Sage.

Ferree, M. (1990). Beyond separate spheres: Feminism and family research. *Journal of Marriage and the Family,* 52(4), 866–884.

Foster, J. (2003). Africa's very own James Bond. Available at: http://news.bbc.co.uk/2/hi/africa/2956043.stm (accessed October 1, 2007).

Frow, J., & Morris, M. (2000). Cultural studies. In N. Denzin & Y. Lincoln (Eds.) (2000). *Handbook of Qualitative Research* (2nd Edition) (pp. 315–346). Thousand Oaks, CA: Sage.

Gibbons, C. (2004). Saatchi and Saatchi: The mark of a loved one. *Financial Mail,* May 14. http://www.adfocus.co.za/adfocus2004/zzzadz.htm (accessed November 21, 2005).

Giroux, H. (2001). Private satisfactions and public disorders: *Fight Club,* patriarchy, and the politics of masculine violence. *Journal of Advanced Composition,* 21, 1. Available at: http://www.henryagiroux.com/online_articles/fight_club.htm. (accessed October 1, 2007).

Giroux, H. (2002). *Breaking into the movies: Film and the culture of politics.* Oxford: Blackwell.

Grossberg, L. (2006). Does cultural studies have futures? Should it? (Or what's the matter with New York? Cultural studies, contexts and conjunctures. *Cultural Studies,* 20, 1, 1–32.

Guinness Global Strategy Presentation. (2001). Internal company presentation.

Hall, M.A. (1996). *Feminism and sporting bodies: Essays on theory and practice.* Champaign, IL: Human Kinetics Books.

Hall, S. (1981). Notes on deconstructing the popular. In Samuel, R. (Ed). *People's History and Socialist Theory* (pp. 21–33). London: Routledge.

Hitt, M.A., Franklin, V., & Zhu, H. (2006). Culture, institutions and international strategy. *Journal of International Management*, 12, 222–234.

Hobson, J. (2003). The batty politic: Toward an aesthetic of the black female body. *Hypatia*, 18, 4, 87–104.

Hodgson, D. (2003). Being Maasai men: Modernity and the production of Maasai masculinities. In L. Lindsay & S. Miescher (Eds.), *Men and masculinities in modern Africa*. Portsmouth, NH: Heinemann.

Holt, D.B., Quelch, J.A., & Taylor, E.L. (2004). How global brands compete. *Harvard Business Review*, 82, 68–75.

Jackson, S., & Andrews, D.L. (2005). *Sport, culture, and advertising: Identities, commodities, and the politics of representation.* London: Routledge.

Jhally, S. (1998). *Advertising and the end of the world* (video). Amherst, MA: Media Education Foundation.

Klein, N. (1999). *No logo: Taking aim at the brand bullies.* New York: Picador.

Koenderman, T. (2002, May 24). Power to your elbow. *Financial Mail.* Retrieved June 5, 2007, from http://free.financialmail.co.za/report/adfocus2002/africa/af2x.htm.

Kristeva, J. (1984). *Revolution in poetic language.* New York: Columbia University Press.

Leung, K., Bhagat, R., Buchan, N.R., Erez, M., & Gibson, C.B. (2005). Culture and international business: Recent advances and their implications for future research. *Journal of International Business Studies*, 36, 357–378.

Lindsay, L., & Miescher, S. (2003). *Men and masculinities in modern Africa.* Portsmouth, NH: Heinemann.

Lord, M.D., & Ranft, A.L. (2000). Organizational learning about new international markets: Exploring the internal transfer of local market knowledge. *Journal of International Business Studies*, 31, 573–589.

Messner, M. (1994). Sports & male domination: The female athlete as contested ideological terrain. In S. Birrell & C.L. Cole (Eds.), *Women, sport & culture* (pp. 65–80). Champaign, IL: Human Kinetics Books.

Messner, M. (2002). *Taking the field: Women, men, and sports.* Minneapolis: University of Minnesota Press.

Messner, M., Dunbar, M., & Hunt, D. (2000). The televised sports manhood formula. *Journal of Sport & Social Issues*, 24, 380–94.

Messner, M., Hunt, D., & Dunbar, M. (1999). *Boys to men: Sports media messages about masculinity.* Oakland, CA: Children Now.

Messner, M., & Montez de Oca, J. (2005). The male consumer as loser: Beer and liquor ads in mega sports media events. *Signs*, 1879–1909.

Morrell, R. (1998). Of boys and men: Masculinity and gender in southern African studies. *Journal of Southern African Studies*, 24(4), 605–630.

Ogujiuba, A. (2004). Michael…the power, the charm. This day online, November 16. [www document] http://www.thisdayonline.com/archive/2001/12/01/20011201sty01.html (accessed November 21, 2005).

Olins, W. (2000). How brands are taking over the corporation. In M. Schultz, M.J. Hatch, & M.H. Larsen (Eds.), *The expressive organization: Linking identity, reputation and the corporate brand.* Oxford: Oxford University Press.

Parker, B. (1999). Evolution and revolution: From international business to globalization. In S. Clegg, C. Hardy, & W. Nord (Eds.), *Managing organizations: Current issues* (pp. 234–256). Thousand Oaks, CA: Sage.

Quelch, J. (2003). The return of the global brand. *Harvard Business Review*, 81, 22–23.

Rao, N. (1985). The woman question: Perspectives for today. *Social Scientist*, 13(10/11), 3–10.

Ripley, M., & Wood, F. (1994). "Beer is best": Tire collective advertising of beer 1933–1970. London: Brewers' Society.

Sabo, D., & Jansen, S. (1998). Prometheus unbound: Constructions of masculinity in sports media. In L. Wenner (Ed.), *MediaSport*. London: Routledge.

Selznick, P. 1957. *Leadership and administration.* Evanston, IL: Row, Peterson.

Silk, M., & Amis, J. (2000). Institutionalized production practices: The case of Kuala Lumpur 98. *Journal of Sport Management*, 14, 4, 267–293.

Silk, M., & Andrews, D.L. (2001). Beyond a boundary? Sport, transnational advertising, and the reimagining of national culture. *Journal of Sport & Social Issues*, 25, 180–201.

Silk, M., & Andrews, D.L. (2005). The spatial logics of global sponsorship: Corporate capital, cola wars, and cricket. In J. Amis & T. Cornwall (Eds.), *Global sport sponsorship* (pp. 67–88). Oxford: Berg.

Sparks, R., Dewhirst, T., Jette, S., & Schweinbenz, A. (2005). Historical hangovers or burning possibilities: Regulation and adaptation in global tobacco and alcohol sponsorship. In J. Amis & T. Cornwall (Eds.), *Global sport sponsorship* (pp. 19–66). Oxford: Berg.

Sugden, J., & Tomlinson, A. (2003) Football and Fifa in the postcolonial world. In J. Bale & M. Cronin (Eds.), *Sport and postcolonialism* (pp. 175–196). Oxford: Berg.

Wenner, L. (1998). In search of the sports bar: Masculinity, alcohol, sports, and the mediation of public space. In G. Rail (Ed.), *Sport and postmodern times* (pp. 301–332). Albany, NY: State University of New York Press.

II. TEXTS AND REPRESENTATION

Brewing Consumption: Sports Dirt, Mythic Masculinity, AND THE Ethos OF Beer Commercials

LAWRENCE A. WENNER

In the early 1980s, Cyndi Lauper's version of Robert Hazard's song "Girls Just Want to Have Fun" became a feminist anthem by pointing out the need for women to have a space for unencumbered fun. More privileged, men have long had such spaces (Oldenburg, 1989). Certainly, the cultures of both sport and drinking, individually and commingled, have been anchored in opportunities for fun that often promotes segregated male camaraderie (Messner, 1992b, 2002; Wenner, 1998). Fun, be it of the sort that Lauper voiced or that had by men recreating through sport or bonding in a pub, implies power. Thus, in hindsight, it may not be surprising that Hazard's original lyrics framed a male fantasy of the fun that may be had with girls, a matter that Lauper reworked in her treatment (Heisler, 2004). Lauper's narrative spoke, beyond girls, to "how women are."

In the commercial marketplace, to paraphrase Lauper's hit, brewers "just want to sell beer." Towards that end, the connection to fun has always been a major selling point. In positioning the story of beer to target their elusive and desirable male demographic, advertisers often capitalize on the fun inherent in television sports programming. Here, through reliance on the "Television Sports Manhood Formula" (Messner, Dunbar, & Hunt, 2004), brewer's narratives are often celebrations of the "fun-squared" meeting place of beer and sport. Yet, such narratives are necessarily more than about beer and sport; they are reliant

on strategic castings of "how men are." Focused thusly, this study explores how beer commercials that build on sport characterize men and their bonding.

MEN, SPORT, AND COMMODITY CULTURE

As a training ground, main stage, and vista of masculinity, sport provides constantly evolving reminders of "how men are" (Burstyn, 1999; Messner, 1992b, 2002). Here, the increasingly commodified narratives that surround sport provide "frames" that may be more important than "the game" in terms of gender identity (Wenner, 2006). In particular, commercials set in televised sport are prone to characterizing "what men want" in contrast to "how women are" (Sabo & Jansen, 1992; Wenner, 2008a). Pronger (1990, p. 178) argues that such strategies problematize gender through dependence on a "myth of difference" where "women are not the fellows of men." This is exacerbated by the twin tendencies of commercials in sport programming to rely on symbolically annihilating women and glorifying men (Messner et al., 2004; Sabo & Jansen, 1992).

Indeed, much in contemporary spectacularized sport relies on its residual power as a "select and powerful bastion of vestigial hypermasculinity" (Wenner, 2006, p. 52). Such a notion does not go against the grain of the idea that the functioning of a monolithic hegemonic masculinity may be fracturing into divergent and sometimes competing "masculinities" (cf. Connell, 2005; Miller, 2001). Rather, it recognizes the staying power of an idealized male "dreamworld" (Jhally, 2007) as a stimulant to many men in commodity culture. After all, if one cannot live the life, one can dream the dream. The tenacity of such appeals may be seen in the lingering mythic masculinity retold in narratives that continue to dominate the media sport landscape. Here, treatments of mega-events such as the Super Bowl and World Cup, as well as the most important regular venues such as the Premier League, NFL, or NBA, rely on a mythic formula that characterizes "real men" reaping rewards from showing their mettle by being aggressive, enduring pain, and sacrificing for the team (Messner et al., 2004).

That sport has played a prominent role in male socialization and served as a safe haven for the "bonding without intimacy" that often characterizes heterosexual men's friendships (Nardi, 1992; Messner, 2001) has not been missed by advertisers. Here, amidst the glow of "real men" in sporting competition, come flattering appeals for men to buy tough trucks, technology to extend power, and, of course, consume beer that is not for sissies. With such appeals, the myth of dominant masculinity lives on. Yet, if nothing else, the marketplace is pragmatic. Industry observers have suggested that touting stereotyped drawings of

hypermasculinity and pandering with sexy women to appeal to men watching sports may be losing functionality (Ives, 2003; Poulton, 2004). In this pushback, Miller (2001) sees new openings for alternative drawings of gender identity to capitalize on sport. Amongst these has been the rise of the male loser countertype (Farhi, 2005; Messner & Montez de Oca, 2005; Wenner, 2008a). In intriguing ways, using the loser to sell remains a case study in male bonding around sport. Here, the bonding of the male sports fan to the beat of vestigial hypermasculinity is replaced by one anchored in sharing the realization that, although dominant masculinity seems to be losing the gender wars, men can still take refuge, away from the humiliations of women, in sport (Wenner, 2008a).

BEER, SPORT, AND COMMODITY CULTURE

Beer and the role of drinking in male socialization and bonding have many parallels with sport. Both set men apart and bring them together, mark privilege and threshold moments in the life cycle, and promise and sign masculinity (Wenner, 1998). Often, of course, beer and sport run on the same track. For example, much of beer's reputation as a tool of male bonding has been ported to sports spectatorship (Collins & Vamplew, 2002). Yet, beer is both special and perplexing in the sporting context. While its consumption is often seen as synonymous with sport spectating, it is also recognized as oxymoronic to athleticism (Wenner, 1991). In the marketplace, beer, like sport, is dependent on men. As they target the desirable 18–49-year-old male demographic, breweries have historically spent over 70% of their advertising dollars in sports broadcasts ("Alcohol advertising...," 2004; Carter, 1976) because men still consume over 80% of beer (Goldhammer, 2000).

There are both real concerns and a bit of moral panic over sport, beer, and its marketing. Anchored in youthful "beer and circus" partying around the team (Sperber, 2000), tailgating gone awry (Clarke, 2006), and the ability to accelerate fan violence and hooliganism (Stainback, 1997; Wann et al., 2001), evidence is mounting. Sport's role in beer marketing stimulates earlier and more positive associations with drinking, earlier and underage drinking, and alcohol abuse (Ellickson et al., 2005; Grube & Wallack, 1994; Slater et al., 1997; Zwarun & Farrar, 2005). Such findings have lead the NCAA and FIFA to "just say no," or at least "not so much," when it comes to alcohol marketing and advertising dollars ("Coaches, CSPI...," 2005; "Give Bud...," 2006). In understanding such issues and what should be done to address them, panicked responses often frame beer relative to sport as a social problem, a characterization, like that of violence, that masks that they are anchored in masculinity and may be encouraged in important ways through commodified drawings of masculinity (Katz, 1999).

In this regard, beer commercials in the context of sport certainly have something to say about how men are imagined and idealized in relating both to women and to each other. Indeed, in their reliance on the "beer commercial formula" (Scott, 2001, p. 75), the genre has been called a "manual on masculinity" (Strate, 1992, p. 78). For many years, beer commercials set in sport have offered a psychic "third place" for men (Oldenburg, 1989; Wenner, 1998) by pandering to them with "beer babes" ranging from the "Swedish Bikini Team" to the "Coors Light Twins" to Miller Lite's "Catfights" (Chambers, 2005; Messner et al., 2004; Wenner, 1991, 2008a). Not surprisingly, the narratives of "real men" are often woven on themes that sport, and the sport and beer mix, is not women's place. Here, men struggle with what to make of women, how to approach them, and how to respond to their demands. Cast as "losers" and "real men" alike, they abandon women to take refuge in their true loves—sport and beer (Messner & Montez de Oca, 2005; Wenner, 2008a). While much has been made about the inability of men to relate to women, whom men consequently frame as "the other" in these commercials, there has been little investigation of the underlying issue of how men are shown to relate to each other and bond in this meeting place of beer and sport. This study addresses such oversight by exploring characterizations of the "fraternal social contract" (Pateman, 2002) in beer commercials reliant on sport.

APPROACHING THE SPORT, BEER, AND MASCULINITY COCKTAIL

The notion of the fraternal social contract opens the door to thinking about the role of the sport, beer, and masculinity mix in television commercials. For Pateman (2002, p. 125):

> Civil individuals have a fraternal bond because, *as men*, they share a common interest in upholding the contract which legitimizes their masculine patriarchal right and allows them to gain material and psychological benefit from women's subjection.

Such observation begs questions about how such common interest comes to be and how it is legitimized. While answers here are complex as Connell (2005) suggests, the beer commercial in the context of sport plays a visible role in stimulating both interest and legitimacy. Indeed, for the fraternal social contract to be endorsed and enforced, there must be a regular performance of the rituals of male bonding. Yet, for the bonding that sets the terms of the fraternal social contract to occur in performance, it must be imagined and displayed in coherent ways on important stages. Increasingly, those stages are the commodified ones designed for ready

consumption. As Crawford (2004) notes, in the hypercommodified setting for the contemporary sport fan role in particular, performance, at a very basic level, requires consumption of an imagined sense of community where there need only be perceptions of shared identity that are compelling. In this regard, the beer commercial set in sport as a masculinity manual fits this bill. Here, vested in their self-interests to promote beer through sport, commercials necessarily aim to inform perceptions by drawing the contours and sensibilities of the bonds that exist among "real men." It should not be a surprise that such a recipe might be suspect.

An overriding assumption guiding this study is that there is no greater main stage for the narrative characterization of male bonding than the beer commercial that builds on sport. Yet, this has not been the central focus of earlier studies of beer commercials. Given that the twin towers of sport and beer have long been bonding sites for men, this is surprising. Of the four gender themes that Messner and Montez de Oca (2005) find in advertising set in sport broadcasts, far more attention has been given to women as *hotties* or *bitches* and to men as *losers* than to men as *buddies*. Interestingly, this categorical scheme serves to showcase an overarching dilemma of archetypal male relational life. Women, as "others," remain mysteries at a distance, positively as hotties, and negatively as bitches. Bested by real men and even by more potent women, "other" men can be comfortably cast as losers (Messner et al., 2004; Wenner, 2008a). But the concept of buddies is perplexing. Being real buddies with either women or men holds real gender identity risks for men. Being "just friends" with a woman one is close to can raise questions of one's sexual attractiveness and prowess. And being "too close" to a special male friend raises the specter of lurking homosexuality.

The latter issue plays large in the intimate distancing that characterizes male bonding and friendship. Here, there is much evidence that men form bonds, often close ones, without the intimacy of sharing their inner lives and feelings that characterizes women's bonding with each other. Rather, men's bonding seems to be based on more neutral ground than self-reflexive revelation. Men's friendships bond around common interests, doing things together, sharing knowledge, and "talking shop." In what has been characterized as an "active style of intimacy" (Swain, 1989, p. 85), men connote rather than emote intimacy. Indeed, emotional sharing may be circumspect, causing discomfort and raising suspicions (Rubin, 1985). This is a particularly sensitive issue in sport or athletic subculture-centered male bonding, where the threat of being perceived as "less than manly" by being too close to men is particularly onerous (Messner, 1992a).

The one study (Strate, 1992) that takes a limited look at the question of "how men relate to each other" in beer commercials reinforces many of these findings. Here male interaction was confined to the relative safety of groups

that sanctioned "the freedom to act irresponsibly" (p. 87). There were few one-on-one relationships and the "emotional tenor" of how men related to each other was "characterized by self-restraint" with "strong emotions" and "overt displays of affection" avoided (p. 87). Indeed, beer became not only "a symbol of group membership" but also, when a man gave another a beer, "a sign of acceptance, friendship, or gratitude" and as such, "a substitute for overt display of affection" (p. 88). This study looks to further Strate's forays into beer commercials and the bonding of men by adding sport to a more complex equation and assessing the resultant cocktail through a critical strategy that merges dirt theory with considerations of narrative ethics.

ON INTERROGATING MALE BONDING, SPORT, AND THE BEER COMMERCIAL

The approach taken to considering the social construction of male bonding in commercial narratives of beer set in sport is grounded in broadly held perceptions of advertising. Collectively, we remain uneasy that creatively savvy and omnipresent advertising may be working us over. Certainly, it seems implausible that advertising would be paid for if it were ineffectual. Still, it remains difficult to believe that mere exposure does the advertising trick. As a result, the sense that fallacious connections are being made to enlist our sympathies is inescapable. It is this sense that likely spurs us on as active readers in pushing back at the logics unwound in commercial messages. In realizing the necessity for resistance, we recognize that our transactions with commercial messages are ethically problematic. It is the merger of these issues that drives inquiry here about the social construction of masculinity and male bonding in beer commercials reliant on sport. To grasp these interwoven concerns, the approach relies on a dirt theory of narrative ethics tailored to deconstruct commercial narratives and their reading and interrogate the ethical nature of that transaction (Wenner, 2007). The three prongs of the approach and the issues it raises for constructions of fraternal bonding in sport-infused beer commercials are discussed in the next sections.

FINDING DIRT

Traceable to the work of Douglas (1966) and Leach (1976), mediated dirt theory advanced through Enzenberger's (1972) and Hartley's (1984) work that has been especially applicable to mediated sport (Hilliard & Hendley,

2004; Wenner, 1991, 1994, 2004, 2007, 2008a, 2008b, 2008c). At its essence, dirt is "matter out of place." Dirt transfers power and logic from one setting to another. Thus, when we speak of "sport's appeal" or that "sport provides a special setting for marketing products," we recognize the power of sport dirt. Through manufactured connections, dirt helps make the sell. This is embraced when advertisers use constructions of sport and masculinity to appeal to the male sport fan. While the dirt, a real or imagined attribute of sport or men, may in itself be benign, the contagion that results from its strategic use may be ethically problematic.

In focusing dirt theory on masculinity and sport in beer commercials, one "follows the dirt." What dirt comes from sport and what dirt comes from gender? Where does dirt come from and where does it go? How is it imported and what is its character? How is dirt used in shaping the narrative? How are logics of dirt from one place appended to the logic of the sell? What distortions, fallacies, or deceptions are facilitated as dirt moves from one setting to another? Questions such as these begin the messy exegesis of dirt analysis and underlie the next set of considerations. These focus on how reading and the characterization of the reader, and hence male bonding and the sell, relate to dirt.

CONSTRUCTING READERS

There has long been a de facto concern with dirt in reader-oriented criticism as the approach hinges on what readers bring to the text. Familiar dirt helps us make sense of new things. There are many variants of reader-oriented criticism and reception theory along the critical landscape (Machor & Goldstein, 2001; Tompkins, 1980). Most appropriate to interrogating dirt are Iser's (1974, 1978, 2006) concerns with the (1) contextualization of implied readers, (2) drawing of readers in and by the text, and (3) nature of the reading act. In beer commercials, we need to understand how marketers as authors reach to readers through contextual understandings of sporting "interpretive communities" (Fish, 1980). As well, we need to look at the characterization of readers through on-screen textual surrogates and off-screen clues, such as direct address or camera position, that help state-preferred reading positions. Finally, reading processes need to be explored by considering the reader's vantage point and the negotiation of both gaps and redundancies in texts.

In starting with dirt, it becomes a key overlay in approaching the reader and reading. Thus, one begins by examining the roles that dirt from sport and masculinity play in contextualizing the interpretive community for beer commercials. Then come questions about dirt in the characterizing of the reader

in and by the beer commercial text. What roles are played by dirt in coaxing a preferred reading position? Finally, dirt's role in shaping the reading act needs consideration. How does dirt from sport and masculinity and their interaction influence the reader's vantage point? What roles are played by dirt in filling gaps and influencing how redundancies in the text are likely to be received? Through these overlapping concerns, much can be learned. Foremost, liberties taken in characterizing sport, masculinity, and the reader of commercial messages are crystallized. In this course, improprieties taken in the attempt to control reading to strategic advantage may be seen. Thus, the next step in dirt theory interrogates the tenor of such realizations.

DECONSTRUCTING ETHICS

The third layer in analysis concerns ethics. Ethical assessments have often been resisted in literary, aesthetic, and cultural criticism as presumptuous (Carroll, 2000). More recently, ethical interrogation has come to be seen both as inescapable in narrative analysis (Booth, 1998; Eco, 1979; Gregory, 1998) and as a necessary remedy to detached relativism in cultural critique (Eaglestone, 2004, Eagleton, 2003; Kellner, 2000; Zylinska, 2005). Key in this ethical turn has been the realization that ethical interrogation is not synonymous with moral prescription. Most importantly, the approach can complement other critical concerns, such as the one here with dirt, to focus on the ethical dynamics of the text and reading. In assessing matters of greater good, minimization of harm, truth telling, exercising other respecting care, and being balanced, fair, just and a host of other issues, ethical criticism can illuminate moral flaws in media products as both aesthetically defective and culturally problematic. As such, the approach is particularly appropriate in interrogating the propriety of dirt imported into commercial narratives and the dirtiness encouraged through characterizations both of the reader and the paths that reading might invite (Wenner, 2007).

In interrogating ethical dynamic of sport and masculinity in beer commercials, it is worth recognizing that a little dirt may be dust, doing little harm. A lot of dirt covers and clogs things, doing harm. Yet little dirt, like water in a gas tank, can cause considerable harm. Thus, a chief ethical stocktaking focuses on what dirt does. Still, it is essential to take stock of what the "matter out of place" really is. It might well be that assumptions concerning sport or masculinity brought to service were ethically flawed prior to importation. In triangulating ethical assessment, questions about the workings, movement, landing, build-up, and interaction of dirt characterizing sport, masculinity, and male bonding with other

matter all need to be assessed. Has the use of dirt taken liberties in characterizing interpretive communities or masculinity pushed improprietously to control reading? Have logics concerning sport and male bonding been used to devalue the greater good, obfuscate inequities or truth, mask injustice or diminish other respecting care? What ethical dilemmas are raised when recombinant sport and male bonding dirt interact? With questions such as these, ethical inquiry can be expansive.

A SIX-PACK SAMPLE OF MALE BONDING

Many beer commercials are produced each year. Virtually all are broadcast in sports programming. Studies analyzing beer marketing in sport have relied on content analysis (Grube & Wallack, 1994; Madden & Grube, 1994; Zwarun & Farrar, 2005). While such studies identify overarching trends, they cannot fully interrogate the marketing message and its reading. The approach here addresses this. An apriori target universe of beer commercials featuring both sports and themes of male bonding was specified. Here all beer commercials in the advertising industry's largest proprietary video database at adforum.com was examined to identify spots featuring dominant themes of male bonding set in backdrops featuring sport or athletic activity. Further, to hone focus and distinguish it from a companion study focused on male-female interactions with sexual relation implications in beer commercials set in sport (Wenner, 2008a), ads featuring male bonding along with meaningful sexualized talk with women were excluded. A six-pack convenience sample was chosen for analysis from approximately 20 spots with dominant themes of male bonding set in backdrops drawing on sport or athletic activity. The winnowed sample considers distinct, nonredundant strategies from a range of brewers. This six-pack strategy magnifies a range of strategies while putting forth a manageable number for interrogation and comparison.

INTERROGATING MALE BONDING, SPORT, AND THE BEER COMMERCIAL

In the next sections, consideration is given to six commercials for both American and European domestic markets. Here, strategies to advance Mahou, Heineken, Amstel, Coors Light, Budweiser, and Bud Light brands illustrate a range of treatments of male bonding, shared wisdom about women and heterosexual relationships, and the positioning of sexual difference.

MAHOU: WHY DO I PUT MYSELF THROUGH THIS?

The Spanish brewer Mahou's "Insight of a Football Fan" mythologizes male football fanship, explaining it with idealized characterization of male bonding. Opening to a building romantic anthem, the spot is structured around one man's soliloquy. Over successive shots—a close-up of a pensive man, three male buddies sitting side-by-side on a couch anxiously awaiting play in a game broadcast, a crestfallen man sitting with head in hand before a switched-off television set—an unseen narrator asks. "Then you wonder, why do I put myself through this?" We hear him pondering further: "What do I care whether they win or lose? What have they ever done for me? Why does it matter to me what these eleven guys in shorts do?" The accompanying montage shows a disappointed man in a front-row stadium seat, anxious men crowding a bar watch game time run out, a man among barroom buddies nervously swig from a Mahou bottle, and prized statues of football players displayed in the living room of a somber male fan taking a gulp from a can of Mahou. Answering the angst and "why do I care" questions, we see loyal male fans sitting in thinly attended cheap seats at a stadium jump up as the narrator exclaims: "Then you say goal! Goal!" He further explains: "And you call your dad and your best friend and you shout like a kid. And for a moment, for a few hours, for a few days, it all makes sense." To reinforce this, we revisit previously forlorn scenes along with some new ones. In charged jubilation, couch buddies "high five," men hoist beers at bars, male fans in stands cheer, a crowded living room of men applaud and toast, a new order of Mahou heads away from a bar, and a packed tavern of men (including the bartender) explode in joy. Over this last scene and a close-up of a bottle and a poured glass of Mahou, the narrator provides closure: "The league is life. The league is Mahou. How it started." Closing graphics reinforce Mahou as the "sponsor of the Spanish Football League."

As dirt, sport and masculinity so converge on beer in this spot that the resultant intertwining becomes a tautological fantasy. Dirt from sport, the primary propellant, is imbued with special powers. Here, football as a man's game undergirds meaning. It is powerful brew, brewing masculinity. Football signs "real men," bringing them together for beer—Mahou beer—cast as equally essential to the "agony of defeat" and "thrill of victory." The version of masculinity imported to beer suggests than men need something "out there," such as sport, to bind their ties, and an affirming lubricant, like beer, to sanction their showing of emotion. An overriding dirty logic poses that there is no stronger basis to male companionship than sport fanship and that a necessary and natural feature of this is beer consumption. Yet the circularity of dirt goes both ways. With Mahou as a sponsor, sport is reliant on beer. It is the perfect dirty storm.

The casting of the interpretive community both excludes and ex-nominates women (Barthes, 1973). It also ex-nominates other gendered roles for men, such as husband or father. Yet, this characterization of an exclusive province of men encourages reading that is surprisingly self-reflexive. In recognizing that men are slightly insane in their unwavering sport fanship, it also recognizes that in the liberty to do so there is privilege. Indeed, the reading position for "why do I put myself through this" hails men with an assertive answer: I am a man and as such have the right to escape and bond with other men to bask in men's glory on this cultural stage away from women. Textual surrogates cast men's fate, suffering privately or permitting bonding over an achievement "out there" that is not personally their own. Men are either alone or alone together. In its course, the propriety of this saga and the interaction of dirt to reading mask many breaches about how to live. In the narrative, the "league" of men find "life" in their fanship and beer. While not ruling out a multidimensional masculinity, there is no prospect or reason for it. Rather, in deifying this "natural order of being," the "life" of a "real man" is offered as a preordained fate with truncated borders for emotional expression. On the margins, it is the fate of women to have no standing in this place of honor where men may reveal even in this limited way.

COORS LIGHT: PROTECTING THE BINDS THAT TIE FATHER TO SON

The Coors Light "Protection" spot relies on an old joke, that fathers often tell sons the "facts of life" after all has been discovered. In a wood-paneled den, a fifty-something father sits on his easy chair throne beside his young adult son watching a televised game. To the son's displeasure, the father breaks the spell of them not having to interact. Over game announcing, he breaches a fatherly talk, saying "So, ya been goin' out huh? Big parties. Pretty ladies. Son, we need to talk about protection." Disgruntled by how this talk is heading, the son indignantly responds "Dad, I'm twenty-six." The father plows ahead, saying, while reaching down for something, "Yeah, I know, but you're never too old for your old man to give you one of these." Expecting a condom, the son in disbelief squirms, "Oh man, Dad." Breaking expectation, father hands son a cold can of Coors Light, stimulating a resigned nod and a wincing "Thanks." The spot then breaks for a narrator to tell us that "Every Coors Light can has a protective liner to lock in that refreshing frost-brewed taste," while sophisticated graphics showcase the can's condom wrap. Returning to the living room narrative, the father reminds the still apprehensive son, "You can never be too careful." A closing tagline returns to the can with a reminder that the beer is frost-brewed and refreshing.

Dirt here is reliant on sport both as a natural setting for fathers and sons to bond and as a "co-dependent" that allows men to avoid talking about anything personal Humor comes from sport as sanctuary seemingly being violated by the father's forays. Further, dirt from masculinity brings meaning to the father-son relationship, one that is cast as comfortable when centered on shared activities such as sport spectatorship, but awkward when focused on relationships and feelings. Indeed, the reading position for the interpretive community assumes this to be an "everyman" experience. Magnifying this, the condom functions in dirty ways as the lone sign of male virility, but one that puts any real and empathetic discussion of it at a distance. Readers are positioned to see how the tenor of male bonding shifts when consideration of condoms (and potentially relational life) is replaced by that of beer. Our textual surrogate, the young man in beer's target demographic, learns that beer wins the day. With it, comes relief that one can forego conversations requiring revelation.

Certainly, the ethical dynamic governing this narrative requires buy-in over the dysfunctionalities of the father-son relationship. Here, fathers are inept and sons are apprehensive about the costs of revealing even a bit. The characterization implies that this is based on cultural knowledge of strained father-son relationships, and further that this is natural. In this, there is reliance on a well-worn stereotype and the father, in particular, is contained by it. Further, one cannot help but be concerned about the propriety of a "joke" over discussions of responsible sex. While the son trembles, it remains open whether the father ever really means to penetrate much depth. Yet, in this intentional ambiguity, there can be a sexual allusion linked to the powers of beer, cast as so sexually potent that they need to be contained. The dirty disingenuousness of this relies on the discomforts of engaging masculinity when sport signals a cultural time-out.

BUD LIGHT: BUDDIES, TECHNO-SIGNING, AND SEXUAL COMPETITION

Relational realities and the ability to deal with them are also the theme of Bud Light's "Picture Phone" commercial. Set in a ballpark, two stoked buddies find their seats with beers in hand. One exclaims, "Wow, I can't believe Carl turned you on to these tickets!" The other responds, "I know, all right! Let's hit him up," as he whips out his phone to take a photo of the two friends enjoying themselves in their friend Carl's seats and, reveling in his techno-sophistication, quickly send the photo to Carl. We see Carl, sitting in a living room watching the game, pick up his phone and see the picture. With his phone, Carl quickly snaps three photos—of the apartment, of his bottle of Bud

Light, and an attractive women heading to him with another Bud Light—and send them back to his friend at the stadium. As the friend receives them, his buddy looks on, providing "play-by-play" commentary on the photos: "Hey, that's your apartment. That's your Bud Light. That's your girlfriend." As this commentary goes from excitement at all this technological wizardry to recognition of the dirty trick that Carl has played, clownish slumping poses as empathy for the wronged friend for having been duped. On the heels of this punch line, the story pauses for a narrator, over a glistening Bud Light bottle, to remind: "Fresh. Smooth. Real. It's All Here." Returning to the narrative, we see the wronged friend, looking in disbelief at the phone, question "Sharon?" His companion, looking on, provides awkward but comedic closure, remarking, "Yeah, she's sharin' all right!" as the two quickly put the incident behind them to attend their beers and the game.

Here, dirt is imported from many quarters. Sport, along with the promise to men that they may safely bond over it, provides a foundation. Dirt from masculinity disrupts this with its unbounded male competition, particularly over women. Thus, the affront may be dually cast as expected but particularly onerous as it has broken the sacred bond of sport. Finally, the dirty importation of technology and men's giddy fascination with it play a key role. Here, technology both hoists men up and drags them down. In each instance, the logic of technology as a tool of male power prevails. McLuhan's "extensions of man" merely become a dirty extension of men's predilection to one-upmanship.

All this disappointment over dirt—the fractured bond of sport, the duplicitous nature of men, and the wake-up call that comes from a more potent techno-offensive—paves the way for the reading position of beer. For the interpretive community of young male sports fans, the lesson cannot be missed. Even as sport's bond is unglued, men betray each other, and technology magnifies the assault, Bud Light may be relied upon. In the end, beer, in companion to sport, repairs the assault that is made on our wronged textual surrogate. This is acknowledged as all is shrugged off in the quick return to the game with beer—a buddy that for the time being may be trusted—in hand. In positioning beer as man's only truly trustworthy friend, this ad poses a vision of an ethics-free world where buddies deceive, technology assaults, and sport's façade may be exposed. Indeed, the wronged man can get only humorous wincing and wisecracks as empathy from his buddy at the stadium. Here, relational life—with men or women—and the emotional investment it may require are not taken seriously. Rather, life should move ahead with a sip of beer and the next pitch. Finally, in the male domain of sport and buddyhood, the naturalized view of Sharon who may be "sharin'" is problematic. Here, Sharon is infantilized, overpowered by the cunning Carl.

BUDWEISER: BREAKING UP IS HARD TO DO (NOT)

Budweiser's "Break-Up" spot provides a further look at male bonding and the structural duplicity that is shown to characterize it. In its construction, the very curtailed limits of male disclosure and empathy are essential dirt. Two male buddies, in their late-20s or early-30s, are seated on bar stools before a television set blaring football commentary. One asks, "What happened?" The other, the "victim" of the break-up, responds, "I don't know what happened. I don't know why she dumped me." To both those assertions, an unseen arbiter, by implication the sponsor of the commercial, inserts the word "false" superimposed over the victimized male. This lie detector tactic provides counterpoint to the remainder of claims and feelings expressed in this conversation. Thus, "false" punctuates the empathetic friend's soothing "Well, you always treated her right." It comes as well when the now indignant victimized buddy says, "Yes, I did" and then "I did, didn't I?" The lying continues to be marked when his buddy nods in empathetic agreement and says, "You did." It comes as well when the victimized man claims "She's insane!" and the empathetic buddy nods in faux agreement. The perpetual disingenuousness continues as further empathetic remarks—"Yeah, I don't even know what you saw in her" and "I mean, I know I would never go out with her"—are revealed as false. In perturbed recognition of these as lies, the relational victim responds, "Yeah, I know," which is also revealed as a lie. Pretending to mend things, the empathetic one offers the final disingenuous suggestion—"You can call her back in the morning"—that is marked as false. The coda of the spot then has a bartender intervene by delivering beer and saying, "You guys need a Bud," which is the only statement in the ad marked as "true."

In this spot, sports dirt serves as a limited but important role. Having the game be the reason these men come together at the bar both provides sanction for beer being poured and de-stigmatizes that these men may have actually come together to share inner feelings on a relationship gone awry. Thus, sport and beer may be seen as enablers to overcome the difficulties of men's emotional sharing. Indeed, the "reason" these guys "need a Bud" is that they can't help lying to each other and beer's "nurture" may help overcome man's "nature." The reading position facilitated by this is an acerbic one. The interpretive community, including both men like these and women who have to deal with them, is encouraged to be resigned to this lack of truthful disclosure and empathy. In these textual surrogates, male readers can take some solace in the characterization of understandable structural flaws in men's relational lives. Facilitating this as an "easy out" seems ethically problematic, making it easier to normalize that which is not other respecting care.

Further, that the vantage point for reading encourages finding humor in such relational ineptitude and deception dances precipitously on an ethical edge. After all, at stake here is the institutionalization of a universal excuse that boys will be boys, expecting them to screw up time and again for failure to bring sufficient sensitivity to virtually any context calling for it. Related to this, the narrative logic in this spot is ethically flawed for the failure to encourage self-reflexivity and honesty. The scorned man takes no responsibility for his actions in this failed relationship, looking outward to assess blame on the women, a strategy that his less than sincerely empathetic friend fails to call him on, which further deepens the depths of self-delusion. On this scarred terrain, there is truth only in beer, and indeed, toward that end, Budweiser has anointed itself as the arbiter of truth.

HEINEKEN: A MAGIC MOMENT OF MALE BONDING GONE AWRY

In "The Male Bonding Incident," Heineken signs the limits of male bonding through comedic treatment of the angst men have over perceptions of homosexuality. As the spot opens, a young man sits on a leather couch pinned to football action on television. In the background, we see his friend entering the room with two beer bottles in hand. Engaged in the action, the man on the couch pulls closer to the set, yelling "Go baby go! Stay off the middle! Go! Run! He's gonna score! He's in! He's gonna…" In support of this, his beer-toting buddy sits down next to him and joins in the cheering. As he nudges his friend to take the beer, all goes well until the two men's hands touch on the passed beer. As the camera stays with a close-up of the hands touching on the Heineken bottle, the familiar tune and lyrics of "This Magic Moment," a romantic ballad made famous by the Drifters, fades in. This passing of the beer is indeed a magic moment in male bonding as the touch lingers, with pregnant and uncomfortable implications, a bit too long. Recognizing their affinity, the two men turn slowly and look into each other's eyes. Injecting humor, a mid-screen graphic signs this as "The Male Bonding Incident" as the lyrics of "This Magic Moment" go full bore into the erotic feelings and romantic love that come from such looks. Appalled by how long this has lasted, the two men nervously and quickly distance themselves. Hemming and hawing, one notes how cold the beer is, both cough a bit in embarrassment and get a hold of themselves by straightening up their musculature. Though now safely apart, both slowly look back and their eyes connect in a way that does not give them comfort. Recognizing this, they nervously laugh and wiggle to opposite corners of the couch. As visuals ironically transition to the slogan "It's all

about the beer" followed by a Heineken graphic, we hear closure. Here, one man remarks, "You know what this year needs, more cheerleaders!" while the other enthusiastically agrees, "Oh yeah, more cheerleaders!" as both laugh in residue discomfort.

Here, dirt from sport is shown to bond men safely together. The signals are straight: these are "real men" sharing football on a leather couch. Yet, this ad has chosen to confront the possibility that this may be artifice. In essential ways, dirt from beer as a disinhibitor is cast as a chief culprit. As the slogan suggests, "It's about the beer." Blaming beer both imbues it with special powers and curbs the need to explore the degrees of latitude that remain possible in masculinity. Or perhaps this is an unusual strategy to encourage responsible drinking. Certainly, what transpires is a lesson in what happens when male bonding gets too close or out of control. These dangers are signed by the touch, something to which heterosexual men, particularly those in athletic subcultures, often have paranoic sensitivity. Here, in the touch, scary new doors are opened for the male. Yet, in this allegory, dirt from dominant heterosexual masculinity successfully fights back.

The travails of these textual surrogates speaks largely to an interpretive community that is anchored in the sensibilities of "real men's" sports, such as football, where the specter of homosexuality and its connotations of weakness remain inherent problems. Indeed, the reading position encourages seeing this narrative as a problem to be resolved rather than as an opportunity. The transaction of dirt and reading position raises a number of ethical issues. A key one, of course, is the blaming of homosexual attraction on beer. This is both cavalier and reductionist. A second ethical affront comes from not taking "This Magic Moment" seriously. By casting this as an embarrassing mistake, there is further marginalization of all that is beyond heterosexual orthodoxy. Thusly posed, the narrative serves to chill rather than stimulate a climate of tolerance.

AMSTEL: ON CHECKING THE CREDENTIALS OF MASCULINITY

In a Dutch ad produced with English subtitles for the broader European market, Amstel's "Offside" spot goes beyond Heineken's "Male Bonding Incident" to firm the boundaries of dominant masculine heterosexuality. Here three male pals in their late-20s are sharing conversation over a brew at a bar. Their collective focus moves to an attractive platinum blonde chatting with a female friend at the other end of the bar. There is much conjecture about the possibilities, and the handsomest and most athletic of the buddies is prodded to make an approach to the blonde. He brings beers for both on approach and sets one down in front of the

blonde as they trade smiles and nervously say "Hi!" Prepared in his line of attack, the athletic man launches into conversation by posing, "Look…if the striker gets the ball…" He continues, using beers on the bar to illustrate opposing players on a soccer field, "between the keeper and the last defender." Shifting focus from his bar top demonstration, he looks at the blonde and queries, "what is it?" Puzzled, but not missing a beat, the blonde shrugs with tresses settling, breathlessly responding in a throaty whisper, "Offside." In this shot, we get a lingering look at the blonde. Dressed, perhaps provocatively, in a pink dress with scooped neckline, "she" has thick lips, perhaps voluptuous, with attractive but solid facial features, perhaps, of a farm girl or of something quite different. With this closer look and the answer to his question in hand, the handsome man says "Thanks" to the blonde and strides with masculine purpose back to his pals. Smirking and seeking confirmation for their implicit assertion, the buddies call for an assessment. The handsome man nods eagerly, with a big smile turning to laughter, as he confirms "It's a man." To this, all the men gleefully smile; one sidekick lifts a beer as if having won a bet while the other is so demonstrably jubilant he may as well have won the lottery. The ad closes on a logo—"Amstel Bier"—and a tagline graphic "Friends Forever."

Here dirt from sport plays an essential role. Indeed, sport knowledge is used as a "truth serum" to clear the clouds of ambiguity about the lines of masculine identity that so concern the three pals in this narrative tale of outing the "other." Dirt from dominant heterosexual masculinity drives this preoccupation. On one hand, this is nothing but a perverse twist on the familiar wagering amongst pals about whether one will be successful in "getting" a targeted woman. On the other, it is a "getting" of men who fall outside the bounds of heterosexual orthodoxy. Regardless, it is clear that these men feel better for "getting" the blonde and hitting their target. Dirt from understandings about beer also underlay the narrative formation. Here, beer bonds these "real men" as "Friends Forever." Further, beer's qualities as a disinhibitor are seen to enable this sexual approach, as it does many others. And the cementing of beer to sport, and thus to dominant masculinity, is signed in beer glasses taking on the role of players in the hypothetical posed to the blonde.

In this spot, both the reading position encouraged for this dirt and the characterization of our three pals as textual surrogates may be seen as ethically problematic. In its vista, it stereotypes women, who, in the course of this screening of gender, are painted as incapable of passing such tests of sporting knowledge. The vantage point as well makes fun of sexual difference and anything that may blur the lines of predictable gender identity. Cast as quintessentially male, our textual surrogates go beyond mere lack of tolerance to mount an embarrassing offensive on the blonde they feel they must "out." This breach of other

respecting care is discouraging. All of this informs an overarching casting of men as emotionally insensitive and immature. Their view bridges a range of intolerance for difference and yet there is no questioning of the worldview oper-ant here. There is no bother to explore the possibility that the blonde might indeed be a woman, with perhaps more masculine features than these men would like, who knows something about sport and, further that both matters are well within social tolerances. And if this is a man in drag, there certainly is no sensitivity to the range of possibilities about why this may be the case. There is merely a rush to expose sexual difference as a joke, and in doing so, reaffirm dominant hegemonic masculinity.

DISCUSSION

This six-pack of analyses shows that dirt from sport and masculinity converges on the selling of beer in variant and resourceful, but not altogether unexpected, ways. Indeed, the brewing of masculinity that is seen in these commercials stirs a drink of gender identity that is particularly reliant on sport as a segregated place where the male standard has long been a benchmark of excellence. In using dirt theory to plumb the depths of the workings of male bonding put forth in these compara-tively complex narratives, attention has been given to a myriad of textual, reading, and ethical dynamics. Yet, even when one considers the variant pushes and tugs of these narrative formations, it is inescapable not to conclude that the topic of male bonding remains an uneasy one in the commercial sphere. Perhaps seeing men emote too much or even interact with each other in a sincere way is prob-lematic as a selling tool. This may explain the reliance on sport as a safe harbor for male bonding to occur. Throughout the six-pack of commercials considered, whether it is a major or minor thematic element, dirt from sport is cast as cultural glue that bonds men to each other and it may be that this dirt serves as a sufficient deterrent to having to consider more about the emotional lives of men that might be brought to bear on the sell.

Perhaps as a consequence, the lessons of masculinity seen here point to a very truncated set of possibilities, rather than the wider range of masculinities that Connell (2005) argues must be understood to fully comprehend men's lives. Indeed, in these cases, the narrative space has lined dirt along some very narrow moral paths. Such, pathways, as Carroll (2000) suggests, are key to understanding the ethical imperatives hailed through narrative construction. Here, as he has put it, "the ethical critic can focus on the probity of the moral experience that an artwork shapes or prescribes as a condition for correctly assimilating it" (p. 370). In this instance, the contours of the reception are

enabled by first posing that it is the natural place of men to be allowed to suffer and revel in sport. Further, in this world, men's bonding is shown to both hinge on sport and be reliant on beer. In explicit ways, sport helps enable a moral excuse because it allows men to bond in a very special kind of moral community where other respecting care and empathy, chief features of femininity and feminist ethics, are marginalized as taboo. Indeed, it seems likely that the win-lose logic of the sports world grants special permission for men to further magnify the constraint and containment that are key features of their emotional lives. Here, beer becomes a co-dependent, enabling and furthering the tug of sport's moral logic. The net result of this is that in this community it is seen as natural that men are unlikely to be truthful in laying their emotional cards on the table before other men.

Taken as a whole, the moral tenor of this community is disheartening. It is a community where fathers are incapable of relating to sons on a level deeper than beer. It is a community where buddies deceive each other gleefully and other buddies show no empathy. It is a community where empathy is characterized by lying, not only to one's buddies, but to women who matter in one's life. It is a community where only beer is truthful. It is a community where seeking truth means confirming that one is not the "other" and does not lean to homosexual tendencies. And finally, it is a community where sport is the ultimate truth serum, "outing" men not only in their duplicity and natural disposition to lie and deceive both for strategic advantage and to not show weakness, but most importantly also in their performance of their gender in ways at odds with heterosexual orthodoxy.

By constructing men's bonding in the ethical and moral logics of such a community, beer and sports remain glued at the hips, beer belly, and hearts of normative masculinity. In highlighting such "truths" of masculinity and casting the contours of the terms and conditions of male bonding, these commercials remain, as Strate (1992) has suggested earlier, a "manual on masculinity." In key ways, they articulate the terms and conditions of what may be thought of as a truncated and commodified "fraternal social contract" (Pateman, 2002). Here, the ethical contours of a male sporting culture suitable for market are put on display. And here, the moral pathways that men are invited to follow are limited by caricatured drawings of men who are not only emotionally out of touch but morally disengaged as well. In returning to Lauper's anthem, there is certainly much "fun" here posed for men, but it is equally clear that it does not come without moral costs. In these tales of beer and sport, we not only learn how brewers seek to cast "how men are," but also how these commodified messages help to grant permission for the moral disengagement that enables such castings to more easily play out in life.

REFERENCES

Alcohol advertising on sports television: 2001–2003 (2004). Center on alcohol marketing and youth (Georgetown University): Washington, DC. Retrieved June 29, 2007 at http://camy.org/factsheets/index.php?FactsheetID=20

Barthes, R. (1973). *Mythologies*. London: Paladin.

Booth, W. C. (1998). Why ethical criticism can never be simple. *Style*, 32, 351–364.

Burstyn, V. (1999). *The rites of men: Manhood, politics, and the culture of sport*. Toronto: University of Toronto Press.

Carroll, N. (2000). Art and ethical criticism: An overview of recent directions of research. *Ethics*, 110, 350–387.

Carter, D. M. (1976). *Keeping score: An inside look at sports marketing*. Grants Pass, OR: Oasis

Chambers, J. (2005). Taste matters: Bikinis, twins, and catfights in sexually oriented beer advertising. In T. Reichert & J. Lambiase (Eds.), *Sex in consumer culture: The erotic content of media and marketing* (pp. 159–177). Mahwah, NJ: Lawrence Erlbaum Associates.

Clarke, S. W. (2006, November). Football tailgating at Virginia Tech (typescript report). Blacksburg, VA: Virginia Tech University College Alcohol Abuse Prevention Center. Retrieved November 10, 2007 at www.ncsu.edu/police/Tailgating_Virginia_Tech.pdf

Coaches, CSPI urge NCAA to end beer ads on college sports (2005, April 1). Center for the Science in the Public Interest (Campaign for Alcohol-Free Sports): Washington, DC. Retrieved June 27, 2007 at http://www.cspinet.org/new/200504011.html

Collins, T., & Vamplew, W. (2002). *Mud, sweat, and beers: A cultural history of sport and alcohol*. New York: Berg.

Connell, R. W. (2005). *Masculinities* (2nd ed.). Berkeley: University of California Press.

Crawford, G. (2004). *Consuming sport: Fans, sport, and culture*. London: Routledge.

Douglas, M. (1966). *Purity and danger: An analysis of the concepts of pollution and taboo*. London: Routledge & Kegan Paul.

Eaglestone, R. (2004). Postmodernism and ethics against the metaphysics of comprehension. In S. Connor (Ed.), *The Cambridge companion to postmodernism* (pp. 182–195). Cambridge: Cambridge University Press.

Eagleton, T. (2003). *After theory*. New York: Basic Books.

Eco, U. (1979). *The role of the reader: Explorations in the semiotics of texts*. Bloomington, IN: Indiana University Press.

Ellickson, P. L., Collins, R. L., Hambarsoomians, K., & McCaffrey, D. F. (2005). Does alcohol advertising promote adolescent drinking? Results from a longitudinal assessment. *Addiction*, 100 (2), 235–246.

Enzenberger, H. M. (1972). Constituents of a theory of the media. In D. McQuail (Ed.), *Sociology of mass communication* (pp. 99–112). Harmondsworth: Penguin.

Farhi, P. (2005, December 31). The frat house is now closed; TV commercials clean up and dumb down. *Washington Post*, p. C1.

Fish, S. (1980). *Is there a text in this class? The authority of interpretive communities*. Cambridge, MA: Harvard University Press.

Give Bud the boot from World Cup, groups say (2006, June 22). Center on Alcohol Marketing and Youth (Georgetown University): Washington, DC. http://www.cspinet.org/new/200606221.html

Goldammer, T. (2000). *The brewer's handbook*. Clifton, VA: Apex.

Gregory, M. (1998). Ethical criticism: What it is and why it matters. *Style*, 32, 194–220.

Grube, J. W., & Wallack. L. (1994). Television beer advertising and drinking knowledge, beliefs, and intentions among school children. *American Journal of Public Health*, 94, 254–259.

Hartley, J. (1984). Encouraging signs: TV and the power of dirt, speech, and scandalous categories. In W. Rowland & B. Watkins (Eds.), *Interpreting television: Current research perspectives* (pp. 119–141). Beverly Hills, CA: Sage.

Heisler, W. (2004). What fun? Whose fun? Cyndi Lauper (re)covers "Girls Just Want to Have Fun." *Echo*, 6 (Spring), 1–24. Retrieved January 15, 2008 from www.echo.ucla.edu.

Hilliard, D. C., & Hendley, A. O. (2004, November). Celebrity athletes and sports imagery in advertising during the NFL telecasts. Paper presented at the annual meeting of the North American Society for the Sociology of Sport, Tucson, AZ.

Iser, W. (1974). *The implied reader: Patterns of reading in prose fiction from Bunyan to Beckett*. Baltimore, MD: Johns Hopkins University Press.

Iser, W. (1978). *The act of reading: A theory of aesthetic response*. Baltimore: Johns Hopkins University Press.

Iser, W. (2006). Reception theory: Iser. In *How to do theory* (pp. 57–69). Oxford: Blackwell.

Ives, N. (2003, July 31). After a wild period, beer ads sober up and put some clothes on. *New York Times*, p. C2.

Jhally, S. (2007). *Dreamworlds 3: Desire, sex and power in music video* (video). Northampton, MA: Media Education Foundation.

Katz, J. (1999). *Tough guise: Violence, media, and the crisis in masculinity* (video). Northampton: MA: Media Education Foundation.

Kellner, D. (2000). Cultural studies and philosophy: An intervention. In T. Miller (Ed.), *A companion to cultural studies* (pp. 139–153). Oxford: Blackwell.

Leach, E. (1976). *Culture and communication*. Cambridge: Cambridge University Press.

Machor, J. L., & Goldstein, P. (Eds.) (2001). *Reception study: From literary theory to cultural studies*. London: Routledge.

Madden, P. A., & Grube, J. W. (1994). The frequency and nature of alcohol and tobacco advertising in televised sports, 1990 through 1992. *American Journal of Public Health*, 84, 297–299.

Messner, M. A. (1992a). Like family: Power, intimacy, and sexuality in male athletes' friendships. In P. M. Nardi (Ed.), *Men's Friendships* (pp. 215–237). Newbury Park, CA: Sage.

Messner, M. A. (1992b). *Power at play: Sports and the problem of masculinity*. Boston: Beacon.

Messner, M. A. (2002). *Taking the field: Women, men, and sports*. Minneapolis: University of Minnesota Press.

Messner, M. A., & Montez de Oca, J. (2005). The male consumer as loser: Beer and liquor ads in mega sports media events. *Signs*, 30, 1879–1909.

Messner, M. A., Dunbar, M., & Hunt, D. (2004). The televised sports manhood formula. In D. Rowe (Ed.), *Sport, culture, and the media: Critical readings* (pp. 229–245). Berkshire: Open University Press.

Miller, T. (2001). *Sportsex*. Philadelphia: Temple University Press.

Nardi, P. M. (1992) "Seamless souls": An introduction to men's friendships. In P. M. Nardi (Ed.), *Men's Friendships* (pp. 1–15). Newbury Park, CA: Sage.

Oldenburg, R. (1989). *The great good place*. New York: Paragon.

Pateman, C. (2002). The fraternal social contract. In R. Adams & D. Savran (Eds.), *The masculinity studies reader* (pp. 119–134). Oxford: Blackwell.

Poulton, T. (2004, May 17). The issue in question: Are the days of T&A over for beer? *Strategy*, p. 2.

Pronger, B. (1990). *The arena of masculinity: Sports, homosexuality, and the meaning of sex*. New York: St. Martin's Press.

Rubin, L. B. (1985). *Just friends: The role of relationship in our lives.* New York: Harper & Row.

Sabo, D., & Jansen, S. C. (1992). Images of men in sport media: The social reproduction of gender order. In S. Craig (Ed.), *Men, masculinity, and the media* (pp. 169–184). Newbury Park, CA: Sage.

Scott, B. (2001). Beer. In R. Maxwell (Ed.), *Culture works* (pp. 60–82). Minneapolis: University of Minnesota Press.

Slater, M. D., Rouner, D., Domenech-Rodriguez, M., Beauvais, R., Murphy, K., & Van Leuven, J. K. (1997). Adolescent responses to TV beer ads and sports content/context: Gender and ethnic differences. *Journalism and Mass Communication Quarterly, 74,* 108–122.

Sperber, M. (2000). *Beer and circus: How big-time college sports is crippling undergraduate education.* New York: Henry Holt.

Stainback, R. (1997). *Alcohol and sport.* Champaign, IL: Human Kinetics.

Strate, L. (1992). Beer commercials: A manual on masculinity. In S. Craig (Ed.), *Men, masculinity, and the media* (pp. 78–92). Newbury Park, CA: Sage.

Swain, S. (1989). Covert intimacy: Closeness in men's friendships. In B. J. Risman & P. Schwartz (Eds.), *Gender in intimate relationships: A microstructural approach* (pp. 71–86). Belmont, CA: Wadsworth.

Tompkins, J. P. (Ed.) (1980). *Reader-response criticism: From formalism to post-structuralism.* Baltimore: John Hopkins University Press.

Wann, D. L., Melnick, M. M., Russell, G. W., & Pease, D. G. (2001). *Sport fans: The psychology and social impact of spectators.* New York: Routledge

Wenner, L. A. (1991). One part alcohol, one part sport, one part dirt, stir gently: Beer commercials and television sports. In L. R. Vande Berg & L. A. Wenner (Eds.), *Television criticism: Approaches and applications* (pp. 388–407). New York: Longman.

Wenner, L. A. (1994). The dream team, communicative dirt, and the marketing of synergy: USA basketball and cross-merchandising in television commercials. *Journal of Sport and Social Issues, 18,* 27–47.

Wenner, L. A. (1998). In search of the sports bar: Masculinity, alcohol, sports, and the mediation of public space. In G. Rail (Ed.), *Sport and postmodern times: Culture, gender, sexuality, the body and sport* (pp. 301–332). Albany, NY: SUNY Press.

Wenner, L. A. (2004). Recovering (from) Janet Jackson's breast: Ethics and the nexus of media, sports, and management. *Journal of Sport Management, 18,* 315–334.

Wenner, L. A. (2006). Sports and media through the super glass mirror: Placing blame, breast-beating, and a gaze to the future. In J. Bryant & A. A. Raney (Eds.), *Handbook of sports media* (pp. 45–60). Hillsdale, NJ: Erlbaum.

Wenner, L. A. (2007). Towards a dirty theory of narrative ethics. Prolegomenon on media, sport and commodity value. *International Journal of Media and Cultural Politics, 3,* 111–129.

Wenner, L. A. (2008a). Gendered sports dirt: Interrogating sex and the single beer commercial. In H. Hundley & A. Billings (Eds.), *Examining identity in sports media. Thousand Oaks,* CA: Sage.

Wenner, L. A. (2008b). Playing dirty: On reading media texts and the sports fan in commercialized settings. In L. W. Hugenberg, A. Earnheardt, & P. Haridakis (Eds.), *Sports mania: Essays on fandom and the media in the 21st century.* Jefferson, NC: McFarland & Company.

Wenner, L. A. (2008c). Super-cooled sports dirt: Moral contagion and Super Bowl commercials in the shadows of Janet Jackson. *Television and New Media, 9,* 131–154.

Zwarun, L., & Farrar, K. M. (2005). Doing what they say, saying what they mean: Self-regulatory compliance and depictions of drinking in alcohol commercials in televised sports. *Mass Communication & Society, 8,* 347–371.

Zylinska, J. (2005). *The ethics of cultural studies.* London: Continuum.

On the Lite Side? Miller Lite's Men of the Square Table, Man Laws, and the Making of Masculinity

LINDSEY J. MEÂN

Sport is a powerful, highly mediated cultural site in an increasingly mediated society. While the influence of mediated texts on the construction of culture and shared meanings is widely acknowledged, Jansson (2002) argues that mediatization itself generates commodification and consumption by deploying the intertextual relations between products, practices, and communities to construct meanings. This positions intertextuality at the heart of meaning making, as a key element in the self-referential process that re/produces coherent interrelated concepts, products, and discourses, and as comprising an important part of interpretation for particular audiences or interpretative communities. This is highly relevant given that sport has been positioned as a site or discourse that has particular intertextual significance or cultural "figurability" (Shapiro, 1989, p. 72). Powerful intertextual relations link sport with politics, war, nation/alism, masculinity, heroics, and associated discourses, positioning sport as a prominent ideological force in the construction of identities and hegemonic masculinity.

The significance of sport for identities suggests that sport audiences are likely to be highly subject to the meanings and definitions of sporting texts (Scherer, 2007; Walsh & Guilianotti, 2001; Wenner, 1991). Similarly, sports texts are noted to have features that provide powerful aids to construct shared meanings amongst their interpretative communities (Wenner, 1991) as part of the

discursive action through which identities are performed and achieved. Indeed, the deployment of familiar narratives, practices, and intertextuality comprises a crucial element to guide and assist shared understandings within categories or interpretative communities (Jansson, 2002). As such, while parody and humor can be used to undermine stable definitions, humor can also ironize or undermine challenges to core category definitions serving to police boundaries rather than expand them. Effectively, in addition to the disciplining of gender transgressions, the humorous deployment of extrematized core definitions can also serve to re/produce more ordinary or familiar central versions or category members

SPORT, GENDER, AND IDENTITY

Gender remains a critical category in culture. Significant in the construction of culture, sport is a crucial site for the demarcation of gender that·serves to re/produce males as the standard and hegemonic hyper/masculinity as the norm. Since categories are constructed through oppositional, dichotomous relations (Lakoff, 1987), sporting masculinity assumes heterosexuality and re/produces nonstandard forms (such as women or gay men) as "othered" (Vertinsky, 2006). This is strategically achieved through the policing of category boundaries and definitions by re/presentational practices and discursive actions that resist and exclude alternative versions of masculinity and femininity to re/produce and police narrow hegemonic definitions (Foucault, 1970, 1972, 1977; Gumperz, 1982). These practices effectively frame nonhegemonic male forms as gay and female forms as hetero/sexualized or else symbolically erased (Kane & Lenskyj, 1998)—acts of power that re/produce hegemony (Foucault, 1970).

Identity categories are not facts of nature but are linked to the re/production of power and knowledge. This in part accounts for the contradictory nature of identities and their category entitlements as we are subject to resisting and re/producing the hegemonies that oppress us (van Dijk, 1993). As such, identity categories are negotiated, achieved, and performed (i.e., constructed) in ways that are strategic, motivated, and political (Potter, 1996) in relation to predominant discourses, definitions, and entitlements (such as knowledge, interests, behaviors). Intertextuality is the process through which meanings, identities, discourses, and the like are re/produced and mobilized through even the most minimal of referents (O'Donnell, 1994), as part of the everyday discursive action of talk and texts (Potter, 1996). Identities arise from and are embedded in discourses, hence we are emotionally subject to the discourses from which our identities arise and especially to foundational or self-constituting discourses (Maingueneau, 1999). As I have suggested elsewhere (e.g., Meân, 2001), the

intertextual and cultural relevance of sport, alongside its intrinsic "innocence" and significance for gendered identities, means that it should be considered a foundational discourse. Thus, while the intertextuality of gendered discourses serves to re/produce a set of interrelated categories, definitions, and entitlements linked to male power, sport serves as a key site and intertextual referent for the construction and performance of masculinity and the myth of hegemonic masculinity (Barthes, 1957/1972).

BEER, SPORT, AND MASCULINITY

Sport remains predominantly male and masculinized, a last bastion of male hegemony, power, and privilege (Hardin, 2005; Messner, 1988). Thus the intertextual benefits for highly masculinized products—such as beer—are evident. Nonetheless, approximately 25% of American women are now drinking beer (http://morefocus.com) and women are increasingly watching sport (estimates include up to 50% of audiences, although digital sport media have low female usership with 96% male traffic reported at sports websites http://sportsdirectinc.com/SPORTS-CONTENT/advertising.html). Equally, while 75% of men may be drinking beer, it is likely that a substantive proportion of beer is purchased by women for male consumers. Advertisers are likely to be aware of these trends, even if most cultural texts still re/produce the idea that women do not have a natural place in sport or beer consumption. Hence mediated sport and beer texts typically include traditional, hetero/sexualized femininity positioned mainly in support roles as part of the commodification of both the product and its concept for consumption (e.g., "Miller Lite Girls," cheerleaders). Nonetheless, as viewers and purchasers (albeit less than men), women themselves are part of the interpretative community that shares and resists the identities, understandings, and ideology re/produced in mediated texts about sport and beer, and thus also subject to the predominant gendered discourses and hegemonies re/produced in their intertextually linked narratives. Both men and women's participation in re/producing the gendered discourses and definitions about sport and beer epitomizes hegemony (van Dijk, 1993), the re/production of power, and the cultural significance and embeddedness of traditional gendered identities.

The increased sport mediatization of the last 20 years has enhanced further the power of sport as a sociocultural force, and hence as a key site for the construction of gendered identities and deployment in the wider processes of commodification. Consequently, it should be considered no surprise that sport has become a highly commodified site used as a powerful intertextual referent

for the construction of meanings, particularly for meanings that re/produce and value traditional hegemonic masculinities and national identities. Thus the link between sport and beer as a *natural* teaming and endeavor for *real* American males effectively re/produces an interrelated set of patriotic, heroic, gendered discourses that constructs a hegemonic version of All-American masculinity as the right to pursue sport, beer, and male liberty. But achieving this version of ideal masculinity requires not only the policing of masculinity, but also that women be framed as traditionally feminine objects of male hetero/sexual possession.

In the analysis that follows, the construction of masculinity and the mobilization of interextual relations to sport and beer within the Miller Lite "Men of the Square Table" or "Man Laws" advertising campaign are explored. The America-specific campaign involved multimedia-integrated marketing that was initially promoted through television commercials and an "interactive" website (which included the television commercials). A brief description at this point (discussed in more detail below) would seem helpful for those unfamiliar with the campaign and its core narrative that centered on a secret all-male "Council" debating and inscribing the "unwritten rules" of masculinity. Thus the television commercials (humorously) depicted the "Council" as making "Man Laws" in a secret room, seated around the "Square Table" and drinking Miller Lite. The "Council" comprised nationally or internationally known hyper/masculine American males (predominantly sport-associated) and the "Laws" concerned beer, masculine behaviors, and masculinity.

As part of the "interactive" element of the campaign, the public could submit "Man Laws" at the website to become part of the "Manlawpedia." The impact of the campaign could be measured by the number of Man Law submissions (in excess of 100,000, according to Fredrix, 2007) alongside the fact that the commercials were widely posted, replicated, mimicked, and discussed—mainly by men—on many Internet sites, blogs, radio (talk) shows, and other media. Thus it seems the campaign became a talking point for and about masculinity. Indeed the "Man Laws" have even their own entry on Wikipedia, which notes that it was "inspired by the unwritten codes by which men live" (http://en.wikipedia.org/wiki/Man_Laws, November 2007).

Based upon the cyclical process that re/produces shared cultural knowledge (Hall, 1997), the analysis focuses on the construction of identity categories and associated concepts within the discursive action of the text; that is, how they are put into action (deployed, enacted, and mobilized) to guide meaning making within the interpretative community. A key element in the process of commodifying for consumption, construction of meaning relies heavily on the deployment of intertextuality and familiar, hegemonic understandings that in turn re/produce

predominant discourses and ideologies. Consequently, critical discourse analysis with an emphasis on rhetoric and discursive action provided a useful approach to exploring how the campaign texts constructed categories and meanings. However, given that humor was a core element of the campaign, strategic deployment and disciplining action of humor need consideration before discussing the analysis.

HUMOR AS A DISCIPLINARY PRACTICE

Humor has multiple, interrelated functions, two of which are pertinent for consideration here. First, humor can be deployed to frame strategic, motivated, political, and social actions as "merely" funny and, therefore, intrinsically innocent. Second, humor can be deployed to re/produce discourses and categories, as part of the disciplinary function of culture to both police (Butler, 1990) and gatekeep category boundaries (Gumperz, 1982).

The accusation of failing to have a sense of humor is often used to undermine the critical analysis of the comical deployment of stereotypical and prejudicial ideas that effectively function to re/produce hegemonic discourses and power. Consequently, humor can be a powerful tool that strategically serves to inoculate against accusations, for example, of sexism and homophobia by implying that a "message" about beer, sport, and masculinity should be treated ironically rather than as endorsing "unreconstructed" masculinity. However, the argument that a "text" was just being funny cannot fully undercut the underlying category definitions and meanings being deployed and hence re/produced, since something can be funny and confirmatory while also being offensive (Billig, 2001). Thus, the presence or absence of a sense of humor does not prevent the re/production of problematic framings and ideologies, particularly widely accepted cultural meanings (or myths). This is especially pertinent given the powerful features that construct shared meanings and identities within the interpretative communities of sport (Scherer, 2007; Wenner, 1991). Indeed, the significance of re/presentational practices lies in the predominance of particular meanings (and the lack of diverse alternative meanings) combined with the significance of the site, and the vulnerability of the interpretative community for that site.

Equally, humor works to (appear to) push category boundaries while simultaneously policing the category. Humor can effectively re/produce predominant power relations and category definitions as well as undermine them, a disciplinary tool deployed to re/produce central category membership and definitions. Humor as a gatekeeping practice serves to maintain external boundaries by "othering" and excluding those who do not "fit" the category, simultaneously serving to re/produce internal category boundaries by policing the performance of

category members (who would otherwise risk category membership). Similarly, the deployment of extrematized versions of category membership (Potter, 1996) also serves to police and discipline identities.

Thus humor can effectively re/produce American masculinity within hegemonic constraints by simultaneously "othering" alternative framings as feminized and gay and providing extremetized versions of core definitions. This strategy is highly relevant for the Man Laws campaign that included the ironic intertextual deployment of sport to re/produce the male category, and hence of beer, as hegemonically masculine. Thus, the humorous scene in two broadcast commercials of Mr. H's (hypermasculine wrestler/actor Triple H) intentionally superfluous ripping off of his shirt to reveal a large, well-muscled body was not deployed to undermine this version of masculinity, but rather to allow us to admire it while acknowledging the extreme version of masculinity being performed. Placed on the website, the broadcast commercials were available for multiple viewings by a self-selecting interpretative community. Nonetheless, copies of the commercials, other Man Laws texts, and related discussion were also readily available at other digital sites (posted on blogs, http://youtube.com, etc.), thus achieving a wide amount of public dissemination.

MILLER LITE'S "MEN OF THE SQUARE TABLE"

In 2006, Miller Lite's Men of the Square Table ("Man Laws") integrated marketing campaign was launched. Initially incorporating television commercials and a website that included consumer-generated content in the form of laws submitted to the "ManLawpedia," the campaign reflected the integrated marketing approach that offers more than traditional broadcast and print advertising. The Man Laws campaign was based on the premise of "A secret council of men who have met behind closed doors for the last 900 years, they determine what's in good taste—and what's not—regarding women, style, fashion, property, shopping behavior, finances,..." (http://cpbgroup.com, 2007) and the "Unwritten Laws of Man" or Man Laws. Intertextually referencing the Knights of the Round Table and the Rules of Chivalry, the Men of the Square Table (a.k.a. The Council) and Man Laws mobilized discourses of an earlier and less complicated age—a time when, popular mythology suggests, men were (real) men, women knew their place (as chattel), and the victor took it all. Equally, the secretive and unwritten nature of the Council and its Laws intertextually references the secret society of the Knights Templar. Heroic narratives and the pursuit of a noble cause are shared features of sport and knight discourses, both of which are replete with pageantry and protagonists noted for athleticism and fighting prowess. Thus, the

similarities between the masculine values and behaviors embedded in the heroic and glamorized discourses of sport and knighting clearly suggest equivalence in their intertextual function as constructors of a traditional version of the male category and its entitlements.

A key focus of the Miller Lite campaign, in addition to the humorous broadcast commercials of the Council making Man Laws, was the website and the opportunity for consumers to submit their own Man Laws to the website ManLawpedia, which was reported to have generated more than 100,000 submissions (Fredrix, 2007). Digital media have arguably had the primary impact on the move to integrated marketing strategies, providing sites that construct a false sense of active participation and control while actually constructing and guiding users' experiences (Graham & Hearn, 2001; Jansson, 2002). Along with other features that render them particularly powerful re/producers of meaning, the illusion of choice and agency has been argued to account for the success of marketing strategies through websites (Graham & Hearn, 2001). Given that the strong identification of sports audiences suggests they are especially vulnerable to sporting commodification (Walsh & Guilianotti, 2001; Wenner, 1991), the special characteristics of websites suggest that the users of sport-associated websites are likely to be highly subject to the meaning making at these sites (as the self-selected interpretative community). Indeed a recent study suggests that these factors largely account for the huge success of the digitally marketed Adidas rugby campaign (Scherer, 2007). Consequently, sport, masculinity, and beer in Miller Lite's digital components of the integrated marketing campaign were likely to be especially powerful sites for the shared construction of meanings, including the re/production of categories.

Additional aspects of the marketing campaign further linked sport, masculinity, and beer, re/producing the intertextual embeddedness of these concepts around a core category of hegemonic masculinity. The campaign included: a public search for the next member of the Council, culminating in a Las Vegas event; integrated marketing with FHM magazine and with the sport-associated charity V Foundation for Cancer Research (founded by ESPN and Jim Valvano, former NC State basketball coach and broadcaster). The charitable partnering with The V Foundation involved selecting it as the site "for the 'Man Laws' football auctions" (Nick Valvano, CEO V Foundation reported on http://sev.prnewswire.com, August 31, 2007), comprising eight regular season auctions around eight selected NFL football games and a national auction at the "big game Feb. 4, 2007"—all featuring many "well-known former players" (http://sev.prnewswire.com). The charitable partnership between the V Foundation and Miller Lite continues, along with the charitable NFL football associated auctions, continuing the key association of beer, American football, and masculinity.

MANLAWS.COM

Typical of alcohol-related sites, entering the website required that consumers enter their date of birth first. Easy to fake, date of birth at ManLaws.com[1] was entered into a simulated wood panel and combination lock enacting access to an exclusive and secret site. Simulated wood invokes images of sophistication, wealth, class, and reverence (wood paneling in luxury cars, traditional upper-class libraries, exclusive men's clubs, etc.) while also acting as a barrier (door, wall) to exclude the undesirable and inappropriate, that is, those who do not fit the category. Successful navigation of the lock triggered the simulation of an automated, mechanical apparatus that rather ceremoniously "unlocked" the barrier allowing the user to enter the site. The blurring of the modern and the historic was apparent in the combination of sophisticated simulation with mechanized apparatus and wood to enact the idea of a form of modernity (or modern man) steeped in traditional values—the wooden veneer giving way to something more complex and sophisticated, suggesting both hidden depths and secrecy.

The opening webpage invited consumers to "POST A MAN LAW" deploying an image of a board resembling a sport scoreboard and a stock exchange board, embedded within wood. The immediate invitation to post suggested interactiveness and a prioritizing of users' contributions as highly valued, constructing an illusion of control and participation. The stock exchange reference mobilized discourses of business, commerce, financial capital, and their associated (white) male power, further enacted by a side panel that mimicked features of the stock exchange. Under the heading "REGIONAL UPDATES," the content moved through a variety of U.S. states and cities, listing three items related to masculinity (listed like commodities or markets) and reporting a percentage figure with a red arrow to indicate whether these were up or down (e.g., "GOATEES ▼ –33.7%," "HAIR GEL ▼ –07.1%," "BLIND DATES ▼ –02.7%"). Both sport and the stock exchange are sites of serious endeavor predominantly associated with aggressive, hegemonic male power, enacting the site as a masculine domain and, thus, positioning beer as a serious male endeavor.

The regional updates were present also on the webpages for "The Council," "Videos" (Man Law broadcast commercials), and "ManLawpedia," along with the Miller Lite logo. An additional intertextual reference to sport and news (general, sport, and business), hence masculinity, was evident in a "tickertape" running across the bottom of "The Council" and "Videos" webpages, which reported both Man Laws and "news." The association of the news with sport and masculinity also was mobilized by sporting content (e.g., "CALI.: LACROSSE MAN STAYS COURSE WITH FOOTBALL TEAM PICKED DURING PRESEASON") and transgressions of masculine behavior (e.g., "MISS.: MAN BUYS HIMSELF

A TAN FROM A SALON.""). While this intertextuality continually re/produces the link between sport, commerce, masculinity, and Miller Lite, mobilizing predominant discourses about masculinity, it also serves to police the category by "othering" those who perform alternative versions of masculinity by highlighting transgressions of category boundaries.

Discourses of hegemonic masculinity were further mobilized through iconic technical imagery associated with vintage spy films, such as the older James Bond movies, as well as spoofs of this genre. Traditional computers and early technology were enacted by the visual deployment of a traditional, old-fashioned metal switch under "SELECT MODE" to choose "POST LAW" or "VIEW LAW." Similarly, large rectangular buttons denoted "RESET" (white, neutral color) or "SEND" (green for go). Below the regional updates, three visual images that appeared to resemble surveillance cameras or videos further enacted iconic imagery of the spy genre and related cultural sites. These also functioned to provide links to "VIDEOS" of the broadcast commercials, "BIOS" of The Council, and "POST A MAN LAW."

The Council

Within the campaign's narrative, the Council's original function was directly beer related as "For centuries, the Men of the Square Table fiercely debated the qualities of great tasting beer....[until] shortly after Miller Lite's introduction in 1975, these arguments came to a halt." Miller Lite was then named the "official beer of the Men of the Square Table" with "truly no debate" (http://manlaws.com). The restriction of the debate to men and the century-old epic quest for the "holy grail" of beer are mobilized through the intertextual referencing of the Knights of the Round Table and associated heroic discourses and narratives that work to re/produce the categories of beer, heroism, and decision making as male. Use of the term "official" can be seen to deploy the common phrasing of sports sponsorship. Similarly, the phrase "no debate" and its repetition in the tagline alongside the familiar sporting phrase and Miller Lite–associated "Good Call" work up notions of great decisions, further mobilizing masculine and sporting discourses.

As the group that makes the "Rules of Man" and made the "Good Call" about Miller Lite, the members of the Council themselves powerfully enact the category of hegemonic masculinity as linked to sport, hence beer. In September 2006, the Council comprised: Mr. Reynolds (Burt), Mr. H (Triple H), Mr. Ralston (Aron), Mr. Murray (Ty), Mr. Griffin (Eddie), Mr. Gesner (Zen), Mr. Flynn (Jackie), Mr. Binnie (Brian), Mr. Bus, Mr. Renteria (Paul), Mr. De La Hoya (Oscar), Mr. Hart (Carey), and The Scribe. Five members were later added: Mr. Blu (Rodney), Mr. Johnson (Jimmy), Mr. Kelly (Jim), Mr. Markbreit (Jerry),

and Mr. Richmond (Mitch). The repeated use of the formal title "Mr." positions the Council members as revered and respected. The members of the Council are acknowledged in other mediated texts, such as wikipedia.com, as "macho" men. Most Council members are linked to two or more activities or professions used to frame them as prototypical, hegemonic males through masculinized discourses of sport, heroism, and womanizing. For example, Burt Reynolds is noted for his acting, stunt driving, college (American) football career, and stock car team ownership as "credentials [that] begin long before he sipped champagne from the shoes of at least five Hollywood bombshells" (http://manlaws.com). This re/produces Reynolds as the quintessential heterosexual male success, measured by his links to sport (as both player and owner) and his success with the prototypical, hegemonically desirable females, "Hollywood bombshells."

Sport and athleticism dominated the Council with ten members linked to traditional professional sport careers, three with other sporting endeavors (college sports, mountain climbing, professional wrestling), and three associated with sport (a coach, a referee, and an "on-air" sport personality). American football comprised the most dominant sport within the Council (three pro players, one college player, one referee, and one coach), intertextually promoting Miller Lite's association with the NFL and its (hypermasculine) values. Equally, three are linked to stunt work and one is an astronaut/pilot, areas of work widely viewed as athletic, daring, and macho. Nine work also as actors, two as musicians, and two as comedians. While examining each member is beyond the remit of the chapter, their biographies constructed a version of heterosexual hypermasculinity steeped in sport and aggression, the latter emphasized for those members whose lack of sporting credentials might lead one to question their category centrality. For example, as an actor and comedian, Griffin's comedy was framed as humor that "takes no prisoners and redefines the term 'brutally funny'" to re/produce the aggressive masculinity required for membership of the Council.

MAN LAWS, MAKING MAN LAWS, AND
MAKING MASCULINITY

Complementing the hyper/masculinity of the Council, three overlapping strategies were identified that deployed the intertextual linking of beer, sport, and traditional masculinity to re/produce hegemonically gendered discourses: constructing and policing masculinity; "othering" homosexuality; and framing femininity. Together these worked to re/produce traditional, oppositional gender categories and power relations around beer and sport as male entitlements.

Constructing and Policing Masculinity

The making of Man Laws was the subject of the broadcast commercials that involved the Council sitting around the Square Table briefly discussing and ruling on a series of dilemmas facing men. The ruling of a Man Law was followed by one of two taglines reiterated in other Miller Lite campaigns: "Miller Lite. Always a good call," intertextually linking Miller Lite to sport and mobilizing associations of excellent judgment over crucial issues; "For great taste there's no debate," linking decisive masculinity and the unquestionable superiority of Miller Lite. A number of the broadcasts closed with a close-up of a man's hand prising open a bottle of Miller Lite using just his thumb, a "macho" action that follows familiar sporting practices that metaphorically and directly frame men and their bodies as tools or weapons in mediated re/presentations (Jansen & Sabo, 1994) and male sporting performances (Messner, 1990).

The Man Law discussions took place in a secret "glass" room with restricted access suggesting valued and secret content, hence the room was soundproof (confirmed in the commercial featuring the singer Jewel, discussed below) and probably bulletproof. Wikipedia.com describes the room as "Dr. Strangelove-esque," reflecting the continued intertextual mobilizing of old-school spy genres and spoofs that bring together traditional masculinity, sex, and technology. The initial camera sequence moved the audience eye into the room from outside, enacting the secrecy and seclusion of the room to signify both the importance of the action in the room and the audience's inclusion and, therefore, collusion in it. This invitation to participate was further enacted via the website and the search for a new member of the Council.

Most of the broadcast commercials were directly or indirectly related to sport. Beyond the specific Man Laws, the framing of their discussion enacted hyper/masculine behaviors and actions that served to re/produce hegemonic male identity as a restricted category linked to particular entitlements. This was achieved through reference to the narratives and actions that constructed the personas or identities of the Council members, mobilizing intertextually linked discourses about hegemonic masculinity and sport or sport-related activities, injury, competitiveness, and other such symbols. Thus the commercial for the Law "Men go for it" was framed around a specific example from American football with Reynolds stating "You're down by one," with the assumption of audience knowledge about the football reference (football was not directly mentioned) framing and gatekeeping the interpretative community for the text. Debating the dilemma of whether to "go for the win" or "play safe," going for it was enacted as the manly, patriotic choice, intertextually making beer the manly patriotic choice. Patriotism, American heroism, and the fight for independence were mobilized in the statement "This nation

wasn't founded on playing it safe," with the deployment of the term "founded" intertextually referencing the founding fathers, the nation, and the constitution (as another set of foundational Laws).

Subsequent narratives further positioned playing safe as unacceptable, deploying extreme male sporting behaviors to construct an idealized version of tough, hegemonic American masculinity. These narratives focused on risk-taking, bravery, and the commonality of injury, first deploying the iconic American pursuit of strapping oneself to a "2000lb bull" (Ty Murray) followed by a reference to Carey Hart's "two broken arms" minimized and made ordinary by his reply "which time?". While the text functioned to re/produce a familiar patriotic, sporting hyper/masculinity as the American standard, the association with Miller Lite similarly served to work up the Miller Lite brand as the American standard. Similarly, the idea that real American "Men go for it" and the immediacy of the Miller Lite tagline (with the beer bottle being pried opened as the closing image) intertextually and contiguously suggested that *real* men go for Miller Lite beer.

The ownership of unopened beer bottle taken to a friend's house culminated in the deployment of the (American) football associated "Tuck Rule" that one beer can be taken home if it "fits in your pocket," linking the desire and ownership of beer to sporting knowledge, hence masculinity. The tainting of beer from another man's "stinking fingers" in the neck of the beer bottle while carrying it from the bar resulted in the ruling "You poke it, you own it," mobilizing discourses that frame men as concerned with ownership and territory, alongside concern about even indirect male contact. Of course, the generality of the language choice of "it" and the multiple meanings of "poke" means that this ruling can be read as refer-ring to women also. This I will return to later in the chapter, but it is relevant to note that this rule works to intertextually re/produce all three categories discussed in this analysis: that is, masculinity that is simultaneously depicted as heterosexual and homophobic, but which also frames women as part of (heterosexual) male territory as sexual objects.

Sole male use of the garage fridge for beer storage confirmed the demarca-tion of the genders and the boundary between male and female domains with the statement that "the line is the line," further referencing the sport/war intertext (Shapiro, 1989) and emphasizing the demarcation of male/female activities and interests—notably in this instance demarcating beer as a male interest. Positioned as the only male "sovereign territory" left, the garage fridge (and the beer inside it) also signified the struggle for domestic power and women's continued insurgence into male domains, potentially including beer drinking. The use of the garage fridge discussion included a narrative referencing the use of powertools, the cut-ting off of fingers, and the life-saving self-amputation of Aron Ralston's forearm

during a solo expedition using just a "pen knife"—all culturally familiar or mythic references that re/produced the predominant codes of masculine behavior around beer, sport, powertools, and heroic manliness.

Equally, rulings about leaving the game early to beat traffic, selecting a team to support when watching sport, and overreliance on the "D-Fence" sign in football all reveal the significance of sport for the intertextual construction of beer and masculinity. Further policing of appropriate male category behavior and entitlements was re/produced in debating the overuse of high fives and the crushing of beer cans on foreheads. Although both were linked to a nostalgia for a past when the high five was cool and cans were more robust and harder to crush, rendering the act of can crushing a meaningful performance of masculinity, the high five was deemed overused but without anything to replace it. Like other parts of the campaign, this served to lament earlier, less complicated times when real masculinity was easier to perform and ascertain. However, the continuance of the high five also served to recognize the widely enacted symbolic function of this gesture as reward or affiliation within sporting contexts.

The Law "Sharing is caring" requiring sharing beer, even amongst friends, was used to work up the significance of beer for men. The ruling was accompanied by disappointment and the grudging sharing of many previously hidden beers, serving to ironize the Law by enacting instead a version of masculinity that is naturally the opposite of sharing or caring. Instead, the cunning and competitive protection of beer apparent in the miraculous revealing of numerous beers (including a keg) re/produces masculinity as naturally, creatively competitive and aggressive, intertextually mobilizing traditional sporting discourses and competition over beer.

The Man Laws disseminated and submitted through the website and its ManLawpedia further revealed the intertextuality between beer, sport, and masculinity. The policing of appropriate masculine behavior through the intertextual mobilization of competitive, aggressive, and heroic discourses of sport and chivalric knights alongside framing the ownership and treatment of women, beer, and men who do not perform appropriate masculinity served to re/produce a clear category definition for the interpretative community. For example, "Men shall nary bump chests when offering a toast relying on a clinking of drinking vessels to punctuate a special moment of import" uses language choices that suggest ancient values and rules ("nary," "vessels") while intertextually referencing a highly masculinized and physical sport-associated celebration ("bump chests"). This works up the "special moment" as sport, and similarly sport as important, and further associates this with drinking (i.e., beer) as an appropriate part of the action and celebration of sport. Equally, it suggests that bumping chests and clinking beer are interchangeable, symbolically equivalent masculine behaviors.

"Othering" Homosexuality

The link between sport and male heterosexuality means that the intertextual deployment of sport ensures that male heterosexuality is assumed. But since categories are not fixed and subject to resistance, the disparaging of homosexuality and "othering" of alternative versions of masculinity re/produces traditional hegemonic male power by strengthening category boundaries. Consequently, while many Man Laws police proper masculine behavior around sport and beer, others function to demarcate and exclude alternative forms of masculinity and to "other" homosexuality. An obvious example was the Law "Don't fruit the beer." Referring to the use of a piece of lime, this Law intertextually references *foreign* beers drunk with lime (e.g., Corona), feminine drinks, and, very overtly, homosexuality. The choice of the phrasing and the use of the word "fruit" to signify both a piece of lime and a gay man directly construct the category as heterosexual, framing gay men as excluded from the category of men and beer drinkers and serving to demonstrate the risks of losing category membership. The feminizing or "camping up" of drinks also was enacted in the script through references to cocktail umbrellas and "beera colada," further "othering" both women and homosexuals.

Antigay rhetoric was further mobilized in the commercial policing the clinking of bottles as a toast. The potential touching of a friend's saliva from the clinking of bottle tops was likened to kissing him, which caused conspicuous concern and was immediately ruled out. Reynolds' subsequent ruling about touching (bottle) "bottoms" was also framed as a reference to homosexuality, with Ty Murray's statement "No thanks Hollywood, I ain't into that" positioning him as heterosexual while simultaneously referencing *Brokeback Mountain* and undercutting the recent Hollywood framing of gay cowboys and the familiar intertextual reference to cowboys as iconic gay figures.

The deployment of feminization to police heterosexual masculinity and to mobilize antigay rhetoric was evident in many of the Man Laws and related items across the campaign sites. One print advertisement in FHM deployed the familiar signifiers of gayness and femininity to police the male category of beer drinkers with the law "No man shall own a dog smaller than a football." Mobilizing the feminized and homosexualized stereotype of a preference for small dogs and deploying a football as a referent for dog size worked to frame "man" as applicable only to heterosexual men. It further served to re/produce sport, hence beer, as a heterosexual male category. Further male/female stereotypical practices were mobilized in the FHM advertisement for the Law "No matter how long the trip, a man's suitcase shall not exceed 1.8 cubic feet." Mobilizing the familiar stereotypes of women as always packing too much alongside the visual image of a man packing a car trunk served to re/produce gendered discourses and police

masculinity by framing men who pack too much as feminized, hence gay. Equally, the man packing the trunk served to re/produce the familiar gendered domestic labor divide. The deployment of volume or capacity measurement mobilized familiar stereotypes about technically minded heterosexual males, intertextually referencing cars and their specifications as another site of male interest. Similarly, Man Laws and website "news" items about tanning, pedicures, and wearing skirts (unless a "Scotlander") consistently mobilized traditional discourses of homosexuality, constructing it in opposition to the hegemonic, heterosexual masculinity of sport-loving, beer-drinking men.

Framing Femininity

The deployment of women and femininity simultaneously constructed masculinity in opposition to femininity, "othering" women from the male categories of beer and sport to re/producing traditional gendered power relations. Thus, like beer, the Council debated the ownership and positioning of women, and when and how men should behave regarding women, beer, and sport. This was apparent in the Law concerning how long your friend's ex-girlfriend was "off limits." The initial idea that a woman was "off limits" forever was overturned in light of the dilemma of her being "drop-dead gorgeous." An instant revision to six months served to re/produce women's value and worth within traditional standards of hegemonic beauty and of men valuing women for their appearance. While the narrative positioned the male friend as having been dumped, potentially framing the women as having some power and decision-making status, this element was arguably more related to the issues of ownership and tainted goods reflected in the "You poke it, you own it" Law. (Indeed, a reedit of these two commercials applying the "You poke it…" Law to ex-girlfriends and entitled "Done right" was found on http://youtube.com, submitted by marqueewrestling.) Clearly then, the reading of the "You poke it…" Law as referencing women was part of the understanding made by the interpretative community.

Equally, while the "off limits" Law could be assumed to presuppose the woman's agreement in dating, the decision and power to decide how long a woman is "off limits" was framed as being outside women's sphere of action and belonging to the men. Indeed, the Man Law "Should two men fall in love with the same woman a challenge must be agreed and the two must compete. Winner take all" (from the ManLawpedia) directly enacts a combative and competitive sporting masculinity as the route to male possession of a female. Despite mobilizing discourses of love, this law positions the woman as a trophy and as part of the spoils of competition ("winner takes all"); further mobilizing the sport/war intertext. Thus, just like the beer, the ball, and parts of the sports field, women were subjected to the rules and ownership of men.

Hegemonic discourses about females and feminine beauty were further mobilized in the commercial featuring singer Jewel, as World Rodeo Champion Ty Murray's girlfriend. In this text the camera switches viewing positions between the inside and the outside of the soundproof "cube," framing oppositional perspectives of male and female viewpoints. Interrupting the Council's debate on whether a man should drive a hybrid car, Jewel arrives talking on her cell phone. Concern about having to move the "glass meeting cube" is countered by Murray's "she won't say nothing," but the idea that Jewel will keep the secret is immediately negated as Jewel states somewhat disparagingly into her phone, "Yeh, he's in his man box." This suggests that not only is she saying something now, but that she has clearly said something before, since the initial utterance ("yeh") suggests confirmation rather than introduction of a new conversational topic. Thus, while Jewel's wearied tone and use of "man box" suggest that she doesn't value or appreciate the Council and the Man Laws, framing them as tiresome, she is also framed as the typical woman who cannot keep a secret and talks continuously (on her phone), re/producing familiar narratives of women as gossipers and as dismissive of men's space and camaraderie.

In response to Murray's apparent plans to leave, Reynolds starts to police the meeting and masculine category, stating there are "rules about ditching your friend." But on viewing Jewel, who is now smiling and waving at him through the glass, Reynolds switches the discussion to next week. Murray eagerly leaves, accompanied by the enthusiastic approval of fellow Council member Jimmy Johnson's "How 'bout that cowboy." Thus, the text re/produces the notion that hypermasculinity gets beautiful women, winning the respect of other men who comprise members of the sporting male category. The text further works to mobilize traditional discourses about the lure and power of beautiful women over men, at the same time suggesting that it is alright to succumb if the woman is beautiful enough. Equally, while Jewel is not dressed as a seductress (little makeup and not highly eroticized, although she is wearing a sexualizing short denim skirt), she is positioned as somewhat duplicitous as her wearied comments about the "man box" are made with her back to the "cube," changing to a performance of sweet and smiling collusion when she turns to interact with Reynolds through the glass barrier. Of course, in this commercial the glass barrier could be seen also as signifying the barrier between the genders and their categorical separation, re/producing the segregation of women from the masculine pursuits of beer, sport, and "law" making.

CONCLUDING REMARKS

Overall the broadcast commercials, the Council, and the Man Laws function to re/produce the category of masculinity and the powerful intertextuality of men,

sport, and beer. The debating of the Man Laws as scripted on the commercials is humorous and ironic but uses culturally familiar or mythic signifiers that effectively re/produce one version of masculinity and render alternatives as problematic. Thus while the ironic elements do offer some satirical humor about men, the text does not function to ironize or undermine the central masculine category. Instead the commercials and Laws serve to mobilize predominant gendered and heterosexualized discourses by framing women, sport, and beer as objects of masculine possession and interest, and alternative masculinities as gay, effectively policing the male category and entitlements within traditional hegemonic, heterosexual boundaries.

While it was reported that the campaign did not result in increased sales of Miller Lite (Fredrix, 2007), it can be viewed as alternatively successful given the public response to "Law" submission, the viewing of the broadcast commercials through both official and unofficial sites (excluding the widespread mimicking of the commercials at sites such as http://youtube.com), the discussion of the Man Laws evident in other mediated texts (print and digital, including blogs), and the planned publication[3] of an expensive book containing "The Unwritten Laws of Man." This suggests that the content of the Miller Lite "Man Laws" campaign "hit a nerve" in the public imagination. Of course, the deployment of humor in the campaign can be argued to suggest that the public was enjoying the parodying of traditional masculinity in ways that may work to undermine its power. However, this analysis indicated that the humor worked more to police categories and violations of gender expectations, suggesting that gender remains a critical category of American culture. Thus the public response to the campaign appears more likely to reflect the "desire for stable definitions" and their reinforcement and reward by the market system (Sloop, 2005, p. 196) evident within the Man Laws campaign.

Indeed, the campaign's success would appear to be the "selling" of masculinity, beer, and sport, particularly if Miller Lite itself did not actually sell more beer. An examination of the Man Laws posted on the interactive website and the many sites discussing and re/producing the Man Laws suggests that the power of the association between beer, sport, and masculinity mobilized in the campaign actually overpowered the individual beer being marketed. Users seized on the core concepts of masculinity, beer, and sport, extrapolating beyond Miller Lite to a generalized beer and wider masculine entitlements. Thus, the campaign could be seen to fall into the trap of previous creative campaigns that got the public talking but failed to make the name of the specific product "stick." Nonetheless, the successful mobilization of sport, beer, and masculinity did work to re/produce and reify the significance of this triadic intertext and its continuing significance for gender performance within American culture.

NOTES

1. http://manlaws.com now defaults to http://millerlite.com. Part the original website remains available at http://cpbintegrated.com/miller/manlaws.
2. For example, the Body Shop produced a male "grooming" product called "No Debate."
3. "The Unwritten Laws of Man" had a publication date of December 2007 (http://amazon.com). Continuing the "joke," the book names the editors as "The Men of the Square Table" and it appears to resemble an aged or ancient book that intertextually mobilizes notions of wisdom, heritage, law, and religion. The blurb states: "It's big, it smells old, and each book comes with its very own 800-year accumulation of dust. The beautifully illuminated pages record decisions on Man Law dating back to 1145 ad. Heavy to lift, as any book of this magnitude should be, hundreds upon hundreds of pages catalogue carefully inked decisions, which have charted the course of male culture over a millennia."

REFERENCES

Barthes, R. (1957/1972). *Mythologies*. Translated by A. Lavers. Hill & Wang: New York.

Billig, M. (2001). Humour and hatred: the racist jokes of the Ku Klux Klan. *Discourse and Society*, *12*, 291–313.

Butler, J. (1990). *Gender trouble: Feminism and the subversion of identity*. New York: Routledge.

Foucault, M. (1970). *The order of things: An archeology of the human sciences*. New York: Vintage/Random House.

Foucault, M. (1972). *The archaeology of knowledge*. London: Tavistock.

Foucault, M. (1977). *Discipline and punish: The birth of the prison*. London: Penguin.

Fredrix, E. (2007). *Associated Press*. Multiple sites and Http://msnbc.msn.com/id/16776659

Graham, P., & Hearn, G. (2001). The coming of post-reflexive society: Commodification and language in digital capitalism. *Media International Australia Incorporating Culture and Policy, 98*, 79–90.

Gumperz, J. (1982). *Discourse strategies*. Cambridge: Cambridge University Press.

Hall, S. (1997). The work of representation. In S. Hall (Ed.), *Representation: Cultural representations and signifying practices* (pp. 13–74). London: Sage/Open University Press.

Hardin, M. (2005). Stopped at the gate: Women's sports, "reader interest," and decision making by editors. *Journalism and Mass Communication Quarterly, 82*, 62–77.

Jansen, S. C., & Sabo, D. (1994). The sport/war metaphor: Hegemonic masculinity, the Persian Gulf War, and the new world order. *Sociology of Sport Journal, 11*, 1–17.

Jansson, A. (2002). The mediatization of consumption: Towards an analytical framework of image culture. *Journal of Consumer Culture, 2*, 5–31.

Kane, M. J., & Lenskyj, H. J. (1998). Media treatment of female athletes: Issues of gender and sexualities. In L. A. Wenner (Ed.), *Mediasport* (pp. 186–201). London: Routledge.

Lakoff, G. (1987). *Women, fire and dangerous things: What categories reveal about the mind*. Chicago, IL: Chicago University Press.

Maingueneau, D. (1999). Analysing self-constituting discourses. *Discourse Studies, 1*, 175–199.

Meân, L. (2001). Identity and discursive practice: Doing gender on the football pitch. *Discourse & Society, 12*, 789–815.

Messner, M. A. (1988). Sports and male domination: The female athlete as contested ideological terrain. *Sociology of Sport Journal, 5*, 197–211.

Messner, M. A. (1990). When bodies are weapons: Masculinity and violence in sport. *International Review for the Sociology of Sport, 25*, 203–220.

O'Donnell, H. (1994). Mapping the mythical: A geopolitics of national sporting stereotypes. *Discourse and Society, 5*, 345–80.

Potter, J. (1996). *Representing reality: Discourse, rhetoric and social construction.* London: Sage.

Scherer, J. (2007). Globalization, promotional culture and the production/consumption of online games: Emerging Adidas's "Beat Rugby" campaign. *New Media & Society, 9*, 475–496.

Shapiro, M. J. (1989). Representing world politics: The sport/war intertext. In J. Der Derian & M. J. Shapiro (Eds.), *International/intertextual relations* (pp. 69–96). Lexington, MA: Lexington Books.

Sloop, J. M. (2005). Riding in cars between men. *Communication and Critical/Cultural Studies, 2*, 191–213.

van Dijk, T. A. (1993). Principles of critical discourse analysis. *Discourse and Society, 4*, 249–283.

Vertinsky, P. (2006). Time gentlemen please: The space and place of gender in sport history. In M. G. Phillips (Ed.), *Deconstructing sport history: A postmodern analysis* (pp. 227–243). Albany: SUNY Press.

Walsh, A. J., & Giulianotti, R. (2001). This sporting mammon: A normative critique of the commodification of sport. *Journal of the Philosophy of Sport, 29*, 53–77.

Wenner, L. A. (1991). One part alcohol, one part sport, one part dirt, stir gently: Beer commercial and television sports. In L. R. Vande Berg & L. A. Wenner (Eds.), *Television criticism: Approaches and applications* (pp. 388–407). New York: Longman.

Lads, Larrikins AND Mates: Hegemonic Masculinities IN Australian Beer Advertisements[1]

JIM MCKAY

MICHAEL EMMISON

JANINE MIKOSZA

INTRODUCTION

Beer advertisements, with their target demographic of essentially men between 18 and 35, offer fertile sites for researchers interested in the ways in which masculinities are constructed in popular culture. In this chapter we use Connell and Messerschmidt's (2005) reformulated concept of *hegemonic masculinity* to analyze changes in representations of masculinities over the last three decades in advertisements for one of Australia's most popular beers, *Victoria Bitter* (VB). We begin by summarizing Connell and Messerschmidt's amended version of hegemonic masculinity and then situate a case study of VB advertisements in the interlinked contexts of "new lad" culture and Australian nationalism. We argue that there has been a significant shift in the VB advertisements from traditionally monolithic representations of hegemonic masculinity toward more complex constructions via the entwined and contradictory concepts of laddishness, larrikinsm, mateship, irony, nationalism, sport, celebrityhood, and the carnivalesque. Overall, our analysis supports Connell and Messerschmidt's thesis that the concept of hegemonic masculinity is still valuable for understanding the contradictory ways in which masculinities are constructed in popular culture. For instance, we show how beer advertisers bring together both global and national motifs in ways that seemingly transgress hegemonic masculinity, while also reiterating, albeit in paradoxical ways, established "boys and beer" narratives.

REFORMULATING HEGEMONIC MASCULINITY

Connell (1987, 1990) introduced the concept of hegemonic masculinity to refer to the "culturally idealized form of masculine character," which associates masculinity with "toughness and competitiveness," the "subordination of women," and "the marginalization of gay men" (Connell, 1990, pp. 83, 94). Although hegemonic masculinity has since become one of the most widely used concepts in research on men and masculinities, it has been also criticized for having one-dimensional, reified, and essentialist tendencies. In a systematic reappraisal and reformulation of hegemonic masculinity, Connell and Messerschmidt (2005) argue that it is still a useful concept provided that scholars are sensitive to four issues. First, hegemonic masculinity needs to be situated in "a more complex model of gender hierarchy" (p. 829). Accordingly, Connell and Messerschmidt use the plural term *hegemonic masculinities* in order to emphasize that hierarchical relations exist within hegemonic configurations and that masculinities are "crosscut by other divisions and projects" (p. 837), such as age, class, race, region, and bodily abilities. They also stress that winning consent is a contradictory and dynamic project in which hegemonic masculinities are constantly subjected to challenges from "subordinated," "marginalized," and "protest" masculinities, as well as from women. Second, Connell and Messerschmidt call for an "explicit recognition of the geography of masculinities, emphasizing the interplay among local, regional, and global levels" (p. 829). They propose that movie stars, politicians, corporate managers, and professional athletes are examples of where the articulations among local, regional, and global masculinities are evident. Consider, for example, David Beckham, who ostensibly belongs to the "frontline troops of patriarchy" (Connell, 1995, p. 79) by virtue of his revered status as former captain of the English national football team. Yet he is also a globally recognized celebrity and fashion icon, who has accompanied his pop star wife to a function wearing a sarong and been applauded as both a quintessential "metrosexual" and an alternative to traditional masculinity (Cashmore, 2002; Simpson, 2002). Third, a "stronger emphasis is required on the dynamics of hegemonic masculinity, recognizing internal contradictions" (p. 829). For instance, they note that even culturally exalted men do not necessarily conform to hegemonic ideals. However, they also contend that even though a minority of men behave strictly according to hegemonic ideals, the majority still benefit from the cultural ascendancy of masculinity through their consent and complicity. Moreover, despite substantial gaps between valorized forms of masculinity and many men's daily practices, hegemonic archetypes "express widespread ideals, fantasies, and desires [and] provide models of relations with women and solutions to problems of gender relations" (p. 829). Finally, Connell and Messerschmidt argue that discursive and material aspects of bodies are central to any analysis of

hegemonic masculinities, so "more specific treatment of embodiment in contexts of privilege and power" is necessary (p. 829). Connell and Messerschmidt (2005) suggest that being mindful of these dynamic and contradictory aspects could produce "possibilities of movement toward gender democracy" (p. 829). For instance, they observe that "new configurations of women's identity and practice especially among younger women ... are increasingly acknowledged by younger men" (p. 848). Before applying these key points to our case study, we need to locate the advertisements in the interweaving contexts of "new lad" culture and Australian nationalism.

SOME GLOBAL AND NATIONAL CONTEXTS

"New Lad" Culture

> You can't write about the golden era of laddism without talking about the magazines; but it was a far wider phenomenon. Music, TV, art, literature and, of course, sport were infiltrated by men with choppy hairstyles and trainers: Britpop bands such as Supergrass, Dodgy and Oasis, TV shows such as Men Bevaing [*sic*] Badly, presenters such as Chris Evans, artists such as Damien Hirst, actors such as Keith Allen and Neil Morrissey, writers such as Nick Hornby and footballers such as Paul Gascoigne. (Jones, 2007)

Our case study needs to be placed in a broader and evolving global context of global popular culture, in which men have been addressed as "new lads" (Mikosza, 2003; Nixon, 1996). The rise of "lad culture" over the past decade, especially via "new lad" magazines, has had a global impact on the form and content of many media genres. These magazines and their digital offspring have both provided a template for masculinities elsewhere and also drawn on "laddish masculinity" in spheres such as music, films, and sport.[2] When "new lad" magazines appeared in the 1990s (*Loaded* in the UK and *Ralph* and *FHM* in Australia), they tended to be dismissed as ephemeral, lightweight, and sexist (Dapin, 2004; Mikosza, 2003). However, they have since assumed global significance as both reflectors and producers of hegemonic masculinities and the "new lad" has become a pervasive archetype (Benwell, 2003). *FHM* is published in 30 different countries, including China, Malaysia, Turkey, Russia, and Estonia. *Nuts* has expanded beyond the magazine market to encompass books, calendars, pub games, and TV. The Nuts TV website includes links to the "Beer Club" and a message board from which some material has been posted on YouTube. In Australia, the ostensibly dedicated sport magazine *Inside Sport* has mimicked the "new lad" magazines formula by using

models in bikinis on virtually every front cover, while the "new lad" magazine *Alpha* showcases "bad boy" Australian athletes such as cricketer Shane Warne and tennis player Lleyton Hewitt.

Both these print and electronic sources use local and global content to construct masculinities of excess and risk-taking, often in sport, both by and for young, white, heterosexual men (Mikosza, 2003; Wheaton, 2003). The content also hails men as consumers, celebrates hedonistic and "aspirational" lifestyles, and relies on humor and fantasy both to defuse criticism and to silence those who are not "in" on the joke (in 1994, *Loaded* was launched with the slogan "For men who should know better"). Many advertisements use "knowingly" sexist jokes, often laced with irony that contains antifeminist and homophobic subtexts (Benwell, 2007, p. 540). Editors also circulate seamlessly across genres and countries: Paul Merrill, the UK editor of *Zoo*, moved to Sydney to start an Australian version of the magazine; James Brown worked at *GQ*, before founding *Loaded*; and Ed Needham recently returned to London from New York after several years of editing *FHM*, *Rolling Stone*, and *Maxim*. However, as Needham (2007, p. 14) noted about his trans-Atlantic editorial experiences, "a winning formula in Britain does not guarantee success in the US." Thus, keeping in mind Connell and Messerschmidt's point about the contradictory ways in which hegemonic masculinities play out at local, regional, and global levels, we now locate our study in the context of Australian nationalism.

Masculinity and Australian Nationalism

Australian nationalism has been shaped profoundly by the traditions of white men: a predominantly male convict population; a frontier and gold rush mentality; the valorization of hard, manual labor, trade union solidarity, and militaristic ANZAC rituals[3]; the exaltation of adventurers and explorers, such as Steve, "The Crocodile Man" Irwin, and "Crocodile Dundee"; a "larrikin" mentality[4]; a love of sport; and a hard-drinking culture (Kirkby, 2003; Pease, 2001; West, 2000). These specifically white masculine traditions have often been mythologized as the universal egalitarian practice of "mateship," even though they have largely excluded Aborigines, gay men, women, and non-European immigrants. Indeed, Lake (1992, p. 161) uses the term "sexual apartheid" to describe the history of gender relations in Australia. This masculine homosocial mythology has rarely been challenged. An exception occurred in 1999, when socially conservative prime minister John Howard was widely criticized for specifying mateship (but not Aboriginal custodianship) as a core value to be included in a draft preamble to the Australian constitution, because it had a "hallowed place in the Australian

lexicon." In summary, images of men and national identity have been mutually reinforcing throughout Australian history:

> …notions of Australian identity have been almost entirely constructed around images of men—the convict shaking his shackled fist; the heroic explorer facing inland; the bushman plodding down a dusty track; the digger scrambling up the slopes at Gallipoli; Bradman and McCabe facing the bodyline attack; Midget Farrelly swooping down the wave-face; front bars, shearing sheds, the Glenrowan Hotel. There are not many women in this world…But there are very definite ideas about masculinity, and ideas about relations between men and women, real or imaginary. (Connell, 2003, p. 9)

"The Dreaded Tradition of Men, Sport, and Beer"[5]

Beer advertisements have been prominent in both reinforcing and reproducing a highly masculine-inflected version of Australian nationalism, especially via sporting themes (McKay, 1991). Moreover, Australia has long been depicted as a nation of beer-lovers (Fiske, Hodge, & Turner, 1987; Kirkby, 2003; Pettigrew, 2002), with some Australian men attaining international fame and notoriety for their drinking behavior. Former prime minister Bob Hawke set a world record for "skulling" a yard glass of beer (about 2.5 points) in under 12 seconds when he was a Rhodes Scholar at the University of Oxford in the 1950s. Actor Paul Hogan became the "face of Australia" after starring in international advertisements for Fosters in the 1980s, and the brewery continues to link its beer to Australian masculinity in targeting American and British markets. Aussie theme pubs have become a ubiquitous player in the global food and beverage industry (West, 2006).

The most recent figures available from the Australian Bureau of Statistics (ABS, 2006) indicate that Australians consumed just over 107 liters of beer per person during 2005–2006, nearly 80% of which was full-strength. Australia ranks fourth in terms of annual beer consumption per capita behind Ireland, the Czech Republic, and Germany. Beer also is the alcoholic beverage of choice for the vast majority of Australians, particularly males. Although beer production remains a highly profitable business, there are formidable pressures on companies in an increasingly competitive and cluttered market place.[6] As Lee (2006a) observes:

> Pity today's beer marketer. He must weep when he looks back at the days when an Aussie working man would spend as much on beer in a week as he did on his mortgage. Back then your choice of beer said as much about you as a man as the car you drove or the team you supported. Occasionally you might have a light beer—if no one else was watching. There was little else on offer.

The diversity of brands and strengths now available means that advertising and marketing have assumed much greater significance. Consequently, a great deal of

money and creative energy has been expended on beer promotion. Award-winning advertisements such as Carlton Draft's "Big Ad"[7] and Lion Nathan's "Tongue Quest"[8] for its Tooheys Extra Dry have been seen as setting new benchmarks for beer commercials with their reliance on viral marketing through the Internet prior to their release on TV. Carlton's Big Ad is estimated to have been seen by over one million Internet users within two weeks of its posting, and the success of its Internet viral release was such that the TV promotion budget was reduced to avoid possible overexposure of the advertisement (Lee, 2005). The multiplicity of brands is a response by advertisers and market researchers to an increasingly diverse 18–35 male demographic and the changing class structure of Australian society. We now use a case study to show how advertisers have combined components of "new lad" culture and "Australianness" to interpellate young, white, heterosexual men.

ANALYSIS AND DISCUSSION

VB Advertising: A Case Study

Key differences in the advertising of VB over the last three decades offer fascinating insights into the changes that have occurred in the way men have come to understand themselves and the hegemonic masculinities that are now valorized in Australia. VB advertisements have appeared more or less continuously in electronic and print form since the 1970s. Moreover, VB can claim to be something of a national alcoholic beverage. Although originally based in the state of Victoria, it has achieved a greater degree of combined market penetration than its major state-based rivals: *XXXX* (Queensland), *Tooheys* (New South Wales), and *Swan Lager* (Western Australia).

For over two decades, VB was advertised with an almost unchanging formula. To the sound of a stirring orchestral score—the theme from the film *The Magnificent Seven* was used for many years—VB was offered as a reward for hard masculine effort and the appeal of the advertisements lay in the ways in which this was depicted. Effort could be associated with paid labor, indeed this was the most common representation, but it could also be connected with sporting achievements. Award-winning actor and national icon John Meillon, who played Paul Hogan's mate in the *Crocodile Dundee* films, was the sole narrator. His baritone voice became one of the most familiar sounds on TV, as he intoned an assortment of activities from which a thirst could be derived, for example:

"You can get it riding" (visual of male bicyclists)

"You can get it sliding" (visual of a fieldsman in a cricket match crashing into the boundary fence)

"You can get it lifting, you can get it shifting" (visual of males in blue tank-tops struggling with heavy objects)

"You can get it working a plough" (visual of farmer on a dusty tractor)

"You can get it any old how—matter of fact, I've got it now."

The advertisements typically ended with images of sweaty men relaxing with their beer and Meillon signing off with the trademark phrase: "A hard-earned thirst needs a big cold beer and the best cold beer is Vic—Victoria Bitter." In these advertisements beer consumption was a masculine endeavor. The occasional advertisement might depict a domestic scene, in which a burly male was shown begrudgingly undertaking some household chore under the watchful eye of his wife, but these were uncommon. In short, it was a world in which the virtues of working class labor and sport were celebrated and rewarded through the provision of alcohol. However, there has been a recent shift in both the form and content of VB advertisements, especially in the use of Australian cricket "legends" David Boon and Shane Warne, known colloquially as "Boony" and "Warnie."

Enter "Boony"

A major change in VB's advertising and marketing format occurred in 2005, when David Boon, a former successful top-order batsman on the national cricket team, was chosen to feature in a new series of advertisements. This was part of a wider promotional strategy called the "VB Boonanza" campaign, which included the distribution of thousands of talking figurines—"Boony Dolls"—in his likeness.[9] Boon was ideally suited for this campaign for several reasons. He was and is a "local hero" in his native state of Tasmania, which is closely associated with the Australian bush and wilderness.[10] Thus, his bucolic masculinity could easily be linked to the "rural idyll" (Campbell, 2000). A nuggetty figure who sported (and still has) an iconic walrus moustache, Boon was affectionately known as "Stumpy" or "The Keg on Legs." In 2003, he appeared on the cover of one of Australia's highest-circulating weekend newspaper magazines. The photo showed him half-dressed in cricket gear in a locker-room and holding a beer can with the headline "52 Not Out." The caption referred to his reputed world record of consuming 52 cans of beer during a Sydney to London flight, when he was a member of the Australian team in 1994, a feat that eclipsed the previous record set in 1983 by Australian wicketkeeper Rodney Marsh (Lalor, 2003).

The advertising campaign used a series of 30-second clips (the most appropriate length for the regular breaks in many sports events) to

highlight Boon's unprepossessing appearance and nonchalant character. For example:

> A hard-earned thirst needs a big cold beer and no one deserves it better than David Boon. Yes he didn't get that rock hard guts [*sic*] from playing hacky-sack—he got it from smashing boundaries. No high-fives or jumping around when Boony made a ton. Just a tweak of the box and back to business.[11]

> We want Boony for Prime Minister. Or stuffed and put on display next to Phar Lap[12] with the word Boony engraved on the glass and a big cold beer in his glove. And the best cold beer is Vic.

Although Boon had a clear physical resemblance to the male figures of the earlier generation of advertisements, there was very little in common with the way he was represented. The additional ingredient was humor, but a particular "knowing" humor that was by then a characteristic feature of "new lad" culture. Boon was "in" on the humor and was clearly enjoying it. For example, in another advertisement a large multidecked cake is wheeled into a living room, and to the amazement of the group of mates sitting watching sport on TV, the top of the cake lifts off and Boon, in cricket gear, appears holding a can of VB. To the accompaniment of some scantily clad dancing young women, Boon, the person, disappears and then reappears as his doll figurine seated next to the men on the settee. In yet others the Boon statuette was joined by the figurine of former English cricket great Ian Botham—Boon's mate and nemesis, who also sported a moustache.[13] Viewers were enjoined to "grab cartons of VB and find out how these two hairy lipped legends of the game can go pound for pound, tash for tash, beer for beer, right there in your lounge room." Gone is the realism of the early advertisements and their almost Soviet-style endorsement of proletarian labor. By contrast, these advertisements celebrate leisure and consumption in an almost carnivalesque inversion of the established order. They are not to be taken seriously—except for the hard-headed business of capturing and maintaining their share of the beer market.

Warnie's Summer of Spin

> Probably the one mistake Shane made in life was to get married. Apart from that he had the perfect life for an Australian male. (School friend of Warne's; as cited in Barry, 2006, p. 181)

The most recent change in VB advertising came in the summer of 2007 with the addition of another cricket legend, the then world record holder for wicket-taking, Shane Warne, as the central figure—and figurine. With

Warne's arrival a different form of masculinity entered the mix. Whereas Boon represents the older, traditional rugged masculinity of the 1970s and 1980s (he could easily have appeared as one of the heaving and perspiring characters in the earlier advertisements), Warne is a classic "new lad." As noted, he appears on the covers of the "new lad" magazines and has provided a constant stream of material for the Australian and British tabloid media, due to his boorish behavior and extramarital sexual affairs. He is a man who "behaves badly" and his incorporation into the VB campaign sent clear signals about the kind of masculinity that the advertisers thought was both prevalent and acceptable.

The advertisements with Warne also provide more "space" for the exploration of the masculine character in the ways in which the ordinary beer consumer is now depicted. In one of them, the notion of masculine fantasies is entertained. The advertisement commences—where the old series typically concluded—with the pouring of a beer accompanied by a male "ocker"[14] voice-over:

> *Visual*: Interior scene of pub, bar tender pours foaming glass of beer from the tap.
> *VO*: A hard-earned thirst means a big cold beer.
> *Visual*: Front-on shot of three very ordinary and casually dressed young men in their early 20s sitting at the bar drinking; camera moves in to a close-up of the middle male who appears with a wistful look on his face.
> *VO*: And the best cold beer is giving you the chance to live every bloke's dream.

At this point in the advertisement something happens that would have been unthinkable in the older VB narratives. A computer-generated image of the head of the man on the body of a skimpily clad nubile woman appears, with the figure sensually preening him/herself in front of a full-length mirror. The scene cuts just as the man/woman appears about to remove his/her upper clothing. The voice-over that anchors this scene is the following:

> *VO*: Not the one where you're a woman for the day.

The scene changes and we now see Warne, in jeans and tee shirt, on a cricket pitch standing by stumps tossing a ball in readiness to bowl and the voice-over mockingly restores the masculine fantasy order:

> *VO*: The *other* one, where you get the chance to face an over from the greatest bowler ever—Warnie!

The advertisement continues:

> *Visual*: Shot of man planting a case of VB on the counter of a liquor store; cut to cricket pitch where man magically appears still holding his case of beer looking surprised; cut to Shane Warne waiting to bowl.

VO: Simply grab slabs of specially marked VB for your chance to face Warnie in the smash for cash.

As the advertisement moves to its conclusion, the initial fantasy theme is revisited but with a twist: there is a recreation of the "woman for the day" scene, but this time comprising only the man dressed in typical daggy male underwear He clumsily jerks his body while admiring himself in front of a miltror; his two male companions enter the room and discover him engaged in his fantasy.

VO. Sometimes it's best to keep your dreams to yourself.

However, order is finally restored in the concluding scene:

Visual: Shot of the three men, the central figure still in his underwear, standing and removing the caps of VB bottles, preparing to drink.
VO: But never your beer and the best cold beer is VB.

It is worth stressing that the men who appear in the new series of advertisements have no connections whatsoever to the traditional images of rugged Aussie bloke. In fact, these men are utterly ordinary, and because there is no representation of their working lives, they appear (relatively) classless. They share their status as "ordinary Aussie blokes" with Warne—the only difference being they do not have the wealth that his cricketing prowess has earned him. However, they are also at ease with their masculinity and can both celebrate and poke fun at its contemporary hegemonic incarnations. We see this most clearly in the fantasy scene where the "school boy's annual" young male dream—playing cricket with a figure such as Warne—is lampooned by the introduction of a second dream—the opportunity to be a woman for a day.[15] As we observed, this would have been inconceivable in the early advertisements, when any form of an "internal" life would have been designated as feminine. In another advertisement from the series, hegemonic masculinity is playfully transgressed by the two celebrity cricketers, Warne and Boon. Warne plays his mother, his father, and himself—as a baby—in a scene set in a hospital maternity ward, as viewers are enjoined to raise their glass to "Australia's favorite son." Later in the same advertisement, the "almost anything" that the "Sultan of Spin (Warne) could get to turn" is represented by Boon perched precariously on a bar stool in a green silk dress and yellow feather boa (the Australian national team colors). These advertisements rely heavily on the "larrikin" archetype alluded to above. Boon, valorized for his beer consumption, is an example of how "old style" masculinity, with the addition of ironic humor, can be inserted seamlessly into contemporary "new lad" culture.[16] Warne is also a loveable larrikin but with a "new lad" twist.[17] The advertisements also address an audience of media-savvy young men, who are familiar with these intermingling

masculinities and larrikin antics, from watching popular TV programs such as *The Footy Show* that feature male panellists who cross-dress (Brooks, 2000).

Our analysis shows that Connell and Messerschmidt are correct to emphasize that winning consent is both a contradictory and dynamic endeavor involving interactions among local, regional, and global masculinities. For instance, many motifs in the recent VB advertisements have been borrowed directly from both broader advertising culture and the global sports stars complex. The advertisements adroitly deploy Boon and Warne via humor, irony, and fantasy, which promoters of "lad culture" have used to negate criticisms that laddish behavior is sexist.[18] Lauding Boon's excessive drinking has parallels with what journalist Ruth Sunderland (2008) calls the "aura of ruined glamour" surrounding other alcoholic and heavy-drinking male sports stars such as George Best, Andrew Flintoff, John Daly, and Paul Gascoigne.[19] Showing Boon in a silk dress and feather boa simulates the cross-dressing practices of former NBA star Dennis Rodman, whose self-promotional strategies show that "hard men" can transgress traditional cultural scripts without threatening their hegemonic status (Rowe & McKay, 2003). Similarly, a legend such as Boon dressing like a drag queen straight out of the Australian film *Priscilla: Queen of the Desert* seemingly disrupts representations of hegemonic masculinity. However, as with "bad boy" Russell Crowe (a mate of Warne's) playing a gay man in the Australian film *The Sum of Us*, it is precisely Boon's assumed virility that allows him to perform this carnivalesque mode of masculinity without undermining his heterosexual credentials.[20] Moreover, despite some disruptions, the advertisements maintain a masculine homosocial structure: young, white, heterosexual mates bonding through drinking beer, and women written out except for occasionally performing the traditional role of accessories to men's pleasure.

Our results also support three other propositions by Connell and Messerschmidt. First, their call for researchers to be mindful of the interplay between discursive and material aspects of bodies was evident in our study, especially in the "woman for the day" advertisement. Our findings also corroborate their argument that hegemonic masculinities are always "crosscut by other divisions and projects." On one hand, VB marketers want to continue cashing in on the signifying power of an iconic, white male working class brand. On the other hand, VB's traditional demographic is shrinking, working classes are being targeted by a wide spectrum of aspirational lifestyle advertisements, and men are now being interpellated as narcissistic consumers. Thus the recent campaign is a "hybrid," containing both familiar codes designed to gratify the traditional demographic (hence the retention of motifs such as the "Hard-earned thirst" voice-over) and also new symbols that will appeal to "aspirational" male consumers. Although not directly evident in the advertisements, Warne's biography shows the importance of such divides. Although Warne

is clearly a beloved larrikin to some Australians,[21] in 2005 Channel Nine terminated his 11-year association and a $(A) 300,000-a-year contract with the network, after yet another series of off-field scandals that culminated in an official separation between him and his wife. This incident shows how the "laddish" masculinity of athletes can clash with the discipline demanded by their corporate bosses who can hire and fire sports stars in order to maximize returns on their investments.[22]

SUMMARY AND CONCLUSION

In this chapter we applied Connell and Messerschmidt's reformulation of hegemonic masculinity to a case study of Australian beer commercials. Overall, our analysis supported their thesis that hegemonic masculinity is still a helpful concept. Although the advertisements we studied showed how advertisers draw on national and global motifs, research is needed at the local level on how both men and women respond to newer representations of hegemonic masculinities. For instance, focus groups could shed light on how consumers read and view beer advertisements. Another related possible research topic is the emerging moral panic about lad culture allegedly generating "ladettes" and "bad girls" such as Amy Winehouse and Britney Spears (Aitkenhead, 2007; Cleland, 2007; Dougary, 2007). The advertisements we analyzed valorized hegemonic masculinity via the entwined narratives of laddishness, larrikinsm, mateship, irony, nationalism, sport, celebrityhood, and the carnivalesque. So, in one sense they demonstrate Connell and Messerschmidt's assertion that hegemonic masculinity is a complex and dynamic process. However, they do not contain what Connell and Messerschmidt (2005) term "possibilities of movement toward gender democracy" (p. 829). In fact, the advertisements exemplify how sport is a handy vehicle for subtly absolving the "crimes and misdemeanors" of male sports stars (McKay and Smith, 1995). As Kell (2005) surmises:

> The status of sports stars in the era of celebrity enables them to assume a prestige and value beyond their own sporting profile... They have become... symbols of national identity which are often stoked by the press and established interests as an artificial and contrived way of symbolising unity when many of the bonds of community have been dismantled by the excesses of the market. So the off-field misdemeanors of the modern sporting celebrity are obscured by a new strident nationalism which is used to excuse all manner of indiscretions. The new bad boys are excused as "our bad boys" and lets [*sic*] them get away with racism, boorish sexism and vacuous conservative ideology dressed up as dedication and sacrifice.

Furthermore, the advertisements also omit several important items. There is no mention of the growing social problem of binge-drinking among young

Australian men and women. For instance, the director of the Community Alcohol Network called the "Boonanza" campaign both "cynical" and "reprehensible" and described Boon as the "patron saint of binge drinking" (Edwards & Smith, 2005). Also there is no reference to the role that alcohol plays in the recurring sensational cases of violence against both other men and women by Australian athletes (Palmer, in press; Rowe, 2005a, 2005b).[23]

As indicated, Connell and Messerschmidt suggest that hegemonic masculinities provide ordinary men with "ideals, fantasies, and desires" and offer "models of relations with women and solutions to problems of gender relations." Our study demonstrates that beer advertisers can now articulate these elements by blending both global and national aspects of hegemonic masculinities. This means that hegemonic masculinities are not only more protean but also more resilient and thus capable of being subtly reconstituted in ways that still articulate traditional cultural scripts. Despite some recent fascinating narrative shifts, the "new" VB men continue to be anchored in familiar "boys and beer" narratives common to previous advertisements that target the young, white, heterosexual male market. Whatever transgressions—gender fantasies, cross-dressing, even the admission that males might have a "private" inner life—are evident in the advertisements, they are invoked in ways that do not seriously threaten the masculine homosocial regime. The message is clear: keep your fantasies to yourself but make sure you share your beer with your mates.

NOTES

1. We would like to acknowledge the helpful comments of Roy Boyne, Helen Johnson, Catherine Palmer, Phillip Smith, Steve Jackson, Lawrence Wenner, and Brad West on an earlier draft of this paper.

2. "Laddish masculinity" has been documented in traditionally "macho" sports such as football (Carrington, 1998), as well as in seemingly more gender egalitarian "lifestyle" activities such as skateboarding and windsurfing (Beal, 1996; Wheaton, 2003).

3. ANZAC is an acronym for the Australian and New Zealand Army Corps, which has a revered status in Australia due to its disastrous-cum-heroic defeat at Gallipoli during WWI.

4. A "larrikin" is an Australian—almost invariably a male—who transgresses normal behavior, but with a degree of irreverence that is tolerated, even admired, because it reinforces egalitarian myths. Some renowned larrikins are former prime minister Bob Hawke, actor Paul Hogan, and the cricketers in our case study, David Boone and Shane Warne. The larrikin motif also can be anthropomorphized and taken up-market: Mercedes-Benz recently ran advertisements for its E-Class Sports Pack with photos of a station wagon and coupe accompanied by the caption. "Impeccable pedigree. Larrikin streak."

5. This term was used by Morris (in Turner, 1992: 653) to encapsulate the strong links among beer, sport, and gender relations in Australia.

6. Beer consumption also has declined over the past 30 years as drinkers have increasingly turned to wine (Australian Food News, 2007).

7. The advertisement features aerial footage of two vast armies, one dressed predominantly in maroon, the other in yellow, who march towards each other singing "O Fortuna" from Carmen Burana, but with lyrics such as "It's a big ad, expensive ad, this ad better sell some bloody beer." The two armies assemble respectively into the shape of a human body and a glass of Carlton Draft that is lifted to the mouth of the human. The viewer then sees the "beer," the army of ecstatic men clothed in yellow, flowing into the stomach of the figure.

8. In this advertisement, the tongue of a sleeping male embarks on a nocturnal journey to locate a bottle of beer (Tooheys Extra Dry) with which it then returns. The male awakes to find himself drinking in his sleep

9. The figurines were offered free by the beer company (Carlton United Brewing) to those who purchased cases of VB. It is estimated that over 200,000 were distributed and they rapidly became collectors' objects, fetching as much as $(A) 30 on eBay (Maiden, 2006). The figurines incorporated a novel interactive technology and were designed to respond to signals from the TV set transmitted during live cricket matches with phrases such as "Have a swing mate," "Show us a replay of that," and "Get me a VB the cricket is about to start."

10. The Tasmanian-based breweries Cascade and James Boag's often use rustic images on their labels. The former favors the extinct Tasmanian Tiger, while the latter usually features an iconic Tasmanian scene, like a pristine river coursing through a wild mountain gorge.

11. "Tweak of the box" is Australian for adjusting the molded piece of plastic worn under an athletic supporter or jock strap.

12. Phar Lap was a racehorse who attained a mythical status in Australia, similar to that of Seabiscuit, for winning many prestigious races during the Great Depression. He died in California in 1932 under mysterious circumstances, often claimed by Australians to have been poisoning by Americans. His huge (17 hands high) stuffed body is in the National Museum of Victoria in Melbourne and his large (14-pound) heart is in the National Museum of Australia in Canberra. One of the highest compliments to bestow on hard-working Australians is to say that they have "A heart as big as Phar Lap," a phrase that is routinely invoked by journalists to describe gritty sporting achievements.

13. Botham attained fame for his cricketing prowess and notoriety for his laddish behavior both on and off the pitch. He subsequently redeemed himself by raising large sums of money for cancer research and was knighted in 2007 for services to cricket and charity work.

14. An "ocker" is an unrefined Australian male. Paul Hogan's portrayal of an ocker in his popular Paul Hogan Show in the 1970s and 1980s made him the obvious choice to play a bushman version of the archetype in the Crocodile Dundee films.

15. In another advertisement from the series, a more conventional heterosexual male fantasy is presented. In this advertisement the male first imagines himself on a beach with two—twins—young blonde women.

16. On the humorous website "Top Aussies," Boon appears 3rd, VB 5th, Warne 6th, Hawke 7th, and Phar Lap 24th; legendary cricketer Sir Donald Bradman heads the list.

17. Journalist Peter Lalor (2005), who wrote the celebratory cover article on Boon's record-setting consumption of beer, also penned a feature piece on Warne titled "The Wild Colonial Boy," in which Warne states that he is an "ordinary" bloke who can laugh at himself and that one of his mantras is "I'm just an ordinary guy who makes mistakes."

18. Hahn has used a similar approach in advertisements for its Premium Light beer. A journalist referred to a larrikin in one advertisement in the series as "Ironic Man" (Lee, 2006b).

19. Gascoigne, who was an immensely talented footballer for the English national team during the 1990s, but also an alcoholic and wife-beater, was admitted to a psychiatric hospital in 2008 after police were called to a disturbance at a hotel. A journalist subsequently described him as "the most talented footballer to emerge from these shores since George Best" (Giles, 2008). The comparison was apt, given that the mercurial and alcoholic Best died in 2005, three years after a liver transplant.

20. Films such as *Priscilla: Queen of the Desert* and *The Sum of Us* and TV programs such as *The Footy Show* also provided a larger semiotic context into which the VB advertisements could be inscribed.

21. According to journalist Larissa Dubecki (2008), "despite his lengthy rap-sheet of sexual wrongdoing…despite arguably being an affront to women everywhere … [Warne] … has the public persona of a loveable if bumbling rogue."

22. The corporate men who own and control Australian sport are often disparagingly called "The Suits" by some athletes, fans, and sports journalists.

23. The most recent case, which has parallels with Gascoigne's demise, involves former Australian Rules Football star Wayne "King" Carey, who has become notorious during the past decade for public drunkenness, sexual assaults, and extramarital sexual affairs. Carey faces up to 15 years in jail pending the outcome of his trial for drunkenly assaulting two Miami police officers in 2007. The officers were called to a luxury hotel where Carey was staying with his girlfriend, who later withdrew a charge of aggravated battery against him.

REFERENCES

Aitkenhead, D. (2007). No wonder men treat us as sex objects if we act like this. *The Guardian*, September 13. http://www.guardian.co.uk/commentisfree/2007/sep/13/comment.pressandpublishing.

Australian Bureau of Statistics (2006). Alcohol consumption in Australia, 4832.0.55.001. Canberra: Australian Government.

Australian Food News (2007). Beverage consumption in Australia. March 19. http://www.ausfoodnews.com.au/db/node/3224.

Barry, P. (2006). *Spun out: Shane Warne, the unauthorised biography of a cricketing genius*. Sydney: Bantam Press.

Beal, B. (1996). Alternative masculinity and its effects on ender elations in the subculture of skateboarding. *Journal of Sport Behavior*, 19, 1: 204–220.

Benwell, B. (Ed.) (2003). *Masculinity and men's lifestyle magazines*. Oxford: Blackwell.

Benwell, B. (2007). New sexism? Readers' responses to the use of irony in men's magazines. Journalism Studies, 8, 4: 539–549.

Brooks, K. (2000). "More than a game": The Footy Show, fandom and the construction of football celebrities. *Football Studies*, 3, 1: 27–48.

Campbell, H. (2000). The glass phallus: Pub(lic) masculinity and drinking in rural New Zealand. *Rural Sociology*, 65, 4: 562–581.

Carrington, B. (1998). "Football's coming home" but whose home? And do we want it? Nation, football and the politics of exclusion. In A. Brown (Ed), *Fanatics! Power, Identity, and Fandom in Football* (pp. 101–123). London: Routledge.

Cashmore, E. (2002). *Beckham*. Oxford: Blackwell.

Cleland, G. (2007). Girls' websites criticised for "lad mag" tactics. *The Telegraph*, September 21. http://www.telegraph.co.uk/news/main.jhtml?xml=/news/2007/09/19/nteen119.xml.

Connell, R. W. (1987). *Gender and power*. Sydney. Allen & Unwin.

Connell, R. W. (1990). An iron man: The body and some contradictions of hegemonic masculinity. In M. A. Messner & D. F. Sabo (Eds.), *Sport, men and the gender order: Critical feminist perspectives* (pp. 83–95). Champaign, IL: Human Kinetics.

Connell, R. W. (1995). *Masculinities*. Sydney: Allen & Unwin.

Connell, R. W. (2003). Introduction: Australian masculinities. In S. Tomsen & M. Donaldson (Eds.), *Male trouble: Looking at Australian masculinities* (pp. 9–21). Melbourne: Pluto Press.

Connell, R. W., & Messerschmidt, J. W. (2005). Hegemonic masculinity: Rethinking the concept. *Gender & Society*, 19, 829–859.

Dapin, Mark (2004). *Sex and money: How I lived, breathed, read, wrote, loved, hated, dreamed and drank men's magazines*. Sydney: Allen & Unwin.

Dougary, G. (2007). Yes, we are bovvered. *The Times*, September 25. http://women.timesonline.co.uk/tol/life_and_style/women/article2523264.ece.

Dubecki, L. (2008). Carey and the forgive-and-forget culture. *The Age*, February 2. http://www.theage.com.au/news/opinion/carey-and-the-forgiveandforget-culture/2008/02/01/1201801032986.html?page=2.

Edwards, L., & Smith, B. (2005). Booze, booze everywhere. *The Age*, December 15. http://www.theage.com.au/news/national/booze-booze-everywhere/2005/12/14/1134500913324.html.

Fiske, J., Hodge, B., & Turner, G. (1987). *Myths of Oz: Reading Australian popular culture*. Sydney: Allen & Unwin.

Giles, K. (2008). Is this final chapter in Gazza tragedy? *The Herald*, February 23. http://www.theherald.co.uk/sport/headlines/display.var.2067936.0.Is_this_final_chapter_in_Gazza_tragedy.php.

Jones, M. (2007). When I was a lad. *The Times*, June 15. www.timesonline.co.uk/tol/life_and_style/men/article1932979.ece.

Kell, P. (2005). Bad boys and the cult of celebrity. Posted September 12. http://www.onlineopinion.com.au/view.asp?article=165.

Kirkby, D. (2003). Beer, glorious beer: Gender politics and Australian popular culture. *The Journal of Popular Culture*, 37, 2: 244–256.

Lake, M. (1992). The politics of respectability: Identifying the masculinist context. In G. Whitlock & David Carter (Eds.), *Images of Australia*. St Lucia: University of Queensland Press.

Lalor, P. (2003). 52 not out. At last, the truth behind David Boon's unbroken record. *The Weekend Australian Magazine*, December 20, pp. 1, 22–25.

Lalor, P. (2005). The wild colonial boy. *The Weekend Australian Magazine*, July 16, pp. 24–26.

Lee, J. (2006a). A change is brewing. *The Sydney Morning Herald*, January 12. http://www.smh.com.au/news/national/a-change-is-brewing/2006/01/11/1136956243020.html?page=fullpage#contentSwap1.

Lee, J., (2006b). Tapping a circle of care—for any occasion. *The Sydney Morning Herald*, January 12. http://www.smh.com.au/news/national/tapping-a-circle-of-care-for-any-occasion/2006/01/11/1136956243023.html.

Lee, J. (2005). Very big ad shows why we still all Carlton a beer. *The Sydney Morning Herald*, July 28, p. 29.

Maiden, M. (2006). Booney tunes. *The Age*, January 28. http://www.theage.com.au/news/business/booney-tunes/2006/01/27/1138319448052.html.

McKay, J. (1991). *No pain, no gain? Sport and Australian culture*. Sydney: Prentice Hall Australia.

McKay, J., & Smith, P. (1995). Exonerating the hero: Frames and narratives in media coverage of the O. J. Simpson story. *Media Information Australia*, 75: 57–66.

Mikosza, J. (2003). In search of the "mysterious" Australian male: Editorial practices at men's lifestyle magazines. *Media International Australia Incorporating Culture and Policy*, 107: 134–144.

Needham, E. (2007). I've had it with men. *The Guardian*, June 4, pp. 12–15.

Nixon, S. (1996). *Hard Looks: Masculinities, Spectatorship and Contemporary Consumption*. London: UCL Press.

Palmer, C. (in press). "A bad start to the season": An analysis of the normalising of sexual violence in Australian football. *Journal of Sport & Social Issues*.

Pease, B. (2001). Moving beyond mateship: Reconstructing Australian men's practices. In B. Pease & K. Pringle (Eds.), *A man's world: Changing men's practices in a globalized world* (pp. 191–204). London: Zed.

Pettigrew, S. (2002). A grounded theory of beer consumption in Australia. *Qualitative Market Research*, 5, 2: 112–122.

Rowe, D. (2005a). Sports stars behaving badly. Posted September 12, 2005. http://www.onlineopinion.com.au/view.asp?article=174.

Rowe, D. (2005b). Ignorant of society's rules—especially when drunk. Posted February 28, 2005. http://www.onlineopinion.com.au/view.asp?article=3073&page=0.

Rowe, D., & McKay, J. (2003). A man's game: Sport and masculinities. In S. Tomsen & M. Donaldson (Eds.), *Male trouble: Looking at Australian masculinities* (pp. 200–216). Melbourne: Pluto Press.

Simpson, M. (2002). Meet the metrosexual. www.marksimpson.com/pages/journalism/metrosexual_beckham.html. July 22.

Sunderland, R. (2008). My name is Ruth. I have a drink problem. I never touch it. *The Observer*, February 3, p. 31.

Top Aussies. www.geocities.com/topaussieguide/Page1.htm.

Turner, G. (1992). "It works for me": British cultural studies, Australian cultural studies and Australian film. In: L. Grossberg, C. Nelson, & P. Treichler (Eds.), *Cultural studies* (pp. 640–652). London: Routledge.

West, B. (2006). Consuming national themed environments abroad: Australian working holiday makers and symbolic national identity in "Aussie" themed pubs. *Tourist Studies*, 6, 2: 139–155.

West, R. (2000). "This is a man's country": Masculinity and Australian national identity in *Crocodile Dundee*. In R. West & F. Lay (Eds.), *Subverting masculinity. Hegemonic and alternative versions of masculinity in contemporary culture* (pp. 44–66). Rodopi: Amsterdam-Atlanta.

Wheaton, B. (2003). Lifestyle sports magazines and the discourses of sporting masculinity in masculinity and men's lifestyle magazines. In B. Benwell (Ed.), *Masculinity and men's lifestyle magazines* (pp. 193–221). Oxford: Blackwell.

Producing AND Consuming Masculinity: New Zealand's (Speight's) "Southern Man"

STEVEN J. JACKSON

SARAH GEE

JAY SCHERER

> For southerners, Speight's is a badge of belonging. It expresses what makes them feel good about being from the South. For northerners, Speight's represents the South, which is a nostalgic ideal, the last bastion of treasured NZ values of a bygone era.
>
> (WWW.SPEIGHTS.CO.NZ)

On July 27, 2007, a boat in the Otago harbor of Dunedin, New Zealand, set sail for London, England. This in and of itself is something of a curiosity, but the fact that the boat was sponsored by a local brewery and indeed contained a specially constructed pub is of particular interest. In order to understand the whole story, one must return to 1998 when two University of Otago students— Tim Ellingham and James Livingston—became friends and shared a love of their favorite beer, Speight's. Early into the new millennium, Tim Ellingham moved to the United Kingdom and regularly complained about warm English beer and how much he missed his local Speight's. In desperation, Tim wrote to the brewery in Dunedin and suggested that Speight's try to market their product in the UK.

Granted this was a long shot with an unlikely outcome, but it was 2007 and the seventh Rugby World Cup was being co-hosted by France and the UK, providing a potential platform from which to promote the Kiwi brand. Speight's was keen to capitalize on the unique opportunity and on April 17, 2007, announced its intentions to appoint a crew to sail a boat containing an official yet portable

"Speight's Alehouse" to the United Kingdom. An extensive competition was held to finalize a crew list: James Livingston (from the original duo mentioned above), Lindsay Gilbert, Tim Cleaver, Mark Wilson, and Jamie Munro. These five Kiwi men (a sixth, Steven Nichol, joined them later) together with a three-member film crew were united with Dutch-born skipper Peter Leek and five professional sailors from Russia/Ukraine on board a freighter boat known as the *Lida*. After 70 days at sea and travelling 24,779 kilometers (15,397 miles), the *Lida*'s epic journey came to an end when it docked in central London, greeted by a crowd dominated by enthusiastic New Zealand expatriates. In conjunction with the actual voyage, a new innovative marketing campaign for Speight's eventually emerged: "If you can't take your mate to the pub, take the pub to your mate."

In one respect this is an endearing human interest story about a man's love for his favorite beer and another man's dutiful responsibility to his mate. However, the 2007 journey, deemed the "Great Beer Delivery," also highlights some important issues in relation to a range of other spheres of contemporary social life, including: (1) the production, representation, and consumption of beer as a gendered commodity; (2) the evolution of a specific brand of beer (namely, Speight's) and its location within the New Zealand popular imagination; and (3) the link between beer as a consumer product, the positioning of the Speight's brand, and the basis of contemporary masculinity. Notably, although a cursory view might suggest that two key elements of the "holy trinity" of masculinity—sport and sex—are missing in the Speight's story, these connections will soon become both implicitly and explicitly evident as we explore the Speight's brand and its promotional campaigns. This chapter traces the emergence and development of the Speight's brand through its "Southern Man" campaign that began in the 1980s. Arguably, the origins and progressions of the campaign, seen most vividly in its advertising strategies, provide insights into the holy trinity and the constitutive nature of contemporary masculinity in New Zealand.

What is striking and simultaneously concerning about Speight's and its iconic "Southern Man" campaign is its success and the seemingly unapologetic celebration of its interpretative representation of what it means to be a real man. Significantly, this is occurring within a global context where there is a greater flexibility in the types of masculinities that men can adopt and inhabit. Yet, the inclusion of a renaissance version of hegemonic masculinity or hypermasculinity such as the "Southern Man" serves to challenge notions of a flexible masculinity in a society steadfast to change. In focusing on the Speight's "Southern Man" advertising campaign, this chapter: (1) examines the relationship between masculinity, beer, and national identity in New Zealand; (2) provides a brief historical overview of the Speight's brewery and brand; (3) highlights the relationship between advertising, beer, and masculinity and, in turn, analyzes specific examples

of the "Southern Man" promotional campaigns, including their links with sport; and (4) examines the contradictions associated with the political economy of the brand as well as with localized forms of resistance to the potentially exclusionary, sexist, and misogynist nature of the campaigns. Overall, this chapter aims to facilitate a better understanding of the complexity of the holy trinity in relation to both the shifting relations of power between men and women and the context of global consumerism.

MASCULINITY, BEER, AND NEW ZEALAND NATIONAL IDENTITY

From a historical perspective, the link between masculinity and New Zealand national identity is perhaps best captured by Jock Phillips' (1987) landmark book: *A Man's Country?* The title itself is a declaration of the strong association between nationalism and masculinity and by default the marginalized position of women. Indeed, Phillips provides one viewpoint about how and why New Zealand developed as a "Man's" country, highlighting both its pioneer heritage and the centrality of rugby, war, and drinking in the historical construction of national identity and national masculinism. According to Phillips (1996), "drinking had always been a central ritual, with the pub the main institution of colonial male culture" (pp. 55–56). As such, he recounts several social and environmental factors along with insightful anecdotes to explain the centrality of alcohol, predominantly that of beer consumption.

One example of the unique context within which beer drinking behavior may have been influenced by both social customs and institutional regulations is evident in the notoriously historic "happy hour" known as the "Six o'clock swill." Up until 1967 (Phillips, 1996), New Zealand legislation strictly enforced a 6 p.m. closing time for pubs; as a consequence, large numbers of men who finished work at 5 p.m. crowded into the pubs to consume as much beer as possible within the hour. According to popular legend, men often wore gumboots as protection against the flow of beer and the urine-drenched floors, given that many of them would rather sacrifice a trip to the toilet than forfeit their place in the queue for their next order (Phillips, 1987).

These early cultural drinking patterns may have foreshadowed some of the contemporary problems associated with alcohol consumption in New Zealand. For example, the most recent public awareness campaign for ALAC (Alcohol Advisory Council of New Zealand) promotes the tagline: "Its not the drinking, its how we're drinking" and is a timely reminder of how the nation's problematic relationship with alcohol developed historically and continues today. Although Speight's was not necessarily the first New Zealand beer brand to be consumed,

nevertheless it has a long and colorful history that has played an important part in shaping the social life of New Zealanders. In the next section, we briefly outline the development of the Speight's brewery and brand with a particular focus on its popular emergence in the early 1990s.

LOCATING SPEIGHT'S IN THE NEW ZEALAND CONTEXT

While our overview of the history and development of the Speight's brewery and brand is necessarily concise, we refer our readers to other authors for more detailed analyses (cf. Campbell, Law, & Honeyfield, 1999; Donald, 1993; Law, 1997). The Speight's brewery was founded in 1876 by James Speight, Charles Greenslade, and William Dawson and currently remains in full working production, occupying the original Rattray Street site in Dunedin. Throughout the first 30 years of the brewery's existence, numerous changes occurred, including: the acquisition of rival breweries, the expansion of production capacity, and shipments to the North Island. We note that in 1923, indicating how state regulation has always impacted the organization of the beer industry, under the threat of prohibition, Speight's amalgamated with nine other companies to form New Zealand Breweries Limited (although the directorships continued to be held by members or descendants of the original founders).

With respect to early promotional culture, we note that while beer advertising per se is not a new phenomenon, the first Speight's advertisement appeared in the *New Zealand Tablet* on June 23, 1867 (www.speights.co.nz). In the early 1950s, a popular Speight's print advertisement campaign entitled "The Barrel Men: Purity, Body and Flavour" emerged. In the 1960s, New Zealand Breweries Limited faced increasing competition and looked to streamline production, resulting in the introduction of the Lucky brand of beer. Distributed nationwide, Lucky simultaneously displaced many local beers from the market, including Speight's. Yet, within months the public outcry forced the company to resurrect the Speight's brand. In 1977, the brewery's first formal links with sport were established when the company sponsored the Dunedin senior rugby union competition under the name of "The Speight's Championship." Four years later a second link with sport was established with the "Speight's Coast to Coast" competition, which has evolved into one of the world's premier multisport events challenging participants to travel across the South Island on foot, bike, and kayak, starting from the Tasman Sea and ending at the Pacific Ocean.

With respect to branding and marketing, in 1982 an internal competition was held to find a company slogan. Malcolm Campbell's submission "Pride of the South" actually placed second but was quickly adopted and has remained a

cornerstone and the official tagline of the Speight's brand ever since. Germane to this chapter, in 1987 the "Southern Man" campaign materialized drawing upon the association between rural New Zealand landscapes, lifestyles, and masculinity (Law, 1997). The original version of the "Southern Man" was quite ordinary—a staunch sheep musterer (herder) riding a horse and wearing a Driza-bone trench coat, similar to the renowned Marlboro Man. Notably, in the late 1980s and early 1990s, the brand and the beer industry as a whole was under pressure as intra-industry competition and changing consumer preferences for wine and other spirits emerged. Indeed, Speight's itself experienced a period of unpopularity at the time and there was even a derogatory phrase associated with the brand: "drink Speight's and lose your mates" (Meares, 2008). As such, the brand needed to be reinvented, which prompted a series of strategic initiatives. First, it became apparent that a strong link could be forged between the Speight's brand and the local University of Otago student culture. Moreover, this was reinforced through Speight's strategic sponsorship of the Otago franchise in New Zealand's premier domestic rugby competition (NPC) and their historic win in 1991. Not only did Speight's sponsor the team itself but it also held naming rights to a particular section of seating in Dunedin's legendary Carisbrook Stadium. These were very basic but important links with sport in a city of 120,000 people (including 20,000 students) that was trying to forge a strong town-and-gown relationship. Moreover, these initiatives provided a foundation from which to launch more regional and national promotional campaigns that included a branded theme song for radio commercials, billboards/posters, and, most significantly, television advertising. Prior to focusing on specific examples of the Speight's promotional campaign, we endeavor to highlight the more general relationship between advertising, beer, and masculinity.

ADVERTISING, BEER, AND MASCULINITY

As a cultural field (Jhally, 1997), beer advertising provides insights into the key stories, themes, and values that are relevant within particular social contexts at specific points in time. Conceptualized more broadly, beer advertising can illuminate some of the major sites and debates that are being contested within society, including issues related to identity politics. Here, our focus is largely on gender identity but we also acknowledge that identities do not exist in isolation; indeed, they form a relatively complex matrix that brings to the fore detailed expressions of identity depending on the context.

With respect to masculinity, Strate (1992) suggests that one way of understanding contemporary manhood is by looking at both the rules and forms of representation that influence how men are defined and, in turn, how men see

themselves. According to Strate (1992), five questions typify masculinity or "what it means be a man," including: (1) What kinds of things do men do? (2) What kinds of settings do men prefer? (3) How do men relate to each other? (4) How do boys become men? (5) How do men relate to women? Granted there are others, but even a cursory examination of these basic five questions signals the potential influence of the "holy trinity"—that is, beer, sport, and sex—in the construction of masculinity. Thus, it is not just the basic answers to these five questions that matter. Rather, it is the assumptions and explanations about why men engage in particular activities, in conjunction with how men are represented (e.g., by the media and advertising), that is our primary concern.

Clearly there are multiple masculinities and many sites and cultural practices at which, and through which, masculinity is confirmed, reproduced, and contested. Sites and practices of consumption and the promotional culture that drives it (advertising and marketing) are key investigative territories. In sum, advertising is one site through which to examine contemporary masculinity, and to a greater extent beer advertising. Beer advertising reveals the assumptions that the advertising industry makes about what men do, what they are interested in, and how they see and differentiate themselves within our world. As Strate (1992) recognized, beer advertisements:

> are not the only source of knowledge on this subject, but nowhere is so much information presented in so concentrated a form as in television's 30-second spots, and no other industry's commercials focus so exclusively and so exhaustively on images of the man's man. (p. 78)

While some might contest Strate's assertion that beer advertisements are the most powerful site for the depiction of masculinity, they certainly play a key role in the construction, representation, and consumption of masculinity. What is crucial is the broader intertextual system through which dominant images of masculanity, including those represented within beer advertisements, are produced, circulated, and consumed.

As such, we explore the unique place of beer advertising in the social construction of modern masculinity. As Strate (1992) asserts:

> The manifest function of beer advertising is to promote a particular brand, but collectively the commercials provide a clear and consistent image of the masculine role; in a sense, they constitute a guide for becoming a man, a rulebook for appropriate male behavior, in short, a manual on masculinity. (p. 78)

In the next section, we explore the integrated nature of the Speight's "Southern Man" campaign and how it may serve as a manual on masculinity. We

begin with the Southern Man theme song that aired on radio and its subsequent links with the Southern Man Identification poster and ultimately discuss the celebrated series of television commercials that Lion Nathan marketing director Stephen Smith describes as "one of the most popular, effective, and consistent campaigns in the history of New Zealand advertising" (Fahy, 2006, p. 3).

THE "SOUTHERN MAN" SONG

It was Speight's tactical partnership with Saatchi and Saatchi advertising in the late 1980s that provided the brand with its preeminent status, both in terms of public popularity and market share. At the time, Saatchi and Saatchi's advertising guru Roy Meares offered his client Lion Nathan Breweries Limited an innovative, though not immediately persuasive, vision of a Southern Man. Building upon the existing themes of Central Otago highland landscapes and quiet heroic figures, Meares collaborated with Murray Grindlay to compose the now infamous ballad the Southern Man song. Meares' lyrics (see below) accompanied by Murray Grindlay's simple harmonica tune is generally accepted as a "theme song" for many in the South of New Zealand and is regularly played at Otago provincial-representative and Super 14 Highlander rugby union games. Indeed, the song was an important launching point for the brand and its links with a particular version of New Zealand masculinity, considering the existing regulations on advertising at the time. Not only was beer advertising banned from television, but also companies were restricted from mentioning brand names on radio (Meares, 2008). To sidestep these restrictions, Saatchi and Saatchi subtly introduced the Southern Man song into mainstream broadcasts, which has undoubtedly contributed to the song's "anthemic" status in the South.

The lyrics of the Southern Man song offer us some potential insights for understanding masculinity and the corresponding Southern Man culture. In very basic terms, the song is about values and loyalty and, in keeping with the theme of this book, works to characterize the relationship between men, beer, and women in ways that advance the marketing goals of a particular brand.

SOUTHERN MAN SONG

(Lyrics by Roy Meares, music and performance by Murray Grindlay)

Some of the boys
Got it into their heads

"Bout movin" up north
To follow the bread
That ain't for me
That kind of thing just don't rate
This is one Southern boy
Who ain't crossin' the strait

Now I might not be rich
But I like things down here
We got the best looking girls
And the best damn beer
So you can keep your Queen City
With your cocktails and cool
Give me a beer in a seven (*7 ounce glass*)
With the boys shooting pool

Chorus: I'm a Southern man
Well I'm Southern bred
I got the South in my blood
And I'll be here 'till I'm damn well dead

'Cos here we just know
What makes a Southern boy tick
And it ain't margaritas
With some fruit on a stick
Well it might not be fancy
But when you come from down here
You know you got the best girl
And you got the best beer.

Most of the song is easy to interpret but a few Kiwi-specific phrases need some clarification. The expression "moving up north" refers to a general pattern of south-to-north migration that is linked with work, leisure, and other opportunities in larger urban centers, particularly Auckland—New Zealand's largest city with a population of over one million people. Auckland, also known as the "Queen City," serves as the symbolic antithesis for many people of the South and the lyrics reflect not only an indifference but at times overt disdain. Phrases such as "So you can keep your Queen City, with your cocktails and cool" and "it ain't margaritas, with some fruit on a stick" confirm a view of Auckland as a city of affluence and pretentiousness with a focus on image and appearance. Moreover, references to what Aucklanders drink, such as cocktails and margaritas, provide a clear differentiation between the "yuppies" of the North and the "real men" of the South (who drink beer). In addition, to Southerners and indeed many who live outside Auckland, anyone who lives in Auckland is considered a JAFA (Just Another Fucking Aucklander), which could be interpreted as a sign of jealousy

or perhaps even resentment of the power and influence that the Auckland region holds in political, economic, and cultural terms. Although the song's reference to women is brief and arguably complimentary—"We've got the best looking girls and the best damn beer"—noting women and beer in the same phrase raises the issue of gender relations and furthermore, the link between beer and females as objects of consumption.

Overall, the narrative establishes Southern identity "out of difference" from the North, Auckland in particular. Southerners value the simple things in life: loyalty, beer, and mateship; but what is most conspicuous is the absence of any reference to rugby or sport in general (although shooting pool is mentioned). In fact, references to sport are used sparingly and subtly throughout the Speight's "Southern Man" advertising and marketing campaign. As previously noted, the Southern Man song deliberately avoided making any strong connections to the Speight's brand itself and this was largely due to the media regulations at the time. However, the Speight's brand and its links to the holy trinity gradually became more apparent through other parts of the integrated marketing campaign. One particular strategy was the introduction of the "How to Be a Southern Man" Identification Chart or poster.

SPEIGHT'S "HOW TO BE A SOUTHERN MAN" POSTER: A MANUAL ON MASCULINITY?

The Southern Man song proved popular and, as previously noted, has become somewhat of an anthem at sporting and other cultural events in the South. The song, through both radio and public performances, provided an opportunity to reach a much wider audience compared to the existing billboard campaigns. When the idea of extending the "Southern Man" campaign was initiated in the late 1980s, one specific initiative was the introduction of the Southern Man Identification Chart. Since then various versions of the "Southern Man Identification Chart" have adorned the walls of student flats, university dorm rooms, rugby clubs, and pubs for over two decades. The chart, which is effectively a poster, features a young Southern Man in the outdoors, wearing a traditional musterer's outfit and often accompanied by his loyal companion dog, with the Speight's logo clearly designated. Around the outside of the poster are a range of key stereotypical phrases relating to the particulars of a Southern Man's fashion style, physical appearance, and behavior. The poster not only helps identify "real" Southern Men but also ensures that the men themselves actually conform to the rules. A few of the basic guidelines are outlined below.

A Southern Man Always:

- Uses his left hand to drink with, leaving his right hand free to prod the chest of anyone who disagrees with his rugby theories, of which he has an abundance.
- Drives a Ute (or similar no-nonsense wagon), it has space for a few kegs of Speight's when the boys come over to watch footy. They're also perfect for hunting and fishing trips or the odd excursion north to support the local team.
- Wears his Speight's jersey with pride whenever he can, especially at his local rugby club or pub.

A Southern Man Never:

- Neither holds hands with his woman in public nor rides scooters or mopeds.

The Southern Man Respects:

- Women who drink Speight's out of a jug.

Sport: The Southern Man:

- Plays any contact sport where there is a risk to life or limb.

Lingo:

- One for the road = Two for the road
- Sip = 5 jugs
- Big sip = in excess of 8 jugs

This particular version of the Southern Man poster offers the most explicit references to sport including: wearing rugby clothing (the Speight's jersey is a rugby jersey); driving a particular kind of vehicle—a Ute (or pick up type truck)—that can transport beer to locations and occasions where rugby is being played and watched; and talking seriously about rugby (since there is no other way to talk about rugby in New Zealand). Beyond rugby per se, there are references to other forms of physical pursuits including hunting and fishing and a general acceptance of any sport as long as "there is a risk to life or limb." Indeed, this "rule" parallels the general acceptance for men to inflict and to (silently) suffer from physical pain in order to display their masculinity (Messner, 1992).

Although women are certainly alluded to in the Southern Man Identification poster, the references are very limited and restricted. One of the things implied by the text in the poster is that a Southern Man respects only those women who drink out of a jug (pitcher). A second "rule" is that a Southern Man never holds hands with women in public, that is, no public displays of affection. These two examples aid in constructing an idea that the only admissible way for women to receive respect from the viewpoint of a Southern Man is by drinking (beer) out of

a jug, and furthermore, she should never expect her Southern Man to show her any outward affection in public. In turn, these references exemplify the marginalized position of women in the Southern Man's world.

Moreover, it is evident that the consumption of beer is central to the Southern Man identity. The "Lingo" of the Southern Man explicitly reinforces heavy alcohol consumption and, furthermore, makes an indirect connection with drinking and driving through the phrase "one for the road = two for the road." However, after public complaints about the original poster's positive spin on excessive alcohol consumption and drinking practices, these references were changed in successive posters. More recent versions of this poster have reduced the emphasis on excessive levels of consumption but simultaneously incorporated other ways in which to confirm a particular form of hegemonic masculinity. This has included the underpinning of a gender order (Connell, 2001), describing acceptable masculine practices and even adequate forms of consumption. For example,

- Teeth: Firmly gritted whenever accidently exposed to "Boy Band" or Pop Princess music while searching for sport.
- Jaw: dropped when heard the news that ballroom dancing was made an Olympic sport.
- Hair: Styled only by a barber or the Southerly wind. Never contains any styling products: gel, glue, or other foreign substances other than wind-blown drench or grease from repairing the Ute axle housing.

Again, the Southern Man is characteristically differentiated from the "other" and in this case, the "other" exists in marginalized references to more alternative (or even softer) forms of masculinity, thus projecting the Southern Man as a hegemonically dominant form of masculinity. Yet, despite the seemingly traditional and conservative nature of the Southern Man, there are signs that he too is a man of consumption. From hair products (or lack thereof) to music, in particular beer and sport, the Southern Man's identity appears to be defined by precise forms of consumption.

Taken at their most basic level, the Southern Man song, billboards, and posters are individual forms of advertising and marketing. To this extent they help define and promote a specific brand of commodity. However, brands are not just commodities with identities, they also construct, reproduce, and appeal to distinct, if fictionalized, markets of consumption (Jackson, 2005a, 2005b). Consequently, they play an active role in constructing and creating the very subjectivities of consumption that they target. Providing a checklist on mannerisms, appearances, and even consumer preferences, the poster offers both a mirror into which young and old Southern men can see how they compare and measure up and, a yardstick by which to judge others. To this extent the poster operates as a tool of surveillance to ensure that aspiring Southern Men conform to a particular

image and identity. Next, we continue to explore how the Speight's "Southern Man" promotional campaign operates as a "manual on masculinity" by focusing on some specific examples of Speight's television advertising. Our aim is to highlight the uniqueness, complexity, and contradictions within particular aspects of the campaign.

SPEIGHT'S "SOUTHERN MAN" TELEVISION CAMPAIGN

The "Southern Man" series of commercials is unique for a range of reasons, but most significantly because Speight's produced the very first beer advertisement to air on New Zealand television in 1992. Prior to February 1, 1992, broadcasting policy in New Zealand prohibited all alcohol brand advertising via electronic media. This not only highlights the prevailing controls over alcohol advertising by New Zealand's relevant regulatory agencies but also points to the wider implications of a new avenue of social and commercial communication. According to Campbell, Law, and Honeyfield (1999):

> It was only in 1992 that beer brand advertising was permitted on television. It was at this point that the long-established relationships between beer consumers and their product of choice became thoroughly disrupted. The taken-for-granted meanings of beer—its gender associations, location with daily life, associations with sport and exclusive male culture, manual labour and complete non-femininity—were now being simultaneously reconstructed, subverted, reconstituted and defended through the process of television advertising. (p. 177)

Thus, the very introduction of televised beer advertising is seen to have had implications for gender relations and the contested nature of contemporary masculinity. Apart from competing for consumer loyalty, the onset of alcohol-related television commercials redefined the inherent associations of beer as a gendered commodity and its consumption as a gendered practice—most of which were understood and yet often went unsaid. With specific reference to Speight's "Southern Man" ads and New Zealand masculine identity, Law (1997) draws from Strate's (1992) five questions in determining what it means to "be a man" and the representation of masculinity:

> The ads draw on typical themes in beer advertising in the Western world (Strate, 1992), and refer to a tradition of idealised representations of masculinity in New Zealand. They show single Pakeha men affirming the importance of male mateship, heterosexuality (in the abstract), hard physical outdoor work, the wisdom of older men being passed on to younger ones, and an unselfconscious authority over the animal world. (p. 25)

Utilizing the Southern Man stereotype, the campaign's two main characters have become representative of hegemonic masculinity within the New Zealand imaginary: "a rugged, outdoor, hardworking folk hero" (Casswell & Zhang, 1998, p. 1211).

The Speight's series of ads is unique also because of its enduring qualities, which is somewhat of a rarity in the field of advertising. Beginning in 1992 and spanning almost an entire decade, at least nine advertisements were produced and, in turn, aired on New Zealand television. It is beyond the scope of this chapter to thoroughly examine all of these; however, in Table 9.1 we have included their titles, locations, and brief descriptions. We focus on two particular commercials within the series, "City Girl" and the "Deer Stalker's Ball." These two were selected in part because they provide points of contrast and comparison between earlier and later examples in the series, thus allowing us to see how the "Southern

Table 9.1 An overview of Speight's "Southern Man" Advertisements

Title	Location	Description
City Girl	Around a campfire	Younger Southern Man seeks advice about moving to Auckland for a girl who does not drink Speight's
Train Tracks	Standing on Rural Train Tracks	Younger Southern Man switches the tracks to prevent train from sending Speight's "north"
Wally's funeral	Attending funeral/ wake of friend	Southern Men find the hidden key to deceased mate's shed full of Speight's
Lucky Last	Mountain range	Elder Southern Man offers Younger man the "last" Speight's if he herds the last sheep
Better Half	Rural Bar/Restaurant	Southern Men console a man separating from wife and facing the split of the Restaurant/Bar business (in the settlement, the man gets the "better half = the "Bar")
Speight's Tour	Speight's Brewery	Southern Men "accidentally" get locked in the Speight's brewery for the weekend
Deer Stalker's Ball	Rural Pub	Young female bartender indicates she has two free tickets to a ball, with Speight's available on tap and a late license. Younger Southern Man eventually accepts them and surprisingly gives one to the Elder man.
Progress	Rural Range	Younger Southern Man tries to impress the technology-opposed Elder man by using his mobile phone to have Speight's delivered to their remote location by a four-wheeler
Nightmare	Rural Pub	Elder Southern Man dreams about an unusual "contemporary" conversation with Younger man whilst drinking margaritas

Man" campaign evolved. In particular, these two television advertisements may reveal how Speight's worked to accommodate female consumers without alienating traditional Southern Men.

"CITY GIRL" ADVERTISEMENT

Speight's very first television commercial "City Girl" is a 60-second spot set in New Zealand's southern, rural highlands at dusk: the gentle melodious sound of a harmonica is playing in the background; two men are present, an Elder Southern Man (ESM) who is unsaddling his horse and a Younger Southern Man (YSM) who is relaxing near the campfire drinking a can of Speight's. The ensuing dialogue proceeds as follows:ESM: I hear you've been seeing a city girl?

> YSM: Yeah, she wants me to move up to Auckland with her.
> ESM: Oh yeah, what's the attraction up there? (As the Younger man gazes upon a photograph of a beautiful blonde woman)
> YSM: Place in the harbour, 500 SL Mercedes, 80-foot yacht, and her old man's got a box at Eden Park.
> ESM: Oh yeah?
> YSM: She doesn't drink Speight's, but.
> ESM: (shaking his head in disapproval) She's a hard road finding the perfect woman boy.
> YSM: Reckon. Still…no hurry, eh?
> ESM: Good on ya mate.
> Narrative Voiceover: Speight's. Pride of the South for over 100 years.

What does this advertisement tell us about Southern Men, beer, masculinity, and gender relations in New Zealand? As a story the advertisement is cunningly written to portray a young man's dilemma: follow his heart (or at least his hormones) North to be with his near-perfect girl or remain loyal to the South. Lured by a beautiful "city girl" and her accentuated affluence, the decision does not appear to be a difficult one. Not only is his city girl beautiful, she comes as part of a larger package that includes a 500 SL Mercedes and an 80-foot yacht, and as if that were not tempting enough, there is one more enticing factor: his girlfriend's father ("old man") has a corporate box at Eden Park (which at the time was New Zealand's premier sporting venue for rugby and cricket). In many ways, the material possessions on offer to the Younger Southern Man parallel that of a traditional dowry system, where a woman's worth is measured by the value she brings to the relationship either directly or indirectly—as in this case, of a sport stadium corporate box through her father (Jackson, 2005a). However,

with all accounts of wealth and assets aside, the Younger Southern Man's decision is solidified by the fact that his girlfriend does not drink the cherished local brew (Speight's). Thus, we can assume from the line "no hurry, eh?" that the Younger Southern Man rejects the idea of moving to Auckland, signifying the dedication of a man to his beer and his loyalty to the brand, and, as the Southern Man song implies, that he is one Southern boy "who ain't crossin' the strait." Finally, we draw attention to the last sentence of the commercial, "Good on ya mate." This is a colloquial New Zealand phrase and perhaps even more specific to the South Island. It can be loosely translated to mean several expressions such as "Good for you," "Well done," and "That's the way" but can also be used as a way of saying "Congratulations" and/or "Thanks," depending on the context of the situation. In this case the older, presumably wiser, Southern Man approves and endorses his younger counterpart's decision, thereby confirming both their masculinities.

Initially, when Saatchi and Saatchi pitched the "City Girl" idea to Lion Nathan (Speight's parent company), the executives were unsure whether the slow, dry humor of the ad would indeed accomplish their intentions to "raise support and loyalty at a local level and reverse the decline and preference of Southern drinkers due to increasing competition from other available brands" (Meares, 2008). But after witnessing the positive responses from a targeted focus group (specifically men from the Otago region who drink beer) and the connection the men had with the way the characters personified true Southern values, the executives approved the idea for production. The success of this inaugural spot has since spurred the creation and production of at least eight other similar advertisements, one of them being the "Deer Stalker's Ball."

"DEER STALKER'S BALL" ADVERTISEMENT

This 60-second advertisement is particularly significant since it is the first one in the "Southern Man" series that introduces a young female character into the plot. The campaign's creators viewed the inclusion of a female as a way to develop a "more interesting script that would utilise a new personality without changing the dynamics of the two guys [Southern Men]" (Meares, 2008). The advertisement opens with a quick shot of two men on horseback riding into the sunset, then it fast-forwards in time and we see the two Southern Men (YSM and ESM) casually drinking a beer in the local pub. The Young Female bartender (YF) opens the conversation posing a question to the Young Southern Man (YSM) as follows:

YF: You planning on going to the Deer Stalker's Ball this year?

YSM: Hadn't planned on it.

YF: They've got a live band. Spot prizes. Mrs. McConnell's making her venison pie for the supper.

YSM: Oh yeah.

YF: They've got Speight's on tap all night and a late license.

ESM: She makes a fair game pie does Mrs. McConnell.

YSM: Is that right?

YF: I've got two tickets. (YF holds up the two tickets) Tell you what…it's on me.

YSM: Fair enough. (YSM takes both tickets out of YF's hand, pauses, gives one ticket to his mate, ESM, and turns back towards YF, puts on his hat and says,) Might see you there then. (YSM walks out the door)(The camera flashes back to YF who gives the departing YSM a look of disgust.)

ESM: (under his breath says) "Good on ya mate." (Finishes his beer and follows the YSM.)

Narrative Voiceover: Speight's. Pride of the South for over 125 years. (The scene is now set at the Deer Stalker's Ball)

YSM: Good sport that Sharon.

ESM: Generous to a fault boy. More pie?

The physical inclusion of a female in this advertisement suggests a potential evolution of the overall campaign, perhaps signaling Speight's awareness that within the context of the new millennium it was time for a change. In an attempt to sustain the younger beer-drinking market, Sharon, the female bartender, was introduced to create a new dimension to the storyline and to: (1) "give the campaign a younger feel that would not alienate the female market"; (2) "open up new script opportunities which could possibly add more modern, relevant storylines"; and (3) explore "the possibility of 'a love interest'" between Sharon and the Younger Southern Man (Meares, 2008). It is well established that the pub, alongside sport and the military, remains as one of the "last bastions" of masculinity (McLauchlan, 1994)—a site where men can still be men—in a society that is rapidly overcome by ongoing change in gender relations. Thus, this borderline "intrusion" of a female within a male-dominated domain presents the question of whether there is anything that can truly be considered a "den" exclusively for men particularly within the context of a highly competitive yet fickle consumer-driven market economy. However, Sharon's intrusion is nonthreatening—she is spatially segregated behind the bar and performing traditional serving duties. More recent promotional initiatives, including the web-based "Speight's TV," feature coverage of sponsored social events that signal a new development in the position of women within the Speight's promotional campaign. For example, consider one strategic extension of the "Great Beer Delivery" idea described at the beginning of this chapter. In order to retain its share of the tertiary student market, in 2008 Speight's ran a competition for the best "brand"-decorated house or

apartment. Winners received 52 cases of Speight's beer, one for each week of the year. Fronting the campaign were three beautiful, scantily clad, bosom-displaying young women. Thus, women are now more visible within the brand's marketing campaign but in a way that explicitly sexualizes them. It would be too simplistic to suggest that these women and those they represent are disempowered; however, there is no denying that they are part of the ongoing reformulation of the holy trinity within the Speight's brand.

DISCUSSION

The Speight's "Southern Man" campaign emerged and evolved during a particular sociohistorical moment with respect to both contemporary gender relations and global consumerist society, a time that some have described as a contemporary crisis of masculinity (Clare, 2000; Edwards, 2006; Horrocks, 1994; Kimmel & Messner, 1992). However, there is no real consensus as to the validity of such a crisis or, more generally, how it is being manifested, represented, accommodated, and resisted. On the one hand, many have argued that we have entered a new phase of flexible masculinity characterized by global media icons such as metrosexual football star David Beckham (Cashmore, 2002; Cashmore & Parker, 2003; Whannel, 2002). Capturing his flexibility not only in terms of masculinity but also as a consumable image and promotional vehicle, Garry Whannel (2002) notes that:

> David Beckham exemplifies indulgence in the consumer market. His image has become the dominant icon of British sport representation, yet it is a strangely anchorless image—a floating signifier that can become attached to a range of discursive elements with equal plausibility. (p. 202)

In short, Beckham represents a more open-ended form of masculinity but nevertheless one that is clearly located within the confines of consumption. Returning to Strate's (1992) assertion that beer advertisements operate as manuals on masculinity, David Beckham, as but one example, might suggest that there is at least the possibility of new handbooks that offer a wider range of ways of being a real man in the new millennium. Yet, there are signs of resistance that indicate that some men, or at least those whom marketing and advertising firms seek to appeal to, feel compelled to return to, or at least retain part of, the past.

Arguably, the Speight's "Southern Man" depicts one aspect of this romanticized hegemonic masculine past. Moreover, while the Southern Man archetype represents a regional geographic location, he undoubtedly symbolizes much more. Beyond a specific spatial formation, he embodies and personifies a site that is

both spatial and temporal: a site that, although defined by real practices that confirm masculinity, is nevertheless a nostalgic bridge to a mythical past. According to Law (1997), "although the ads are not explicitly set in the past, the depiction evokes nostalgia for simpler times, and a poignant recognition that this way of life is threatened" (p. 25).

The longevity of the "Southern Man" campaign is testimony to its success both in the marketplace and in particular segments of the New Zealand popular imaginary. However, it is not without its critics, nor without signs of resistance. Our examples here are necessarily brief but worthy of note. One example involves a Speight's billboard in Dunedin that shows an attractive blonde woman standing next to a rural tavern named "Bonnie's Pub," underneath it is the tagline from the very first Speight's television advertisement that states: "It's a hard road finding the perfect woman, boy." In this case, someone has spray painted over the tagline so that it read: "Its a hard road finding a fuck machine, boy" followed by "These ads are sexist!!!" This could be a simple act of graffiti, but it is difficult to ignore the strong feminist message being communicated.

In a related, but more coordinated, case of resistance, during the 1990s a one-day campaign was held with flyers being attached to the windshields of cars parked near a New Zealand rugby stadium prior to a major international game. The white flyer with bold, black text was titled "Do Not Recycle" and made links between images of Speight's beer cans, a rugby ball, and domestic violence. A carefully designed set of arrows connected concepts of beer, sport, and violence using various letters from the word "Speight's" to spell other words (e.g., hits, she, he, pig, pits, and shits). Underneath the images additional text read:

> Alcohol is consumed in vast quantities at/during rugby matches
> Alcohol consumption has been linked to increased domestic violence
> When the All Blacks/Otago win, domestic violence increases.

The bottom of the flyer concludes in large text: "Who ends up All Black?" This campaign was clearly aimed at raising awareness of the darker side of the holy trinity. The statements made are certainly serious and there is some anecdotal evidence of the connection between alcohol and domestic violence largely from women's shelters and occasional police comment (Jackson, 1993). Clearly, this is in an important area warranting future research.

One aspect of the success of the overall "Southern Man" campaign was its clever construction that worked to accommodate much of the potential resistance. The understated advertisements avoid using any form of explicit sexual

innuendo and are largely supported by a subtle use of humor. According to Law (1997):

> The ironic humour is crucial, since it allows the ads to be enjoyed by male (and perhaps even female) readers on two levels: they can identify with the heroic image of the Southern Man, but can protect themselves from ridicule and feminist challenges by implying that it all a performance." (p. 24)

In sum, the advertisements are assembled in a way that enables men to engage in an unapologetic form of willful nostalgia that celebrates, however subtly, elements of the holy trinity. Moreover, the "Southern Man" campaign is strategically created to accommodate a range of criticisms by arguing that the advertisements are so hyperbolic in nature that they cannot really be taken serious, thereby defusing the objections of critics who then risk being ridiculed on two counts: not having a sense of humor and/or just not getting it.

CONCLUSION

The Speight's "Southern Man" campaign is a multidimensional promotional vehicle that draws upon invented traditions, geographic/regional loyalties, humor and a unique combination of powerful visual iconography, musical soundtracks, and sport culture that all form the backdrop for both a beer brand and a social construction of New Zealand masculinity. Speight's is but one particular brand of beer in a world of literally thousands. In fact, Speight's is only one of many brands under its parent company Lion Nathan whose head office is located in Australia and whose majority stakeholder is Japanese brewery Kirin, making it the fourth largest brewing alliance in the world (www.lion-nathan.com). As such, the "Southern Man" advertising campaign forms part of an ever-expanding transnational network of corporations that seek to identify, target, and exploit particular markets of masculinity often through links with sport (Jackson, 2005a, 2005b). As Collins and Vamplew (2002) note: "The increasingly global nature of sports brands...makes them even more attractive to an industry which itself is consolidating across national boundaries into "super-breweries" [such as Belgium's Interbrew] making marketing and advertising campaigns simpler and cheaper" (pp. 123–124).

To this extent, the Speight's "Southern Man," as an iconic representation of a quintessential New Zealand male, serves as a vehicle of consumption in two highly interrelated ways: (1) through the masculinization of consumption and (2) through the consumption of masculinity. However, we cannot and should not ignore the fact that the Southern Man represents a particular—in many respects,

exclusionary—form of masculinity. For example, it is a masculinity that clearly privileges Pakeha (White European New Zealander) over Mäori (New Zealand's indigenous people) who are absent from any of the campaigns. And, it is a staunch heterosexual masculinity that symbolically annihilates gay men and only reluctantly includes women either on the margins or as sexual objects. There is some evidence of cultural resistance to the Speight's Southern Man stereotype, but the reality is that the success of the Speight's brand may actually lie in its overt challenge to such resistance. Drawing a link to Edwards' (2006) view of the emergent images of the New Man and New Lad, we argue that, as a media invention, the Speight's Southern Man may be as much about "patterns of consumption and marketing, or the commodification of masculinities" (p. 4), as he is a deliberate attempt at challenging sexual politics. Consequently, despite his remote location in the antipodes, it is apparent that the "Southern Man" campaign is one site through which the emerging neoliberal agenda effectively partners with global capitalism to construct, deconstruct, or reproduce masculinities that serve its interests (Jackson, 2005a, 2005b).

Ultimately, as a nationally promoted, distributed, and consumed commodity, Speight's and its assimilated Southern Man masculinity—although regionally exclusive to Otago and Southland—have moved beyond mountains, plains, and straits to become a national symbol for New Zealand. Peter Kean, Lion Nathan's New Zealand managing director, claims: "Speight's stands for mateship, generosity, loyalty and practicality. While the brand originated in the South, these values are New Zealand values and what sets us apart from the rest of the world in spirit and attitude" (www.speights.co.nz). The "Great Beer Delivery" is evidence in and of itself that there are no lengths too great to communicate these highly coveted New Zealand values—values that have their own local flavor but are arguably becoming part of an increasingly global, dynamic, and shifting holy trinity.

REFERENCES

Campbell, J., Law, R., & Honeyfield, J. (1999). What it means to be a man: Hegemonic masculinity and the reinvention of beer. In R. Law, H. Campbell, & J. Dolan (Eds.), *Masculinities in Aotearoa/New Zealand* (pp. 166–186). Palmerston North: Dunmore Press.

Cashmore, E. (2002) *Beckham*. Cambridge, UK: Polity Press.

Cashmore, E., & Parker, A. (2003) One David Beckham? Celebrity, masculinity, and the soccerati. *Sociology of Sport Journal, 20,* 214–231.

Casswell, S., & Zhang, J-F. (1998). Impact of liking for advertising and brand allegiance on drinking and alcohol-related aggression: a longitudinal study. *Addiction, 93,* 1209–1217.

Clare, A. (2000). *On men: masculinity in crisis*. London: Chatto & Windus.

Collins, T., & Vamplew, W. (2002). *Mud, sweat and beers: A cultural history of sport and alcohol.* Oxford: Berg.

Connell, R. W. (2001). Masculinity politics on a world scale. In Whitehead, S. M. & Barrett, F. J. (Eds.), *The masculinities reader* (pp. 369–374). Cambridge: Polity.

Donald, G. (1993). *Speight's: The story of Dunedin's historic brewery.* Dunedin: Avon Publishers in association with McIndoe Publishers.

Edwards, T. (2006). *Cultures of masculinity.* New York: Routledge.

Fahy, B. (2006, June 10–11), "Sushi and the Southern man," *Otago Daily Time Weekend Magazines*, p. 3.

Horrocks, R. (1994). *Masculinity in crisis.* New York: St. Martin's Press.

Jackson, S. J. (1993), Beauty and the beast: A critical look at sports violence. *Journal of Physical Education New Zealand, 26* (4), 9–13.

Jackson, S. J. (2005a). *Producing and consuming masculinity: Sport, beer and advertising.* Paper presented at the 37th Annual conference of the International Institute of Sociology, Stockholm, Sweden, July 5–9.

Jackson, S. J. (2005b). *Mediating masculinity: Sport, beer advertising and identity.* Invited Presentation, Sport and Alcohol Conference, Massey University, New Zealand, 8–10 February.

Jhally, S. (1997). *Advertising and the end of the world.* Northampton, MA: Media Education Foundation.

Kimmel, M. S., & Messner, M. A. (1992). *Men's lives.* New York: Macmillan.

Law, R. (1997). Masculinity, place, and beer advertising in New Zealand: The Southern Man campaign. *New Zealand Geographer, 53* (2), 22–28.

McLauchlan, G. (1994). *The story of beer: Beer and brewing—a New Zealand history.* Penguin: Auckland.

Meares, R. (2008, March 28). Personal communication.

Messner, M. (1992). *Sport, men and gender. Power at play: Sports and the problem of masculinity.* Boston: Beacon Press.

Phillips, J. (1987). *A man's country? the image of the Pakeha male—A history* (1st edition), Auckland: Penguin Books.

Phillips, J. (1996). *A man's country? the image of the Pakeha male—A history* (2nd edition), Auckland: Penguin Books.

Strate, L. (1992) Beer commercials: A manual on masculinity. In S. Craig (Ed.), *Men, masculinity and the media* (pp. 78–92). London: Sage.

Whannel, G. (2002). *Media sport stars: Masculinities and moralities.* London: Routledge.

Lubrication AND Domination: Beer, Sport, Masculinity, AND THE Australian Gender Order

DAVID ROWE

CALLUM GILMOUR

BEER AND AUSTRALIANNESS

Advertising campaigns for Australian beer brands reveal the significant role of beer in the cultural construction and promotion of Australian national identity and masculinity. The iconographic representations and thematic concerns utilized within Australian alcohol promotional culture have proved remarkably durable—persistently reproducing dominant discourses of masculine power, Anglo-Celtic predominance, feminine exclusion or exploitation, nationalistic sporting prowess, and masculinist "workerism." The promotion of alcohol has heavily deployed stereotypical representations, with beer, in particular, linked to the performance of Australian lifestyle rituals (Fiske, Hodge, & Turner, 1987). These recurring discourses reveal a stubborn and outmoded tendency within Australian beer commercials to promote archaic depictions of a homogeneous national identity in which gender, race, and ethnic representations are either essentialized or excluded wholesale—while sociocultural change, contestation, or resistance are rarely addressed or acknowledged. Alcohol is naturalized within these commercials as an essential everyday lifestyle accoutrement, with its consumption portrayed as an almost mandatory habit within Australian leisure.

The marketing of beer within Australia has a long history of reflecting and promoting many of the traditional national myths and enduring masculine

discourses that color its popular culture. Advertising, although often global in terms of organizational structures and campaigns, tends to situate desire within recognizably local national frameworks. Thus, such apparently mundane practices as the consumption of beer—a liquid produced in large quantities by largely industrial methods—are woven into the national narrative through a media-generated process that reproduces elements of socialization within specific contexts. As Hogan (1999, p. 747) remarks, "advertisements aestheticize articulations of (the) core values of a society," utilizing exaggerated and stereotypical representations that "seek to persuade through their symbolic articulation of a society's ideals and desires." In this manner, beer advertising promotes preferred meanings that relate to selected Australian social and cultural norms. As a consequence, there exists a recurring narrative of exclusion within many Australian television beer commercials released over the past three decades (the subject of this chapter), especially with regard to gendered, multicultural, and indigenous representational power relations.

This chapter addresses, in particular, the ubiquitous thematic triumvirate of beer consumption, sporting prowess, and masculinity that has remained a potent symbol of an Australian national identity that is consistently endorsed within promotional culture. In this chapter, three main commercial television advertisements will be presented as analytical examples to illustrate our overall argument—a 1984 Victoria Bitter commercial (George Patterson Bates Agency) (http://www.youtube.com/watch?v=4wfgi9hGx1o&feature=related), a Carlton Midstrength commercial from 2002 (George Patterson Bates Agency) (http://www.youtube.com/watch?v=jDFwQFqK4fo), and a Tooheys New commercial from 2003 (Singleton Ogilvy & Mather Agency) (http://www.youtube.com/watch?v=3yGJVnOwxz0). The two decades that they span indicate both continuities and variations, although the former are regarded as of considerably greater sociocultural importance than the latter. Before engaging in this textual analysis, though, it is useful to examine briefly the practice in Australia of consuming the legal drug of alcohol, and the particular form of it that is often referred to as the "amber fluid" or, less poetically, as "piss"—beer.

THE CULTURE OF ALCOHOL CONSUMPTION IN AUSTRALIA

Alcohol consumption is fostered (the pun on the name of a popular brand of Australian beer is intentional) within Australian society through familial influence, media representation, and peer (social) group rituals. The cultural site of the barbeque is especially important within the Australian context. Social situations and occasions such as weddings, birthdays, barbeques, sporting events, picnics,

and dinners are frequently marked by the consumption of alcohol. Indeed, to a significant extent social activity and alcohol consumption in Australia are viewed as inextricably intertwined. Youthful rites of passage such as eighteenth and twenty-first birthdays, and the end of secondary school education (especially so-called "schoolies week" on the Gold Coast, Queensland) are often marked by excessive (binge) drinking. These rituals are routinely condemned (Australian Associated Press [AAP], 2005) but also tacitly endorsed or accepted as inevitable modes of youthful behavior by large sections of Australian society. Indeed, Fiske, Hodge, and Turner (1987, p. 1), in their key work of cultural reading of *Myths of Oz*, note that "Australians are both proud and ashamed of their enthusiasm for alcohol—and [that] the Australian image has had an alcohol problem from the earliest days of the colony." Alcohol looms large alongside sport as pivots of leisure, with beer as the staple "lubricant" of an Australian pub culture that, until the 1980s, quite commonly confined women to the part of the establishment known as the "ladies lounge."

Australia's colonial convict history, initially rural-based economy, and cyclical booms in mining have inspired a particularly blue-collar, working class, and overtly masculine perception of national identity that is closely tied to the heavy consumption of alcohol, in particular beer. Sport is especially important to this cultural constellation in Australia, and conspicuously so in the realm of male team sport celebration. As Rowe and McGuirk (1999) have noted, for example, when the Newcastle Knights (a rugby league team in a working class eastern Australian city) succeeded in the same year that its major steelworks announced impending closure, its players were routinely represented as "men of steel" who had arisen from their tough, blue-collar environment. Class-masculinity rhetoric was deployed even against the Sydney-based team that they defeated, as provincial determination was seen to overcome metropolitan glamour:

> Newcastle has been drunk for three weeks. It is a city intoxicated not just on beer, although there has been plenty of that flowing since the Knights victory in the Australian Rugby League grand final.

> Newcastle is drunk on pride. It is celebrating having stuck it to the establishment, of having humiliated those who gave its footie team no chance against the slick superstars of Manly, of having put its head down and driven forward against the odds and earned the shield of victory. (Riley, 1997, p. 15)

Television coverage showed players and fans alike holding cans of beer (often that of the sponsor of the time, Lion Nathan's Tooheys brand) and often spraying each other with the foaming liquid. Beer remained central to the notion of both physical and emotional intoxication in the securing of victory, not just for

the local team against another, but for the regional male proletariat against the "metrosexuality" in the capital city, and in the city of capital.

As a relatively young nation, the popular formulation of Australian national identity is reliant on a number of resilient and antiquated national myths that serve to reinforce a hypermasculine Australian character (Pearse, 2004) "conceived" on the "masculine" proving grounds of battlefield, outback, and sporting field. However, the promotion of the beer swilling, uncouth "ocker" stereotype (most famously articulated in the *Barry McKenzie* films of the 1970s), a postmodern form of which still exists today in Australian advertising, presents an outmoded picture of Australian alcohol consumption—which has both decreased and diversified over the past two decades. According to the Australian Institute of Health and Welfare, alcohol consumption increased in Australia from the mid-1960s to the early 1980s, after which there occurred a significant decline (Australian Institute of Health and Welfare [AIHW], 2005).

Despite the enduring potency of the hard-drinking Australian character within popular culture, the nation no longer ranks amongst the world's leaders in terms of alcohol consumption, with the Commission for Distilled Spirits placing Australia 22nd out of 45 established market economies regarding alcohol consumption in 2005 (Commission for Distilled Spirits [CDS], 2005). By 2003, Australian beer consumption had reached its lowest level since 1961 and, during the same period, *per capita* wine consumption quadrupled (Modern Brewing Age, 2003). While it should be noted that this fall in beer sales and rise in wine consumption corresponded to the Australian invention of cheap so-called "bag in the box" wine sales (what was called a "wine cask" consisting of two or more liters of low-grade wine, sold in aluminum foil bags placed inside a cardboard box and served by means of a plastic stopper), there was an accompanying increase in premium wine sales. Thus, although much of the extra *quantity* of wine consumed in Australia was at the lower end of the market (what in the United Sates has been called the "two-buck chuck"), a greater proportional sales value increase took place in the mid-market and fine wine categories.

Similarly, while beer consumption has declined in Australia, its market value has increased as Australians have embraced premium brands either imported from overseas or locally brewed (Tillbury, 2007). These up-market beers—with their particular attention to attractive bottle design—are also coded in a less masculinist manner and are intended to appeal also to women in an attempted connotative detachment of the practice of beer drinking from unsophisticated, aggressive modes of maleness. Indeed, even the Newcastle Knights team—after another sponsorship deal with major brewer Carlton and United Brewers (CUB), producers of the Fosters and Carlton brands—is now sponsored by local "boutique" brewer Bluetongue (Freed & Lee, 2006). Despite this trend, the traditional and nostalgic

discourses invoked to promote Australian beer remain pervasive, even as the country continues to emerge as a diverse and heterogeneous nation, its cosmopolitanism deriving from its location as a major attractor of migrants and tourists from across the globe (Rowe, 1998a). However, these outmoded national myths are more exclusionary than inclusive, denying representation to large sectors of the population and marginalizing others. Beer advertisements in Australia, we will argue, tend to be conservative renditions of an imagined homosocial life within a nostalgically conceived male-dominated society under challenge from a range of directions, including the decline of male manual labor and the advancement of gender equality.

RECURRING AUSTRALIAN MYTHS, ICONOGRAPHIES, AND DISCOURSES

The larger a product's intended market, the more conventional and mainstream the messages and images conveying that product's meanings are likely to be in their form and content. Beer marketing in Australia—a large federated nation with a relatively small population concentrated on the eastern seaboard—predominantly targets broad audiences addressed either on a state- or nation-wide level. Therefore, beer advertising is mostly based on constructed collective, place-based identities that can broadly be framed within Anderson's (1983) overused but nonetheless still useful concept of a "imagined community." When a national (as opposed to a regional) population is interpellated through the promotion of a set of discourses, images and social and cultural values are recognized as being shared by that intended audience, this is, as Fiske, Hodge, and Turner (1987, p. xi) assert, where "advertisements try to connect their products with the signified 'Australia.'" This conceptual entity does not simply exist before it is "hailed" but comes into being at the moment that the practice it represents is imbued with a particular inflection of national cultural identity—in this case, as a nation at least partially defined by a love of beer and sport.

The medium of advertising has long acknowledged the value of national identity discourses, and subsequently there exists a persistent link between Australian beer promotional campaigns and patriotism. Here, sport is especially important in its international form, because national identification and differentiation supply the dynamic that makes the nation affectively potent through the process of competitive rivalry with other nations (Tomlinson and Young, 2006). As Pettigrew (1999, p. 1) has observed, "the ways in which beer is promoted provides indicators of its cultural meanings," with Australian beer commercials frequently exhibiting depictions of national iconographic symbols, idyllic lifestyle modes, dominant values, ideals, and stereotypes.

The three main advertisements under discussion in this chapter depict the most powerful and recurring national narratives and myths within Australian beer commercials. Explored within these commercials are sporting endeavor and success, rural and outback spaces, service in the armed forces, and working class values (Victoria Bitter). The Carlton Midstrength advertisement (among many others) addresses the trope of Australia as "the lucky country," an ironic and critical proposition by Horne (1965, p. 220) that is often (mis)interpreted literally and incompletely, given that he, in fact, wrote that "Australia is a lucky country run mainly by second-rate people who share its luck." Features of this blessed nation, it can be observed, include plentiful privatized suburban space, gender exclusion, and mateship. The Tooheys commercial, in related fashion, explores the pub as a masculine-coded space for "larrikinism" (an Australian expression connoting an unruly, mischievous and irreverent form of youthful masculinity), sport, patriotism, and female sexual objectification. In this manner, beer advertising both inserts and reveals the dominant codes and conventions on which national identity construction is based.

The beer-sport nexus has become embedded in Australian public culture through historically derived, multiform cultural production. It is part of a mythological ensemble available for activation and commodification—although not entirely without contestation and, indeed, policy intervention (Bennett & Carter, 2001). In the process, some texts have been proposed as quintessentially Australian, including film (such as *Mad Max, Gallipoli, Crocodile Dundee*), television (*Prisoner, Neighbours, Home and Away*), literature (*Capricornia, Voss, My Brilliant Career*), and theatre (*Summer of the Seventeenth Doll, Dimboola, The Club*). Indeed, as Cunningham (1992) has argued, advertising texts themselves are important but neglected expressions of Australian culture. The field of advertising production and consumption, furthermore, both registers and influences important shifts in national culture and media (Sinclair & Spurgeon, 2006).

In a comparative analysis of the role of television advertisements in the gendering of national identity in Japan and Australia, Hogan (1999, p. 751) identifies four representational conventions that "consist of appeals based on geography, leisure practices, cultural heritage, and social values." In a more concrete appraisal of the concerns of selected Australian beer advertisements aired between 1988 and 1998, Pettigrew (1999, p. 3) views "extremes of temperature, hard work, the physical characteristics of the product or its packaging, mateship/socializing, sport and pubs," as the most frequently recurring themes within the commercials. In adapting Hogan's and Pettigrew's categories, this chapter recognizes five interlinked, recurrent thematic preoccupations that characterize the promotional culture surrounding the marketing of Australian beer:

1. Australian Sporting Excellence (closely linked to narratives of patriotism and nationalism)
2. The Lucky Country (the promotion of an Australian "leisure class" and suburban "paradise")
3. The Bush Myth (as related to the Pioneer Myth)
4. Pub Life (portrayed as a masculine-coded "third space")
5. Bonds of Masculinity (linked to mateship rituals and the characterization of the Australian ocker).

These five themes dovetail and intersect, contributing significantly to dominant, often nostalgic, regressive and outmoded renderings of Australian identity promoted in Australian beer advertising. The visual and linguistic settings for the advertisements usually entail representations of an identifiable Australian landscape as manifest in a plethora of texts, such as the poetry of Banjo Paterson and Henry Lawson, the paintings of Frederick McCubbin and Sidney Nolan, and the historical recreations of such films as *Picnic at Hanging Rock* (Weir, 1975) and *Sunday Too Far Away* (Hannam, 1975). This mode of cinematic framing of the Australian landscape depicts a harsh and ominous realm that is also a site of both individual character and nation building in a manner influentially described in Ward's (1958) standard work, *The Australian Legend*. In discussing his latest film *Australia* (2008), prominent director Baz Luhrmann describes how his central character's narrative trajectory is directly connected to her interaction with the Australian landscape—"that land which seemed brutal and foreboding is now achingly beautiful, and, through the way she starts to relate to that land, she comes alive and finds her inner strength" (George, 2006, p. 6). This treatment is but the latest display of how "the natural environment feature(s) prominently as a backdrop of narrative action, and in many cases as a 'character' or narrative presence of great importance" (Prescott, 2005, p. 2). It is central to the metaphorical depiction of the conquering of the land (symbolically fused with the "native" Aboriginal population) as part of a wider narrative of (white) nation building and colonization that appears frequently in Australian film and wider popular culture.

The heavily mythologized attachment of (mostly male) Australians to the remote "outback" environment (an ironic fantasy given that over 75% of the population resides in urban areas: Australian Bureau of Statistics [ABS], 2005) is a recurring motif in Australian alcohol-related promotional culture as manifestations of the "Bush" and "Pioneer" myths (Rowe, 1998a, b). The Bush Myth depicts a struggle for mastery over the natural landscape by Australian masculinity, generating an image of the Australian man in a subgenre of alcohol commercials as laboring strenuously in difficult conditions and being "rewarded" for his Herculean efforts with beer. This representation is particularly evident in

the Victoria Bitter advertisement from the early 1980s that depicts a middle-aged, Anglo-Celtic farmer toiling on a plough with a wide expanse of rural scenery in the background, as the narrator declares, "a hard earned thirst needs a big cold beer, and the best cold beer is Vic! Vic Bitter." This white masculinized depiction of Australian identity (with indigenous Australians almost entirely eradicated from the landscape), through a partial, revisionist symbolic account of "ownership" and "mastery" of the land, clears the ground (sometimes literally) for leisure, sport, and beer consumption.

A contrasting but equally common representation of Australian national identity presents it as the product of the "Lucky Country" from which leisure is always effortlessly at hand, a "view of Australia as 'God's own country', (where the nation) is represented as a land of plenty, an island cornucopia, its gifts bounteously bestowed by nature, now conceived as the prime source of pleasure" (Rowe, 1998b, p. 81). Here the focus moves from the inland to the beach, and/or from the colonial-rural to the modern-suburban, where the pursuit of happiness revolves around the consumption of alcohol and myriad outdoor leisure activities. This hedonistic, "pleasure-seeking" advertising representation of Australian life positions a prosperous leisure class bathed in bright sunshine, actively sporting and inhabiting idyllic beach-side landscapes or well-maintained, sociable backyards. Again, this representation is more fantasy than documentary, with Australians' working year currently the longest of all Western nations (Tiffen & Gittins, 2004), and the second longest in the developed world (Australian Council of Trade Unions [ACTU], 2003). Australia also at present has the world's most overpriced housing, with affordability at its lowest levels for two decades (Jeffree, 2006), and only 27% of Australians aged 15 years and over are self-reportedly engaged in sport and physical activity (Australian Bureau of Statistics, 2007). This is, then, a societal context well suited to fantasy-oriented advertising campaigns emphasizing sporting achievement and the carefree ingestion of beer in the face of sedentary lifestyles, high mortgages, and elongated work hours. It is also a site at which Australian gender formations are clearly exposed.

ADVERTISING BEER, MASCULINITY, AND SPORT

Beer advertising in Australia, operating within the socio-cultural framework briefly traced above, foregrounds a clear connection link "between beer drinking, masculinity and Australian nationalism" (Kirkby, 2003, p. 244) that constitutes a resilient process of reinforcement of male hegemony and female exclusion, marginalization, and subjection. Just as "the beer advertisements of the 1980s for brands like Tooheys and Castlemaine XXXX drew heavily on rural imagery and

made it clear that "Men do, Women don't'" [drink beer] (Kirby, 2003, p. 252), the aforementioned Victoria Bitter commercial from the 1980s, although displaying multiple images of Australians at work and play, entirely excludes women from its epic national narrative. Here Australian men are depicted variously in key, nation-building roles as farmers, members of the armed forces, blue-collar workers, and as sportsmen, especially as members of the Australian cricket team. This overtly masculine and mainly working class depiction of "Australianness" retained considerable resonance as the new century came into view.

Indeed, post-1980s beer advertising "sustained the religious trinity of masculinity, nationalism, and beer" (p. 253), promoting male sporting endeavor as central to Australian national identity. Summers's (1975, p. 70) canonical historical critique of the Australian gender order, *Damned Whores and God's Police*, noted over thirty years ago that:

> Sport is recognized as being of particular significance to Australian men, and ranks along with (beer) drinking, gambling and an obsession with cars as national pastimes—all these activities thus earn a mandatory mention by the carvers of cultural myths and stereotypes.

Such mythologized "mandatory mentions" are still recorded within Australian beer advertisements, and the depiction of gender within Australian beer commercials recreates a clear hierarchy. While men appear as active participants in the leisurely pursuits portrayed as indicative of the Australian lifestyle, women exist more often as "window dressing'—either as recipients of the male gaze or simply as individuals relegated to the domestic sphere. As Hogan's (1999, p. 754) aforementioned comparative study of Australian and Japanese television advertising reports:

> Australian women in the ads are more than four times as likely as their male counterparts to embody Australianness through their domestic roles. Australian men are much more likely to demonstrate their Australianness through their leisure activities than women, whom they outnumber four to one as they surf, cycle or share a beer with their mates. The Australian sample shows men outnumbering women in representations of both contemporary culture/society (by a ratio of 3:1) where they are, for example, Rotarians, cricket stars and surf iron men, and traditional culture/society (by a ratio of 12:1) where they wear Akubras [rural-coded clothing] and work as farmers and stockmen.

In the Carlton Midstrength commercial from the 2000s, women are portrayed as repressing men within the domestic sphere and as impediments to masculine sociality who must be outwitted by men's collective ingenuity. This advertisement depicts the classic Australian suburban spaces of home and backyard and situates them as sites of gender conflict—feminine and masculine spaces that are clearly

demarcated. The men in the commercial have gone to extraordinary lengths to escape from their female companions, engineering a secret male-only space that allows them to enact masculine leisure rituals revolving around beer consumption and sport—in this case, playing pub sports such as snooker and darts and watching international cricket on television. The home is depicted as a feminized space that inhibits and emasculates, thus creating a need to construct a shared exclusive masculine space formed by modifying the walls of their backyard sheds. The humor of the advertisement, therefore, lies in the men's pretence of working in the segregated male space within the home (the work shed)—in each case, they tell their female partners that they are going to "fix" malfunctioning domestic devices such as toasters and lawn mowers—while, in fact, indulging in men's pleasures of beer and sport.

The Carlton advertisement represents sport in two forms—as casual, grassroots play and as professional international competition—with beer consumption integral to both participation and spectatorship. Sport's centrality to Australian society and culture has been well documented by historians and sociologists, especially as a primary site at which Australian national identity can be crystallized (Cashman, 1987, 1995; McKay, 1991; Parker, 1996; Stoddart, 1986). The professionalization and commodification of sport were made possible through its functional and symbolic linkages to gambling, advertising, sponsorship, and spectatorship that enhanced a range of forms of consumption (Crawford, 2004). Sporting imagery is especially efficacious in situating products within national narratives, particularly in countries such as Australia in which sport in many ways has come to *define* the nation. All three of the main advertisements discussed in this chapter depict images or representations of Australian national sporting teams—archive footage of the Australian one-day cricket team is embedded within the VB commercial, and, as noted, in the Carlton advertisement, cricket on television is switched on as a vast glass cabinet full of beer is triumphantly revealed. In the Tooheys commercial, the protagonists are draped in the green and gold colors of the Australian national rugby union team (the Wallabies) and their antagonists' style (although without national insignia) indicates that they are supporters of the New Zealand All Blacks team.

The most consistently linked commercial product to professional sport—certainly since tobacco advertising on television was banned in most countries—is liquor, in particular beer (Collins & Vamplew, 2002; Messner & Montez de Oca, 2005). The depiction of sporting competition within Australian beer marketing observes many of the tenets of what Messner, Dunbar, and Hunt (2000, pp. 380–381) describe as the "televised sports manhood formula" within American sports programming and advertising, presenting "a narrow portrait of masculinity" and stressing "stereotypical messages (communicated) about race, gender, and violence." Such discourses of masculine domination, female exclusion/sexualization,

competition, masculine violence, and racial exclusion are also widely promoted in Australian beer commercials. Given the influence of U.S. professional sports and media industry development across the globe (Miller et al., 2001), it is not surprising that American practices should register in the Australian context, but there are local variations and differences of emphasis that should also be noted.

Traditionally, the relationship between sport, beer, and masculinity in Australian advertising is depicted through three modes of representation within mainly masculine coded spaces. The first is the domain of professional sport, sports stars, and spectators, often within the stadium, where beer is represented as a post-match reward for the players (almost exclusively male), and as a social lubricant facilitating the vociferous support of a largely male audience. The use of Australian sports stars of both the past and the present within beer advertising has been a consistent strategy of marketers, most recently the 2007/8 VB campaigns used prominent cricketers Shane Warne and David Boon.

Second, beer advertisements also show the consumption of televised sport taking place within the male-dominated space of the pub (and sometimes the domestic living room in which, as the aforementioned Carlton Midstrength commercial reveals, there is greater gender-based contestation). Here televised sport may be central to social interaction (the focus of attention) or incidental (part of the ambience). Since the 1970s, most Australian pubs have contained one or more television screens. These devices have become more conspicuous as satellite subscription television (introduced in Australia in 1995) has carried a greater and more diverse number of sports broadcasts, and, more recently, with widescreen television sets competing for the attention of the clientele. In the 1980s, Fiske, Hodge, and Turner (1987, p. 6) observed the masculine character of an Australian pub interior, in which "a TV set bore the admonition, 'To be used for watching sporting events only.'" Two decades later, the focus on sport has remained, while the TV sets have proliferated and widened.

Indeed, the social space of the pub is where several other significant Australian masculine rituals, stereotypes, and myths are enacted and embellished within the constructed realities of beer advertising. The pub exists within advertising as one of the principal sites of male bonding, where "mateship" rituals are enacted within a clearly defined gendered space. The Australian vernacular term "mate" is associated predominantly with the close, supportive relationships formed in adversity between Australian soldiers during World War 1 (a seminal moment in the birth of Australian nationhood and its link to the Australian and New Zealand Army Corps (ANZAC) Myth—Pearse, 2004), and from Australia's pioneering past (as closely related to the Bush Myth). Despite the positive ascription of friendship, mutuality, and egalitarianism to the ethic of Australian mateship, it is also a "particularly male-oriented concept [and one whose] values are arguably

male values—[and] women tend not to be included in most understandings of mateship and what it means to be a mate" (Page, 2002, p. 195).

The pub tends to be depicted within beer advertising as a masculine domain where women exist as scenery—objects of the male gaze or part of the visual "amenity," but not active and welcome participants in the various rituals of mateship and bonding. Here, beer consumption is coded as "masculine because it (is) associated with sex-segregated drinking spaces and culture in pubs" (Kirkby, 2003, p. 246). In this manner, the pub as a symbolic site where women are excluded, marginalized, or required to be accompanied by men can be read as a male-oriented "third space," existing as a buffer between the workplace and the female-dominated domestic sphere. Men drinking beer and watching televised sport with other men are free from the twin inhibitors of exclusive, sometimes excessive masculine behavior—women and children. The Carlton Midstrength advertisement cleverly positions this masculine third space *within* the domestic sphere by transforming the male domain of the backyard shed into a "pubscape." Here the protagonists "escape" from their suspicious female partners (depicted as obstructing the course of male bonding and socialization) to enact their masculine rituals of mateship, beer drinking, and sports consumption in their ingeniously retrofitted all-male contexts.

It is not, though, our intention to suggest that women are now formally or literally excluded from Australian pubs, or that there has been no change in their power dynamics. Rather, we argue that Australian television beer commercials tend to exaggerate—and even celebrate—historical and contemporary disparities of gender power. Men are either shown to dominate women entirely or as dominated by, but artfully resistive of, powerful women. Both scenarios pander to a nostalgic fantasy of homosociality, with beer and sport pivotal to the pleasure of the male pub experience. Thus, when women are present, they are seemingly anomalous. For example, in the Tooheys New commercial from around 2002, the space of the pub is the primary location for the competitive nationalistic masculine posturing associated with the consumption of alcohol. As noted above, competition is depicted between rugby union supporters of the Wallabies and the All Blacks. A contest ensues over which national group can open their beer bottle in the most "macho," "hands free" fashion by pressing and twisting the cap against parts of their body. In the end, it is the only female foregrounded in the bar, a young blonde Australian women, who secures "victory for Australia" by appearing to open the beer bottle under the bar with her vagina—later shown to be her navel. The advertisement concludes with the slogan "what mates do." In this case, a rare leading performance by a female within a pub scene involves gaining respect and status through success within the competitive masculine ritual enacted within the scene. While the woman is triumphant, the comic twist of the beer commercial relies on a variant of

the misogynistic myth of the *vagina dentata* and does not normalize the place of women within the site of the pub or within sport spectatorship.

Beyond the confines of the drinking establishment is the third main site of the beer commercial—the space of active outdoor participation. Sport and beer consumption are presented here in terms of their relationship to communal social activity in a leisured, "lucky" country. Outdoor spaces such as backyards, swimming pools, barbeques, parklands, and the beach are depicted as sociospatial contexts where friendly, "amateur" sports competition, such as backyard and beach cricket or park football, is a key component of the overall experience of alcohol consumption and social interaction between friends and family groups. These outdoor landscapes and social occasions are celebrated within advertising as being intrinsically Australian, usually by emphasizing good weather and abundant, telegenic space. The Australian home in such texts is usually a house with a large garden (the standard quarter-acre block) that is becoming less common in large Australian cities as population growth and diminishing land availability lead to denser, high-rise apartment living (Butler-Bowdon & Pickett, 2007). This dimension of Australian lifestyle was strongly featured in the Opening Ceremony of the Sydney 2000 Olympic Games and is consistent with the idea of the backyard both as a social space (with ready opportunities for copious beer drinking) and as an ordinary, informal sportsground on which future sports champions are bred from childhood.

A succession of commercials has directly linked Australian sporting excellence with generous availability of outdoor space, particularly backyards, but also parkland, beaches, and swimming pools. The most provocative of these so far is a television advertisement for Bundaberg rum (a drink that has begun to challenge but by no means yet overcome beer hegemony) in the lead-up to the 2007 Rugby World Cup, "We Wish England Was Australia" (Leo Burnett Sydney Agency, 2007) that lampoons English life as miserable and monochrome when compared to that of happy, colorful Australia. Here, once more, Australian liquor advertising has tended to draw—ironically, of course—upon the Lucky Country Myth, neglecting to recall that Horne's description of it as such was more than a little "back-handed." However, perspective becomes somewhat clouded when gained through the bottom of a beer glass in a room full of television sets showing tonight's big game.

BEER, SPORT, AND AUSTRALIANISM: POSTMODERN ADAPTATIONS AND HISTORICAL LEGACIES

In this chapter, we have argued that the narratives, myths, and representations promoted historically within Australian beer commercials have remained rather static, with most variations and changes restricted to subgenres and stylistic

devices. Attempts to shift the agenda to represent an increasingly cosmopolitan, gender-equitable, and multicultural Australian society have met with mixed results, perhaps due to the broad markets targeted by Australian beer corporations. While a desire exists within Australian public discourse to extinguish the burden of the "cultural cringe" (a postcolonial inferiority complex), tensions are evident within some of the popular cultural output of the past decade that has embraced representations of Australian working class culture and ocker stereotypes in ways that may be interpreted as ambivalent critiques or ironic celebrations (e.g., in comedy television programs such as *Kath and Kim*, and in films such as *The Castle*).

This politicocultural uncertainty has registered to a degree in recent representations of Australian masculinity within beer advertising, which have adopted a similar postmodern, ironic mode that can be read as concessions to or defenses against feminism. As we have noted, representation of men within Australian beer commercials has worked with well-established depictions of ocker and larrikin cultural figures. The ocker caricature—boorish, chauvinistic, and defiantly anti-intellectual—is presented as "loveable" in the Australian context through his instinctive resistance to an even more odious male stereotype, that of the condescending, colonial, British aristocrat. Similarly, the figure of the larrikin—the mischievous, rebellious male youth—can be provided with a culturally resistive alibi through his rejection of the unbending, supercilious, to-the-manor-born British (or Anglophile) establishment.

Beer-related promotional culture in Australia has to an extent modernized the portrayal of the ocker and the larrikin in the light of postcolonialism and the rise of feminism. This shift has been achieved by means of a paradoxically reactionary response originating from the United Kingdom in the 1990s that has been dubbed "new lad" culture. As Whannel (1999, p. 255) has argued, "two decades of feminism is portrayed as contributing to male uncertainties, producing both responses, such as 'New Man,' and reactions such as 'New Lad.'" Indeed, since the 1980s, a series of often fad-based masculine identities has been variously celebrated and denigrated within public discourse. These include the SNAG (Sensitive New Age Guy), the New Lad, and the Metrosexual, as embodied by the world's most famous current sport celebrity—David Beckham. The "New Laddism" phenomenon, popularized in the 1990s by young male-oriented British magazines such as *Loaded* and *GQ*, attempted to justify and indeed naturalize an ironically "knowing" approach to sport, alcohol, sexism, and nationalism bordering on racism (Carrington, 1998). "New Laddism" could be adapted to the Australian sociocultural context as a way of reconnecting sport and masculinity in beer advertising campaigns by means of an ironic reproduction of ockerism and larrikinism that enlisted humor as a shield from accusations of sexism, insensitivity, selfishness, and so on. A "knowing wink"

towards objections to outrageous sentiments is, therefore, intended to defuse critique in the name of the comedic and the carnivalesque. Whannel (1999, p. 257) summarizes this discursive tactic in the following way:

> Lad culture represents a continuation of masculine fears of the female "other" masquerading as desire. As for irony, this is merely the cloak within which the cultural producers of new lad culture smuggle in sexism. As Leon Hunt has commented, postmodern irony means never having to say you're sorry.

Therefore, some of the newer Australian beer commercials now feature multiple Australian versions of the "new lad" (Mikosza, 2003), including those in the above-mentioned Tooheys New campaign. This is an example of the ways in which beer (and other product) advertising seeks to present promotional texts as fresh and new but is also attentive to older themes and techniques that have been commercially successful in previous times. For instance, a Victoria Bitter commercial (George Patterson Y & R, http://www.youtube.com/watch?v=F8gmgW0fztk), tied into the 2007–2008 Australian cricket season, trivializes the perceived crisis in masculinity and symbolically derides attempts to reconcile it with feminism. At first, it appears to promote a daring version of Australian masculinity and sexuality, yet it swiftly extinguishes this "deviant" portrayal in deference to the hegemonic triumvirate of beer, sport, and mateship. In the advertisement, an Australian "new lad" is depicted in a bar fantasizing about being a woman for a day, while being reminded by the narrator of the more conventional Australian male fantasy of playing cricket against the legendary Shane Warne. When he is discovered acting out his cross-dressing fantasy by his "mates," he is "re-masculinized" through laconic, collective consumption of beer and televised sport. By such means "new lad" culture deals with the "threat" of feminization of hegemonic masculinity.

Sport is a cultural form that simultaneously emphasizes the new (the next game and its uncertain result, the prospect of the next season) and replays the past (the keeping of records, the collecting of memorabilia). Sport commerce, likewise, is constantly in the process of branding—of itself, its constituent entities, and the organizations with which it contracts (see, for example, Scherer and Jackson's [2007] analysis of advertising, branding, and "corporate nationalism" in relation to the All Blacks). At the same time, the informal networks that constitute sport's fan base must register and position themselves in relation to the brand identifications made available to them. As sport, media, and advertising become more global, there is an uneasy process of both smoothing out differences between media sport "jurisdictions" in the name of trade and commerce, and of recognizing/asserting those distinctions that give substantive meaning to sport affiliation.

In this chapter, therefore, much of what has been discussed about the role and impact of beer advertising and sport in the Australian context will be echoed in other countries (the beer-sport-nationalism linkage, for example), but the specific qualities of Australian mythological structures, histories, and characters (such as the Bush, Pioneer, Lucky Country, and ANZAC myths, and the figures of the ocker and the larrikin) require locally specific interpretation and "translation."

Beer and sport in Australia have a close historical, social, and cultural association that is inexplicable without a grasp of its prevailing gender order. It would, of course, be quite possible to visit a modern bar in the center of a major Australian city and be largely oblivious to the relations of gender power being played out in suburban locations or in other pockets of the inner city as part of the diurnal round, or to watch beer advertisements featuring sport on the hotel television without grasping their ideological implications. It is for this reason that a touristic approach to national cultural formations (the sampling of quaintly different and fleeting experiences), especially when coupled with de-politicized modes of postmodern ironic detachment, is not serviceable to the task of critically engaging with such popular cultural practices as watching television, observing sport and its signifiers, and consuming beer. Instead, it is necessary to know about, for example, such historically conditioning sociocultural factors as the "six o'clock swill'—that is, the state-enforced closure of Australian pubs at 6 p.m. in 1916 in order to deter drunkenness in wartime (Macintyre, 2004). This regulation was successfully extended by temperance advocates until 1955, thereby creating the practice of men crowding at the bar and hurriedly consuming multiple beers—sometimes, it has been claimed, urinating where they stood. The "six o'clock swill" also contributed to the Spartan design of many Australian pubs, whose bare tiled floors and walls could be easily hosed down. Football stadia for most of the twentieth century were similarly constructed around what was deemed acceptable for mainly working class male patrons (Stoddart, 1986), meaning that neither the public site of sport nor of beer drinking was welcoming to most women who, as noted above, were in any case often not permitted to enter all the spaces of the pub even after crossing its threshold.

We have argued that this longstanding gender segregation in sport and beer drinking has persisted in television advertising well after it had begun to be seriously eroded. It has tended to look nostalgically towards such times in the commercial harnessing of homosocial fantasies of separate leisure spheres where men could play/watch sport and drink beer "unencumbered" by women and children or at least could continue to dominate shared leisure space. Even "postmodern" concessions to change have perpetuated advertising images of male-dominated beer and sport practices and sites. This shift is evident in the advertising industry's presentation of personalities such as Shane Warne, the aforementioned

Australian sport "superstar." Warne, who no longer plays for the national team, is a polarizing figure in Australia, as famous for the tabloid media coverage of his sexual indiscretions as his record-breaking cricketing exploits (Haigh, 2005). His habit of sending sexually explicit text messages to numerous women, a succession of "tell all" revelations by former sexual partners he was involved with during and after his marriage, and other scandals involving betting and performance-enhancing drugs, have all made Warne a conspicuous but often derided figure in the media. The latest advertising campaign for Victoria Bitter featuring Warne (George Patterson Y & R Agency) (http://www.youtube.com/watch?v=2sIaz5 vxetU&feature=related), aired during the 2007–2008 Australian cricket season, makes knowing "new laddish" site gags about sex, sexuality, mental illness, and drinking. The representational pattern that we have outlined linking sport, beer, and a male-dominated Australian gender order has been relatively undisturbed by the major social changes of recent decades. In the insulated, nostalgic world of the Australian television beer commercial, the "amber fluid" still lubricates the dry throats of men whose manual and sporting labor has, in the main, been limited to shouting at the television during intense sporting moments. Meanwhile, the ethic of gender equity remains a little parched.

REFERENCES

Anderson, B. (1983). *Imagined communities: Reflections on the origin and spread of nationalism.* New York: Verso.

Australian Associated Press. (2005, November 21). Police plead with binge drinking schoolies. *The Melbourne Age.* Retrieved January 9, 2008, http://www.theage.com.au/news/national/plea-to-binge-drinking-Schoolies/2005/11/21/1132421586298.html

Australian Bureau of Statistics. (2005). *Population by Age and Sex, Australia, June 2004.* Retrieved December 8, 2007, from http://www.abs.gov.au/ausstats/abs@.nsf/ProductsbyReleaseDate/6 E1E89C93B66E895CA25719C0012290D?OpenDocument

Australian Bureau of Statistics. (2007). *Involvement in Organized Sport and Physical Activity, Australia, Apr 2007.* Retrieved December 26, 2007, from http://www.abs.gov.au/AUSSTATS/abs@.nsf/ Latestproducts/6285.0Main%20Features1Apr%202007?opendocument&tabname=Summary& prodno=6285.0&issue=Apr%202007&num=&view

Australian Council of Trade Unions. (2003). *Working Hours and Work Intensification Background Paper.* Retrieved September 8, 2007, from http://www.actu.asn.au/congress2003/papers/work-inghoursbp.html

Australian Institute of Health and Welfare. (2005). *Statistics on Drug Use in Australia 2004.* Retrieved September 8, 2007, from http://www.aihw.gov.au/publications/phe/sdua04/sdua04.pdf

Bennett, T., & Carter, D. (Eds.). (2001). *Culture in Australia: Policies, publics and programs.* Melbourne: Cambridge University Press.

Bundaberg Rum (2007). *We wish England was Australia* [Television advertisement]. Australia: Leo Burnett Sydney.

Butler-Bowdon, C., & Pickett, C. (2007). *Homes in the sky: Apartment living in Australia*. Carlton, Sydney: Miegunyah Press in association with Historic Houses Trust.

Carlton United Breweries (1984). *The best cold beer* [Television advertisement]. Australia: George Patterson Bates.

Carlton United Breweries (2002). *Stay a little bit longer* [Television advertisement]. Australia: George Patterson Bates.

Carlton United Breweries (2007a). *The best cold beer* [Television advertisement]. Australia: George Patterson Y & R.

Carlton United Breweries (2007b). *The best cold beer* [Television advertisement]. Australia: George Patterson Y & R.

Carrington, B. (1998). "Football's coming home." But whose home? And do we want it? Nation, football and the politics of exclusion. In A. Brown (Ed.), *Fanatics! Power, identity and fandom in football* (pp. 101–123). London: Routledge.

Cashman, R. (1987). The Australian sporting obsession. *Sporting Traditions, 4*(1), 47–55.

Cashman, R. (1995). *Paradise of sport: The rise of organized sport in Australia*. Melbourne: Oxford University Press.

Collins, T., & Vamplew, W. (2002). *Mud, sweat and beers: A cultural history of sport and alcohol*. New York: Berg.

Commission for Distilled Spirits. (2005). *World drink trends 2005*. Oxfordshire: World Advertising Research Centre.

Crawford, G. (2004). *Consuming sport: Fans, sport and culture*. London and New York: Routledge.

Cunningham, S. (1992). *Framing culture: Criticism and policy in Australia*. Sydney: Allen & Unwin.

Fiske, J., Hodge, B., & Turner, G. (1987). *Myths of oz: Reading Australian popular culture*. Sydney: Allen & Unwin.

Freed, J., & Lee, J. (2006, January 6). Bluetongue lures Singo into its corner. *The Sydney Morning Herald*. Retrieved January 13, 2008, http://www.smh.com.au/news/business/bluetongue-lures-singo-into-its-corner/2006/01/05/1136387573060.html

George, S. (2006, November 23). Baz sees the big picture in Australian landscape. *The Australian*. Retrieved November 12, 2007, http://www.theaustralian.news.com.au/story/0,20867,20805929–2702,00.html

Haigh, G. (2005, August 7). Profile: Shane Warne. *Observer Sport Monthly*. Retrieved December 27, 2007, http://observer.guardian.co.uk/osm/story/0,,1541728,00.html

Hannam, K. (Director) (1975). *Sunday too far away* [motion picture]. Australia: South Australian Film.

Hogan, J. (1999). The construction of gendered national identities in the television advertisements of Japan and Australia. *Media, Culture & Society, 21*(6), 743–758.

Horne, D. (1965). *The lucky country*. Ringwood, Victoria: Penguin.

Jeffree, D. (2006). Overpriced and over here: Housing affordability. *Online Opinion,* Retrieved December 26, 2007, http://www.onlineopinion.com.au/view.asp?article=4156

Kirkby, D. (2003). Beer, glorious beer: Gender, politics and Australian popular culture. *The Journal of Popular Culture, 37*(2), 244–256.

Lion Nathan (2003). *What mates do* [Television advertisement]. Australia: Singleton Ogilvy and Mather.

Macintyre, S. (2004). *A concise history of Australia*. Melbourne: Cambridge University Press.

McKay, J. (1991). *No Pain, no gain? Sport and Australian culture*. New York: Prentice Hall.

Messner, M. A., Dunbar, M., & Hunt, D. (2000). The televised sports manhood formula. *Journal of Sport and Social Issues, 24*(4), 380–394.

Messner, M.A., & Montez de Oca, J. (2005). The male consumer as loser: Beer and liquor ads in mega sports media events. *Signs: Journal of Women in Culture and Society, 30*(3), 1879–1909.

Mikosza, J. (2003). In search of the "mysterious" Australian male: Editorial practices in men's lifestyle magazines. *Media International Australia, 107*, 134–144.

Miller, T., Lawrence, G., McKay, J., & Rowe, D. (2001). *Globalization and sport: Playing the world.* London: Sage.

Modern Brewing Age. (2003). *Australian beer consumption continues to drop—alcohol consumption data for Australia, Luxembourg, United Kingdom, United States.* Retrieved December 1, 2007, from http://findarticles.com/p/articles/mi_m3469/is_14_54/ai_100606969

Page, J.S. (2002). Is mateship a virtue? *Australian Journal of Social Sciences, 37*(2), 193–200.

Parker, C. (1996) An investigation of the Australian passion for sport. *Australian Studies.* Retrieved May 14, 2007, from http://people.hws.edu/mitchell/oz/papers/ParkerOz.html

Pearse, A. (2004). *Death takes a holiday: Tourist site tragedies and myths of national character.* Unpublished PhD Thesis. Newcastle, Australia: University of Newcastle.

Pettigrew, S. (1999). An analysis of Australian beer advertisements. *Australian and New Zealand Marketing Academy Conference.* November 30–December 2. University of New South Wales. Retrieved October 28, 2007, from http://smib.vuw.ac.nz:8081/www/ANZMAC1999/Site/P/ Pettigrew2.pdf

Prescott, N. (2005). All we see and all we seem: Australian cinema and national landscape. *Understanding Cultural Landscapes Symposium.* July 11–15. Flinders University. Retrieved November 22, 2007, from http://dspace.flinders.edu.au:8080/dspace/bitstream/2328/1565/1/N_Prescott.pdf

Riley, M. (1997, October 17). Newcastle rising. *The Sydney Morning Herald*, p. 15.

Rowe, D. (1998a). Tourism, "Australianness" and Sydney 2000. In D. Rowe, & G. Lawrence (Eds.), *Tourism, leisure and sport: Critical perspectives* (pp. 74–85). Melbourne: Cambridge University Press.

Rowe, D. (1998b). My fellow Australians: Culture, economics and the nation state. *Australian Studies, 13*(1), 69–90.

Rowe, D., & McGuirk, P. (1999). "[D]runk for three weeks": Sporting success and city image. *International Review for the Sociology of Sport, 34*(2), 125–141.

Scherer, J., & Jackson, S. (2007). Sports advertising, cultural production and corporate nationalism at the global-local nexus: Branding the New Zealand All Blacks. *Sport in Society, 10*(2), 268–284.

Sinclair, J., & Spurgeon, C. (Eds.). (2006). Advertising and the media. Special Issue. *Media International Australia, 119*, May, 1–178.

Stoddart, B. (1986). *Saturday afternoon fever: Sport in the Australian culture.* Sydney: Angus and Robertson.

Summers, A. (1975). *Damned whores and god's police: The colonization of women in Australia.* Ringwood, Victoria: Penguin.

Tiffen, R., & Gittins, R. (2004). *How Australia compares.* Cambridge: Cambridge University Press.

Tillbury, A. (2007, February 2). Super home-brand beer. *The Courier Mail.* Retrieved July 3, 2007, http://www.news.com.au/couriermail/story/0,23739,21163307-3122,00.html

Tomlinson, A., & Young, C. (Eds.). (2006). *National identity and global sports events: Culture, politics, and spectacle in the Olympics and the football world cup.* New York: State University Press.

Ward, R. (1958). *The Australian legend.* Melbourne: Oxford University Press.

Weir, P. (Director) (1975). *Picnic at hanging rock* [motion picture]. Australia: Australian Film Commission.

Whannel, G. (1999). Sports stars, narrativization and masculinities. *Leisure Studies, 18*(3), 249–265.

III. CONSUMPTION AND RECEPTION

"THE Grog Squad": AN Ethnography OF Beer Consumption AT Australian Rules Football[1]

CATHERINE PALMER

INTRODUCTION

This chapter examines the cultural practices of a group of Australian Rules football fans known as the "Grog Squad." Among these exclusively male fans, heavy alcohol consumption is considered nothing untoward. For these loyal followers of the North Adelaide Football club, most weekends involve a substantial amount of drinking whilst watching the football, some drink regularly throughout the week, and much attention is given to preparing for the following weekend's drinking. In short, much of the cultural identity of the Grog Squad, or the Groggies as they are also known, is built around drinking an exceptional amount of alcohol (even by Australian standards).[2]

The concern of this chapter is to couple an ethnographic analysis of drinking with an exploration of how a particular social identity is constructed and embellished within the Grog Squad. While social anthropologists have often examined alcohol consumption as a feature of generalized community experience (see Brady, 1993; Collman, 1979; Douglas 1987; de Garnie, 2002; Gefou-Madianou, 1992; Gusfield, 1987; Heath, 1995), my concern is to examine drinking's contribution to the reproduction of social identity *within* a community, in this case, a group of football fans. Members of the Grog Squad do not consider it abnormal or unusual to consistently drink to excess; indeed, this is seen to be a fundamental part of

the group's routine cultural practices. But this is not to say that drinking is not remarked upon: an individual's drinking habits, the rising price of beer, and the particular quirks of bar staff are just a few of the recurrent conversational topics among the Grog Squad. From this discourse of drinking, I argue, constructions of identity emerge. As is explored in this chapter, drinking is done in very particular, culturally prescribed ways that provide a basis for social cohesion and a way of ordering social life among the Groggies.

Borrowing Schouten and McAlexander's (1995) theoretical framework of a "subculture of consumption," I present an ethnographic analysis of the drinking-based consumptive practices of the Grog Squad that is located within the broader promotional culture of the South Australian National Football League (SANFL)—the premier league and governing body for Australian Rules football in South Australia. While much of the marketing of "local footy" trades on a narrative of a family friendly experience in which alcohol is largely peripheral to the activity, the SANFL is nonetheless sponsored by the West End Brewery (part of the Lion Nathan group), and many of its clubs are dependent on alcohol revenue to remain viable. This presents both a paradox and an ethnographic gold, for the Grog Squad has adopted and appropriated a number of cultural objects and practices that quite explicitly foreground alcohol in the construction and communication of a particular social identity. As is made clear in the following pages, the Grog Squad is a distinctive, homogeneous, enduring subculture that is defined by both a particular cultural activity (drinking) and a single cultural product (beer).

THE ETHNOGRAPHIC METHOD

Before developing this analysis, it is necessary to first introduce some methodological details. The material presented on the Grog Squad is part of a wider study examining the culture of alcohol in Australian Rules football (funded by the Alcohol Education Rehabilitation Foundation). Ethnographic fieldwork was conducted throughout the 2005 football season (March to September). Four clubs in metropolitan Adelaide were purposively selected on the basis of geography and attendant socioeconomic factors that may account for differences in fan type (Bale, 1991, 2000), as well as the position of the teams on the SANFL ladder. Additional research was conducted with fans of the remaining five teams in the SANFL, although these were not the central focus of the study. In total, two focus groups and 93 in-depth interviews were conducted with male and female fans across these nine clubs. The interview and focus group data were thematically analyzed with the assistance of the NVIVO software package.

To contextualize these data, and to elicit additional insight about the social identity of SANFL football fans and the place of drinking in the construction of that identity, the research team involved with this project visited football games, club rooms, and a range of social functions such as after-game presentations, bingo days, "claret and stout" luncheons, and member's happy hours to triangulate the data gathered through the focus groups and interviews. The material presented in this chapter is drawn primarily from observational data gathered at these locations.

The period of fieldwork spent with the Grog Squad spanned approximately four months of the 2005 football season (March–June), during which time myself and a co researcher attended seven home games of the North Adelaide football club that were played at Prospect Oval and several of the away games played at other clubs' grounds. Each visit lasted approximately five hours, from roughly 1 p.m. when the game started, until 6 p.m., when the game finished and the Grog Squad either went home or continued their drinking at a local bar. [3]

The main vantage point from which we chose to conduct our fieldwork at Prospect Oval was "the Hill." Like most other Australian football grounds, Prospect Oval has a raised, terraced area directly behind the goal square and, like most other football grounds, the Hill at "Prossie" (as Prospect Oval is colloquially referred to) attracts supporters who are particularly boisterous and passionate in their support for their team. Indeed, the Hill is the principal site at which the Grog Squad congregates to watch the on-field performances of "the Roosters" or "the Reds," as the North Adelaide team is also known.

In addition to visiting the Hill, we also accessed and analyzed much of the content on the rocketrooster.com website, particularly the online forum known as "The Roost." This involved monitoring the traffic over "The Roost," usually on a Friday and a Monday to follow the build up to and the subsequent postmortem of the weekend's game. This Internet research provided an important complement to the face-to-face fieldwork and, in turn, proved to be a crucial mechanism through which the Groggies maintained their particular cultural identity (see Palmer & Thompson, 2007).

The research also involved collecting a range of media and advertising materials about alcohol in Australian Rules football. Much of this data included the SANFL's marketing and promotional materials as well as newspaper advertisements for alcohol companies and products. Some of these are described and presented here as well, for many of the activities and behavior of the Grog Squad underscore the promotional discourse of the SANFL in which alcohol, more specifically beer, has a certain symbolic capital that constructs the experience of "local footy" for the Grog Squad in very particular ways.

"LOCAL FOOTY": THE PROMOTIONAL CULTURE OF SANFL

Before unpacking the promotional work of the SANFL, some preliminary details about the SANFL itself are needed to contextualize the consumptive sub-culture of the Grog Squad that has developed within it. With the entry of two South Australia teams into the national Australian Football League (AFL)—the Adelaide Crows in 1991 and Port Power in 1997—a two-tiered competition developed and the SANFL became regarded as more "grassroots" and "authentic" when compared with the highly commercialized and essentially professional Australian Football League.

Importantly for the marketing activities of the SANFL, prior to the elevation of the Crows to the AFL, a fan's loyalty to a football club was based upon specific inner-city locales in Adelaide. The Redlegs, for example, were based at Norwood Oval; their eastern suburb rival Sturt was based at Unley Oval; West Adelaide was based in the inner-west suburb of Thebarton, while the proudly working class Central Districts were based in the outer-northern suburb of Elizabeth. When following a football club generated such place-based loyalties, fans felt a strong sense of identity that was sharpened against the identities of rival clubs and suburbs. While the nine clubs in the SANFL still train and play at their local grounds, these strong, parochial connections to a neighborhood have been slowly eroded since the entry of the Adelaide Crows into the Australian Football League. As Warren points out:

> for many football followers living in these localities, a central element of social activity has been removed and supplanted with television coverage of elite standard games...traditional local rivalries have been supplanted by new state based ones, and the game is increasingly becoming a spectator sport through television coverage which extends to the dissemination of entire games and highlights on most week-ends. (1993, p. 6)

Launched in 1991 as "a team for all South Australians," and with "The Pride of South Australia" as the club's official theme song, the Adelaide Crows transcended the locality-based loyalties that had previously defined following a football club in Adelaide. As Shilbury and Hooper (1999) write, "the club began from scratch. It had no identity, no players, no tradition and no home" (p. 96). With a training ground that had no prior affiliation to an SANFL club or neighborhood and a ferocious marketing campaign that promoted geographical inclusivity, the Crows were soon embraced by residents in Adelaide. Their victory in the 1997 Grand Final did much to alleviate local resistance to an Adelaide club playing in the AFL, and the city went on a ticker-tape parade to welcome the victorious Crows home.

However, the entry of the Port Adelaide Football club into the AFL competition in the same year saw a return to the public outrage that had initially surrounded the presence of the Crows in the national league. The proudly parochial supporters of the Port Adelaide Magpies labeled the management of the football club traitors who had defected to the national league. For Magpie fans, the connection between club and place was particularly powerful. "The Port," as the area is known, has been a working port since 1840, and a strong cultural identity has developed around the area, trading, in particular, on its maritime and working class heritage. To further strengthen the link between team and place, the Port Adelaide Football club has been in existence since 1870, and this has generated a long, locality-based connection of fans to their club. While the Crows pursued a marketing strategy of transcending the traditional place-based loyalties of the SANFL, the Port Adelaide Football Club, on their ascension to the AFL, re-branded themselves as "Port Power" to preserve the connection to the maritime and working class heritage of the Port.

Such historical notes are important, for they provide the backdrop to an enduring cultural narrative of football in South Australia. The neighborhood-based clubs of the SANFL continue to be viewed as "community oriented" and "family based," in opposition to the growing commercial juggernaut of the AFL. Local newspapers often feature stories of "average Australian families" being unable to attend AFL games due to prohibitively expensive ticket prices and high cost of food and beverages. By contrast, the SANFL operates a modest gate fee; entry is free for children, and adults may enter the ground gratis at the start of the third quarter. Unlike AFL games, which are played in huge, impersonal stadia, the proximity of the fans to the action and the lack of barricades and fencing at SANFL games enable spectators to access the oval between quarters to do "dobs"—short kicks of the football between friends or, more frequently, between father and son. Each oval also hosts a "Family Friendly" area—designated locations around the ground where alcohol consumption is not permitted. The combination of such policies, structures, and practices does much to promote a culture of "local footy" that is unashamedly community and family based.

Of particular importance for this chapter, such history carries much cultural currency amongst local football fans and provides an important backdrop to a highly particular promotional culture that positions the SANFL and the place of alcohol in it in some distinctive ways. The commercial imperatives of the AFL have enabled football to develop from a club to a corporate sport, and its high television profile and audience ratings now attract a number of sponsors whose companies and products are not alcohol-related (Andrews, 2000; Stewart & Smith, 2000). Automotive companies sponsor the Melbourne Kangaroos (Mazda), the

Geelong Cats (Ford), and Port Power (Fox trucking). Electrical goods companies sponsor the Adelaide Crows (Panasonic) and the Brisbane Lions (Vodaphone), amongst others. By contrast, the SANFL remains inextricably linked to alcohol sponsorship. Eight of its nine clubs are sponsored by West End brewery; Coopers Brewery sponsors the ninth. In something of an annual tradition, the club colors of the victorious team in the Grand Final are painted on the chimneystack of the West End Brewery that dominates Adelaide's skyline. Additional sponsors include wine companies and pubs and hotels. Accordingly, much of the promotional activities of the clubs involve alcohol in some way through members' lunches, happy hours, wine-tasting tours, and a practice known as "the silver circle" (a ritualized drinking game that raises money for the end-of-season trip for players). Moreover, alcohol is widely available at each football oval through various beer stalls around the ground, as well as in more formal venues such as members' and public bars.

In light of the cultural narrative of community-based, family-friendly clubs outlined earlier, the close association with alcohol sponsorship represents something of a paradox for the SANFL. On the one hand, much of the "match day" activities of the SANFL works hard to present a game that is family friendly and relatively accessible to all through the kinds of initiatives described earlier. On the other, a great part of any football club's promotional and membership activities is orchestrated around drinking. Members of the West Adelaide football club, for example, have access to an exclusive bar where drinks are available at a reduced price. The licensed, public bar offers Happy Hours five nights of the week, and half-priced pints and schooners from 12 p.m. to 2 p.m. on a Sunday afternoon. Such drinking-based club activities are not peculiar to the West Adelaide football club but are indicative of the kinds of drinking-based club activities that are commonly found in any SANFL club.

In further examples of promotional drinking, the SANFL "blog" offers contributors the chance to win a carton of West End beer in a competition known as "Have Your Shout on Us"—the reference to the cultural practice of buying a round of drinks is no doubt self-evident. Many of the advertisements in *The Budget* (a weekly listing of the SANFL match fixtures) are for West End brewery and feature tag lines such as "We're proud to be part of the SANFL team" or "SA footy's number one supporter." Advertisements for the Tintara and Hardy wine companies are equally common. In other words, in almost every conceivable way, the connection between alcohol and the SANFL is undeniable and unavoidable, and it is this broader promotional culture that provides a context within which the "doing" of drinking can emerge as entirely unproblematic.

Indeed, this broader promotional culture highlights a series of tensions within which the Grog Squad must necessarily be considered. Alcohol occupies a central space in the lives of the Grog Squad, as well as in the wider marketing activities of the SANFL, and it is in this context that the following ethnographic analysis of drinking is best understood.

THE GROG SQUAD

The Grog Squad developed out of a North Adelaide cheer squad that has been around since the 1960s. Many of the Groggies have been following North since they were young boys, and several members had rarely missed a game in more than 30 years. The growth of the Internet also enables the Grog Squad to support their team through a dedicated website (rocketrooster.com), a chat room and discussion forum that is devoted to all things Groggie (Palmer & Thompson, 2007). While high levels of alcohol consumption are central to their style of spectatorship, it is also important to note that a deep allegiance to "Norf," as the North Adelaide team is also referred to, is an equally important marker of cultural identity for the Grog Squad. The degree of dedication of these men to their team is aptly summarized by the customary sign-off by one of the Groggies from each week's web posting: "I might as well face it I'm addicted to Norf" (Rob's Grog Files, 2005).

Details about the exact demographics of the Grog Squad are scant. Conversations with and observations of the group would suggest that they are exclusively male, Anglo-Australian, and aged between 25 and 45. As can be gleaned from their website, the Groggies are employed in a wide range of professions—from farmers and warehouse workers to police officers and accountants. While most of the Groggies reside in metropolitan Adelaide, a few have moved to regional areas of South Australia or interstate, returning to "Prossie" when they can, but nonetheless staying connected to the rest of the Grog Squad through The Roost forum. With the exception of those exalted members of the group who are part of the "Grog Squad Hall of Fame," a point to which I will return, the Groggies are strikingly homogeneous. The Grog Squad is exclusive of anyone other than white Australian males, and such male sociality is a key reinforcing marker of "mateship" within the group.

The wearing of a uniform is one of the key—and most visible—markers of allegiance to a football club.[4] As Back et al. (2001) point out: "the notion of 'wearing the shirt' summons in football [soccer] fan vernacular the deepest level of symbolic identity and commitment. It captures the embodied meanings associated

with the football club as an emblem of locality and identity" (p. 82). The Groggies are easily identifiable on the Hill by their red and white T-shirts, replica team guernseys, scarves, beanies, duffle coats, and polar fleece tops. Those members of the group who have been inducted into the Grog Squad Hall of Fame are further distinguished by their eponymous, purpose-made polo shirts that signify they are a class apart from the rest of the Groggies. The slogan on the back of their shirts also supports the clear association between drinking and membership in the group: "it may be crap footy, but three beers from now, anything will look good" (field notes, April 16, 2005). The wearing of the uniform, in other words, locates very particular sports-related commodities in the everyday patterns of social interaction that convey both tradition and allegiances among the Grog Squad.

Such commodified expressions of identity are also in keeping with the orienting concept that underpins this chapter. Subcultures of consumption are a "distinctive subgroup of society who self-select on the basis of a shared commitment to a particular product class, brand or consumption activity" (Schouten & McAlexander, 1995, p. 43), in this case drinking. It is a point to which I'll return, but other characteristics of subcultures of consumption include "an identifiable, hierarchical social structure, a unique ethos or set of shared beliefs and values, and unique jargon, rituals and modes of symbolic expression" (Schouten & McAlexander, 1995, p. 43). The point to note here, however, is that the particular subculture of consumption that is the Grog Squad trades on a dual narrative of allegiance to North Adelaide and a commitment to heavy drinking,

Indeed, while loyalty to the North Adelaide football club is a key marker of commitment to the Grog Squad, the ability to consume exceptional amounts of alcohol is of equal importance in gaining acceptance among the group. The mythology of alcohol-fuelled exploits that has built up around the Groggies is captured in one of the group's slogans: "be afraid, be very afraid, The Grog Squad is coming to a bar near you" (field notes, March 5, 2005). The Groggies have developed a number of chants and songs that reflect their culture of heavy drinking. Stubbie holders have been printed with song lyrics on them so, in the words of one Groggie, "we can remember them when we're pissed" (field notes, March 5, 2005). Song lyrics are posted onto the rocketrooster.com website and supporters are encouraged to learn their words so they too can join in on match day. Here, simplicity and repetition are important, as evidenced in the song the Groggies usually sing at the start of a game to rouse support: "here we go, here we go, here we go, it's the only fucken' song that we know. Here we go, here we go. Here we go, here we go, here we go" (field notes, March 19, 2005). While similar versions of this song are sung in sporting stadia worldwide, it is the next line in

the Grog Squad's version that is worth noting: "it's sung by the alca—holics, here we go, here we go here we go" (field notes, March 19, 2005). In other words, the shared commitment to the cultural activity of drinking binds and defines the Grog Squad in very particular ways, and it is to the *doing* of drinking that this chapter now turns.

Doing Drinking: A Subculture of Consumption. Within the Grog Squad, a number of definitions, limitations, and understandings surround the consumption of alcohol, which ensures it is done in certain, culturally prescribed ways. Where to drink, what to drink, and how (and how much) to drink are patterned in very particular ways that are mutually agreed and understood by the Groggies. As is explored in this section, the consumption and sharing of beer, in particular, is a process of social organization through which the Grog Squad members meaningfully construct their social world.

While alcohol is readily available at football grounds from public bars, member's bars, beer tents and stalls, for the Groggies, drinking is not done just anywhere. As mentioned previously, the Hill at Prospect Oval is the prime site at which the Grog Squad congregates to watch the on-field performances of North Adelaide. It is here that most of their drinking is done, for the Hill offers a site at which to conspicuously display one's drinking prowess. The Hill is a very public space—elevated, noisy, and colorful with the Groggies wearing their requisite T-shirt uniform. The Hill is, in short, the perfect platform from which to enact conspicuous consumption.

The central focus of the Hill is "the Taj"—a small, spartan stall atop the Hill—which is entirely bare, save for a long ice-filled trough from which quite spectacular amounts of beer and bourbon are sold. The limited availability of alcoholic beverages is important, for it helps to order the routine of drink buying in certain ways that confer commitment to the Grog Squad. The Taj is the centerpiece for Grog Squad activity, and it is frequently featured in many of the missives and exchanges across the rocketroster.com website. The first home game for the 2005 season, for example, was announced as follows: "Saturday is the day, the royal palace of Prospect Oval, the Taj Mahal will be open for business for the first time for the year" (Bullitt, 2005). In many ways, the exclusively male drinking environment of the Hill and the Taj is reflective of the historical gendered segregation of drinking in Australia. As Kirby points out, "by the middle of the twentieth century, Australia had a clearly defined, sexually differentiated drinking culture" (2003, p. 245).[5]

Doing Drinking: Where and What to Drink. It is largely within the commensal setting of the Taj and the Hill that the Groggies construct their personal relationships. Belonging, identity, and social status are all communicated

and conferred through banter, "piss takes," wind ups, and practical jokes that take place on the Hill and at the Taj. Incriminating photographs of invariably drunken exploits, if not shared via the web-based activity of the Grog Squad and the new technology of camera phones, are posted above the bar in the Taj, alongside the membership list of the Grog Squad Hall of Fame. Perhaps not surprisingly, hall of fame membership and alcohol-fuelled antics are closely related, with a particularly eventful drinking session involving a close call with the police or "the missus" elevating one to the status of "legend" within the group. However, unless a Groggie routinely turns up to the Hill or the Taj to take the brunt of the group's banter, he runs the risk of marginalizing himself from the discourse of drinking on which his own status within the Grog Squad depends. In other words, to be a "true" Groggie, one must be able to give as good as he gets through the ripostes that characterize the verbal exchanges of the Grog Squad. Such discursive practices are reminiscent of what Campbell describes as "conversational cockfighting" (2000, p. 565) among male pub goers in rural New Zealand. Among the drinkers in Campbell's ethnographic study, verbal sparring and the trading of light-hearted insults demonstrate a kind of masculine mastery. In much the same way, the playful teasing, banter, and wind-ups among the Grog Squad are not executed to cause offence but to see if a man can "take it."

This discourse of drinking is further aided by the use of the rocketrooster. com website, which promotes the cultural identity of the Grog Squad to the Grog Squad. Apart from giving information regarding match activity—statistics, player transfers, injuries, and so on—the website also features several pages that are given over to mythologizing the hard-drinking reputation of the Grog Squad. Links take the reader to "the Grog Files" and to the "Grog Squad Hall of Fame." Much of the content of these pages has the flavor of the great Australian yarn, with many of the tales of hard drinking seeking to outdo one another. In doing so, the importance of being able to "put away a skinful" (drink copious amounts of alcohol) is reinforced as a key marker of belonging to this particular sporting identity.

Importantly, the nature of the banter and exchanges experienced on the Hill, at the Taj, or in the website forum is so very dense and detailed that it is largely beyond the capacity of non-Groggies to contribute to it. Nicknames, abbreviations, colloquialisms, and slang are all part of the discourse of the Grog Squad that serves to exclude those not privy to the cultural import being traded in such exchanges. The sheer detail and volume of constantly changing information of the website, in particular, results in the Groggies both realizing and maintaining a distinct, bounded discourse around their sporting-based drinking domain that is difficult for others to penetrate.

While the Hill and the Taj are the key drinking locales for the Grog Squad, other socially sanctioned drinking locations include neighboring pubs to which the Groggies retire on conclusion of a football game; on the occasion of particularly lengthy drinking sessions, night spots, strip clubs, and then private houses are visited in order to continue drinking. In light of (a) the long-standing affiliation to the North Adelaide football club and (b) the historical context sketched out earlier in which following a football club in the SANFL is strongly rooted in neighborhood loyalties, it is perhaps not surprising that the Grog Squad visits certain pubs over others. In a return to the neighborhood-based loyalties of club and place, the Groggies drink in the pubs in and around the suburban Prospect Oval that fall into the catchment area of the North Adelaide Football Club.

What is striking about each of these settings—the Taj, the Hill, and the pub—is that they represent key sites at which the Grog Squad can display their physical toughness, for a good deal of physical horseplay accompanies any serious drinking bout. In between play at a game, the Groggie will often kick a football (or an empty beer can) around in a relatively harmless display of footballing skill. When the drinking spills over to the private and domestic spheres of pubs and houses, such horseplay invariably involves physical behavior that is ill-thought out and dangerous. The rough and tumble of the friendly sparring observed at the Taj and on the Hill now takes a sinister edge, as wayward punches are delivered more forcefully than perhaps intended once alcohol dulls the reflexes and coordination. In other instances, illegally obtained firecrackers are launched in private backyards and, in one particularly memorable case, from the window of a fourth-floor apartment. All manner of things are set alight—hair, clothing—not to mention the schoolboy trick of attempting to light one's own fart. It is some small miracle that, to date, none of the Groggies have been seriously injured through such drinking-related antics, although there is no shortage of public health data linking drink-related accidents to admissions to Accident and Emergency hospital departments.

Apart from where to drink being clearly defined and limited to by and large the Taj, the Hill, and certain pubs close to Prospect Oval, *what* to drink also takes on particular cultural properties among the Grog Squad. Social anthropologists have long had an interest in how people drink, whether that relates to alcohol or other beverages. The ritualized layering that accompanies quite mundane everyday practices such as stopping for a cup of tea in a Day Centre in East London (Hazan, 1987), drinking fermented maize liquor in Subranum (Frake, 1964), or relishing a whisky chaser in a long house in Newfoundland (Mars, 1987), all provide us with important symbolic means of identifying and constructing cultural values and of defining behavioral norms and expectations.

In the case of the Grog Squad, the important property of alcohol is that it is publicly consumed. The Groggies all know what each other customarily

drinks—for it can only be beer or bourbon—and when there is a marked variation, not only is it noted but also some explanation is sought. Moreover, there is a clear order to how their drinking unfolds. Drinks are consumed only through the practice of buying a "round," and each round is limited to any one buyer purchasing a maximum of four beers in a single round. Pragmatics as well as sociality underpin such practices. It is not possible for an individual to carry more than four beers (usually pint glasses) from the bar to the group's vantage point on the Hill. This means that if there are more than four Groggies in attendance, which there usually are, a complex set of subgroups forms to enable the purchase of the rounds to occur in this predetermined way. Should a member of a round drink at a faster pace than the rest of the group, he may opt to purchase a "wedgie," usually a smaller-sized schooner of beer that is consumed while waiting for the rest of the group to reach his level of consumption.

"Drinking Well": Reputation and Drinking. Apart from buying in rounds, extended drinking sessions are another hallmark of the Grog Squad's consumptive practices, with participants engaging in anything up to 10 hours of drinking in a single session.[6] While the focus of such drinking encounters, in Frake's (1964) terminology, is ostensibly on drinking, it, in fact, affords the Groggies with a key opportunity through which to extend and define their social relationships. As is detailed elsewhere (Palmer & Thompson, 2007), such sessions on the Hill provide the Grog Squad with access to a range of networks, supports, resources, and benefits that operate in ways that are of mutual benefit to them. To focus on the drinking alone is to obscure the very real social supports and connections that exist among the Grog Squad (Palmer & Thompson, 2007). But, there is another dimension of sociality at work here as well. In these drinking encounters, we see the expression of a particular form of cultural competence. Erving Goffman once wrote—albeit in an entirely different context—that "people are obliged not only to carry out their tasks and routines, but also *express* their competence in doing so" (1959, p. 33). For the Grog Squad, drinking competence is a key marker of cultural identity and it is in these regular, extended drinking sessions that the Groggies construct their personal reputations as drinkers.

Thus, it is virtually a cultural requirement that to be a member of the Grog Squad, one must be able to drink well. Witness some of the tips for auditioning to the Grog Squad that one member posted on the rocketrooster. com website:

1. Dress correctly. Please ensure it is something that can stretch over your guts (especially by the end of the game after consuming copious amounts of the amber fluid).

2. Be enthusiastic. Often, some new members can focus so much on watching the footy that they will look lost or introverted when it comes to the actual drinking—not a good thing to happen in front of your peers at the Taj or worst in front of the scummy opposition supporters.

3. The judges are not only looking for how well you do with the drinking but also how much you can consume and still sing in time with the rest of the group. We do look at how you generally handle yourself in front of a group of people.

4. Don't be afraid of looking or sounding dumb—that will come naturally by the end of the game when you are pissed. (Guest, 2005)

As such comments suggest, the idea that an effective and successful member of the Grog Squad could not drink well would be considered out of the question. The reference in the first audition tip to wearing clothing that can "stretch over your guts" also conjures up images of perhaps the single most iconic symbol of male drinking in Australia—the beer gut.

It is in the long drinking sessions where members of the Grog Squad display their ability to "hold their beer well." At the end of a day's or, as in most cases, a night's drinking, they will boastfully be comfortably "full" but will rarely admit to more serious inebriation. This is important. As the sessions on the Hill or in the Taj are the key locales through which the Groggies construct their personal reputations, as men as well as drinkers; to publicly suffer the effects of not being able to hold one's beer is a humiliating prospect that no one relishes. In other words, this is not part of the discourse of drinking that one wants to be a part of.

Accordingly, there is a certain order in which drinking within a round—or drinking encounter—unfolds or escalates. While beer or bourbon are the only drinks available for purchase at the Taj, all participants in a round will order equal strength and equally priced drinks in a given round. It would be inappropriate, for example, to request a more expensive can of bourbon and cola, while others in your group are drinking only beer. This serves a practical and social function, for apart from respecting the etiquette of the round, the ordering of such behavior helps keep the reputations of the drinkers in check. Over the course of an afternoon at the football, which can be in excess of four or five hours, any one Groggie may be a part of anything up to 10 rounds. Quite clearly, an exceptional amount of alcohol is consumed in these drinking sessions and to hit the hard spirits too soon into the session is to court disaster. As such, much self-monitoring of the effects is undertaken, and any switch to bourbon is reserved until much later in the afternoon, upon which all members of the drinking encounter engage in this switch from beer to bourbon.

While it is largely outside the scope of this chapter, it is important to note that in constructing their personal reputations as drinkers, the Grog Squad members are, of course, also constructing their personal reputations as *men*. The Grog Squad operates within a patently heterosexual male subculture in which women are by and large absent, and the long drinking sessions that the Groggies engage in allow the men to display themselves as men. As conceptualized by Connell (1995), it is through particular social practices (such as sport or drinking) that hegemonic masculinity is secured and accepted as normal. That said, and as I have argued elsewhere (Palmer & Thompson, 2007), to concentrate on this alone as yet another example of hegemonic masculinity in sport (Connell, 1995; Connell & Messerschmidt, 2005; Demetriou, 2001) obscures the ways in which a single cultural activity (drinking) and a single cultural product (beer) gives meaning to the actions, behaviors, and reputations of these men.

CONCLUSION

This chapter has located the ethnographic world of the Grog Squad within a broader theoretical framework of a subculture of consumption. It has detailed the social structure, the dominant values, and the revealing symbolic behaviors of this distinct, drinking-oriented group of men. As has been argued here, the collective identity of the Grog Squad finds consistent expression through persistent drinking. Their drinking-based cultural practices help confer membership of and commitment to the group, provide an identifiable social structure through "drinking well," and communicate a unique set of shared beliefs and values through a dense discourse of drinking and associated modes of symbolic expression such as the extended, round-based drinking session. Such properties are characteristic of a subculture of consumption (Schouten & McAlexander, 1995, p. 43).

Such attention to the social patterning of drinking is of ongoing interest to anthropologists and others for it plays an important social role in many cultures and contexts. Almost every event of any significance in our lives is marked with some sort of ceremony or celebration—and almost all of these involve alcohol. These have been subject to consistent ethnographic scrutiny. It is noteworthy, however, that anthropologists have not devoted this same degree of ethnographic attention to the symbolic capacity of alcohol in relation to sport or, indeed, to the role of heavy or exceptional drinking as a particular form of social cohesion and identity building. It is these gaps in the ethnography of drinking practices that this chapter has sought to address.

ACKNOWLEDGMENT

The research was supported by a grant from the Alcohol Education Rehabilitation Foundation (Australia).

NOTES

1. Parts of this chapter have been published in Palmer, C., & Thompson, K. (2007). The paradoxes of football spectatorship: on field and on line expressions of social capital among the "Grog Squad" *Sociology of Sport Journal,* 24, 187–205. This chapter extends this work and yet in places retains much of the empirical core of the original article.
2. It is something of a dubious national achievement that Australia routinely ranks highest for per-country alcohol consumption.
3. The gendered dimensions of this fieldwork, and the personal and political issues it raised for us as female researchers, are discussed in Palmer & Thompson (2007). Although key to our position vis-à-vis the all-male Grog Squad, it is outside the scope of this present chapter and readers are referred to the citation noted above.
4. Other commentators (Redhead, 1993; Fawbert, 1997; Crawford, 2003) have noted the importance of the wearing of the shirt in relation to the construction of a football fan's identity and allegiance to their club.
5. The segregated nature of drinking is also noted by Campbell (2000) in relation to "pub culture" in rural New Zealand.
6. Such ritualized drinking practices are by no means particular to the Grog Squad. Overman and Terry (1991) found that many Australian athletes consider that shared involvement in drinking promotes the traditional values of mateship and sporting participation, while Mendoza and O'Riordan (1995), Lawson and Evans (1992), and Lawson et al. (1992) state that drinking is regarded by participants as being integral to the mateship of the game.

REFERENCES

Andrews. I. (2000). From a club to a corporate game: The changing face of Australian football, 1960–1999. *International Journal of the History of Sport,* 17 (2&3), 225–254.

Back, E., Crabbe. T., & Solomos, J. (2001). *The Changing face of football: Racism, identity and multi-culture in the English game.* Oxford: Berg.

Bale, J. (1991). Playing at home: British football and a sense of place. In J. Williams & S. Wagg (Eds.), *British Football and Social Change* (pp. 130–143). Leicester: Leicester University Press.

Bale, J. (2000). The changing face of football: Stadiums and communities. In J. Garland, D. Malcolm, & M. Rowe (Eds.), *The future of football: Challenges for the twenty-first century* (pp. 91–101). London: Cass.

Brady, M. (1993). Giving away the grog: An ethnography of Aboriginal drinkers who quit without help. *Drug and Alcohol Review,* 12 (4), 401–411

Bullitt (2005). *Taj Mahal 2005.* Retrieved March 31, 2005, from www.rocketrooster.com/NAFC/Forum/phpBB2.

Campbell, H. (2000). The glass phallus: Pub(lic) masculinity and drinking in rural New Zealand. *Rural Sociology*, 65 (4), 562–581.

Collman, J. (1979). Social order and the exchange of liquor: A theory of drinking among Australian Aborigines. *Journal of Anthropological Research*, 35 (2), 208–224.

Connell, R. W (1995). *Masculinities*. Berkeley: University of California Press.

Connell, R. W., & Messerchmidt, J.W (2005). Hegemonic masculinity: Rethinking the concept. *Gender & Society*, 19 (6), 829–859.

Crawford, G. (2003). *Consuming sport*, London, Routledge.

de Garine, I., & de Garine, V. (Eds.) (2002). *Drinking: Anthropological approaches*. New York: Berghahn Books.

Demetriou, D. (2001). Connell's concept of hegemonic masculinity. *Theory and Society*, 30, 337–361.

Douglas, M. (Ed.) (1987). *Constructive drinking. Perspectives on drink from anthropology*. Cambridge: Cambridge University Press.

Fawbert, J. (1997). Replica football shirts: A case of incorporation of popular dissent. *Social Science Teacher* 1, Autumn, 9.

Frake, C. O. (1964). How to ask for a drink in Subanun. *American Anthropologist*, 66, 127–132.

Gefou-Madianou, D. (Ed.) (1992). *Alcohol, gender and culture*. London: Routledge.

Goffman, E. (1959). *The presentation of self in everyday life*. New York: Doubleday.

Guest (2005). *Grog Squad recruiting auditions*. Retrieved April 2, 2005, from www.rocketrooster.com/NAFC/Forum/phpBB2.

Gusfield, J. R. (1987). Passage to play: Rituals of drinking time in American society. In M. Douglas (Ed.), *Constructive Drinking: Perspectives on drink from anthropology* (pp. 73–90). Cambridge: Cambridge University Press.

Hazan, H. (1987). Holding time still with cups of tea. In M. Douglas (Ed.), *Constructive drinking: Perspectives on drink from anthropology (*pp. 205–219). Cambridge: Cambridge University Press.

Heath, D. B. (1995). *International handbook on alcohol and culture*. Westport, CT: Greenwood Press.

Kirby, D. (2003). Beer, glorious beer: Gender politics and Australian popular culture. *The Journal of Popular Culture*, 37 (2), 244–256.

Lawson, J., Gowland, J., Tutt, T., & Black, D. (1992). Colossal alcohol consumption among some Australian rugby footballers—implications for health promotion. *Health Promotion Journal of Australia*, 2 (3), 51–54.

Lawson, J. S., & Evans, A. R., (1992). Prodigious alcohol consumption by Australian rugby league footballers. *Drug and Alcohol Review*, 11 (2), 193–195.

Mars, G. (1987). Longhouse drinking, economic security and union politics in Newfoundland. In M Douglas (Ed.), *Constructive drinking: Perspectives on drink from anthropology* (pp. 91–101). Cambridge: Cambridge University Press.

Mendoza, J., & O'Riordan, D., 1995. *Young adults and alcohol consumption at sporting venues* (Unpublished Report). School of Public Health, Queensland University of Technology.

Overman, S., & Terry, T. (1991). Alcohol use and attitudes: A comparison of college athlete and non-athletes. *Journal of Drug Education*, 21 (2), 107–117.

Palmer, C., & Thompson, K. (2007) The paradoxes of football spectatorship: On field and on line expressions of social capital among the "Grog Squad." *Sociology of Sport Journal*, 24, 187–205.

Redhead, S. (Ed.) (1993). *The passion and the fashion: Football fandom in the New Europe*. Aldershot: Avery.

Rob's Grog Files (2005). Retrieved March 4, 2005, from www.rocketrooster.com/NAFC/Rob'sGrogFiles.htm.

Schouten, J. W., & McAlexander, J. H. (1995). Subcultures of consumption: An ethnography of the new bikers. *Journal of Consumer Research*, 22, 43–61.

Shilbury, D., & Hooper, G. (1999). Great expectations; From Port Adelaide to Port Power—a club in transition. *Sport Management Review*, 2 (1), 83–109.

Stewart, B., & Smith, A. (2000). Australian sport in a postmodern age. *International Journal of the History of Sport*, 17 (2&3), 278–304

Warren, I. (1993). *Violence in sport: Some theoretical and practical issues in the Australian context*. Paper presented a Second National Conference on Violence. June 15–18, Canberra. Australian Institute of Criminology.

"I Laughed Until I Hurt": Negative Humor IN Super Bowl Ads

MARGARET CARLISLE DUNCAN

ALAN AYCOCK

INTRODUCTION

In his classic work on advertising, John Berger (1972) famously remarked that advertising

> is about social relations, not objects. Its promise is not of pleasure, but of happiness: happiness as judged from the outside by others. The happiness of being envied is glamour...The spectator-buyer is meant to envy herself as she will become if she buys the product. She is meant to imagine herself transformed by the product into an object of envy for others, an envy which will then justify her loving herself. One could put this another way: the publicity image steals her love of herself as she is, and offers it back to her for the price of the product. (pp. 132–134)

In the decades since Berger initially stated this working model of the allure and effects of advertising, many scholarly volumes have been published on the subject. Surprisingly little, however, is to be found in these volumes regarding one of Berger's basic assumptions, that advertising is typically positive in its effects: Berger refers to "happiness," "envy," and "love" as the principal urges set in motion by advertising and satisfied (or to be precise—almost, but not quite, satisfied) by purchase.

At the time of his initial writing, Berger may have been correct in identifying what we might term *positive* advertising as its predominant form. But what was canonical in the decade of *Abbey Road* and *Sergeant Pepper* is perhaps no longer as relevant in the grim Orwellian world of post-9/11. *Negative* advertising has come to the fore, as we shall see, in a significant way that invites fresh examination and a careful reinterpretation about what it is that is "really going on here." Although we cannot claim to present as definitive a statement as Berger's, we hope to construct the beginnings of an effective model of negative advertising.

SUPER BOWL ADS AND THE SAMPLING PROCESS

To provide an empirical basis for our discussion of negative ads in public discourse, we began by looking at Super Bowl ads. It's widely believed that the Super Bowl audience constitutes a broadly based national sample. As many as 80–90 million Americans view the game, in age, gender, and racial proportions that roughly represent the entire population. For this reason, we might expect Super Bowl ads to in some sense define a public discourse associated with advertising that has the capacity to legitimize certain modes of movement, speaking, or behavior. This argument becomes even more persuasive as we elaborate the context of these ads.

During the past decade, Super Bowl advertising, once merely a commercial subsidiary of the game, has emerged as a competition sui generis. The placement cost of a 30-second Super Bowl ad has risen to more than $2.5 million, considerably raising the stakes of a successful production. In addition, a critical industry has sprung up around Super Bowl advertising, supported by critics who are ad industry professionals, by individual bloggers who have adopted a role as live critics during the game itself, and by web-based voting that proclaims some ads better than others (though on what ground these voters make their choices is rarely clear or straightforward). There are even parodic or over-the-top Super Bowl ads (e.g., the Snickers *Kiss* ad, the GoDaddy *Basic Instinct* ad, or the Miller Lite *Cat Fight* ad) that are aired on the web and subjected to analysis or response even though they do not actually appear on TV during the Super Bowl.

This "commentariat" functions before, during, and after the actual airing of the ads on Super Bowl Sunday, and may, in fact, determine whether a particular ad campaign continues after its inaugural offering (e.g., the MBNA [2005] banking ad that featured Gladys Knight playing rugby, or the Silestone [2005] ad for Diana Pearl quartz kitchen and bathroom surfacing, featuring Dennis Rodman, Mike Ditka, Jim McMahon, and Refrigerator Perry).

One useful byproduct of this burgeoning body of public discourse is that the ads themselves have become widely available on the web, since they must

be documented and archived to supply suitable fodder for debate. A site such as iFilm.com includes nearly all Super Bowl ads aired between 2001 and 2007, making our empirical task that much simpler.

We decided to focus on beer ads because of the traditional connection between beer and sport that persists both in America and Europe. Although several beer companies have sponsored Super Bowl ads, we chose to examine Budweiser advertising because of Anheuser Busch's preeminence in the American market—almost 50% of all beer sales in the United States involve Anheuser Busch products. Finally, we perceived a distinction between two types of Anheuser Busch ads, those for Budweiser and those for Bud Light. Budweiser ads, in our opinion, tend to be more generic and less "edgy" than Bud Light ads. The latter seem to us to have been designed specifically in a eponymously "light" vein, that is, meant to be humorous, although not necessarily humor in which light-heartedness prevails. Many of these humorous Bud Light ads, as we shall see, are actually quite negative.

Over the period 2002–2007, we located 29 Bud Light ads. Although we relied predominantly on iFilm.com as a source, we supplemented its listing of 2006 ads with references from video.google.com. From this sample, we discarded several types of ads: (1) ads in which the primary characters were animals or other nonhumans; (2) ads that were sexist but were not otherwise negative; (3) ads that we found neutral, neither positive nor negative in tone. The remaining 15 ads expressed negative themes, which we defined as involving the infliction of pain or suffering, anger, threatened or implied violence, betrayal, scenes of chaos or extreme disorder, substantial embarrassment, or some combination of these.

We find it intriguing that approximately half of the Budweiser Light Super Bowl ads were negative in the terms that we have defined them above, and we take this as an indication that there is something here that merits explanation.

BUD LIGHT AS AN AD GENRE

Bud Light ads are distinctive in form. Each presents a brief 20–25-second vignette in which a young man is so totally focused on getting his Bud Light beer that he becomes oblivious to commonsense considerations such as personal safety, normal social interaction with friends, or the consequence to innocent bystanders of his lust for the beer. This vignette is then followed by a two-second stock shot of Bud Light being poured into a beer glass. Each ad is completed by a "kicker," by which we mean a very brief three-second return to the vignette that offers a twist that emphasizes the essential humor of the situation.

An example will help to illustrate the basic pattern. In *Naked Guy* (2008), the story line involves a woman's attempt to seduce her husband. She tells him

that she's put the satin sheets on the bed, which appears to be an intimate signal between the couple. She's also put on a sexy nightie and is lighting candles (although, oddly, the lights remain fully on).

We see the husband, however, sprawled in front of the TV, unshaven, eating his munchies, and more or less impervious to her efforts. However, his wife then tells her husband that she has Bud Light, and the camera pulls back to show two Bud Lights on ice in the bedroom. Galvanized by his desire for beer, the husband rushes upstairs (there is, in fact, the sound of a stampeding elephant in the background), stripping his clothes off, and flings himself on the bed. He slides across the satin sheets and sails out the open window. The end of the vignette shows him being stripped of his only remaining clothing—his boxer shorts—by the tree limb outside the bedroom window. His wife winces as she watches him fall. The man lands with an "ouch," reassuring us that he is not really as seriously hurt as would be the case in a second-story fall in real life.

The stock shot of Budweiser Light being poured apparently signifies the end of the ad; however, we then return to the kicker, in which the naked man scurries out of the bushes clutching a welcome mat in front of his genitals, only to run into the couple from next door out for an evening walk, who seem somewhat taken aback. His humiliation is complete.

Overall, the pattern is clear. The ad poses a cultural opposition between women and men. Women are stereotyped as being interested in the physical and emotional satisfaction that close-knit couples enjoy, while men are counter-stereotyped as being primarily interested in their own selfish pleasures, irrespective of their partners' wishes. In fact, as the vignette progresses, the husband continues to pursue his own self-interest, in effect consenting to have sex with his wife only because she bribes him with his favorite beer. The ironic twist of the narrative begins when the man gets his comeuppance, overreaching himself in his attempt to get his beer and flying out the window. By contrast, had he approached his wife in the seductive manner that she presumably would have preferred, he would not have been traveling at a sufficiently high velocity to have an accident. It's interesting that the wife seems oblivious to her husband's passionate shortcomings: even as he falls from the window, she remains a sympathetic witness. Thus the gender opposition is asymmetrical in the sense that the man recognizes what the woman does not, that he is violating the intimacy of their marriage by desiring a beer more than he desires his mate. One obvious interpretation might be that the ad is very male-centered, since the woman is only a minor character in terms of the plot development.

The final kicker brings this point out very clearly. The wife is nowhere to be seen, which reinforces the idea that she was never a principal of the vignette. At the same time the last scene reiterates the underlying comic theme of the

man hoist by his own petard (literally, considering the fate of his boxer shorts) and makes his predicament even clearer by introducing innocent bystanders to underscore his embarrassment. And, of course, we're reminded that the mishap has no lasting physical consequences, since the man's only injury is to his pride. Yet male pride, we shall see, is no small matter to constitute what is at stake in a Bud Light ad.

In this context, it's important to highlight the underlying theme of male dominance (or its opposite in this instance, male humiliation). Bud Light ads return again and again to the homology that just as teams of ferocious males are competing for absolute dominance on the playing field, male centered Bud Light ads replicate that competition in their basic assumptions and structure. In this respect, Bud Light ads are very much like playing football, but without helmets and padding. The naked guy's humiliation in the kicker scene isn't merely adding insult to injury: it *is* the very injury contemplated by the ad throughout its narrative, the revelation that a male is less than competent to assert himself successfully in every situation.

NEGATIVE THEMES IN THE *NAKED GUY* AD

The themes involved in the *Naked Guy* ad are scarcely obscure from a common-sense point of view. The predominant theme is the violence of a man falling from a second-story window. If you doubt the force of this theme, just try to imagine yourself laughing at this in real life! The embarrassment of being discovered naked in public comes a close second; this is discomfiting to the male ego, but not nearly as shocking. A third, latent theme is the estrangement between wife and husband, which does not quite amount to a betrayal yet introduces an intimation of falseness into a relationship that we know ought to be sincere. All three of these are negative; there is not a positive theme to be found in this ad.

What, then, does the use of negative themes accomplish in the *Naked Guy* ad? There are several possibilities, not necessarily mutually exclusive.

First, it seems unlikely that Anheuser Busch wants the consumers of Bud Light to associate the brand with themes of violence, embarrassment, or betrayal. One reasonable interpretation, however, is that if we are meant straightforwardly to remember the brand, that act of recall is probably enhanced merely by inflecting the ad with an emotional tenor or mood. Studies of negative political advertising, for instance, suggest that negative emotions are at least as effective as positive emotions not only in stimulating recall, but also in prompting a preferred reaction on the part of the viewers of the ad (Brader, 2006; Mark, 2007). Here, presumably, the desired reaction would be to purchase Budweiser Light beer.

Second, is the ad encouraging people to be indifferent to their domestic partners' needs, or alternatively warning that those who become indifferent to their spouses are more likely to fall from a second-story window? Probably not, in any simple sense. The ad vividly expresses a model of gender opposition and of the irresistible impulse of selfish consumption—the lust for Bud Light beer—that lies at the core of capitalism. Further, although the ad does propose that American males may suffer the penalties of excessive risk-taking, the ad nonetheless models male risk-taking and impulsiveness as entirely understandable and culturally logi-cal, given sufficient cause. *This* is just the way men are, the ad reminds us.

We wish to argue here that the use of negative themes in this ad, and others of its ilk, need not be construed as incidental or exogenous to the ad itself. Instead, we claim that to be fully appreciated, the ad as constructed actually *requires* the use of negative themes. Absent negative themes, the ad fails in its purpose. Thus, the negative themes expressed achieve a sense of narrative completion that could not be attained were positive themes substituted instead.

We hasten to point out that we don't intend to imply that only negative advertising can work "as advertised," so to speak. We merely believe that we can demonstrate that such a strategy is coherent, one among others that can be used effectively. Returning for a second to our overall sample of Bud Light ads, remem-ber that negative themes are approximately only half of the total sample; the remaining half employ other strategies, some of which include positive themes.

Yet imagine a simple thought experiment in the *Naked Guy* ad: substitute positive themes for negative and consider whether the reconstructed ad retains the flavor of the original. For instance, the husband could turn off the TV and go upstairs at a normal pace, happily acceding to her wish for sex. They could be seen at the end of the vignette climbing into bed and turning out the light, followed by the stock shot of pouring Bud Light. There could even be a kicker scene in which the fond couple murmur happily to each other, a little tipsy from the beer, but ready for intimacy.

Would this work? It sounds very much like the sort of ad that was so common in the 1950s and 1960s, except that the couple would have to be in separate beds. To pose the problem this way automatically invites a response that the placement of the *Naked Guy* ad would not be worth $2.5 million, it's just too darned lame; it lacks punch, creativity. We're reminded of the possibly apocryphal remark about the significance of violence in football: "Can you imagine 80,000 people filling a stadium to watch a game of touch football?"

To make this point more emphatically, we note that even Bud Light ads that *do* involve positive themes introduce some additional plot twists to enliven them a little, for example, the Bud Light *Auctioneer* ad (2008) in which the best man arranges for an auctioneer to perform his wedding so that he, the groom, and his

friends can get to the beer-drinking part of the celebration more quickly. Again, a sort of gender opposition is presented comparable to the *Naked Guy* ad: men crave beer, women desire satisfaction with their partners. Enter an auctioneer to demonstrate the groom's male competence in achieving his goal. Cute, but not as memorable, in our view, as the *Naked Guy* ad.

We now consider our broader sample of 15 Budweiser Light negative ads in light of the approach we've sketched above.

BUDWEISER LIGHT SUPER BOWL ADS (2002–2007): WHICH NEGATIVE THEMES?

So that we can offer a concrete analysis of our sample of Bud Light negative ads, we need first to identify the themes involved. Table 12.1 indicates the name and year of the ad and their primary and secondary negative themes.

We present this table with some equivocation. First, the ranking of negative themes is subjective: we simply tried to decide which theme seemed most important in each of the ads, then which theme was of secondary importance. Second, we also decided to rank at most two themes for each ad, since we found that few expressed three clearly discernible themes, perhaps a function of the brevity of the ads. Third, finding a stable set of names for the themes wasn't easy. For instance,

Table 12.1 Bud Light negative ads and their themes

Ad and year	Primary theme	Secondary theme
Naked guy (2002)	Violence	Embarrassment
How much? (2002)	Violence	Embarrassment
Bird handler (2002)	Chaos	Violence
Crab (2003)	Violence	
Barbecue (2004)	Violence	
Bikini wax (2004)	Violence	Embarrassment
Fergus (2004)	Violence	Betrayal
Desert island (2005)	Violence	
Parachuting (2005)	Embarrassment	Violence
While you were out (2005)	Betrayal	
Bear (2006)	Betrayal	Violence
Hidden Bud Light (2006)	Chaos	Violence
Rock, paper, scissors (2007)	Violence	Betrayal
Slapping (2007)	Violence	Embarrassment
Hitchhiker (2007)	Violence	

the violence in *How much?* (a woman hits a man with her foot, then her fist) is very direct, the violence in *Desert Island* is anger (two women harangue their male partner), the violence in *Parachuting* is only implied (a man leaps from a plane without a parachute), and the violence in *Hitchhiker* exists only on the level of a perceived threat (the driver picks up one hitchhiker—and putatively a second as well—despite their carrying deadly weapons).

Given these uncertainties, however, several clear patterns are evident even in such a small sample. We note, parenthetically and anecdotally, that were we to move beyond the sample of beer ads to look at other Super Bowl ads as well, we would find patterns very similar to those described here. It was this latter observation of the universe of Super Bowl ads, in fact, that originally spurred us toward a more systematic examination of a specific set of negative ads.

Some form of violence, however defined, occurs in all but 1 of the 15 ads; in 11 of the 15 ads, it is the dominant theme. In fact, since in the two ads where "chaos" is a dominant theme "violence" also ensues as a direct consequence, it would be just as reasonable to say that 13 of the 15 ads principally express violence.

By contrast "embarrassment" and "betrayal" are relatively weak secondary themes: in only two of the ads is betrayal the main theme, and in only one ad is embarrassment the main theme. However, either embarrassment or betrayal is presented as a typical accompaniment of violence: in eight of the ads where embarrassment or betrayal is present as a negative theme, violence also is a theme.

We accept the criticism that part of the pervasiveness of violence in our sample of ads is due to the flexibility with which we've used the term. Were we to become the victims of violence, we would certainly have a preference among its varieties, for example, angry shouting versus being struck in the head, slapping versus an attack with a chainsaw. Nevertheless, it's hard to escape the conclusion that what chiefly characterizes Bud Light negative Super Bowl ads is a persistent theme of violence in one or more of its many possible forms. These ads do not portray an innocent, placid universe!

BUDWEISER LIGHT SUPER BOWL ADS (2002−2007): WHY VIOLENCE?

According to the argument we presented earlier, the rationale for the use of negative themes rests with the need for such themes to be available as a driving force behind effective Bud Light ads. It follows, therefore, that we must also then argue that there is a special case to be made for the prevalence of violence as the premiere negative theme that appears in such ads. As we've reflected on ways to make this case, we lean towards a qualitative approach rather than a quantitative

one: while not disparaging the latter, we are more comfortable with the former at this stage of our inquiry.

Thus we now consider five Bud Light ads as a subsample that reflects varying degrees of violence. We've attempted to select ads in which violence is relatively nuanced, from implication to actuality. In addition, we've emphasized the more recent 2007 ads that contrast nicely in this respect with earlier ones. And finally, we consider in each case the structural link between gender competence or gender dominance and the thematic use of violence, embarrassment, or betrayal in the ad, since it's clear from the patterns we've described thus far that Bud Light ads are highly androcentric.

Violent Bud Light Ad #1: *Bird Handler*

The *Bird Handler* (2002) is one of the more fascinating negative ads of the entire series, in large part because of its broader implications. The vignette begins innocuously, though predictably in terms of a beer commercial, with two attractive women bracketing a man at a party. The man dispatches a hawk, which disappears and returns with a Bud Light for them to savor. When he sends the hawk out to fetch another beer, one of the women asks where the hawk gets the beers from. The man merely looks quizzical and says "I don't know." There is an immediate jump cut to an outdoor restaurant where the waiter is screaming "here it comes again!" while the diners scream and scatter, knocking over tables as they try to escape and hide from the swooping hawk. The stock shot of Bud Light being poured ends the vignette, then the kicker scene returns to the party where the hawk returns with a bra clutched in its talons. The man muses, "He's never done *that* before."

This commercial functions at two levels simultaneously, each informing the other. On the one hand, *Bird Handler* is a stereotypic beer commercial, where one competent male can readily attract two women, and it ends with gender opposition humor in which the male hawk, a doppelganger of its owner, has removed a woman's article of intimate apparel. On the other hand, the ad foregrounds the persona of the young man whose single-minded (even simple-minded) desire for beer leads him to pursue an apparently innocent hobby that causes fear and chaos on the streets, as people scramble desperately to save themselves.

We find it remarkable that this ad was aired at the Super Bowl immediately following the American 9/11 disaster, since it plays so closely upon that tragedy: the sidewalk scene is shot from the point of view of its victims, the hawk swooping down on them in an analogue of the planes that crashed into the tower. To make this ad palatable, however, the violence of the hawk's attack has to be muted by re-rendering it as gender opposition humor—like a panty raid—which everyone

"knows" to be a harmless prank. Another way of looking at the hawk's return in the kicker, of course, is to see it as a symbolic rape, though that interpretation is undercut by the blasé responses of the two women and the man who witness the hawk's plunder.

In other words, the violence in the ad is necessary on both levels, that of gender opposition and that of chaos in the streets, in order to make the joke especially poignant. Although it's clear how the gender opposition violence is reduced and managed, the ad requires several viewings to understand how the hawk's attack is rendered harmless: during the attack, a man crouching under one of the tables reaches up and grabs a Bud Light atop his refuge—yet another male whose need for beer overcomes his rational self, yet at the same time assuring the viewers that the violence in the streets isn't mortal.

Violent Bud Light Ad #2: *Parachuting*

The *Parachuting* ad (2005) offers another stereotypic beer commercial theme gone bad, as three men, presumably buddies, prepare to jump from a plane in a panorama of male risk-taking. The jumpmaster urges on his companions, and one of them roars in testosterone-fueled excitement before flinging himself from the plane's open hatch. At this point, the theme of embarrassment comes to the fore, as the second of the three buddies hangs back, afraid to leap despite his friend's repeated urging.

The jumpmaster produces an "ultimate" inducement, a six-pack of Bud Light, and throws it from the hatch. Unexpectedly, the pilot rushes from the cockpit and flings himself after the beer. Here a theme of implicit violence emerges and disappears in a flash, since we see that the pilot isn't wearing a parachute—he's going to die—but the ad is too preoccupied with its male embarrassment theme to take account of the pilot's imminent demise. His death goes unremarked in the context of the much longer and emotionally more fraught embarrassment of an incompetent male, since the increasingly tense verbal give and take of the insistent jumpmaster and the shrinking jumper dominates the ad. We note that this mutual blindness of the two remaining jumpers to the death of the pilot also underscores the ad's implicit assumption that a lust for beer overcomes all rational obstacles, including the normal wish to live.

By contrast, were the pilot to scream as he plummets to earth, or were either of the characters remaining on the plane to comment overtly on his unhappy end, the theme of violence would upset the emotional balance of the vignette. But like the second-story fall of the *Naked Guy*, we "know" that the pilot will somehow be okay.

The stock shot of Bud Light pouring helps to defuse the tension between violence and embarrassment by interrupting the scene, allowing it to be

reframed and biased towards the latter. The kicker scene focuses again on male embarrassment, as both jumpmaster and reluctant parachutist momentarily stare, dumbfounded, at the now-empty cockpit and at each other. The jumpmaster then leaps from the plane, abandoning his friend who pleads for him to "Wait!" The ad closes as the fearful buddy confronts his terrible dilemma: a pilotless plane versus a parachute jump that terrifies him. Note, please, that at this point the purpose of the pilot's leap is clarified: the pilot had to disappear from the scene to heighten the shamefulness of the reluctant jumper's symbolic emasculation. The reluctant parachutist is rightfully embarrassed, within the premise of the ad. Since he's afraid to take a risk, he's not sufficiently manly to *deserve* Bud Light—at least the pilot had the right stuff, however misguided he may have been otherwise.

We find it interesting that in this ad, as in the *Bird Handler* ad, violence has been entirely trivialized in the service of the vignette's smooth denouement. In other words, there is nothing special about violence. It's simply another tool, a routine enticement, wielded in the visual "contract" between Anheuser Busch and its viewer/consumers. In this ad, too, violence is available for the ad's purposes precisely because it has been sanitized, represented as inoffensive.

Violent Bud Light Ad #3: *Slapping*

Slapping (2008) is the first of our final three ads, all drawn from the 2007 Super Bowl. These last three ads bring into sharp relief the theme of violence, in particular, how closely that theme is connected to the problem of male dominance.

The Bud Light ad *Slapping*, like the *Bird Handler*, works on two levels. The opening of the vignette portrays three buddies—two White, one Black—hanging out in a pool hall. When one of the White men tries to "fist bump" the Black man, the latter informs him that "fist bump is out." When his White friend asks what's "in," he's told that a light face slap has replaced the fist bump. The Black man then demonstrates the face slap and takes one in his turn. The three men laugh as they slap each other on the face. The racial interplay here is interesting in itself, since the Black man is identified as the arbiter of fashion, and although two White men slapping around a Black man would be politically unacceptable violence, the spectacle of a playful face slap initiated by the Black man makes the racial implication tenable in the same way that the hawk's return with the bra downplays the symbolic rape that must have preceded it. These men are equals, though the difference between a slap and—for instance—a hug suggests that even among male friends, violence is at least symbolically available at any moment as a component of their interaction.

The vignette then switches levels. It employs a collage of jump cuts to show face-slapping in a wide variety of public situations, from sporting events to weddings. There's an ambiguity about the slapping that makes the violence more problematic, since the viewer is uneasily aware that some of these scenes involve real, not mock anger. However, the violence is kept somewhat under control by its symmetry: men slap only other men, women slap only other women, and reciprocal slappers are always apparently of the same race or ethnicity. Again, the viewer is encouraged to perceive interpersonal violence as a mundane phenomenon, not to be taken too seriously even in situations where it seems unlikely that the participants will be sharing a Bud Light at any time in the near future. The more intense the slapping, in fact, the more we sense the contrast between how people usually behave face-to-face under civilized circumstances, and the irrationality that presumably seizes all who desire Bud Light.

The kicker, however, demonstrates what the ad already "knows," that the slapping scenes may forebode a costly social blunder. As a young man and his boss emerge from a meeting, the boss congratulates his employee on "saving the account," whereupon the younger man rewards his boss with a celebratory slap. At once a new opposition comes rather starkly into play: boss-employee relationships cut across male-male ties, and the former outweigh the latter in significance. Violence in pursuit of beer can apparently escalate from situations such as hanging out with your friends in which it is tolerated, or even preferred, then to public situations where it is less obviously appropriate, finally to fateful situations where violence constitutes a mortal gaffe. The struggle for masculine dominance, like the Super Bowl itself, produces winners and losers, as well as the occasional beer.

At the same time that the ad suggests that violence—as in the *Bird Handler* sequence—connotes public disorder, it fails to offer a contextual remedy to remind us that everything is really okay, that the young guy won't be fired, that his boss will say that he appreciates the male camaraderie. In short, we seem to have moved from earlier Bud Light ads where the producers felt reassurance was appropriate and even necessary on this score, to an ad in which the violence portrayed seems to be glorified in and of itself via a series of jump cuts. The only limitation placed upon the violence of the ad is that it must be violence among equals, that is, persons of the same age, race, and gender, a sort of symmetrical violence that defines and affirms existing structural cleavages. Only when existing male hierarchies are threatened—the worker attacks his boss—is violence proscribed.

Violent Bud Light Ad #4: *Rock, Paper, Scissors*

In a similar vein, the Bud Light ad *Rock Paper, Scissors* (2007) doesn't trouble itself to disguise or mitigate the violence involved. Two young men at a wedding reach

for the last Bud Light at the same time and agree to play a "rock, paper, scissors" sequence to decide who gets to drink it. As they count out rock, paper, and scissors one of the men throws a missile at the other, hitting him in the head. The victim collapses on the ground, and the missile-thrower takes the Bud Light.

The victim says "I threw paper" (which should have made him the victor), but his opponent replies matter-of-factly "I threw a rock" as he walks away with the Bud Light. The stock shot of Bud Light pouring into a glass follows. In the kicker scene, the victim is still lying on his back moaning, one hand to his head, the other sticking up in the air. As a man walks past the prone guy, he slaps his hand and says "low five." The victim's male competence has now been ritually degraded.

The interesting thing about this ad, we think, is that like the *Slapping* ad, it's not very subtle. It's a straightforward morality play of sorts, in which an innocent male is depicted as a sucker who plays by the rules and is, as a result, defeated by another male. Although it's true that he's not lying there unconscious, he also isn't moving around as if nothing had happened, by contrast with the *Naked Guy*. He's obviously *really* hurt, and on top of it he lost the main prize, his standing in the male hierarchy. Also, both young men have—in their inordinate desire for beer—engaged in a competition that resulted in betrayal and injury.

By contrast, for instance, with *Parachuter*, the male in *Rock, Paper, Scissors* isn't behaving incompetently, he's not a timid male. By contrast with *Slapping*, male competence is one domain that hasn't been mistakenly transposed to another domain where it's inappropriate: remember that this occurs at a backyard party. What has happened here is that the standard male competence involved in competing according to accepted rules of public conduct has been overwhelmed by an even greater male competence of engaging in violence to get what is wanted. Commoditization trumps civility. The essential meanness of this ad is unmistakable, for all that it's meant to be humorous.

Violent Bud Light Ad #5: *Hitchhiker*

Our final example, *Hitchhiker* (2007) nicely summarizes the violence theme we have explored in these ads, even though there is—strictly speaking—no actual violence in the ad itself. It also clarifies the important link in Bud Light ads between violence and masculine struggles for dominance.

The ad is shot almost entirely in shadows, beginning with a car moving through a dark landscape. Throughout the ad, only the faces of the driver and his girlfriend are lit, emphasizing the contrast between the safe haven of the car (or at least of its front seat) and the forbidding world outside. The driver slows down for a hitchhiker, preparing to give him a ride because "he has Bud Light." His girlfriend protests, pointing out that the hitchhiker is carrying an axe, which

she interprets as a sign of likely violence, an obvious cue for anyone who watches slasher movies. When the driver asks the hitchhiker why he's carrying an axe, the hitchhiker hesitates, then comes up with the implausible excuse that he uses it as a bottle opener. To the goggle-eyed horror of his girlfriend, the driver tells the hitchhiker to hop in. As usual in these ads, the male passion for Bud Light overwhelms normal standards of reason and prudence.

The stock shot of pouring Bud Light follows, and in the kicker scene the driver is slowing down again to pick up another hitchhiker with Bud Light. This time, however, it's the first hitchhiker, sitting in the back seat, who demurs, "He's got a chainsaw!"

In *Hitchhiker*, the hero is exercising his male prerogative to drive himself and his woman friend, an act of competence belied by his innocence in the face of imminent danger (unlike *Parachuter*, we are not invited to perceive the driver as a conscious risk-taker). The driver is another guy who plays by the rules, but the viewers share the perspective of the woman friend who knows that this will lead to disaster. In other words, this ad combines some aspects of *Slapping* and some of *Rock, Paper, Scissors*. The violence is only prospective, not actualized, but commonsense tells us that this vignette will not have a happy ending.

The ad itself functions mainly on an intimate level of the relationship between the driver and his female passenger but shifts, in the kicker, to include the first hitchhiker as a companion. We find it intriguing that an ad that is so "dark" both cinematically and narratively is relieved slightly by the inclusion of an outsider— the first hitchhiker—who throws in his lot with the pair in the front seat against an even more dangerous-seeming outsider, the second hitchhiker. Although we are invited to see the first hitchhiker as salvageable, not entirely beyond moral redemption, we are also being warned that the second hitchhiker will not prove to be quite so benign. In other words, the ad offers narrative relief only to snatch it away again at the end. Another way to look at it is that the ad presents an escalating series of assertions of male dominance, starting with the driver of the car, then succeeded by men with progressively more dangerous phallic weapons, first an axe and then a chainsaw. The woman, as in *Naked Guy*, is just a passive bystander unable to influence any of the males or to deflect the mayhem that will surely follow.

Is *Hitchhiker* a paradigm of Americans in a dangerous world? It's tempting to see it this way, particularly by contrast with *Bird Handler*, where the 9/11 disaster is commodified in such a way as to render it relatively inconsequential (merely a rape). But what began so ingenuously at a party in *Bird Handler* in 2002 has now become, in the dark landscape of *Hitchhiker* in 2007, far less so. According to Anheuser Busch, there really are villains out there, and violence is often simply the result of being a man who plays by the rules when other men do not.

These five examples suggest a fairly broad range of meanings of "violence" in Bud Light advertising. We surmise that the prevalence of violence in negative ads may be due to its particular quality of malleability, a potential for harm that inheres in every male encounter despite our efforts to see them instead as humorous.

By the same token, Bud Light ads do not attempt to sell happiness, love, or the personal transformation contemplated by Berger's formula. In this respect, they resemble many other Super Bowl ads. And that leads us now to our conclusion.

CONCLUSION: BUD LIGHT AND THE UNIVERSE OF NEGATIVE SUPER BOWL ADS

We have argued that negative themes are so integrally embedded in the narrative structure of the Bud Light ads that in some dramatic sense, the ads would be incomplete or insufficient in the absence of violence, embarrassment, betrayal. These negative themes have in each case been inextricably linked to the presence in Bud Light vignettes of various forms of struggle among males to assert their superiority either by actively overcoming their male rivals through violence or betrayal, or else by allowing us to witness the embarrassment of males who have been revealed as less than fully competent at routine male pursuits.

First, if we remain within the empirical domain of Bud Light commercials, a comparison between negative ads and positive (or neutral) ads strongly suggests itself. For instance, there are more than a few sexist Bud Light ads that involve positive or neutral themes.

Second, even when we move from Bud Light ads to other ads aired at the Super Bowl, we note that the year 2007 was especially rich in negative advertising: for instance, Doritos, Sierra Mist, Quatro Science, CareerBuilder, Sprint, General Motors, and FedEx all produced at least one negative ad, and some more than one. We found CareerBuilder's *Office Jungle Fight* and *Office Torture* ads to be especially notable in this regard, and the General Motors *Robot* ad amazingly depressing. Though many of these ads contain the same element of masculine struggle for dominance that is ubiquitous in Bud Light ads, not all do.

Third, we chose to emphasize televised ads in large measure because they were associated with the Super Bowl and must, therefore, assume pride of place as the most visible and most celebrated (as well as the most expensive) advertising. A comparison with print media and online advertising might well be of interest: it is our strong impression that negative ads are far more prominent

in full-motion video than in magazine art, perhaps because negative themes are inherently more "televisual"—that is, amenable to the narrative movement that is the peculiar advantage of TV—but this connection remains to be elaborated.

Finally, it would make sense to consider various models of the role of negative emotions in American culture and experience—for example, the "culture of fear" (Furedi, 1997; Glassner, 1999; Stearns, 2006), the "emotional labor" that the consumer performs (Hochschild, 1983; Leidner, 1993; Pierce, 1995), the loss of authentic self-realization in a commodified society (Illouz, 1997, 2007, 2008; Lasch, 1991)—to determine whether it may be possible to account for the prevalence of negative ads in this broader context. Even Bataille (1997) might be harnessed to the purpose: we think he would have argued that an ad represents a moment when rational bourgeois economy irrupts, inevitably, into excess or transgression. For Bataille (1997), the pleasure of the humor would occur simultaneously with its intimations of sexuality or violence, or both. We note with some reluctance that any such ambitious ventures would require quite a different methodology than we have adopted here.

We close on a personal note. Scholarly objectivity aside, we find the accumulation of negative ads somewhat disturbing, especially because they rely upon a fascination, an aesthetic, very nearly a fetishization of violence in everyday life. We are well aware that critical media studies have not been wholly successful in ascribing the American malaise reported in many recent public opinion polls to media representations of alienation and the erosion of public life. Yet it would be disingenuous of us to deny that there could be any connection at all, or to suggest that further research would fail to address the issues that arise merely because a satisfactory methodology is not immediately available.

As we reflect on the ads we have described, we think it's particularly striking that the males who desire beer to the exclusion of all other considerations are often portrayed by the Bud Light vignettes as apparently innocent victims of the violence that ensues. Yet as Boorstin (1961) has remarked, in advertising, such innocence is often itself disingenuous: "The deeper problems connected with advertising come less from the unscrupulousness of our 'deceivers' than from our pleasure in being deceived, less from the desire to seduce than from the desire to be seduced" (p. 211). These deceptions and seductions are a key part of each advertising vignette that we have examined. Thus the aestheticization of violence revealed in these ads may point to a much deeper structural connection in consumer culture between deception and seduction, persistent desire and unrelenting conflict. This also, for us, evokes an intriguing venue for future investigation.

REFERENCES

Bataille, G. (1997). Sacrifice, the festival, and the principles of the sacred world. In F. Botting & S. Wilson (Eds.), *The Bataille reader* (pp. 210–219). Oxford, UK: Blackwell.

Berger, J. (1972). *Ways of seeing*. London: Penguin Books Ltd.

Bird handler. Retrieved March 29, 2008, from http://www.ifilm.com/video/2419140/collection/18376/minisite/superbowl

Boorstin, D. J. (1961). *The image: A guide to pseudo-events in America*. New York: Atheneum.

Brader, T. (2006). *Campaigning for hearts and minds: How emotional appeals in political ads work*. Chicago: University of Chicago Press.

Furedi, F. (1997). *Culture of fear: Risk-taking and the morality of low expectation*. London: Cassell.

Glassner, B. (1999). *The culture of fear: Why Americans are afraid of the wrong things*. New York: Basic Books.

Hitchhiker. Retrieved March 29, 2008, from http://www.ifilm.com/video/2819735/collection/18373/minisite/superbowl

Hochschild, A. R. (1983). *The managed heart: Commercialization of human feeling*. Berkeley, CA: University of California Press.

Illouz, E. (1997). *Consuming the romantic utopia: Love and the cultural contradictions of capitalism*. Berkeley, CA: University of California Press.

Illouz, E. (2007). *Cold intimacies: The making of emotional capitalism*. Cambridge, UK: Polity Press.

Illouz, E. (2008). *Saving the modern soul: Therapy, emotions, and the culture of self-help*. Berkeley, CA: University of California Press.

Lasch, C. (1991). *The culture of narcissism: American life in an age of diminishing expectations*. New York: Norton.

Leidner, R. (1993). *Fast food, fast talk: Service work and the routinization of everyday life*. Berkeley, CA: University of California Press.

Mark, D. (2007). *Going dirty: The art of negative campaigning*. Lanham, MD: Rowman & Littlefield.

Naked guy. Retrieved March 29, 2008, from http://www.ifilm.com/video/2419144/collection/18376/minisite/superbowl

Parachuting. Retrieved March 29, 2008, from http://www.ifilm.com/video/2664043/collection/18379/minisite/superbowl

Pierce, J. L. (1995). *Gender trials: Emotion lives in contemporary law firms*. Berkeley, CA: University of California Press.

Rock, Paper, Scissors. Retrieved March 29, 2008, from http://www.ifilm.com/video/2819647/collection/18373/minisite/superbowl

Slapping. Retrieved March 29, 2008, from http://www.ifilm.com/video/2819694/collection/18373/minisite/superbowl

Stearns, P. N. (2006). *American fear: The causes and consequences of high anxiety*. New York: Routledge.

Promotion AND Prevention OF Drinking IN U.S. College Sports

CHARLES ATKIN

WALTER GANTZ

INTRODUCTION

This chapter examines the intersection of alcohol, college sports, and media campaigns. Some types of media messages, notably televised beer commercials, can contribute to higher consumption and problematic drinking in the campus setting. On the other hand, there is an increasing array of prevention messages seeking to advance responsible drinking practices among collegians; these are primarily sponsored by college organizations and secondarily by the alcohol industry.

The presentation focuses on four key topic areas. First, we examine a variety of issues related to beer ads and televised sports. The second section describes the content of TV ads in college and professional sports telecasts, which have potential to influence the drinking patterns of student viewers. Third, we shift the analysis to prevention efforts on campus, summarizing national data and presenting a case study of the problems and solutions at one specimen university. In the final section, we discuss the role of industry-sponsored prevention messages designed for younger age groups, assessing both beneficial and counterproductive approaches.

ISSUES INVOLVING TV BEER ADS IN SPORTS PROGRAMMING

Although most young people don't begin drinking until they become teenagers, most are quite aware of alcohol ads on television well before adolescence. First graders can recognize and identify 200 brand logos and trade characters (Gotwals et al., 2005), and children aged 9 to 11 were more familiar with Budweiser's frogs than Kellogg's Tony the Tiger (Leiber, 1996).

Interest in sports programming also begins at a young age, as a majority of youth between ages 7 and 18 watch sporting events on TV; the prevalence of sports fandom is much higher among youth than adults, with 29% of kids claiming to be "die-hard fans" of NBA games (compared to 14% of adults), and the most avid fans of the NFL profess to have followed their teams on TV since the age of 12 (Center on Alcohol Marketing and Youth, 2003). Fully 88% of young males watch televised sports, while 73% of young females are viewers.

There is a correlation between sports fandom and alcohol consumption; fans drink more frequently and are more likely to be "binge drinkers" (Nelson & Wechsler, 2003). Universities that are deemed to be "sports schools" have higher rates of binge drinking and negative consequences such as being assaulted (Wechsler et al., 1995, 2000).

The alcohol industry spent $5.7 billion to place approximately 1.4 million commercials on television between 2001 and 2006; expenditures increased 27% over this period, which lead to a 30% increase in alcohol ad exposure (Center on Alcohol Marketing and Youth, 2003, 2007). About three-fifths of the TV spending is typically allocated to sports programming (Center on Alcohol Marketing and Youth, 2003). Collegiate sports telecasts attract a higher proportion of advertising devoted to alcohol products (4.5% of all ads) than do non-sports TV programming where 1.7% of all ads are for alcohol. The proportion of ads devoted to alcohol varies from sport to sport; during 2001, for example, 1 in 12 commercials during soccer games were for alcoholic beverages, 1 in 14 for hockey games, 1 in 15 for professional basketball games, 1 out of 21 for baseball games, and 1 out of 25 for college basketball games (Center on Alcohol Marketing and Youth, 2003). Beer commercials are prominently showcased in the annual Super Bowl football game, which is the most heavily viewed sporting event among all age groups; the dominance of Anheuser-Busch ads within the Super Bowl context is regularly demonstrated in high rankings of liking for these ads.

Television networks, the NCAA, and the beer industry offer a variety of established and evolving guidelines on the use of alcohol advertising. Many of these guidelines deal with the way in which alcohol use is presented as well as the age of characters depicted in the ads and the age of audiences viewing the programming carrying the ads. For example, NBC does not permit ads that: promote the use

of alcohol products as a "mark of adulthood"; equate alcohol with sodas and fruit drinks and are pitched in ways that would be particularly appealing to those under the legal drinking age; or that use well-known athletes or stars in the entertainment arena who primarily appeal to persons under 21 (NBC, 2001). Brewer advertising codes indicate that the messages should not portray use of their products by those underage and should not portray alcohol as necessary to achieve personal/social goals; drinking should be presented in a responsible way (not consumed rapidly, excessively, or involuntarily) (Beer Institute, 2006). Other guidelines focus on ad limits associated with specific programs. For example, ESPN permits beer and wine ads on most sports programming, except for the X Games and Little League World Series (and any other content targeted at those under age 17) (ESPN, 2005). Alcohol ads are banned on the newly launched Big 10 Network (Center for Science in the Public Interest, June 29, 2006), and the NCAA allows no more than 60 seconds of beer advertising per hour of sports programming or more than 120 seconds total in any telecast or broadcast (NCAA, 2006). (Anheuser-Busch Companies, 2008a; Center on Alcohol Marketing and Youth, 2007; Center for Science in the Public Interest, 2008).

Leading NCAA coaches have sought to restrict alcohol ads in TV programming featuring collegiate teams. An open letter to Congress in 2004 from Dean Smith, John Wooden, Rene Portland, Joe Paterno, and Jim Calhoun stated that "Advertising alcoholic beverages during college sports telecasts undermines the best interests of higher education and compromises the efforts of colleges and others to combat epidemic levels of alcohol problems on many campuses today" (Gotwals et al., 2005). The Center for Science in the Public Interest sought to convince colleges to sign The College Commitment, which features a prohibition of alcohol ads during televised collegiate sports events. The document was signed by officials of more than 250 schools, including major athletic institutions such as Ohio State, Minnesota, Florida, Maryland, North Carolina, and Northwestern (Center for Science in the Public Interest, 2008).

Many adults are concerned about the extent and nature of alcohol advertising, including the amount that is seen by those under 21, and the presentation of certain appeals such as the sexist portrayal of females in these ads. In 2006, 6% of all TV alcohol ads were aired on programs that attracted audiences composed of more than 30% underage viewers, compared to 12% three years earlier prior to the adoption of industry guidelines (Center on Alcohol Marketing and Youth, 2007). When young people are asked which alcohol ads are aimed at their age group, they most often mention spots that portray youthful characters, depict "cool" people participating in extreme sports, and feature rap/rock music (Chen et al., 2005). Male adolescents respond more positively to TV beer ads placed within a sporting context than in non-sports programming (Slater, 1997).

Critics assert that beer ads link alcohol and sexuality. While males are more likely to appear in beer ads than females, bodyisms (portrayals of bodies and body parts) are more likely for the female characters (Hall & Crum, 1994), and there are negative stereotypes of females such as Stroh's Bikini Team (Rouner et al., 2003).

There are widespread negative opinions about beer commercials in TV sports, according to a 2003 national survey of adults sponsored by Center for Science in the Public Interest. Nine out of ten respondents perceive that beer ads in sports telecasts reach a significant number of teenagers. Half of the adults believe that viewing these beer ads increases the chances that teenagers will get into trouble with alcohol. Moreover, two-thirds of all adults believe that airing beer commercials on college sports programs is inconsistent with the mission of colleges and universities; more than four-fifths say the ads are not in the best interest of higher education. Regarding restrictions, the survey shows that 71% of adults support a ban on all alcohol ads on televised college games and 87% of adults support requiring equal time for counter-ads about drinking risks (Center for Science in the Public Interest, 2003).

CONTENT ANALYSIS OF BEER ADVERTISING IN COLLEGE VERSUS PROFESSIONAL SPORTS

To consider the extent and nature of beer advertising on college sports and to see if it differed from that on telecasts of professional sports, we recorded a total of 35 NCAA men's basketball and NBA basketball games that were played over a three-week period in February 2008 and examined all of the beer ads (n = 67) aired during those games. The games were aired on seven networks (ESPN, ESPN2, ESPNU, TNT, Big Ten Network, ABC, and CBS) and featured ads for eight beers (Budweiser, Bud Light, Coors Light, Corona Extra, Guinness, Heineken, Miller Lite, and Samuel Adams).

The 67 beer ads actually reflected 21 different creative executions. Nine of the ads ran more than once; this is not surprising, given the limited time period we selected. What was surprising, though, was that one ad, for Miller Lite, ran 26 times, seemingly having blanket coverage across these games. No other single ad aired nearly as frequently; the second most frequently aired ad was shown 8 times.

Two-thirds of the games we recorded featured college teams. Despite that, 60% of the ads were shown on the pro basketball telecasts. Every pro basketball game featured at least two beer ads; 82% of the games had more than two ads. On average, we spotted 3.6 beer ads per NBA game out of an average of 79 ads for all products that appeared per game. On the other hand, 46% of the college games

we recorded did not have any beer ads. Across all college games, we found an average of 1.1 beer ads per game out of an average of 55 ads for all products that appeared per game. This isn't to say beer ads were used quite sparingly during college games: One college game had five beer ads; an additional three college games had three beer ads each. Nonetheless, the amount of time devoted to beer ads during college games appears to be consistent with NCAA expectations. (As noted earlier, the NCAA will not permit more than 120 seconds of beer ads in any single game. The five beer ads featured in one college game did not exceed the NCAA's 120 second limit: two were 30-second ads, two were 15-second ads, and one was 20 seconds long.) Since beer manufacturers advertise their products more liberally during professional basketball games, they are showing restraint with college games or, perhaps more likely, are simply working within the strictures of the networks airing those games.

Most (85%) of the beer ads were 30 seconds long, the length of the typical television ad. The remaining ads were 15 or 20 seconds long. Most (66%) used a humorous rather than a serious hard-sell approach. This soft sell approach is consistent with recent Super Bowl ads and is likely to reflect the preferences of the target audience that views sports events.

A large majority (82%) used human actors or real life settings; the other ads were completely or partially animated. Close to half (42%) included at least one animal in the ad. It should be noted, though, that 26 of the 28 ads that included an animal were the same—an ad for Miller Lite that featured a good number of Dalmatians running down the street after a Miller Lite truck, an obvious dig, for those who know beer ads, at Budweiser and their use of Clydesdale horses and a Dalmatian. In case the comparison was not clear, the message "Miller Lite has more taste than Bud Light" was printed on the back of the truck.

The ads were situated in seven different settings. A plurality (40%) were in the streets (all but one featured the Dalmatians). The other locations included stadia (13%), bars (9%), breweries (9%), homes or apartments (9%), and the countryside or beaches (5%). None of the ads suggested the setting was at a college or in a dorm room. This pattern may reflect brewer decisions to not limit the applicability of their ads—or their conformance to self-regulatory, industry constraints. Roughly 13% of the ads' settings were depicted in animated, imaginative spaces. Two ads illustrate this. In an ad for Guinness, a good number of animated people wearing race car driver-like outfits fly around, energetically hitting drums and making lively sounds. The space turns out to be within a glass of the beer. The animated space for a different ad looked like a stage or broadcast studio and featured an animated robotic woman wearing revealing clothes and demonstrating the freshness of Heineken keg beer along with two women (duplicates of the first woman and wearing the same revealing clothing).

All of the ads featured people; 58% of these beer ads had three to five people, and 33% had at least 10 people. In short, beer ads do not spotlight loners or those apparently isolated from other human contact. Not all of the people featured, of course, were major characters in the ads. Indeed, 60% of the ads focused on one character who had a major role in the ad. Perhaps with an eye toward their primary target audience, 70% of the ads featured only males as the major actors. Only 6% of the ads we watched featured only females in starring roles. The remaining ads either had an equal mix of male and female leads or more male than female actors.

Coders offered rough estimates of the age of the major characters. They appeared to range in age from their 20s to their 50s; 60% were coded as being in their 20s with an additional 19% in their 30s. None of the major characters looked like they might be under 20. The breweries and their advertising agencies appear to have carefully addressed the age issue raised by those worried about promoting underage drinking.

After examining a number of beer ads and considering the content in beer ads that have aired in the past few years, we developed 10 categories that captured the persuasive appeals used in these ads. These were: taste; refreshing; calories/less filling; good times with friends; attributes of the beer/how it is produced; fresh/not old; way to attract/meet/do well with people of the opposite sex; drink responsibly; good thing to have when enjoying life; company doing good things/deeds such as helping people/the community; and other. We coded primary and secondary persuasive appeals. Every ad featured a primary appeal; it was the longest or most focused persuasive argument offered. Secondary appeals needed to represent a different argument and had to be more substantial than a fleeting comment or visual. As noted below, a good number of ads ended with a super that called on viewers to "drink responsibly." Unless that message was integrated into the ad beforehand, those were not counted as secondary appeals.

More often than not, the primary persuasive appeal focused on the product: 39% stressed the beer's taste, and an additional 31% highlighted attributes of the beer or the way it was produced. One in five ads (21%) focused on their brand of beer as a good thing to have when enjoying life. Three ads illustrate this appeal: In the first, a man in his 30s has a really good time watching a sports game in a stadium. After the game, he wants to finish his fun day with a drink of beer. When he is about to get to the beer stand bar, the place is shuttered, much to his obvious disappointment. The second example takes place at a wine and cheese party hosted by a woman in her early 20s, A number of young men come with Bud Light beers placed inside faked packages (e.g., a big cheese and a baguette). While women are enjoying the wine and cheese party in the living room, the men have fun in the kitchen drinking beers while watching a sports game on a

portable television set which one of the men brought, disguised as a wine box. Finally, a young couple enjoys a nice and quite vacation on a beach. The camera slowly zooms in to the two bottles of Corona Extra beer that are on a small table between the couple.

An additional 5% of the ads suggest their beer might help the viewer attract/meet/fare well with people of the opposite sex. Three examples here: The first ad takes place at a party in a young woman's apartment. Two young men arrive at the same time, one bringing Heineken and the other, nothing. At the door, the man who came empty-handed takes the other's beer, as if he brought it. Women at the party surround him as he demonstrates how to open the beer while the other man stands alone. In the second ad, a group of Asian, Hispanic, and black men at a bar try to pick up women using a variety of well-worn clichés. All of them fail. Eventually, they see an Asian man with a strong accent win a woman over, apparently just by offering a Bud Light. The final illustration features a man and woman having dinner in her apartment. The voice-over says that Bud Light recently added the ability to breathe fire to the list of the abilities that people could possess through drinking Bud Light. The man lights two candles on the table with a gentle, focused breath and charms his companion. However, at that moment, the man has an allergic reaction to the woman's cat and starts to sneeze, blowing fire everywhere. The next scene shows the apartment, the woman, and the cat full of soot. The ad ends with a voice-over noting that Bud Light no longer offers the ability to breathe fire.

One ad focused on drinking responsibly. In this 15-second spot, the major actors (animated men) come out of a bar, say goodbye to each other and watch as one of them catches a taxi. The voice-over says, "Drink responsibly, get home safely."

A small number of ads (n = 11) featured a secondary appeal. These focused on the attributes of the beers being promoted as well as the ways in which the beer was a good product to have when enjoying life. While it did not rise to the level of a primary or secondary appeal, 53% of the ads mentioned or superimposed "Drink responsibly." Such notation is in line with NCAA expectations that these ads incorporate the "drink responsibly" message.

Because beer ads have been linked with the presentation of women as sex objects, we included seven measures that related to sex. Coders felt that four ads (6%) presented women as sex objects. As it turns out, this reflected one ad aired four times in the games we recorded. The ad featured a robotic woman wearing revealing clothing, akin to a swim suit, to demonstrate the attributes of Heineken keg beer. The ad suggests the beer is very fresh by featuring a scene where the beer seems to come out of the woman's breasts. The ad was described by Advertising Age columnist Garfield (2007) as "arguably the most sexist beer commercial ever produced."

None of the ads featured ogling, although women were seen as the objects of men's interest and desire in three different ads. The reverse was never encountered. Finally, when a voice-over was used (n = 15), it was always a male's voice.

Because we felt there might be content differences between beer ads aired on the college games and those aired during NBA games, we compared the two groups of ads. In many respects, the ads were quite similar. For example, a majority of the ads were for light beers (Miller Lite for the pros, Bud Light for college); most of the ads were 30 seconds long; most relied on real action rather than animation; most relied on males to play the major actors in the ads.

Differences did emerge, though. Here, we'll describe trends that would be worth examining with a larger and more representative sample of ads. Beer ads on college games were more likely to use humor (74 to 60%) but less likely to include animals (26 to 53%). Beer ads aired during NBA games were more likely to be set in the streets (53 to 22%). In contrast, one-third of the beer ads on college games were set at stadiums (33 to 0%).

Ads during college games included more people. Over half (56%) of the college game ads featured at least 10 people; for the pro games, 68% featured between 3 and 5 actors. Similarly, beer ads during college games tended to have more major characters: 48% of the ads had at least two whereas 68% of the ads on the NBA had one major actor. Surprisingly, the major actors in the NBA appeared slightly younger than those in the college games: 80% of the actors in the NBA ads were coded as in their 20s. For college games, 48% were evaluated as in their 30s, with 30% in their 20s.

The persuasive appeals differed as well but were in line with the number of people in the ads and, perhaps, with beer manufacturers' understanding of the somewhat differing interests of younger and slightly/somewhat older adults. For the pro games, the focus was on the beer: 53% of the ads addressed the beer's taste; an additional 33% described other attributes associated with the beer; 10% of those ads relied on the appeal that their beer was a good thing to have when enjoying life. In contrast, 37% of the college ads emphasized how their beer was a good thing to have when enjoying life. One 15-second ad aired during college games focused on drinking responsibility (and was described earlier). None of the ads aired during NBA games used this responsible drinking theme as its primary appeal. The Heineken ad that objectified women only ran during NBA games. However, the two ads where women were seen as the objects of men's interest aired during college games. This, too, seems consistent with the increased importance of social settings in ads aired during college games.

PREVENTING DRINKING PROBLEMS ASSOCIATED WITH
COLLEGE FOOTBALL AND BASKETBALL

Student drinking problems associated with sports events plague hundreds of campuses across the United States. Before presenting an in-depth examination of one campus, results from a national survey of college students will provide a broad overview of their behavior and attitudes about campus sports events. The survey was conducted by Harris Interactive for Anheuser-Busch in May 2007 (Anheuser-Busch Companies, 2008b). It should be noted that the 1,038 respondents were of a minimum age of 21, so more than half of the college-age undergraduates were excluded from the defined population. To further qualify for the survey, respondents must have attended a football or basketball game on campus within the past year.

Almost 90% of the national sample state that sports is an integral part of college life. Fully 70% of students attending home football games typically tailgate or party before the game, and those who are drinkers are much more likely than nondrinkers to attend these pre-game gatherings. Alcohol is consumed by 76% of attendees, and 83% of those who were drinking alcohol claim that they do so responsibly and in moderation. Nearly all students who attend these gatherings feel safe, and 88% look out for their friends to avoid problems.

In the stadium or arena, 10% of students report fighting with other fans at most games they have attended; 11% report throwing beverages and other items onto the field or arena floor. Regarding destructive behavior, 6% report that they had participated in rioting after games, 6% report destroying city or school property, and 5% report destroying others' personal property.

There are two other notable findings from the national survey. After attending football games, 58% say they go to post-game parties at friends' houses or bars, where 83% of these students consume alcohol. To travel safely on game days, 75% have utilized alternate modes of transportation, such as a designated driver, a cab, bus, train, or metro. Indeed, 54% report that they've been driven home by a designated driver.

Michigan State University is well positioned for a case study for three reasons: it's a typical large, state university with showcase Division I football and basketball teams , there's a decade-long series of "unfortunate events" surrounding sports and alcohol, and significant investments have been made to combat celebratory problems via mediated prevention campaigns as well as policy initiatives.

The alcohol-and-sports incidents began with a football-related riot late in the spring semester of 1998. University officials sought to reduce the rather ordinary excesses of student tailgating by announcing that in the fall it would close the

prime tailgate location near the football stadium (a site where raucous behavior could be readily observed by respectable alumni and donors). This led to major riots protesting the prospective closure. In each of the following two years, sports-related street riots occurred at the end of NCAA tournament runs by the MSU basketball team (an isolated reprise of tournament rioting also occurred five years later). During the turn-of-the century period, the university repeatedly ranked high on the Princeton Review's annual list of "party schools."

The initial spate of problems led to a number of restrictive policies combined with prevention campaigns. A team of communication researchers collaborated with health center specialists to design media messages targeted to the student population. With the support of grants from the U.S. Department of Education, the National Social Norms Research Center, and the Anheuser-Busch Foundation, the campaigners have been able to disseminate an extensive array of messages in each of the last eight years. The central thrust has been prevention of extreme "celebratory" drinking, and the key persuasive strategy utilizes the social norms marketing approach. Celebratory drinking and related misbehavior tend to focus on home football games and televised NCAA basketball tournament games as well as on non-sports holidays such as Halloween, St. Patrick's Day, and spring break. The strategy is to correct exaggerated misperceptions of the proportion of students who drink on these special occasions and the amount of alcohol consumed by describing accurate percentages and quantities based on large-sample campus surveys of alcohol consumption patterns. The normative data constitute an incentive to drink moderately (or to choose not to drink) in accordance with the responsible majority, rather than perceiving more extreme drinking as widely practiced.

The various stages of the overall campaign have been regularly evaluated via semiannual online surveys with more than 1,000 randomly selected students. First, the questionnaire asks about everyday and celebratory drinking patterns and protective behaviors. These survey data produce normative information to be cited and presented in subsequent messages. There is also a lengthy section for measuring responses to 8 to 12 messages that appeared during the prior two months.

The 2005 survey finds that the prevalence of drinking is indeed greater on home football gamedays, when 38% of all students report consuming an average of 6.7 drinks of alcohol. This compares to just 23% who consume an average of 5.4 drinks on a typical nongame Saturday. Among the drinkers, the rate of drunkenness is higher too: 50% get drunk (56% for games against in-state rival Michigan), compared to 39% on a typical Saturday. It should be noted that drunkenness rates are higher on St Patrick's and Halloween celebration days.

Fully 76% of MSU students tailgated at one or more of the six home games in the 2005 season; on the other hand, it should be noted that only 17% participated

in tailgating at most games (four, five, or all six). The mean number of tailgating occasions is a rather moderate 1.8 per year. For college students, the two primary forms of tailgating include gathering very early in the day at off-campus houses and apartments (and occasionally bars), and later at outdoor locations near the football stadium. At Michigan State, 40% of the students started the game day with off-campus tailgating at least once in the football season, but only 9% did this prior to a majority of the home games. Almost all of those early off-campus drinkers subsequently participated in on-campus tailgating.

In addition, 47% participated in drinking games at least once during the tailgate season. Many practiced protective behaviors that tend to reduce drunkenness and harm, such as eating food (90%), staying with the same group of friends the entire time (85%), drinking only one kind of alcohol (54%), arranging for a designated driver (48%), and keeping track of the number of drinks (44%). However, far fewer report setting a limit (21%) or maintaining a pace of one drink per hour (22%).

The heaviest consumption and problematic behavior tend to occur when MSU is hosting arch rival University of Michigan. In 2005, the survey found that 48% drank on the day of the Michigan game, averaging almost 7.8 drinks in total. Most of the student sample overestimated the proportion who drank on that day; the typical respondent calculated that 70% of all students consumed alcohol and that 50% got drunk.

Fully 87% of all students reported that they watched the big game. It is interesting to note that that the survey showed more students watched the game on TV (49%) than in the stadium (38%); almost all of the TV viewing occurred at home or at a friend's home (46%) rather than a bar (3%). Given the limited allotment of student seats in many college stadia, it's likely that this greater prevalence of TV viewing rather than spectatorship is a widespread phenomenon.

The MSU prevention campaign emphasizes the goal of moderating the quantity of alcohol consumed at tailgates, rather than seeking to discourage attending tailgates. The vast majority of on-campus tailgaters drink alcohol; among the drinkers, the median quantity consumed is 4.5 drinks and the mean is 5.4. These descriptive data provided the basis for subsequent social norms messages. In the form of posters, newspaper ads, or table tents, these messages are disseminated widely to the student body in several waves each fall semester. There are numerous creative variations in the form and content of message executions, but a consistent feature is the presentation of survey-based statistics that focus on game day behavior.

The first example is a table top displaying the key lines "State vs. Michigan…Great Games, Great Students, Great Traditions." Citing the survey

of 1,213 students in a footnote, three large-majority percentage figures and one verbal description are presented: "Over 85% of MSU students report watching the MSU vs. UM football game each year"; "65% of MSU students drink moderately or not at all on MSU vs. UM game day"; "Of those who do choose to drink on game day, most do one or more of the following: Eat before or while drinking…Stay with the same group of friends for the entire day…Avoid drinking games….Stay with the same group of friends for the entire day"; and "74% of MSU students believe that individual responsibility keeps things peaceful during and after tailgates."

The second example is a more detailed flyer with the functionally plain key line "Michigan State Tailgating Information." Although there are no quantitative figures, social norm data are verbally characterized in the heading "Most MSU Students" followed by: "Spend some of their leisure time watching sports;" "Stay with the same groups of friends when they tailgate": "Consume 0–4 drinks when they party;" and "Tailgate (with or without alcohol) at MSU home football games." This is followed by a list of directive and persuasive appeals (e.g., respect that there are families on campus, pick up trash, drinking too much makes it tough to enjoy the whole game, do not urinate in public or risk arrest).

These two current examples are not the first ones designed to prevent tailgate problems; two earlier specimen messages also illustrate the approach. Several years ago, a poster depicting the marching band told the audience, "You remembered your Spartan shirt, the drinks, the Frisbee and the food. Remember to pace yourself when drinking…one drink per hour." An early newspaper ad portrayed students tailgating outside the stadium, accompanied by the headline "82% of MSU students drink moderately or not at all on football Saturdays"; a key point presented in the message is that most students do one of the four behaviors that were listed, including "pace themselves with one drink per hour" and "alternate alcohol and non-alcoholic beverages."

Post-campaign measurement of audience responses indicates that all four of these current and previous tailgate messages are well received. On average, these messages were seen by more than one-third of the student body; two-thirds of the students regard the content as "believable" and more than three-fifths say that they learned "new information."

Recent spring semesters have featured messages with a basketball theme. One 2006 newspaper ad states that "Michigan State Basketball is filled with Great Tradition. Spartans know celebrating responsibly honors that tradition"; it points out that 94% watch the team on TV, and that almost as many stay with the same group and eat while drinking. Another current ad says, "Coach Izzo knows what he's doing" (demonstrated with list of accomplishments) and "So do most Spartans" (with a list showing percentages for widely practiced

responsible drinking behaviors). Several years ago, an ad depicted students watching basketball on a large screen TV, accompanied by a headline "Most MSU Students Drink Moderately or Not At All" (identifying two majority practices).

The evaluation data again show positive responses from the audience. Averaging across the three messages, one-third of the students have seen each one (average frequency is 2.5 exposures). Seven out of ten rate the content as believable, and almost half say they have learned new information from the messages.

Tracing the behavioral impact of certain sets of messages is difficult. The overall campaign has coincided with a six-year downward trend in quantity of consumption and a rise in practicing protective behaviors, along with MSU's disappearance from the Princeton Review rankings. In general, there has been progress in responsible tailgating behavior, but there's still plenty of room for improvement. Aside from the 2005 post-basketball riot, there have been no other "unfortunate incidents" since the campaign began. It should be noted that this changed climate contrasts with nationwide figures during the first half of this decade that showed an upward trend in drinking on college campuses (de Jong et al., 2006).

STUDENT RESPONSES TO BREWER-SPONSORED PREVENTION MESSAGES

The beer companies have elaborate programs designed to combat certain alcohol problems and to enhance the image of the industry. Since the 1980s, the beer industry has regularly sponsored "private service" TV spots promoting moderate or responsible drinking (Smith, Atkin, & Roznowski, 2006). Traditionally, Anheuser-Busch has promoted the "Know When to Say When" theme, while Miller has used the slogan "Think When You Drink." Between 2001 and 2005, the alcohol industry spent approximately $100 million to place about 41,000 "responsibility" spots on TV, which represents 2% of their total TV budgets (Center on Alcohol Marketing and Youth, 2006).

Recently Anheuser-Busch jointly produced a public service spot with the National Association of State Universities and Land-Grant Colleges, primarily to be aired during the widely viewed NCAA basketball tournament. The message features the themes of "Celebrate Smart" and "Good Clean Fun" by depicting a basketball referee and a throng of college team mascots to tout "responsibility" and the "designated driver."

The Anheuser-Busch website in early 2008 posts five TV spots, including the "Good Clean Fun" message with its mascots and a referee. The other messages deal with checking ID's of underage buyers, avoiding purchase of alcohol for underage

children, and designated driver themes. The company has also produced 18 print ads (mostly to prevent underage drinking), plus print, billboard, and audio ads for its designated driver message. Aside from the "Good Clean Fun" spot, there are no messages with manifest college-related themes; underage drinking focuses on teenagers, and the designated driver concept applies to all age groups.

Anheuser-Busch has participated in a series of collegiate prevention programs, including basic alcohol awareness and education at 585 colleges, National Collegiate Alcohol Awareness Week programs on 87 campuses, and designated driver programs on 180 campuses. The company has distributed more than 600,000 sets of program materials called *College Talk* over the past six years and has placed more than 10,000 social norms messages (typically newspaper ads and posters) on campuses nationwide (Anheuser-Busch Companies, 2008c).

Self-regulation and marketing communication tactics are two strategies employed by national brewers and distillers in an effort to curb the rising criticism of their product and its advertising. The nation's three largest brewers, Anheuser-Busch, Miller Brewing, and Coors, are individually involved in consumer awareness activities to fight the alcohol misuse issues of drinking and driving and underage drinking, and to promote responsible consumption of beer by adults who choose to drink.

At first glance these campaigns may seem similar to conventional public service announcements (PSAs) sponsored by governmental agencies or consumer groups in that they both promote a message on behalf of a cause. However, the "drink responsibly" advertising campaigns developed by the brewers have the characteristics of institutional or corporate advertising, which is usually designed to create a positive image of the firm (Belch & Belch, 2004). Hence, these campaigns may reflect a hybrid of conventional commercial and public service messages that can be termed *private service messages*.

On one hand, the campaign may create a positive image or reputation of the firm if target audiences—consumers (both current and potential), public health advocates, or legislators—equate the campaigns with being socially responsible. But at the same time, the ads may still communicate messages that promote brand purchase and alcohol consumption.

A theoretical framework for examining audience responses to "drink responsibly" campaigns is derived from the "strategic ambiguity" approach that is characterized by the strategic and purposeful use of messages with high levels of abstraction in order to simultaneously accomplish multiple, and often conflicting, organizational goals. Strategically ambiguous messages are designed to engender different interpretations of the same set of symbols within and across different receivers (Eisenberg, 1984).

There are two primary outcomes of strategic ambiguity: (a) diversity of message interpretations within and between audience segments, and (b) widespread consensus in bottom-line attitudinal outcomes across the overall audience. To attain diverse responses, an ambiguous message facilitates inference-making by receivers who "fill in" context and meaning according to their attitudinal predispositions and cognitive processing abilities.

The three-pronged goals of a "drink responsibly campaign" combine attempts to maximize sales of the company brand (through standard advertising portrayals and symbols), to enhance their corporate image and reputation (by displaying sensitivity and concern about the well-being of its customers, and by projecting the company as respectable, pro-social, and community-minded), and to actually diminish alcohol problems (primarily by encouraging prevention of drunkenness and drunk driving).

This can be illustrated by an analysis of spots in the Anheuser-Busch campaign. For many years, their primary slogan has been "Know When to Say When," along with "Drink responsibly," "Be responsible," and "Please use a designated driver." Visually, most messages portray drinkers enjoying alcohol in a party setting (although several are of the "talking head" variety). The spots never depict the harmful consequences of excessive or unsafe drinking.

The content of these messages features an array of ambiguities that enable the audience to draw differential interpretations: The spots don't clearly define "when" to stop drinking either in terms of quantity consumed or degree of intoxication. Hence, light and moderate drinkers may interpret that vague stopping point conservatively, while heavy drinkers may interpret it quite liberally. The spots don't suggest the option of not drinking for certain situations or certain types of individuals (e.g., youth, pregnant women, alcoholics). In particular, the message doesn't proscribe drinking by drivers.

In addition, the classic Coors "Not Now" campaign produced spots featuring brief visual depictions of a series of acceptable drinking settings (parties, campfires, and sports events) with song lyrics labeling Coors as the "right beer now," intercut with three obviously risky situations for which the announcer progressively disclaims as "not now," "definitely not now," and "absolutely, positively not now." The first form of ambiguity is a manifest commercial element in each message in direct juxtaposition with the distinct warnings about unsafe drinking. Second, the ads don't clearly specify whether "not now" means zero consumption, no additional consumption, or limited quantity of consumption, nor do the messages elaborate on the meaning of the three levels of warning.

Most college-age young adults will have gained the requisite combination of maturity, experience, savvy, and skepticism to see through superficial message attributes and appeals in order to detect the underlying strategies of "drink

responsibly" campaigns and to form more distinct and uniform interpretations of these messages.

Smith, Atkin, and Roznowski (2006) performed a message testing study with high school and college students to examine responses. Respondent interpretations of the message content and campaign purposes were indeed diverse, with a considerable spread across perception answer categories, a fairly even split among the three basic perceived purposes, and a highly disparate set of interpretations regarding company drinking policies and recommendations; moreover, large proportions of respondents drew divergent multiple implications of campaign purposes and drinking policies.

As expected, there was a substantial difference in response patterns between the teenage and young adult subsamples on a number of measures. In almost every comparison, the pattern of deviation scores for these younger viewers indicated greater diversity than those for the older viewers. It appears that their lack of sophistication and attitudinal polarization led the teenagers to draw particularly varied implications from the messages.

The findings also showed that evaluative ratings were generally positive and more uniform than the interpretive responses. Evaluations of both the message content and the company image are clearly positive, and this was reflected in greater attitudinal favorability toward the sponsors.

The question of whether these campaigns benefit the public is more doubtful, as there is no solid evidence of message effectiveness in encouraging responsible drinking behavior; it is likely that unambiguous public service messages are more influential. Furthermore, the appearance of addressing the problem may preempt more persuasive campaign efforts from government agencies and prevention organizations.

CONCLUSION

This chapter examined the interrelated issues involving alcohol advertising, prevention messages, sports, and drinking in the campus context. Drinking among college students continues to be widespread and is often associated with sporting events and telecasts (although certainly not limited to sports), and problematic outcomes have been linked with sports-related drinking.

Even within guidelines and restrictions imposed by breweries, television outlets, and relevant organizations (NCAA), there's a significant amount of appealing beer advertising on sports programming; these ads are frequently viewed by college students as well as those who are in older and younger age groups. Overwhelmingly, beer messages point to pleasure, enjoyment, fun, and

social activity, even with the requisite "drink responsibly" message tagged on at the end (of ads on college games).

Prevention initiatives on campuses that seek to promote responsible alcohol consumption in sports contexts must compete with the commercial ads that promote drinking. To counter the advertising and the exaggerated misperceptions of collegiate drinking, students are increasingly exposed to social norms campaigns featuring messages that appear to be more effective than the "responsibility" messages sponsored by the alcohol industry.

Although it's unlikely that the linkage between collegiate sports and student drinking will diminish substantially in the next few years, there are ample cases of successful prevention efforts to provide a basis for optimism that negative outcomes can be reduced. This will require continued investment of resources combined with a strategic blend of sophisticated persuasive messages and skillful environmental management activities.

REFERENCES

Anheuser-Busch Companies (2008a). Advertising and marketing code.
 http://www.beeresponsible.com/home.html
Anheuser-Busch Companies (2008b). Safe celebration study 2007.
 http://www.alcoholstats.com/mm/docs/4563.doc
Anheuser-Busch Companies (2008c). Corporate social responsibility programs.
 http://www.anheuser-busch.com/ResponsibilityMatters.html
Beer Institute (2006). Advertising and Marketing Code.
 http://www.familytalkonline.com/docs/Document_Library/2006ADCODE.pdf
Belch, G. E., & Belch, M. A. (2004). *Advertising and promotion: An integrated marketing communications perspective*. New York: McGraw-Hill.
Center on Alcohol Marketing and Youth (2003). *Alcohol advertising on sports television, 2001 to 2003*. Washington, DC: Center on Alcohol Marketing and Youth.
Center on Alcohol Marketing and Youth (2006). *Still growing after all these years: Youth exposure to alcohol advertising on television, 2001–05*. Washington, DC: Center on Alcohol Marketing and Youth.
Center on Alcohol Marketing and Youth (2007). *Drowned out: Alcohol industry "responsibility" advertising on television, 2001–05*. Washington, DC: Center on Alcohol Marketing and Youth.
Center for Science in the Public Interest (2003). *Sports, youth & alcohol advertising study*. Washington, DC: Center for Science in the Public Interest.
Center for Science in the Public Interest (2008). Retrieved from http://www.cspinet.org/booze/CAFST/schools.htm
Chen, M. J., Grube, J. W., Bersamin, M., Waiters, E., & Keefe, D. B. (2005), Alcohol advertising: What makes it attractive to youth? *Journal of Health Communication, 10*, 553–565.
De Jong W., Schneider, S. K., Towvim, L. G., Murphy, M. J., Doerr, E. E., Simonsen, N. R., Mason, K. E., & Scribner, R. A. (2006). A multisite randomized trial of social norms marketing campaigns to reduce college student drinking. *Journal of Studies on Alcohol, 67*, 868–879.

Eisenberg, E. (1984). Ambiguity as strategy in organizational communication. *Communication Monographs, 51,* 227–242.

Entertainment and Sports Programming Network (ESPN) (2005). *ESPN Advertising Standards and Guidelines.* Retrieved from www.espncms.com/downloads/doc/1_6_espnad2005.doc

Garfield, B. (August 27, 2007). *Heineken "DraftKeg": The most sexist beer commercial ever produced?* Advertising Age. http://adage.com/garfield/post?article_id=120078&search_phrase=garfield

Gotwals, A. E., Hedlund, J., & Hacker, G. (2005). *Take a kid to a beer: How the NCAA recruits kids for the beer market.* Washington, DC: Center for Science in the Public Interest.

Hall, C. C., & Crum, M. J. (1994). Women and "body-isms" in television beer commercials. *Sex Roles, 31,* 329–337.

Leiber, L. (1996). *Commercial and character slogan recall by children aged 9 to 11 years: Budweiser versus Bugs Bunny.* Berkeley: Center on Alcohol Advertising.

National Broadcasting Company (NBC) (2001). *NBC advertising standards, procedures and policies.* Retrieved from http://www.nbcumarketplace.com/marketplace2/_broadcast/NBC_Entertainment/downloads/advertising_guidelines.pdf

National College Athletic Association (NCAA) (2006). *The NCAA's advertising and promotional standards.* Retrieved from http://www1.ncaa.org/eprise/main/Public/CBA/BrdcstMan/Sect3/AdvPromoStandards.pdf.

Nelson, T. F., & Wechsler, H. (2003 January). *School spirits: Alcohol and collegiate sports fans. Addictive Behaviors, 28* (1), 1–11.

Rouner, D., Slater M., & Domenech-Rodriguez, M. (2003). Adolescent evaluation of gender role and sexual imagery in television advertisement. *Journal of Broadcasting & Electronic Media, 47,* 435–454.

Slater, M. (1997). Adolescent responses to TV beer ads and sports content/context: Gender and ethnic differences. *Journalism and Mass Communication Quarterly, 74,* 108–122.

Smith, S. W., Atkin, C. K., & Roznowski, J. (2006). Are drink responsibly alcohol campaigns strategically ambiguous? *Health Communication, 20,* 1–11.

Wechsler, H., Kelley, K., Weitzman, E., & San Giovanni, J. (2000). What colleges are doing about student binge drinking. *Journal of American College Health, 48,* 219–226.

Wechsler, H., Moeykens, B., Davenport, A., & Castillo, S. (1995). The adverse impact of heavy episodic drinkers on other college students. *Journal of Studies on Alcohol, 56,* 628–624.

Consuming Sport, Consuming Beer: Sport Fans, Scene, AND Everyday Life

GARRY CRAWFORD

INTRODUCTION

It is the aim of this chapter to contribute to the understanding of the location and consumption of sport in patterns of everyday life. Though sport can often be encountered and consumed in fairly mundane and everyday ways (see Crawford 2004), it is evident that at certain points and in certain places, sport can take on deeper and more significant meaning for its followers. In considering the importance of these particular times and places, this chapter uses alcohol (and most frequently beer) as a mechanism for highlighting specific times and places where the consumption of sport takes on increased social significance. For, as Collins and Vamplew (2002, p. 69) write in their cultural history of sport and beer : "it is no exaggeration to suggest that, no matter what the sport or its level of popularity, the consumption of alcohol is almost an intrinsic part of the spectator experience." In particular, the relationship between beer and sport allows us to identify certain locales, such as the sport stadium, the public house, spaces in front of large screens, and the home, as places where through (performative) consumption, sport takes on significant and "extraordinary" meanings.

This chapter draws most notably on the work of Brian Longhurst (2007) and his recent attempt to theorize contemporary forms of "elective belonging" through the utilization of the concept of "scene." In particular, this application

is useful in that it addresses many of the weaknesses encountered with existing theorizations of sport fan culture, which either seek to divide fans into distinct categories or at best sees them moving in and out of "groups" (such as neotribes), as it allows for an understanding of how sport is experienced and consumed in "ordinary" and "everyday" life but takes on more "extraordinary" (i.e., spectacular and performative) meaning at specific times and places.

The chapter begins with a brief consideration of "elective belonging" and suggests that theorizations of this have followed two broad trajectories (that of "community" and "subculture," both of which in recent years have struggled with theorizing the increasingly fragmented nature of contemporary life). And here, the concept of scene, as recently theorized by Longhurst (2007), is offered as a useful way of understanding the "ebbs and flows" of elective belongings in our everyday lives. The next section specifically addresses the intersection of sport, beer, and place and considers the importance sport takes on in specific places, such as the sport stadium, the public house, spaces in front of large screens, and the home. Finally, the third section of this chapter suggests that of significance in understanding the importance of these places is the performativity of both masculinity and deviances in these locales, and also closely tied into both of these is the significance of narratives in structuring social performances.

THEORIZING "ELECTIVE BELONGING"

There is a long and troubled tradition within sociology of attempting to understand and theorize social groupings, and in particular, the extent to which those we belong to are chosen or attributed to us. There appears to be two main threads to this argument that have frequently converged and intertwined at various points, and both ultimately end up at similar positions: those of "community" and "subculture."

First, debates over what community means and its continued importance, or even existence, have perplexed sociologists for a very long time. Community was first and most commonly associated with rural locations and premodern times (Byrne, 1999). The archetypical idea of community, therefore, is a small preindustrial village or tribe that is based around a "collective consciousness" (Durkheim, 1933). It has been suggested by several authors, such as Benedict Anderson (1983) and Anthony P. Cohen (1985) that in more contemporary times the nature of community has become much more "imagined" or "symbolic," rather than based around place or proximity. The logical conclusion to this argument is carried through by Zygmunt Bauman (2001) who suggests that in more "liquid modern" times community has been lost forever, never to be regained but

continues to be sought by individuals through membership of what Bauman sees as "peg communities," "ad hoc communities," "explosive communities," and other disposable substitutes. A good application of these ideas on the changing nature of community to sport fan culture is the little read but excellent paper by Ian Taylor (1995) "It's a Whole New Ball Game." In this Taylor suggests that sport fans (and in particular here he considers football fans) are increasingly making rational choices about their sporting allegiances, based upon individual preferences or attributes rather than their locality—which has always been (and continues to be, though notably less so) the main factor in determining sporting preferences.

Second, the idea of "subculture" among many, beginning with Chicago University scholars such as Albert K. Cohen (1955), recognizes that there exist subgroups or cultures within wider (dominant) culture. For the Chicago scholars and later for those who developed the concept further at Birmingham University in the 1970s (such as Stuart Hall, Dick Hebdige, and their colleagues), subcultures are formed as a direct and class-based response to youth's exclusion from legitimate career paths and/or alienation from wider society, which sees them develop their own culture and values in order to gain (in-group) prestige and/or rebel against wider society. Though this thematic path has contributed significantly to our understanding of popular cultures and subcultures, it suffers from numerous weakness, including most notably its overemphasis on the apparent cohesion and stability of these groups, as well as ignoring individual agency and choice in joining subcultures. Consequently, in recent years several alternatives to the conception of subcultures have been offered by a long succession of authors, such as those with ideas of "lifestyle" (e.g., Chaney, 1996; Jenkins, 1983), "scene" (e.g., Shank, 1994; Straw, 1991) (a concept I will return to in a moment), "neotribes" (a concept that in its usage by Bauman [e.g., 1992] highlights a crossover between post-subculture[1] and community debates), as well as those who argue for a continued, but adapted use of the concept of subcultures (e.g., Hodkinson, 2002). Though most of these theories differ in subtle ways, key similarities are that they emphasize the more fluid and sometimes temporal nature of many contemporary social groups and the "elective" nature of membership.

Though few fan studies authors directly utilize the concept of subcultures, many have drawn on its vernacular. In particular, several key studies of fan cultures—such as the work of Henry Jenkins (1992), and more specifically those on sport fan cultures such as Rogan Taylor (1992) and Steve Redhead (1997)—have sought to identify fans (or at least who they see as "real" fans) as different and distinct in their practices and culture from wider audiences/consumers. In particular, the early work of Ian Taylor (e.g., 1969) comes closest to a subcultural model, highlighting the "resistant" nature of "football hooligans." In recent years, several fan and sport studies authors (such as Crawford, 2003) have attempted to move

away from simplistic models that seek to distinguish "real" fans from others on the basis of highly subjective codes of "authenticity."

In particular, elsewhere (Crawford, 2004) I propose the adoption of the concept of neotribes in theorizing contemporary sport fan culture as a way of moving away from simplistic distinctions between ("real") fans and consumers/audiences. However, a limitation of the concept of neotribes is that it still retains some of the baggage and limitations of the subcultural/community debates out of which it grew. In particular, neotribes are understood, though more numerate and fluid, still as mini subcultures into which individuals regularly pass in and out of. Hence, neotribes are best understood as a Venn diagram of elective belongings, through which individuals move. However, this then begs the question of what happens outside of these individual and/or intersecting "circles"? And more specifically, does the influence and sense of identity derived from these neotribes simply cease to exist when an individual is not actively engaging within these?

An attempt to deal with these and other difficulties with subcultural and community (and post-subculture and postcommunity) debates is offered by Longhurst's employment of the concept of "scene." In attempting to theorize elective belongings, Longhurst (2007) proposes the (though to some degree expanded and clarified) use of the concept of "scenes." The concept of "scene" has most commonly been applied to a consideration of popular music cultures; in particular, Longhurst (2007, p. 57), drawing on Hesmondhalgh (2005), suggests this has generally been used in two ways: either to understand "place bound" music cultures (such as the "Mersey Beat" of the 1960s or the "Madchester" scene of the late 1980s/early 1990s) (as used by Shank, 1994) or as "complex spatial flows of music affiliations" (such as could be characterized in the "goth" scene) (as employed by Straw, 1991). Though Hesmondhalgh highlights these two separate usages of the term as incompatible and, therefore, questions the validity of the concept of "scene," Longhurst suggests that these are not necessarily conflictual readings of "scenes," and, in fact, highlight the very usefulness of this term. For two main reasons: first, scene allows for an understanding of how elective belongings are lived out and experienced in our ordinary lives. Unlike subcultures that are seen as coherent groups, or neotribes as sets we move in and out of, scenes are part and parcel of our "ordinary" lives (I will return to this concept in a moment) and identities, which are always present but most often experienced in fairly mundane or ordinary ways. However, second, these scenes take on "extraordinary" meaning at certain times and in specific locations—this concept, therefore, retains an emphasis on the importance of "place." A good illustration of this point would be the "goth" scene. Goths are part of a wider society and culture, most have jobs, interests, and friends outside of the goth scene, but they remain

part of this scene in their ordinary lives, primarily through a sense of identity and belonging to this scene and their music and fashion tastes. However, this scene becomes "extraordinary" and takes on increased significance at certain times and in certain places, such as at goth clubs, or most visibly at the biannual goth weekends in Whitby in North Yorkshire. Focusing on the ordinary lives of goths may lead one to highlight the "ephemeral" and fluid nature of elective belonging and identity, while concentrating on "extraordinary" events may lead one to emphasize the coherence and "substance" of this group (and lean towards a subcultural reading, as Hodkinson, 2002 does). Scene, therefore, Longhurst argues, allows for a greater understanding of the importance of elective belonging in ordinary life and how in certain places this can take on extraordinary significance. Also, Longhurst argues that scene can be employed to understand elective belongings and "enthusiasms" beyond music; in particular, he clearly (and very helpfully) suggests that this could be employed to understand sport fan cultures—as he writes: "[t]his sort of approach…can inform the sort of study of sport undertaken by Crawford (2004)" (2004, p. 59).

Longhurst's employment of scene ties into his earlier work with Nick Abercrombie on *Audiences* (Abercrombie and Longhurst 1998), and in particular, their concept of the "diffused audience." Put simply, the diffused audience is a contemporary progression from "simple" audiences (direct observers at an event, such as at a theatre or football match), through "mass" audiences (being an audience member to "mediated" texts such as television, cinema, or sound recordings) to a contemporary situation, where in an increasingly spectacular and performative society we become both audience and performers in our everyday lives. In this, the mass media becomes a "resource" that people draw on in the construction of their social identities and social performances, performing to others, as we likewise become "audienced" by others social performances—and I will consider this in more detail in the following section. Another significant element that Longhurst highlights within scenes is the importance of "narrative," recognizing scenes as constituting a narration, composed of interrelating and individual narratives, and also located within wider narratives—and again, this is a concept and aspect of scene that I will seek to employ and develop later in this chapter.

Finally, before seeking to employ this theorization to the case at hand (sport fans and beer), it is important to clarify the (theoretical) distinction between "ordinary" and "everyday" life. In particular, Longhurst (2007) argues against the use of the term "everyday life," as he suggests this has frequently been employed in two main ways: first to highlight the exploitative and repressive nature of the everyday (such as Lefebvre, 1991), or second, as the site of potential resistance and rebellion (such as the work of de Certeau, 1984). Instead Longhurst advocates

the use (through some adaptation) of Raymond Williams' (1989) concept of "ordinary life," which highlights the social significance of cultural creativity but locates this within individuals' often mundane ordinary lives. Though agreeing with the general tenet of Longhurst's argument (that culture should be understood as "ordinary"), I would suggest he overlooks the critique of Williams' work as overly celebratory of ordinary creativity (something he rejects de Certeau for) and also avoids making the mistake of viewing the work of de Certeau through the lens of how it has been employed by others such as Jenkins (1992) and Fiske (1989). However, Buchanan (2000, p. 87) suggests that de Certeau is "not nearly so frivolous as some of his followers." In particular, de Certeau still has a lot to offer how "extraordinary" moments happen with "ordinary" lives, and hence (at least for now), I am not following Longhurst in his rejection of the concept of the "everyday." Therefore, here I choose to categorize the "ordinary" (and also the "extraordinary") as parts and components of the everyday.

SPORT, BEER, AND PLACE

Sport is usually encountered and consumed in everyday life in fairly ordinary and mundane ways, such as observing (or sometimes paying partial notice to) the myriad television and news programs and stories, billboard, television and press advertisements, clothing, consumer items, and conversations of those around us that are all sport-related and contribute to an everyday and "ordinary" sport scene (Crawford, 2004). However, this engagement with, and consumption of, sport becomes "extraordinary" at certain times and in certain places (such as in sport stadiums or in pubs)—and what is significant about these times and places is that frequently these are where there is a frequent intersection between the consumption of sport and beer.

This is not simply to suggest that it is alcohol that makes the consumption of sport take on greater significance; however, this is likely to be a contributing factor in making sport "extraordinary." Research by Sayette (1993) (amongst others) suggests that alcohol can reduce social inhibitions and Pernanen (1976) (again, amongst others) suggests that alcohol greatly reduces an individual's ability to think rationally. Hence, in situations where individuals are drinking alcohol, sport is likely to take on greater significance for many, and also their performativity, and that of those around them, is likely to be increased. However, it is not alcohol alone (or at least not the chemical effect this has on our brains) that gives sport its increased importance at certain times and places, but rather the social significance and culture that has developed around the consumption and engagement of sport (and alcohol) in these particular locales.

For as numerous ethnographic and sociological studies (such as Heath, 1998; Mandelbaum, 1965) on the consumption of alcohol have shown, the social and cultural setting in which alcohol is consumed significantly shapes how individuals behave while drinking alcohol and react to its effects. Moreover, Weed (2006) has shown that even when pubs showing major football matches are not serving alcohol (such as outside normal licensing hours), supporters can still turn the watching of the match into a significant and extraordinary social event, through singing and chanting and other forms of social performing. This is also the case at football stadiums around the UK, where the consumption of alcohol in sight of the field of play has been banned since the 1985 Sporting Events Act (see Greenfield & Osborn, 2001). However, alcohol, and in particular beer, continues to play a significant role in the ceremony of "going to the game" for many (and not just in football).

Hence, this section considers the social significance and the relationship between the consumption of sport and alcohol in four specific and "extraordinary" places and times: the sport stadium, the pub, in front of open-air large screens, and in the home. However, it is important that these four places (at specific times) are not understood as sites of "fandom." As fan interests and identities are primarily located within the imagination and ordinary practices of everyday life, but at certain times and places fan interest can take on greater significance—and here this chapter highlights four common sites where the consumption of sport (and beer) becomes extraordinary for many.

The first and most obvious and visible of these places is the "live" sport stadium. It is evident that the stadium, for many fans, provides a deeply important place where their fandom takes on extraordinary significance. As Bale (1993) suggests, the meaning of the sport stadium can be understood through the metaphors of "home," "educator," "heritage," and "religious" site, and all of these can be tied into a fan's relationship with beer. It is a place where fans feel relaxed and at home, and drinking constitutes part of this, it is frequently the place where "boys" become "men," as this is often the first place they are allowed to socialize and learn to drink with the men (and the obvious gendered nature of this will be returned to in the next section), and tied into this are the traditions and rituals of generations of supporters drinking and "going to the game." Collins and Vamplew (2002, p. 73) suggest that drinking is such an integral part of attending football in the UK that it forms the basis of many support songs and chants, such as the Sheffield United FC ("the blades") song "All the Blade Men love their gravy [beer]." And, drinking alcohol can provide many with one of the greatest reasons for going to watch sport. As Crabbe et al. (2006, pp. 78–79) suggest of the group of "new dads" that they interviewed, going to football provided one of the few pastimes that "allows them to spend time with their mates' and "get pissed."

However, the 1985 Sporting Events Act in many respects made sport fans' love of beer the scapegoat of "football hooliganism." Though alcohol can contribute to increased levels of aggression, due to the increased likeness of misunderstanding (due to reduced cognitive responses—see Steele & Joseph, 1990), reduced social inhibitions (see Pernanen, 1976), and/or increased frustration (see Berkowitz, 1978), there is no evidence that alcohol alone *causes* football-related disorder. In particular, Collins and Vamplew (2002) suggest that there is no evidence that alcohol played a significant role in any major act of "football hooliganism," and that there is evidence to suggest that known and committed "football hooligans....deliberately eschewed alcohol on match days in order to keep their wits keen and their fighting skills sharp" (Collins & Vamplew, 2002, p. 84). Moreover, the Sporting Events Act did not outlaw the drinking of alcohol at other sporting events (such as rugby and cricket), nor did it prevent fans from drinking alcohol before and after football games, and even inside the football grounds themselves, such as in restaurants and bars out of sight of the playing field. The availability of alcohol at cricket, rugby, and most other sporting events in the UK and beyond means that most sport fans around the world have the opportunity to drink alcohol in the stadium (and in sight of the playing area)—and most manage to do so without being too "disorderly."

The second place I wish to highlight is the public house. The pub has a long association with sport. From the sixteenth century, if not before, the pub was a major venue for the staging of sporting events such as cockfighting and boxing bouts, as well as frequently the start and end point of fox and other hunts. And it is from the very start of organized professional sport and the rise of mass spectating in the ninetieth century that the pub becomes associated with "going to the match" (Collins & Vamplew, 2002). The pub is where friends and co-supporters frequently gather and meet before games, and post-match, drinking will often continue, sometimes for a considerable amount of time (depending on whether fans are celebrating or drowning their sorrows) in pubs and bars. And in certain sports, post-match drinking can involve the mingling and association between both players and spectators in pubs, bars, or club houses. In particular, Collins and Vamplew (2002) suggest this was quite common in rugby union in the UK. Though professionalization has now reduced the commonality of this in rugby union, it continues in many other sports such as rugby and ice hockey in the UK, and in other sports and countries beyond. And in our ice hockey fan research (Crawford & Gosling, 2004), we suggest that drinking and socializing with players post-match was a major attraction for many supporters, both male and female—though especially for many of the young (often too young to be there legally drinking) female fans.

However, the relationship between the public house and sport, certainly in the UK, has been further cemented since the early to mid-1990s with the growing popularity of watching sport in pubs. Sport has been watched in pubs for a considerable amount of time, most commonly on small televisions positioned above the bar or in the corner of the pub. However, the popularity of watching sport in the 1990s increased significantly, due to a number of reasons. The first, is quite specific to the UK and relates to the exclusive deal *Sky* television struck with the newly formed FA Premier League in 1992, taking "live" coverage of top-flight English football off terrestrial television; due to the lack of widespread ownership of *Sky* television within the UK population, the pub became a communal place for watching games. Second, though he provides little evidence for this, Weed (2006) suggests that a contributing factor to the increasing popularity of watching sport in pubs might the changing nature of sport venues, as these become increasing "sanitized" locations (see Bale, 2000). In particular, Weed suggests that pubs may have become the "new terraces" and, in this respect, quotes the former (self-proclaimed) "football-hooligan" Dougie Brimson:

> The shift towards a culture of pub supporting has already started. It is cheaper and easier to simply go to the pub and watch the game while having a few beers. In most cases it will be with the same group of geezers and so the atmosphere will be as good if not better that at the actual game. (Brimson, 1998, p. 166, cited in Weed, 2006, p. 79)

However, there is little evidence to suggest that pub viewing has had any significant, if any at all, impact on attendance rates at sporting events. Third, Collins and Vamplew (2002) highlight the changing role of the brewing industry, where (often brewery-controlled) chain pubs seek to turn going to (often themed) pubs into a "leisure occasion" that includes providing coverage of major televised sporting events. Finally, I would add to this list technological changes that have made large-screen televisions not only possible but also relatively cheap for landlords and breweries to install them in their pubs and bars.

A key advantage that pubs do have over home viewing is that pubs can offer a communal gathering often missing (though not necessarily—see later) in people homes. As Weed (2006, p. 80) suggests "[p]ubs tend to become more sociable during and in the run up to football broadcasts, and people are more prepared to chat to people they don't know about the prospects of the game." In particular, Weed suggests that watching sport in pubs offers individuals the close social proximity often missing in a contemporary and increasingly fragmented society—both in a social and physical sense, as sport fans in pubs are more willing to be crowded in with strangers and have their "personal space" compromised, as if reminiscent of the crowding of stadium terracing. As Stone (2007, p. 175) writes "it may be that

other key organizing processes of everyday life are becoming ever more invalid leaving people clinging to football as a way of giving meaning to their increasingly fragmented lives." This is particularly noticeable in many "ex-pat" clubs, where the watching of teams from "back home" (even if that is an imagined "home") can provide an important focal point and a sense of identity for the "dislocated" or similarly for the children of immigrants. For instance, both of my brothers can frequently be found watching Glasgow Celtic FC games in their local Irish social club—one in the Wolverhampton (UK) and one in Brisbane (Australia). And in particular, this highlights the important role Longhurst (2007) suggests scene plays in processes of "belonging," "distinguishing," and "individualizing"—as individuals at these extraordinary times and places, such as watching sport in a pub or in a stadium, construct a sense of who they are, to what and to whom they belong, and also, who they are not.

However, I would disagree with Weeds assertion (and this also appears to be implied by Collins & Vamplew, 2002) that modern pubs have "little sense of place" (Weed, 2006, p. 80). Pubs, especially "local" pubs or pubs with a long association with sport clubs (such as those close to stadiums), often have a real and significant sense of place for those who frequent them. Also, "themed" pubs and others at times of major sporting events will often seek to create a sense of place. For example, Crabbe et al. (2006, p. 26) discuss how pubs frequently seek to create their own version of an "authentic experience," such as the example they cite of the *Titled Wig Pub* in Warwickshire, which during the 2006 football World Cup purpose built a stadium-like stand in its garden in front of a large screen. Even if it could be argued that these creations of authenticity and place are somewhat "hyperreal," fans have a tendency to make places meaningful and extraordinary by their presence and activities—even if this is an "imagined" place (see Stone, 2007), the imagination is after all where Taylor (1995) suggests that sport fandom is increasingly located (if it has not always been, see Crawford, 2004). An important way that fans create this sense of place is through their social performing, such as replicating the singing and chanting witnessed at "live" sport events. It is this performing (and in turn the audiencing of others) that gives the pub as well as other sights of sport consumption their sense of "place" and meaning. However, it must also be noted that the contemporary relationship between pubs and sport fandom is not confined just to watching sport, as frequently sport is the subject of conversations shared over a beer or two in bars and public houses the world over—as places that are sometimes extraordinary also become ordinary at different times and in different contexts.

It is also notable that the advent of big screen viewing of sport has spread out of pubs into public open-air spaces—most commonly during major sporting events such as the football World Cup. Often these screens are temporally

located in open spaces next to sport stadiums hosting major events, to provide a focus and access to the game for those who could not get in or simply for those who want to "soak up" the atmosphere and experience of place by being as physically close to the event as possible—such as the large screen Bale (1998) describes that was erected outside the national football stadium in Copenhagen during a Danish-German football match. As with the pub, a sense of place is often created in front of these screens by fans celebrating and cheering on their team—creating an imagined sense of connection with these. It is also evident that drinking and alcohol can play a significant role in helping create this sense of occasion and place for fans watching on big open-air screens—as Bale (1998, p. 275) writes of the event in Copenhagen: "it was a form of carnival with drunken fans celebrating." The popularity of these screens certainly seems to be increasing, undoubtedly fuelled by fans' increased sense of commonality and camaraderie achieved by such a large gathering of fellow supporters. For instance, Crabbe et al. (2006, p. 26) cite the examples of how organizers of the 2006 football World Cup in Germany claim that over one million people watched games on large screens in Berlin, while the BBC erected large screens in many British cities for the viewing of games during this competition. Also, I watched most of the 2006 football World Cup finals on large screens in various Italian cities (the nation that would eventually win the competition); at each, temporary bars were constructed nearby and other supporters came fully laden with their own supplies of alcohol—turning every game and every victory along the way into alcohol-fuelled celebrations.

However, the location where the majority of fans and followers of sport watch, consume, and connect with sport is in their own homes. Though this is often done in a fairly mundane and ordinary way—such as reading about sport in a newspaper or magazine, conversing between friends and family, or paying only partial attention to the television—at certain times and/or for certain events, the home can take on a significant meaning and sense of place, beyond the ordinary. For some supporters, watching sport at home is better than watching it in the pub, or even being at the game itself, as the home offers obvious convenience and comforts that have to be forsaken in more communal public settings (such as comfy chair, cheap and easily accessible alcohol, and convenient access to a toilet); as Crabbe et al. (2006) suggest, home can frequently provide a better and unobstructed view of events. Watching sport at home can be made into an extraordinary event by creating a sense of place and occasion, frequently by buying in beer and food for games, and even by the dressing of a location by draping it with flags (something that has become more common in the UK in recent years), or fans wearing team shirts or colors to watch games at home. This can also be a communal event; Crabbe et al. (2006, p. 25) discuss how the home of one of

their "new dads" has become known as the "football house"—as this is where friends most commonly gather to watch games together. But even when sport is watched alone, or within family groups, the mass media plays an important role in the (imagined) construction of the belonging, distinguishing, and individual-izing of fans (Longhurst, 2007)—by providing fans with a sense of identity and "community."

In concluding this section, what I would like to suggest is that, what is significant and similar about all of these locations—be that a sport stadium, pub or bar, open-air space in front of a big screen, or someone's home—is the creation and sense of "place" that makes these "extraordinary," and that this is achieved through (often alcohol-enhanced) social performances (and in turn audiencing) within these locations. And specifically, discussed in the next sec-tion, it is the performance of masculinity and deviance that often has the most significance here.

PERFORMING MASCULINITY, PERFORMING DEVIANCE

What makes each of the specific locations "extraordinary" is not just the events taking place or being viewed within these, but also the interactions and social per-formances of audiences within these places. As several authors such as Rinehart (1998) indicate, it is the fans and audience themselves through their social per-formances who play a significant role in generating the atmosphere and social significance of an event. In particular, Crawford (2004), drawing on the work of both Abercrombie and Longhurst (1998) and Hills (2002), identifies "perfor-mative consumption" as an important mechanism for understanding contempo-rary fan culture—that is to say, how consumer and media "texts" are drawn on as "resources" in the social interactions and social performances of sport fans. Here, I wish to suggest that in the specific places and times identified in the previous section (the sport stadium, the public house, spaces in front of large screens, and the home), the social performances of fans revolve primarily around the twin (and interconnected) themes of masculinity and deviance.

Gosling (2007) highlights the discriminatory and exclusionary nature of sport fandom for women. In particular, professional team sports have always been and continue to be primarily a male enclave, excluding women as both participants and spectators. However, as Butler (1990) alerts, gender is not an innate attribute, but rather one that finds stability through the repeated performativity[2] of "mascu-line" and "feminine" roles. Hence, sites of sport consumption (such as sport stadi-ums, pubs, in front of large screens, and the home) are probably best understood as sites of masculine (and feminine) performativity.

Longhurst (2007) takes issue with Butler, as he argues that Butler overlooks the important role of the audience in patterns of social performativity, and when she does consider this, she appears to do so in rather simplistic (incorporation/ resistance) terms. Hence, Longhurst suggests that a theory of social performativity is needed that takes into consideration the role of the audience; he suggests that we, therefore, need to consider the dual processes of both "performing" and "audiencing." And I concur that the role of the audience is crucial in understanding sport fan identities and performativity. In particular, Stone (2007, p. 172) suggests that sport fan performativity plays a particular and specific role in the construction and maintenance of masculinity and, drawing on the work of Gary Armstrong (1998), suggests that football fans must play to a variety of different audiences and, therefore, "contextualize, negotiate and improvise" the "correct" masculinity for each audience.

It is also evident that beer plays an important role in both sport fandom and the performativity of masculinity. Drinking beer, particularly in pubs, is often associated with an almost ritualistic initiation into "manhood," and the ability to "hold your beer" is often drawn on in both the performativity and the measurement of masculinity (Collins & Vamplew, 2002). In particular, utilizing the work of Blackshaw (2003), sport, its relationship with beer and alcohol, and how it is consumed in these "extraordinary" times and places could be understood as providing men with a "solid" place in an increasingly "fragmented" world. That is to say, in an increasingly insecure and uncertain world, sport, as experienced in places such as stadiums and pubs, is one of the few remaining spaces where men can create a "solid" and "modernist" world based on performed ideas of "traditional" masculinity—played out to an audience of others seeking to likewise recreate or live out (at least for a short while) this "solid" world and identity.

Pub viewing of sport can also provide some women with an increased opportunity to watch sport in a communal setting. For instance, Crabbe et al. (2006) suggest that during their observations of watching football in pubs during the 2006 football World Cup finals, women could be seen watching games. However, the numbers they cite (about a dozen women on seats, and "another gathering... at the back" in a room of over 200 men—2006, p. 28) would suggest that this was still a small minority in this (and most other) pubs and certainly Weed's (2006, p. 76) ethnography during the same competition suggests that where he watched games, "pub clientele was almost exclusively white males."

Furthermore, women's roles within sport fan communities is still often defined by their traditional (supporting) gender roles as wives, girlfriends, and/ or mothers to the (legitimate) male occupants of these places (Gosling, 2007). For instance, in Crawford and Gosling (2004, p. 486) we cite the example of one ice hockey supporter ("Harry," male, aged 37) who, when interviewed, suggested

he liked that he was able to take his wife to ice hockey, as she could "keep an eye on" their little son, while he wandered off for a beer. Otherwise, women are often required to fit into (performed) masculine roles by acting like "one of the lads" (see Coddington, 1997), or to find their "authenticity" and legitimacy within these performed masculine places questioned by fellow (most frequently male) fans (see Gosling, 2007).

The rising popularity of open-air big screens does (sometimes) provide women with a more inclusive space; certainly during football viewing in cities around Italy, a high proportion (though still significantly not equal number) of women watched their team zoom ahead on its road to World Cup glory. However, observations of big screen sport events, particularly at those located close to sport stadiums can see the replication of fan composition and behavior (and masculine performativity) most commonly associated with the predominantly masculine space of sport stadiums. Furthermore, Crabbe et al. (2006) highlight how two of the screens erected by the BBC during the 2006 football World Cup finals in city centers in the UK had to be taken down due to violence that erupted around these.

Though these forms of sport- and beer-related masculine performances are most frequently associated with public and predominantly male spaces (such as the pub or sport stadium), this performativity can also be carried over into the home. For instance, Crabbe et al. (2006) describe a particular scenario from their research, where a group of male friends gathered with their wives and children at one of their houses for a barbeque and to watch an England football game. However, the events of the day followed very predictable gender roles and performances as "the dads moved slowly towards the living room, colonizing it as a male only space [and] [b]y the end of the first half, a form of gender apartheid had developed with all of the mums and kids in the kitchen and men drinking in the house together" (2006, p. 80). Moreover, this alcohol- and sport-fuelled "gender apartheid" continued after the game as "the new dads continued drinking together, largely ignoring their wives and children" (2006, p. 80) and would frequently move onto the pub where they would continue dinking. In particular, Crabbe et al. describe one occasion after a match when two of the "new dads" arrived home "completely 'out-of-it'" (2006, p. 83). Though Crabbe et al. suggest that this "laddish behaviour was…ultimately brushed aside as being 'just what they [the "new dads"] do'"; they suggest that this kind of behavior did often lead to arguments and that the drunkenness associated with male "football 'days out' can be a source of fear" (2006, p. 83). In particular, they cite how during the first weekend of the 2006 football World Cup finals, "domestic violence calls to the police doubled in Lancashire alone compared to the same weekend in 2005," and that many British police forces set up "World Cup Domestic Violence squads" (2006, p. 84).

I would like to avoid the direct and simplistic reading of these domestic violence and other crime- and violence-related statistics that might be taken to suggest that sport and/or alcohol *cause* violence. For to answer why violence exists in contemporary society we need to look much wider than simply the "effects" of sport and/or alcohol—possibly towards gender and patriarchy (Connell, 2000), possibly the pleasures derived from violence (see Elias, 1978), or elsewhere. However, I do not have the time, space, nor desire to explore theories of violence here. However, it is evident that sport and beer are often associated (at least) with the performativity of deviance. For instance, Armstrong (1998), like many before and since, has highlighted that much of what is frequently deemed "football hooliganism" is often little more than performed (rather than physical) aggression, such as provocative chanting and goading of opposition fans, while actual acts of physical violence at football are relatively infrequent. For instance, Weed (2006, p. 89) suggests that in his ethnography, football fans in pubs would often engage in nationalistic and even racist chanting and singing, such as "No Surrender to the IRA," though he doubts if many there had any real "commitment to English nationalism or to defeating the IRA," but that rather they "simply wanted to enjoy communal singing and chanting." In particular, similarities can be drawn between the places and performative deviance of sport fandom and the "cruisers" considered by Blackshaw and Crabbe (2004). The particular form of "cruising" Blackshaw and Crabbe describe is (mostly) young men who gather in car parks or industrial wastelands (which drawing on Lash, 2002, they categorize as "wild zones") to race and perform their modified cars, but more than this, it is also about a performed (but most commonly safe) deviance and exaggerated masculine gender roles, which are mirrored by the few women there, who likewise play out exaggerated sexualized feminine roles.

An important part of performative deviance that Blackshaw (2003), King (2001), and others alert us to is the role of narrative within this. For instance, King suggests that for "football hooligans," "collective memory" and storytelling plays an important role in the creation and maintenance of social group identity and stability and also helps establish levels of status within the group. Similarly, Blackshaw (2003), drawing on the work of Ricoeur on "narrative identity," suggests that the "lads" he discusses are not the sole authors but rather coauthors in their own narratives. For Ricoeur (1988), the idea of "narrative identity" suggests the idea of a self as a "storied self," made up of stories told by the person about themselves and their lives, stories told by others about them, and wider social and cultural narratives. Each individual, therefore, develops a life narrative and a sense of who he/she is (a self-identity) through narratives. This then recognizes the temporal nature of identity, for, as with a never-ending story, this is always being constructed, developed, and hence, ever changing. It also overcomes the

dualism of fiction and history, recognizing that our narrative identities are a construct of both of these. Likewise, narrative identity mediates both "sameness" and "selfhood," locating individuals within a wider community and cultural narrative but identifying the individual's specific location and personal narrative within this.

In particular, narrative is identified by Longhurst (2007) as an important part of his consideration of "scenes." He suggests not only that a scene can be understood as part of a wider narrative, but also that narratives play an important role in the construction of place, who we are, and also who we are not (Anthias, 2005, cited in Longhurst, 2007). Therefore, the narratives that are played out and constructed by sport fans in their everyday lives, and in particular, in certain "extraordinary" places, such as the pub house and the sport stadium, play an important role in establishing a sense of belonging, distinguishing oneself from who we are not, and establishing our own individual identity—which are all particularly important in an increasingly fragmented world (see Longhurst, 2007). And as with all good storytelling, this is often enhanced greatly by the presence of beer.

CONCLUSION

It is still the case that relatively little is known about the location, uses, and importance of sport in everyday social life. Though sport fans (beyond the tiresome academic and media obsession with so-called "football hooliganism") have increasingly become the focus of academic discussions (such as Crawford, 2004; Wann et al., 2001) and ethnographic studies (such as Stone, 2007; Weed, 2006), there still exists a tension between understanding the ordinary, if not mundane, consumption of sport and the significance this takes on in certain places and at certain times. A potential reason for this is that many discussions of sport fan cultures have drawn on, or built upon, theorizations that develop out of community and/or subcultural debates, where the tendency here is to see cultures as distinct and identifiable groups and/or focus only on the exceptional times when individuals are within these groups and specific places. Though the concept of "scene" likewise develops out of the "post"-subculture debate, in particular, the discussion of pop music cultures, its recent adaptation by Longhurst (2007), which seeks to marry the various ways that this concept has previously been used (as either "place bound" or "complex spatial flows"—Longhurst, 2007, p. 57), allows for a consideration of how our "elective belongings" are located and experienced in our everyday lives in mundane and "ordinary" ways but at certain times and places can take on "extraordinary" significance.

This chapter used beer as a useful mechanism for identifying certain places where sport and beer intersect and sport fandom takes on more "extraordinary" meanings. In particular, it discussed how the consumption of beer is intrinsically linked to certain sporting locations that have significance and meaning for sport fans. The first of these I identified as the sports stadium, where beer always has and continues to play an important part of the match day experience for many—even in professional football in the UK where drinking alcohol is severely restricted. Second, the chapter considered the importance of the public house in sport fan culture, as a meeting place before and after sport events, and increasingly as a location for watching sport on television, and also as a place for chatting and discussing sport between friends. Third, the advent of big-screen televisions means that increasingly we are witnessing the viewing of major sporting events at open-air sites, where again beer plays an important part of making these events significant and extraordinary for the fans there. And finally, I considered the importance of the home, as both a solitary and communal location for the consumption of both sport and beer.

What this chapter identifies as significant in providing these places, at these particular times, with their importance, is not just the events taking place or being televised within these, but also the social performances of the fans and audiences in these locations. In particular, it is argued that it is the (interconnected) performativity of masculinity and deviance that provides these places with their specific meanings. Significantly, all of the places considered are primarily male places or become colonized as such—making the presence and role of women here marginal to men whose association with sport and beer makes them much more "legitimate" inhabitants within these places. The sport stadium at most professional spectator sports remains primarily a male space; while the public house may not be the "masculine republic" (Collins & Vamplew, 2002, p. 25) it was in the nineteenth century, during the showing of sport these spaces frequently become masculinized once more. Even the home, the domestic retreat and enclave of many women, can frequently become colonized by men during the watching of major sporting events. The rising popularity of open-air big screens does (sometimes) provide some women with a more inclusive space; however, even here, the masculine performativity of fans and the violence that sometimes erupts at these locations can again render women's role within these as marginal. In particular, the performance of deviance (though admittedly often in relatively "safe" ways) plays a significant role in making these places "extraordinary" and in cementing gender roles (and accepted gender performances).

Finally, within these performative places (again drawing on Longhurst, 2007), narrative plays an important role in understanding sport fan culture. Specifically, scenes can be understood not only as located within wider social narratives, but

also as involving narratives within them that play a significant role in shaping forms of belonging, distinguishing, and individualizing undertaken by fans and audiences. In particular, the significance of narrative in the construction of fan culture and other forms of elective is an area that deserves further and fuller attention in future research.

ACKNOWLEDGMENT

This chapter was planned and developed in conjunction with Victoria Gosling (Salford), who also passed comments on earlier drafts, so I (and this chapter) owe her a significant debt and thanks.

NOTES

1. I use the term "post subculture" here in its loosest sense to refer to theories that have drawn on and developed out of a subcultural debates, and not to refer specifically to post-subcultural theory (as advocated by Muggleton, 1997, amongst others), which is specifically one variation of this group of theories.
2. Though we don not have the space to go into detail here, often a distinction is drawn between the term "performances" and "performativity." Where the first is associated with the work of Erving Goffman, which is often understood to provide a modernist view of identity, which sees a "real" self behind the social performance. The latter (more "postmodern") idea of "performativity" is used by Butler to suggest that there is no "real" behind performativity. However, Butler herself does frequently use the terms performance and performativity interchangeably (Longhurst 2007), and I would suggest that the distinctions between Butler and Goffman are often overstated. Hence, I am fairly loose in my use of the terms "performance," "performativity," and "performing" (the term is preferred by Longhurst 2007) in this chapter, and here (apologetically) uses the interchangeably.

REFERENCES

Abercrombie, N., & Longhurst, B. (1998). *Audiences*. London: Sage.

Anderson, B. (1983). *Imagined communities*. London: Verso.

Anthias, F. (2005). Social stratification and social inequality: Models of intersectionality and identity. In F. Devine, M. Savage, J. Scott, & R. Compton (Eds.), *Rethinking class: Culture, identity and lifestyle* (pp. 25–45). Basingstoke: Palgrave.

Armstrong, G. (1998). *Football hooligans: Knowing the score*. Oxford: Berg.

Bale, J. (1993). *Sport, space and the city*. London: Routledge.

Bale, J. (1998). Virtual fandoms: Futurescapes of football. In A. Brown (Ed.), *Fanatics, power, identity and fandom* (pp. 265–278). London: Routledge.

Bale, J. (2000). The changing face of football: Stadiums and communities. In J. Garland, D. Malcolm, & M. Rowe (Eds.), *The future of football: Challenges for the twenty-first century* (pp. 91–101). London: Frank Cass.

Bauman, Z. (1992). *Intimations of postmodernity*. London: Routledge.

Bauman, Z. (2001). *Community: Seeking safety in an insecure world*. Cambridge: Polity Press.

Berkowitz, L. (1978). Whatever happened to the frustration-aggression hypothesis? *American Behavioural Scientist*, 32, 691–708

Blackshaw, T. (2003). *Leisure life: Myth, masculinity and modernity*. London: Routledge.

Blackshaw, T., & Crabbe T. (2004). *New perspectives on sport and "deviance": Consumption, performativity and social control*. London: Routledge.

Brimson, D. (1998). *The geezers guide to football: A lifetime of lads and lager*. London: Mainstream.

Buchanan, I. (2000). *Michel de Certeau. Cultural theorist*. London: Sage.

Butler, J. (1990). *Gender trouble: Feminism and the subversion of identity*. London: Routledge.

Byrne, D. (1999). *Social exclusion*. Milton Keynes: Open University Press.

Chaney, D. (1996). *Lifestyles*. London: Routledge.

Coddington, A. (1997). *One of the lads: Women who follow football*. London: Harper Collins.

Cohen, A. K. (1955). *Delinquent boys: The culture of the gang*. London: Macmillan.

Cohen, A. P. (1985). *The symbolic construction of community*. London: Tavistock.

Collins, T., & Vamplew, W. (2002). *Mud, sweat and beers: A cultural history of sport and alcohol*. New York: Berg.

Connell, R. W. (2000). *The men and the boys*. Cambridge: Polity Press.

Crabbe, T., Brown, A., Mellor, G., & O'Connor, K. (2006). *Football: An all consuming passion*. Manchester, Substance Research Report, retrieved from http://www.substance.coop/?q=publications_ea_sports

Crawford, G. (2003). The career of the sport supporter: The case of the Manchester storm. *Sociology*, 37, 219–237.

Crawford, G. (2004). *Consuming sport: Sport, fans and culture*. London: Routledge.

Crawford, G., & Gosling, V. K. (2004). The myth of the puck bunny: Female fans and men's ice hockey. *Sociology*, 38, 477–493.

de Certeau, M. (1984). *The practice of everyday life*. Berkeley: University of California Press.

Durkheim, E. (1933 [1893]). *The division of labour in society* (Trans. G. Simpson). Glencoe, IL: Free Press.

Elias, N. (1978). *The civilising process (Vol. I): The history of manners*. Oxford: Blackwell.

Fiske, J. (1989). *Understanding popular culture*. London: Unwin Hyman.

Gosling, V. K. (2007). Girls allowed? The marginalization of female sport fans. In J. Gray, C. Sandvoss, & C.L. Harrington (Eds.), *Fandom: Identities and communities in a mediated world* (pp. 250–260). New York: New York University Press.

Greenfield, S., & Osborn, G. (2001) *Regulating football: Commodification, consumption and the law*. London: Pluto Books.

Heath, D.B. (1998). Cultural variations among drinking patterns. In M. Grant & J. Litvak (Eds.), *Drinking patterns and their consequences* (pp. 103–128). Washington DC: Taylor & Francis.

Hesmondhalgh. (2005). Subcultures, scenes or tribes? None of the above. *Journal of Youth Studies*, 8, 21–40.

Hills, M. (2002). *Fan cultures*. London: Routledge.

Hodkinson, P. (2002). *Goth: Identity, style and subculture*. Oxford: Berg.

Jenkins, H. (1992). *Textual poachers*. London: Routledge.

Jenkins, R. (1983). *Lads, citizens and ordinary kids: Working class youth lifestyles in Belfast*. London: Routledge.

King, A. (2001). Violent pasts: Collective memory and football hooliganism. *The Sociological Review*, 49, 568–586.

Lash, S. (2002). *Critique of information*. London: Sage.

Lefebvre, H. (1991). *Critique of everyday life* (Vol. 1, Introduction). London: Verso.

Longhurst, B. (2007). *Cultural change and ordinary life*. Maidenhead: McGraw Hill.

Mandelbaum, D. G. (1965). Alcohol and culture. *Current Anthropology*, 6, 281–293.

Muggleton, D. (1997). The post-subculturalist. In S. Redhead, D. Wynne, & J. O'Connor (Eds.), *The club culture reader: Readings in popular cultural studies* (pp. 167–185). Oxford: Blackwell.

Pernanen, K. (1976). Alcohol and crimes of violence. In B.K. Kissin & H. Begleiter (Eds.), *Social aspects of alcoholism*. New York: Plenum.

Redhead, S. (1997). *Post-fandom and the millennial blues: The transformation of soccer culture*. London: Routledge.

Ricoeur, P. (1988). *Time and narrative (Vol. 3)*. (Trans. Kathleen Blamey & David Pellauer). Chicago: University of Chicago Press.

Rinehart, R. (1998) *Players all: Performance in contemporary sport*. Bloomington: Indiana University Press.

Sayette, M. A. (1993). An appraisal-disruption model of alcohol's effect on stress responses in social drinkers. *Psychological Bulletin*, 114, 459–476

Shank, B. (1994). *Dissonant identities: The rock "n" roll scene in Austin, Texas*. Hanover, NH: Wesleyan University Press.

Steele, C. M., & Joseph, R. A. (1990). Alcohol myopia: Its prized and dangerous effects. *American Psychologist*, 45, 921–933.

Stone, C. (2007). The role of football in everyday life. *Soccer and Society*, 8, 169–184.

Straw, W. (1991). System of articulation, logics of change: Communities and scenes in popular music. *Cultural Studies*, 15, 368–88.

Taylor, I. (1969). Hooligans: Soccer's resistance movement. *New Society*, August 7, 204–206.

Taylor, I. (1995). It's a whole new ball game. *Salford Papers in Sociology*. Salford: University of Salford.

Taylor, R. (1992). *Football and its fans*. Leicester: Leicester University Press.

Wann, D. L., Melnick, M. J., Russell, G. W., & Pease, D. G. (2001). *Sport fans: The psychology and social impact of spectators*. New York: Routledge.

Weed, M. (2006). The story of an ethnography: The experience of watching the 2002 World Cup in the pub. *Soccer and Society*, 7, 76–95.

Williams, R. (1989 [1953]). *Resources of hope: Culture, democracy, socialism*. London: Verso.

Contributors

John Amis (Ph.D., University of Alberta) is an Associate Professor in the Department of Management at the University of Memphis. His recent publications include *Global Sport Sponsorship* (co-edited with T. Bettina Cornwell). His research predominantly focuses upon issues of organizational, institutional, and societal change. johnamis@memphis.edu

Charles Atkin (Ph.D., University of Wisconsin) is Professor and Chair of the Department of Communication at Michigan State University. He is co-editor of *Public Communication Campaigns* and *Mass Communication and Public Health*. Recently, he has conducted research supported by the Department of Education and Robert Wood Johnson Foundation, examining the effects of mass media alcohol campaigns on college students. atkin@msu.edu

Alan Aycock (Ph.D., University of Toronto) has been Professor and Chair of Anthropology at the University of Lethbridge, Alberta, Canada. He is currently Associate Director of the Learning Technology Center, University of Wisconsin-Milwaukee. His research in sport sociology focuses on advertising and the media. aycock@uwm.edu

Robert V. Bellamy (Ph.D., University of Iowa) is Associate Professor in the Department of Journalism and Multimedia Arts at Duquesne University in

Pittsburgh, Pennsylvania. He has published widely in the areas of media and sport, television programming, and media technology. His most recent book (co-authored with James R. Walker) is *Center Field Shot: A History of Baseball on Television*. bellamy@duq3.cc.duq.edu

Liliana Castaneda (M.A., Simon Fraser University and IAED-Colombia) is an independent researcher based in Vancouver, British Columbia. She worked as an assistant professor of Communication and Journalism in several universities in Colombia between 1997 and 2002. Her current research focuses on cultural industries and marketing trends in Latin America. lilocamo16@yahoo.com

Garry Crawford (Ph.D., University of Salford) is a Senior Lecturer in Cultural Sociology at the University of Salford. He is review editor for *Cultural Sociology*. His research focuses primarily on media audiences and fan cultures. Much of his writing and research, including the book *Consuming Sport*, has examined sport fan cultures. His current projects explore the dynamics of digital gaming patterns. g.crawford@salford.ac.uk

Margaret Carlisle Duncan (Ph.D., Purdue University) is Professor of Human Movement Sciences at the University of Wisconsin, Milwaukee. She is a past president of the North American Society for the Sociology of Sport, a past president of The Association for the Study of Play, former editor of *Play & Culture*, and a former Wisconsin Teaching Fellow. mduncan@uwm.edu

Michael Emmison (Ph.D., University of Queensland) is Associate Professor in the School of Social Sciences, University of Queensland, Australia. His previous books include *Accounting for Tastes: Australian Everyday Cultures* (with T. Bennett and J. Frow), *Researching the Visual* (with P. Smith), and *Calling for Help: Language and Social Interaction in Telephone Helplines* (co-edited with C. Baker and A. Firth). His current research focuses on the impact of technological modality on social interaction in children's helplines. m.emmison@uq.edu.au

Walter Gantz (Ph.D., Michigan State University) is Professor and Chair of the Department of Telecommunications at Indiana University. His current research in sports focuses on the origins and correlates of sports fanship. He also conducts content analyses of health messages in news programs and advertisements. gantz@indiana.edu

Sarah Gee (Ph.D. candidate, University of Otago) received her B.A. (Hon.) and Master's degrees in Kinesiology from Lakehead University, Canada. Her research examines sport and the contemporary crisis of masculinity with a particular focus on media, advertising, and consumer culture. sarah.gee@otago.ac.nz

Callum Gilmour (B.A. Hon., Queensland University of Technology) is a research assistant at the Centre for Cultural Research (CCR), University of Western Sydney, Australia. His research interests include media sport, global media conglomerates, and international television flows. His work has appeared in the *International Journal of Sports Communication, American Behavioral Scientist, Asia Pacific Yearbook*, and *The Media and Communications in Australia*. c.gilmour@uws.edu.au

Rebecca J. Haines (Ph.D., University of Toronto) is a postdoctoral trainee in the IMPART program (Integrated Mentorship Program in Addictions Research Training) at the University of British Columbia in Vancouver, Canada. Her current research focuses on gender and the visual culture of adolescent substance use prevention campaigns. Rebecca.Haines@nursing.ubc.ca

Nelson Hathcock (Ph.D., Pennsylvania State University) is Professor of English at Saint Xavier University, Chicago. He has published on the literature and culture of mid-twentieth century America, and his current research focuses on the American South and the cold war. hathcock@sxu.edu

John Horne (Ph.D., University of Edinburgh) is Professor of Sport and Sociology at the University of Central Lancashire, Preston, UK. He is the author, co-author, editor, and co-editor of ten books and numerous articles and book chapters on sport and leisure and serves as co-managing editor of *Leisure Studies*. His most recent works are *Sport in Consumer Culture* and *Sports Mega-Events* (with Wolfram Manzenreiter). His current research focuses on themes of globalization, commodification, and social inequality in sport and leisure. JDHorne@uclan.ac.uk

Steven J. Jackson (Ph.D., University of Illinois) is a Professor at the University of Otago, New Zealand, where he teaches Sociology of Sport and Sport, Culture, & Media. He is currently the President of the International Sociology of Sport Association. His present research focuses on globalization, media, and national identity. sjackson@pooka.otago.ac.nz

Shannon Jette (M.A., University of British Columbia) is a doctoral candidate at the University of British Columbia. Her primary research interests are in areas related to the body, health, media, and gender. Her doctoral dissertation examines the production of medical knowledge about prenatal exercise from the late nineteenth century to the present and the dissemination of this knowledge in the mass media. shannonjette@hotmail.com

Jim McKay (Ph.D., Australian National University) is Professor and Head of Subject for Sport in the School of Applied Social Sciences at Durham University, UK. He is a former editor of the *International Review for the Sociology of Sport*

and has served on editorial boards for the *Journal of Sport & Social Issues, Journal of Sociology,* and *Men and Masculinities*. His current research and teaching interests include the links among sport, nationalism, globalization, social inequalities, and the media. james.mckay@durham.ac.uk

Lindsey J. Meân (Ph.D. University of Sheffield, UK) is Assistant Professor in Communication Studies at Arizona State University. Co-author of the book *Language and Gender*, her research focuses on identities, discourses, and language with an emphasis on sport and diversity. Her research crosses multiple sites and contexts, including organizations, events, and media. Lindsey.Mean@asu.edu

Janine Mikosza (Ph.D., University of Queensland) recently completed her doctorate in sociology. Her thesis focused on the production of gender and the readership of Australian lifestyle magazines for men. She is currently working as a researcher in the School of English, Communications, and Performance Studies at Monash University, Melbourne. jmikosza@optusnet.com.au

Ronald L. Mower (M.S., University of Memphis) is a doctoral student in the Sport Commerce and Culture Program in the Department of Kinesiology at the University of Maryland. He has served as the Graduate Research Coordinator in the College Sport Research Institute (CSRI) at the University of Memphis. His current research focuses on power, ideology, and the influence of cultural intermediaries in commodified sport production. rmower@memphis.edu

Catherine Palmer (Ph.D., University of Adelaide) is Reader in Sport and Social Policy at Durham University, UK. Her current research focuses on conceptual and methodological issues of drinking and sport; sport and social exclusion; and place, memory, and identity among refugee communities. catherine.palmer@durham.ac.uk

Ilana Pinsky (Ph.D., Federal University of São Paulo) is Professor-Supervisor at the Psychiatry Department of the Federal University of São Paulo (Unifesp) and a researcher at the Research Unity on Alcohol and Drugs (Uniad). Her current research focuses on alcohol policies, especially on alcohol advertising and driving while intoxicated. She is also an individual and family therapist in private practice. ilanapinsky@uol.com.br

David Rowe (Ph.D., University of Essex) is Director of the Centre for Cultural Research (CCR), University of Western Sydney, Australia. His principal research interests concern media and popular culture, with current work addressing broadcast and online sport, tabloidization, cultural policy, and urban leisure. His books include *Popular Cultures: Rock Music, Sport and the Politics of Pleasure; Globalization and Sport: Playing the World* (with Miller, Lawrence, and McKay); *Sport, Culture*

and the Media: The Unruly Trinity, and the edited *Critical Readings: Sport, Culture and the Media*. D.Rowe@uws.edu.au

Jay Scherer (Ph.D., University of Otago) is Assistant Professor in the Faculty of Physical Education and Recreation at the University of Alberta. His research interests include: globalization and sport, the commodification of national sporting mythologies, and sport and popular culture. His work has been published in journals including *Sociology of Sport Journal*, *Policy Sciences*, *New Media & Society*, *Sport in Society*, *Cultural Studies/Critical Methodologies*, the *International Journal of Sport Management and Marketing*, and the *International Journal of Sports Marketing and Sponsorship*. jscherer@ualberta.ca

Michael L. Silk (Ph.D., University of Otago) is Senior Lecturer in Education at the University of Bath, UK. He has published extensively on media-sport mega events, national identity and globalization and is on the editorial boards of the *Journal of Sport & Social Issues*, *Sociology of Sport Journal*, and the *Journal of Sports Tourism*. His current research focuses on the governance of abject bodies and representations of urban space. m.silk@bath.ac.uk

Robert E. C. Sparks (Ph.D., University of Massachusetts) is Professor of Human Kinetics at the University of British Columbia, Vancouver. Over the last ten years his research has been focused in the areas of consumer culture, public health, and the political economy of tobacco and alcohol marketing with particular emphasis on the processes of social communication in advertising and the mass media, and theories and methods in audience research and reception analysis. robert.sparks@ubc.ca

James R. Walker (Ph.D., University of Iowa) is Professor and Chair of the Department of Communication at Saint Xavier University, Chicago. His books include *The Broadcast Television Industry* (with Douglas Ferguson), and three books with Robert V. Bellamy, Jr., including most recently *Center Field Shot: A History of Baseball on Television*. His research focuses on televised sports, television programming and promotion practices, and the impact of remote control devices on television viewing. walker@sxu.edu

Lawrence A. Wenner (Ph.D., University of Iowa) is Von der Ahe Professor of Communication and Ethics at Loyola Marymount University, Los Angeles. He is a former editor of the *Journal of Sport and Social Issues* and his books include *Media, Sports, and Society* and *MediaSport*. His current research focuses on media criticism on the ethics of racial and gender portrayals in commodified narratives. lwenner@lmu.edu

Garry Whannel (Ph.D., University of Birmingham, UK) is Professor of Media Cultures at the University of Bedfordshire, UK. His books include *Culture, Politics and Sport*, *Media Sport Stars*, *Masculinities and Moralities*, and *Fields in Vision: Television Sport and Cultural Transformation*. His current research interests include journalism, politics, and the Olympic games; celebrity culture and the vortextuality process; and the growth of commercial sponsorship. garry.whannel@ beds.ac.uk

Index

Toby Miller
General Editor

Popular Culture and Everyday Life is the new place for critical books in cultural studies. The series stresses multiple theoretical, political, and methodological approaches to commodity culture and lived experience by borrowing from sociological, anthropological, and textual disciplines. Each volume develops a critical understanding of a key topic in the area through a combination of thorough literature review, original research, and a student-reader orientation. The series consists of three types of books: single-authored monographs, readers of existing classic essays, and new companion volumes of papers on central topics. Fields to be covered include: fashion, sport, shopping, therapy, religion, food and drink, youth, music, cultural policy, popular literature, performance, education, queer theory, race, gender, and class.

For additional information about this series or for the submission of manuscripts, please contact:

> Toby Miller
> Department of Media & Cultural Studies
> Interdisciplinary Studies Building
> University of California, Riverside
> Riverside, CA 92521

To order other books in this series, please contact our Customer Service Department:

> (800) 770-LANG (within the U.S.)
> (212) 647-7706 (outside the U.S.)
> (212) 647-7707 FAX

Or browse online by series: www.peterlang.com